2021
清华国际艺术与设计教育大会暨优秀毕业作品展

COLLECTION OF 2021 TSINGHUA INTERNATIONAL CONFERENCE ON ART & DESIGN EDUCATION

清华大学美术学院 编

中国建筑工业出版社

图书在版编目（CIP）数据

2021清华国际艺术与设计教育大会暨优秀毕业作品展＝
COLLECTION OF 2021 TSINGHUA INTERNATIONAL
CONFERENCE ON ART & DESIGN EDUCATION / 清华大学美
术学院编. -- 北京：中国建筑工业出版社，2022.4
　　ISBN 978-7-112-27239-6

　　Ⅰ. ①2… Ⅱ. ①清… Ⅲ. ①艺术－作品综合集－中
国－现代 Ⅳ. ①J121

中国版本图书馆CIP数据核字(2022)第047649号

主　　编：杨冬江
副 主 编：师丹青　封　帆
责任编辑：唐　旭　吴　绫
文字编辑：李东禧　孙　硕
装帧设计：王　鹏
责任校对：王　烨

2021清华国际艺术与设计教育大会暨优秀毕业作品展
COLLECTION OF 2021 TSINGHUA INTERNATIONAL
CONFERENCE ON ART & DESIGN EDUCATION
清华大学美术学院　编
＊
中国建筑工业出版社出版、发行（北京海淀三里河路9号）
各地新华书店、建筑书店经销
北京星空浩瀚文化传播有限公司　制版
天津图文方嘉印刷有限公司　印刷
＊
开本：880毫米×1230毫米　1/16　印张：31½　字数：896千字
2022年4月第一版　2022年4月第一次印刷
定价：678.00元
ISBN 978-7-112-27239-6
　　（39103）

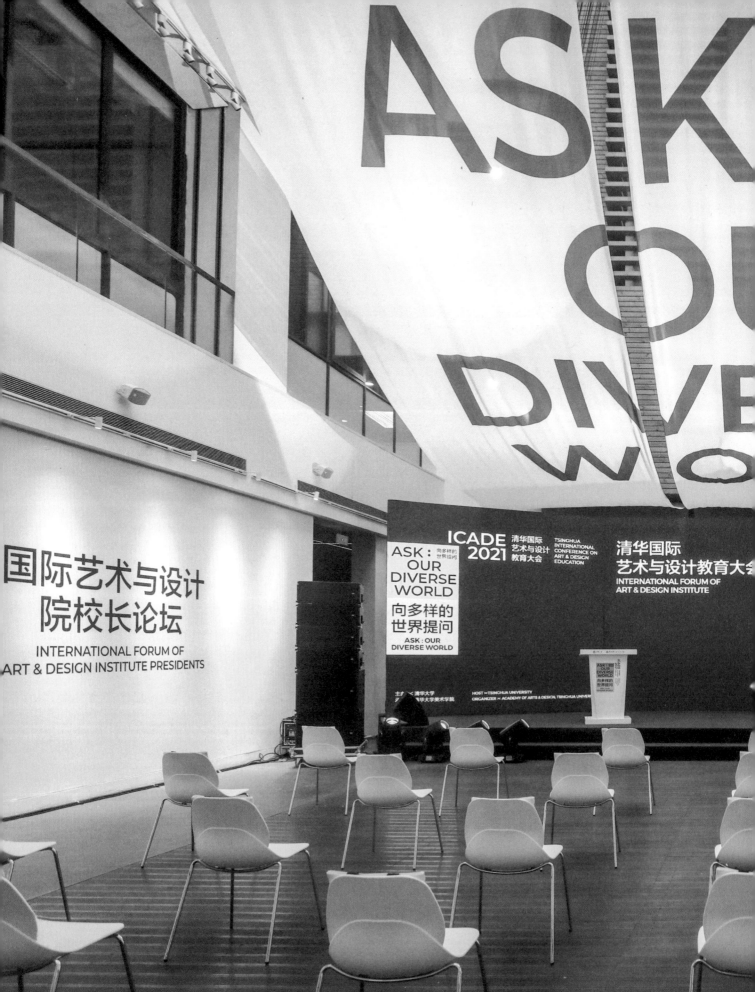

目录
CONTENTS

CONFERENCE ORGANIZATION

HOST : TSINGHUA UNIVERSITY
ORGANIZER : ACADEMY OF ARTS & DESIGN, TSINGHUA UNIVERSITY

ORGANIZING COMMITTEE

CHAIR
PENG GANG
ACTING CHAIR
LU XIAOBO, MA SAI
DEPUTY CHAIR
LI JINLIANG, ZENG CHENGGANG, SU DAN, WU QIONG, YANG DONGJIANG, FANG XIAOFENG, ZHAO CHAO, LI HE, ZANG YINGCHUN
SECRETARY GENERAL
YANG DONGJIANG
DEPUTY SECRETARY GENERAL
SHI DANQING, FENG FAN
COMMITTEE MEMBER
BAI MING, ZHANG LEI, CHEN LEI, SONG LIMIN, WANG ZHIGANG, WEN ZHONGYAN, DONG SHUBING, HONG XINGYU, CHEN ANYING, QIU SONG, ZHANG BAOHUA, REN QIAN, HE JING, MI HAIPENG, GUO LINHONG, LI WEN, LIU RUNFU

ACADEMIC COMMITTEE

DIRECTOR
LU XIAOBO
COMMITTEE MEMBER
BLINOVA ELENA KONSTANTINOVNA, HANS BERNHARD, JONATHAN STITELMAN, IAN CAMPBELL, ANDREY ALEXANDROVICH NOVIKOV, MIGLIORE LODOVICO, JOHN ATKIN, GUILLAUME DÉGÉ, SILVIA ELVIRA MARIA PIARDI, JESSICA SAUNDERS, SUSANNE SLAVICK, PAUL CHAPMAN, NANCY VERONICA MORGADO DINIZ, SHONA KITCHEN, BINE ROTH, SWOO K. SUH, MANFREDO MANFREDINI, SVEN TRAVIS, RUT BLEES LUXEMBURG, MORINO AKITO, YAMAMURA SHINYA, MASAKO KITAZAKI, FENG YUAN, HAN MEILIN, WANG MINGZHI, LIU GUANZHONG, LIU JUDE, DU DAKAI, MA SAI, ZENG CHENGGANG, WU QIONG, YANG DONGJIANG, LIU MAOPING, SU XINPING, LOU YONGQI, FANG XIAOFENG, SU DAN, STEPHEN J. WANG, SONG XIAOFENG, ZHANG JIE, ZHANG GAN, LI HE, ZHAO CHAO, ZHAO LU, CAO XIAOYANG, GUO ZHENSHAN, SNOW YUNXUE FU, JIANG TIELI, ZANG YINGCHUN, CAI YONGHUA, CHEN HUI, SHI DANQING, FENG FAN

组织机构

主办单位：清华大学
承办单位：清华大学美术学院

组织委员会

主席
彭刚

执行主席
鲁晓波、马赛

副主席
郦金梁、曾成钢、苏丹、吴琼、杨冬江、方晓风、赵超、李鹤、臧迎春

秘书长
杨冬江

副秘书长
师丹青、封帆

委员
白明、张雷、陈磊、宋立民、王之纲、文中言、董书兵、洪兴宇、陈岸瑛、邱松、张宝华、任茜、何静、米海鹏、郭林红、李文、刘润福

学术委员会

主任
鲁晓波

委员
布利诺娃·埃琳娜·康斯坦丁诺夫娜、汉斯·伯恩哈德、乔纳森·斯蒂尔曼、伊恩·坎贝尔、安德烈·亚历山德罗维奇·诺维科夫、米利·洛多维科、约翰·阿特金、纪尧姆·德热、西尔维娅·埃尔维拉·玛丽亚·皮亚迪、杰西卡·桑德、苏珊·斯拉维克、保罗·查普曼、南希·维罗妮卡·莫加多·迪尼兹、修纳·基钦、宾·罗斯、徐秀卿、曼弗雷多·曼弗雷迪尼、斯文·特拉维斯、鲁特·布莱斯·卢森堡、森野彰人、山村慎哉、北崎允子、冯远、韩美林、王明旨、柳冠中、刘巨德、杜大恺、马赛、曾成钢、吴琼、杨冬江、刘茂平、苏新平、娄永琪、方晓风、苏丹、王佳、宋晓峰、张杰、张敢、李鹤、赵超、赵璐、曹晓阳、郭振山、傅韵雪、蒋铁骊、臧迎春、蔡拥华、陈辉、师丹青、封帆

CONFERENCE THEME

The 2021 Tsinghua International Conference on Art & Design Education (ICADE 2021) builds an international academic exchange platform as well as a bridge of multicultural communication. Running on the theme"ASK: Our Diverse World", the conference features more than 50 top art and design institutes, across 5 sections:

> Presidential Forum
> Academic Symposia
> Graduation Exhibition
> Workshops
> Student Forum

These directly and comprehensively display new trends in art and design education, seeking the epochal value of art and design between difference and consensus.

INTERNATIONAL FORUM OF ART & DESIGN INSTITUTE PRESIDENTS
> October 29th, 2021

INTERNATIONAL ACADEMIC SYMPOSIA OF ART & DESIGN EDUCATION
> October 30th, 2021

INTERNATIONAL GRADUATION EXHIBITION OF ART & DESIGN INSTITUTES
> October 29th - November 15th, 2021

INTERNATIONAL ART & DESIGN WORKSHOPS
> October 16th - October 31st, 2021

INTERNATIONAL ART & DESIGN STUDENT FORUM
> October 31st, 2021

大会主旨

2021清华国际艺术与设计教育大会旨在搭建国际化学术交流平台，构筑多元文化沟通桥梁。大会以"向多样的世界提问"为主题，邀请全球50余所顶级艺术院校，通过院校长论坛、教育学术研讨会、优秀毕业作品展览、系列工作坊、学生论坛五大版块，全面直观地展示国际艺术与设计教育最新成果，在差异与共识中，探求艺术与设计的时代价值。

ICADE 2021 清华国际艺术与设计教育大会 TSINGHUA INTERNATIONAL CONFERENCE ON ART & DESIGN EDUCATION

国际艺术与设计院校长论坛
> 2021.10.29

国际艺术与设计教育学术研讨会
> 2021.10.30

国际艺术与设计院校优秀毕业作品展
> 2021.10.29–2021.11.15

国际艺术与设计系列工作坊
> 2021.10.16–2021.10.31

国际艺术与设计院校学生论坛
> 2021.10.31

INTERNATIONAL PARTICIPATING INSTITUTES

Royal College of Art

Parsons School of Design, The New School

Rhode Island School of Design

Central Saint Martins, UAL

Chelsea College of Arts, UAL

School of Design, Polytechnic University of Milan

The Glasgow School of Art

Repin Academy of Fine Arts

School of Arts, Design and Architecture, Aalto University

Pratt Institute

School of Visual Arts, New York City

School of the Art Institute of Chicago

Art Center College of Design

California Institute of the Arts

London College of Fashion

ECAL, University of Art and Design Lausanne

Maryland Institute College of Art

Yale School of Art, Yale University

School of Art, Carnegie Mellon University

Stuart Weitzman School of Design, University of Pennsylvania

Tisch School of the Arts, New York University

School of Art & Design, Southern Illinois University

Sam Fox School of Design & Visual Arts, Washington University in St. Louis

Rochester Institute of Technology

French National Institute for Advanced Studies in Industrial Design

French National School of Decorative Arts

Goldsmiths, University of London

Slade School of Fine Art, University College London

Kunsthochschule Kassel

Academy of Media Arts Cologne

国外参与院校

英国皇家艺术学院

帕森斯设计学院

罗德岛设计学院

伦敦艺术大学中央圣马丁艺术与设计学院

伦敦艺术大学切尔西艺术与设计学院

米兰理工大学

格拉斯哥美术学院

列宾美术学院

阿尔托大学艺术设计与建筑学院

普瑞特艺术学院

纽约视觉艺术学院

芝加哥艺术学院

艺术中心设计学院

加州艺术学院

伦敦时装学院

洛桑艺术设计大学

马里兰艺术学院

耶鲁大学艺术学院

卡耐基梅隆大学艺术学院

宾夕法尼亚大学韦茨曼设计学院

纽约大学帝势艺术学院

南伊利诺伊大学设计艺术学院

圣路易斯华盛顿大学设计与视觉艺术学院

罗切斯特理工学院

法国国立高等工业设计学院

法国国立高等装饰艺术学院

伦敦大学金史密斯学院

伦敦大学学院斯莱德美术学院

卡塞尔艺术学院

科隆媒体艺术学院

ICADE 2021

ASK:
OUR
DIVERSE
WORLD

向多样的
世界提问
ASK : OUR
DIVERSE WORLD

清华国际
艺术与设计
教育大会

TSINGHUA
INTERNATIONAL
CONFERENCE ON
ART & DESIGN
EDUCATION

University of the Arts Bremen

Stuttgart State Academy of Art and Design

School of Design and Creative Arts, Loughborough University

School of Art, Royal Melbourne Institute of Technology

School of Architecture and Planning, The University of Auckland

Emily Carr University of Art + Design

Tokyo University of the Arts

Musashino Art University

Tama Art University

Kanazawa College of Art

Kyoto City University of Arts

National University of Singapore

School Of Art, Design and Media, Nanyang Technological University, Singapore

Sookmyung Women's University

DOMESTIC PARTICIPATING INSTITUTES

Central Academy of Fine Arts

China Academy of Art

LuXun Academy of Fine Arts

Sichuan Fine Arts Institute

Guangzhou Academy of Fine Arts

Xi'an Academy of Fine Arts

Hubei Institute of Fine Arts

Tianjin Academy of Fine Arts

Shanghai Academy of Fine Arts, Shanghai University

College of Design and Innovation, Tongji University

School of Design,The Hong Kong Polytechnic University

Beijing Institute of Fashion Technology

不来梅艺术学院

国立斯图加特艺术学院

拉夫堡大学设计创意艺术学院

皇家墨尔本理工大学艺术学院

奥克兰大学建筑与规划学院

艾米丽卡尔艺术与设计大学

东京艺术大学

武藏野美术大学

多摩美术大学

金泽工艺美术大学

京都市立艺术大学

新加坡国立大学

新加坡南洋理工大学艺术设计媒体学院

淑明女子大学

国内参与院校

中央美术学院

中国美术学院

鲁迅美术学院

四川美术学院

广州美术学院

西安美术学院

湖北美术学院

天津美术学院

上海大学上海美术学院

同济大学设计创意学院

香港理工大学设计学院

北京服装学院

ASK : OUR DIVERSE WORLD

As the world changes, new challenges, new ways of thinking and new solutions emerge rapidly. In a post-pandemic new normal, how can we review art and design education from a global perspective again? How can we seek continuing interactions between different cultures and deepen interdisciplinary collaborations? What is the best way to cultivate talents with a forward-looking perspective? Our diverse community has endless expectations and infinite possibilities. Confusion ends in raising questions and exploration begins with answers. Between questions and answers, we are connected to each other. It's the right time to question the diverse world.

向多样的世界提问

世界更迭变换，新的挑战、新的思维与新的解决之道应运而生。在后疫情时代，我们如何"再次"以全球化的视角审视艺术与设计教育，寻求不同文化间可持续的互动与发展，鼓励跨学科的深层融合，培养具有时代特色与国际前瞻视野的人才……多样的世界蕴含着无尽的期待，多样的世界海纳了无限的可能。混沌止于提问，探索始于回答，问答之间，我们彼此相连。向多样的世界提问，一切恰逢其时。

ASK：
OUR
DIVERSE
WORLD

向多样的
世界提问

向多样的
世界提问

ASK : OUR
DIVERSE WORLD

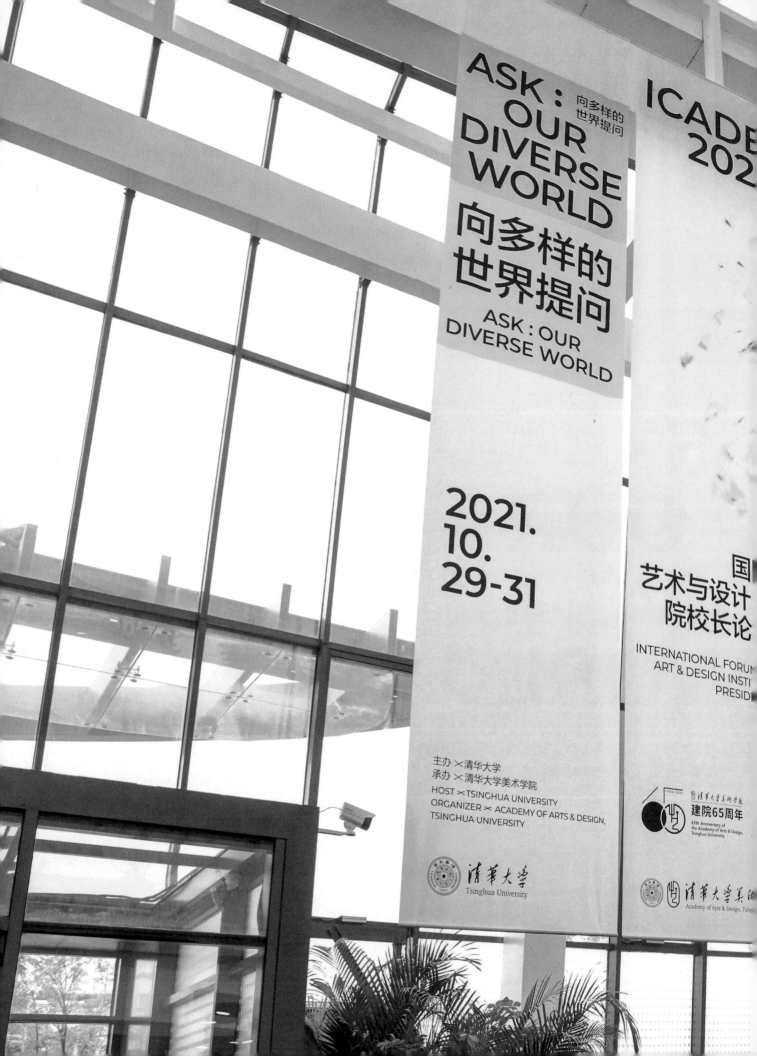

国际
艺术与设计
院校长论坛

INTERNATIONAL FORUM OF ART & DESIGN INSTITUTE PRESIDENTS

OPENING CEREMONY OF 2021 TSINGHUA INTERNATIONAL CONFERENCE ON ART & DESIGN EDUCATION AND INTERNATIONAL FORUM OF ART & DESIGN INSTITUTE PRESIDENTS

Time: October29th,2021
Venue: Block B, Academy of Arts & Design, Tsinghua University

As an important part of 2021 Tsinghua International Conference on Art & Design Education, the Opening Ceremony of the Conference as well as the launching of International Forum of Art & Design Institute Presidents will be hold on October the 29th, which invites presidents from world renowned art and design institutes. The presidents will share professional insights on how to break through the limitations of physical space and reflect on the art and design education issues of our common concern. This forum will serve as a vibrant space, reflecting the status of global art and design education, as well as a platform for meaningful cross-border and interdisciplinary exchange between institutions from different backgrounds.

2021 清华国际艺术与设计教育大会开幕式
暨国际艺术与设计院校长论坛

时间: 2021.10.29
地点: 清华大学美术学院 B 区

作为 2021 清华国际艺术与设计教育大会的重要组成部分, 10 月 29 日将举行大会开幕式暨院校长论坛。来自世界各地知名艺术与设计院校的负责人, 将在论坛中分享专业观点, 讨论如何突破物理空间的限制反思艺术与设计教育领域共同关心的问题 在探讨全球艺术与设计教育现状的同时, 论坛将会为来自不同背景的学术教育机构打造意义深远的跨界、跨学科交流平台。

ASK : 向多样的
世界提问

ASK :
OUR
DIVERSE
WORLD

向多样的
世界提问

ASK : OUR
DIVERSE WORLD

ASK:

OUR

DIVERSE
WORLD

国际艺术与设计
院校长论坛
INTERNATIONAL FORUM OF
ART & DESIGN INSTITUTE PRESIDENTS

OPENING CEREMONY OF 2021 TSINGHUA INTERNATIONAL CONFERENCE ON ART & DESIGN EDUCATION

Time	Schedule
9:00-9:05	Opening and introducing guests by Prof. Ma Sai, Tsinghua University
9:05-9:15	Speech by Prof. Peng Gang, chair of the Conference Organizing Committee, vice president of Tsinghua University
9:15-9:25	Speech by Prof. Feng Yuan, vice chair of China Federation of Literary & Art Circles, deputy director of Central Research Institute of Culture and History, honorary chair of China Artists Association
9:25-9:35	Speech by Prof. Lu Xiaobo, dean of Academy of Arts & Design, Tsinghua University
9:35-9:45	Conference Launching Ceremony

INTERNATIONAL FORUM OF ART & DESIGN INSTITUTE PRESIDENTS

Time	Schedule
9:45-9:50	**Prof. Yang Dongjing** deputy dean of Academy of Arts &Design,Tsinghua University, hosts the morning session of the forum
9:50-10:00	**Lu Xiaobo** Dean of Academy of Arts & Design, Tsinghua University
10:00-10:10	**Naren Barfield** Deputy Vice-Chancellor and Provost of Royal College of Art
10:10-10:20	**Fan Di'an** Dean of Central Academy of Fine Arts
10:20-10:30	**Rachel Schreiber** Dean of Parsons School of Design

2021 清华国际艺术与设计教育大会开幕式

时间	具体安排
9:00-9:05	清华大学美术学院党委书记马赛 主持大会开幕式并介绍到场嘉宾
9:05-9:15	大会组委会主席、清华大学副校长彭刚致辞
9:15-9:25	中国文联副主席、中央文史馆副馆长、 中国美术家协会名誉主席冯远致辞
9:25-9:35	清华大学美术学院院长鲁晓波致辞
9:35-9:45	大会开幕启动仪式

国际艺术与设计院校长论坛

时间	具体安排
9:45-9:50	清华大学美术学院副院长杨冬江 主持上午院校长论坛
9:50-10:00	**鲁晓波** 清华大学美术学院院长
10:00-10:10	**纳伦·巴菲尔德** 皇家艺术学院副院长
10:10-10:20	**范迪安** 中央美术学院院长
10:20-10:30	**瑞秋·施莱博** 帕森斯设计学院院长

ICADE 2021 清华国际 TSINGHUA INTERNATIONAL CONFERENCE ON ART & DESIGN EDUCATION
艺术与设计 教育大会

ASK: OUR DIVERSE WORLD
向多样的 世界提问
向多样的世界提问
ASK : OUR DIVERSE WORLD

| 10:30-10:40 | **Xu Fen** |
| | Dean of Hubei Institute of Fine Arts |

| 10:40-10:50 | **Luisa Collina** |
| | Dean of School of Design，Polytechnic University of Milan |

| 10:50-11:00 | **Allyson Green** |
| | Director of Tisch School of the Arts, New York University |

| 11:00-11:10 | **Lou Yongqi** |
| | Vice president, Dean of College of Design and Innovation, Tongji University |

| 11:10-11:20 | **Frederick Steiner** |
| | Dean of Stuart Weitzman School of Design,University of Pennsylvania |

| 11:20-11:30 | **Pang Maokun** |
| | Dean of Sichuan Fine Arts Institute |

| 13:30-13:40 | **Prof. Fang Xiaofeng** |
| | deputy dean of Academy of Arts &Design, Tsinghua University, hosts the afternoon session of the forum |

| 13:40-13:50 | **Han Xu** |
| | Deputy Dean of China Academy of Art |

| 13:50-14:00 | **Nagasawa Tadanori** |
| | President of Musashino Art University |

| 14:00-14:10 | **Li Jinkun** |
| | Dean of Guangzhou Academy of Fine Arts |

| 14:10-14:20 | **Kent Kleinman** |
| | Provost of Rhode Island School of Design |

| 14:20-14:30 | **Akira Tatehata** |
| | President of Tama Art University |

| 14:30-14:40 | **Zhu Jinhui** |
| | Dean of Xi'an Academy of Fine Arts |

| 14:40-14:50 | **Penny Macbeth** |
| | Director of The Glasgow School of Art |

10:30-10:40	**许奋** 湖北美术学院院长
10:40-10:50	**路易莎·科里纳** 米兰理工大学设计学院院长
10:50-11:00	**艾莉森·格林** 纽约大学帝势艺术学院院长
11:00-11:10	**娄永琪** 同济大学副校长、设计创意学院院长
11:10-11:20	**弗雷德里克·斯坦纳** 宾夕法尼亚大学韦茨曼设计学院院长
11:20-11:30	**庞茂琨** 四川美术学院院长
13:30-13:40	清华大学美术学院副院长方晓风 主持下午院校长论坛
13:40-13:50	**韩绪** 中国美术学院副院长
13:50-14:00	**长泽忠德** 武藏野美术大学校长
14:00-14:10	**李劲堃** 广州美术学院院长
14:10-14:20	**肯特·克莱曼** 罗德岛设计学院教务长
14:20-14:30	**建畠哲** 多摩美术大学校长
14:30-14:40	**朱尽晖** 西安美术学院院长
14:40-14:50	**彭妮·麦克白** 格拉斯哥美术学院院长

14:50-15:00	**Frédérique Pain** Dean of French National Institute for Advanced Studies in Industrial Design
15:00-15:10	**Li Xiangqun** Dean of LuXun Academy of Fine Arts
15:20-15:30	**Jia Guangjian** Dean of Tianjin Academy of Fine Arts
15:30-15:40	**Alexis Georgacopoulos** President of University of Art and Design Lausanne
15:40-15:50	**Yamazaki Tsuyoshi** President of Kanazawa College of Art
15:50-16:00	**Zeng Chenggang** Dean of Shanghai Academy of Fine Arts, Shanghai University
16:00-16:10	**Kun-Pyo Lee** Dean of School of Design, the Hong Kong Polytechnic University
16:10-16:20	**Joel Baumann** Dean of Kunsthochschule Kassel
16:20-16:30	**Jia Ronglin** Dean of Beijing Institute of Fashion Technology

14:50-15:00	**弗雷德里克·佩恩** 法国高等工业设计艺术学院院长
15:00-15:10	**李象群** 鲁迅美术学院院长
15:20-15:30	**贾广健** 天津美术学院院长
15:30-15:40	**亚历克西斯·乔治亚科普洛斯** 洛桑艺术设计大学院长
15:40-15:50	**山崎刚** 金泽工艺美术大学院长
15:50-16:00	**曾成钢** 上海大学上海美术学院院长
16:00-16:10	**李健杓** 香港理工大学设计学院院长
16:10-16:20	**乔尔·鲍曼** 卡塞尔艺术学院院长
16:20-16:30	**贾荣林** 北京服装学院院长

国际艺术与设计教育学术研讨会

INTERNATIONAL ACADEMIC SYMPOSIA OF ART & DESIGN EDUCATION

INTERNATIONAL ACADEMIC SYMPOSIA
OF ART & DESIGN EDUCATION

Time: October 30th,2021
Venue: Floor 4, Block A, Academy of Arts & Design, Tsinghua University

How should art and design education cope with the rapidly changing new world? What roles will art and design education play in the overall sense of higher education, blending in the knowledge teaching and talents cultivating of other disciplines? Educators, designers and artists from renowned art and design universities all over the world will share their thoughts and ideas, seeking the value and possibility of art and design while facing the challenges of the times through differences and consensus.

国际艺术与设计教育学术研讨会

时间: 2021.10.30
地点: 清华大学美术学院 A 区 4 层

艺术与设计教育应如何应对当今这个急剧变化的新世界? 艺术与设计在高等教育大格局中将扮演何种角色, 并融入其他学科的知识传授与人才培养之中? ⋯⋯ 来自中外知名艺术与设计院校的教育家以及设计师、艺术家们将分享各自的思想与观念, 在差异和共识中寻求艺术与设计在应对时代挑战时的价值与可能性。

ASK :
OUR
DIVERSE
WORLD

向多样的
世界提问

向多样的
世界提问

ASK : OUR
DIVERSE WORLD

ICADE 2021 清华国际 艺术与设计 教育大会　TSINGHUA INTERNATIONAL CONFERENCE ON ART & DESIGN EDUCATION

ASK :
OUR
DIVERSE
WORLD
向多样的
世界提问
ASK : OUR
DIVERSE WORLD

Time	Schedule	
09:00 – 11:30	**Symposium 1** New Species ? In a Cross-Disciplinary Paradigm	A435
	Symposium 2 New Syntax ? In a Compound Spatial Scale	A437
	Symposium 3 New Value ? In Mutual Learning of Form and Function	A439
	Symposium 4 New Responsibility ? Art as Method in a Challenging World	A440
12:00-13:00	**Lunch Break**	
13:30 - 16:00	**Symposium 5** New Experience ? Under a New Tempore-Spatial Condition	A435
	Symposium 6 New Direction ? Searching for a Path for Traditional Heritage Revival	A437
	Symposium 7 New Aesthetics ? In an Expression of Morphological Reconstruction	A439
	Symposium 8 New Trend ? In a Multiculturalist Collision	A440

时间	具体安排	
09:00 – 11:30	**第一会场** 学科交叉背景下的"新物种"	A435
	第二会场 复合空间尺度中的"新句法"	A437
	第三会场 形式功能互鉴中的"新价值"	A439
	第四会场 回应世界挑战中的"新责任"	A440
12:00-13:00	**午餐**	
13:30 – 16:00	**第五会场** 混合时空状态中的"新体验"	A435
	第六会场 传统复兴探索中的"新方向"	A437
	第七会场 形态重构表达中的"新审美"	A439
	第八会场 多元文化碰撞中的"新潮流"	A440

ASK :
OUR
DIVERSE
WORLD

向多样的
世界提问

ASK : OUR
DIVERSE WORLD

SYMPOSIUM 1

NEW SPECIES?
IN A CROSS-DISCIPLINARY PARADIGM

9:00 October 30th, 2021
A435, Block A, Academy of Arts & Design, Tsinghua University

When the art and design issues are becoming more and more complex, the importance of interdisciplinary innovation has become a consensus. In this context, many "new species" have emerged in our education. How shall we define these new disciplines? How to define the new boundary between disciplines? Or should there be the boundaries?

A435

MODERATOR

Wang Zhigang

Academy of Arts & Design, Tsinghua University
Chair of Department of Information Art & Design
Associate Professor

SPEAKER

Lu Xiaobo

Academy of Arts & Design, Tsinghua University
Dean, Professor

Wu Qiong

Academy of Arts & Design, Tsinghua University
Professor

Sven Travis

Parsons School of Design
Associate Professor

Shona Kitchen

Rhode Island School of Design
Associate Professor

Jin Jiangbo

Shanghai Academy of Fine Arts, Shanghai University
Deputy Dean, Professor

Stephen J. Wang

School of Design, the Hong Kong Polytechnic University
Professor

Liu Shuming

Tianjin Academy of Fine Arts
Associate Professor

Paul Chapman

The Glasgow School of Art
Professor

第一会场

学科交叉背景下的"新物种"

2021 年 10 月 30 日 9:00
清华大学美术学院 A 区 A435

面对日趋复杂的艺术和设计问题, 学科交叉创新已经成为共识。 在这个背景下, 艺术设计教育中, 也相应出现了许多"新物种", 如何定义新的学科? 如何界定学科之间新的边界? 学科之间是否应该有边界?

A435

学术主持
王之纲
清华大学美术学院
信息艺术设计系主任、副教授

发言嘉宾
鲁晓波
清华大学美术学院
院长、教授

吴琼
清华大学美术学院
党委副书记、教授

斯文·特拉维斯
帕森斯设计学院
副教授

修纳·基钦
罗德岛设计学院
副教授

金江波
上海大学上海美术学院
副院长、教授

王佳
香港理工大学设计学院
教授

刘姝铭
天津美术学院
副教授

保罗·查普曼
格拉斯哥艺术学院
教授

SYMPOSIUM 2

NEW SYNTAX?
IN A COMPOUND SPATIAL SCALE

9:00 October 30th, 2021
A437, Block A, Academy of Arts & Design, Tsinghua University

In the fields of architectural research and urban planning, whether it is visible structure or invisible space, today's temporal-spatial vocabulary is disrupted by new ideas brought by digital technology, the isolation due to the pandemic, and the needs of social development. In such a complex spatial scale, how can we reconstruct the vocabulary in order to form a new syntactic structure to realize today's expression?

A437

MODERATOR
Cui Donghui
Central Academy of Fine Arts
Deputy Dean of school of Architecture, Professor

SPEAKER
Manfredo Manfredini
School of Architecture and Planning,the University of Auckland
Associate Professor

Song Xiewei
Central Academy of Fine Arts
Dean of School of Design, Professor

Blinova Elena Konstantinovna
Repin Academy of Fine Arts
Professor

Zhou Haoming
Academy of Arts & Design, Tsinghua University
Professor

Song Limin
Academy of Arts & Design, Tsinghua University
Chair of Department of Environmental Design, Professor

Swoo K. Suh
Sookmyung Women's University
Executive Director of School of Design, Professor

Xie Xuan
Guangzhou Academy of Fine Arts
Professor

John Atkin
School of Design and Creative Arts, Loughborough University
Director of Internationalization (Creative Arts), Professor

第二会场
复合空间尺度中的"新句法"

2021 年 10 月 30 日 9:00
清华大学美术学院 A 区 A437

在建筑研究和城市规划领域中,不论是有形的结构还是无形的空间,今天的时空语汇被数字技术、疫情的隔绝以及社会发展的需要带来的新观念打散。在这样的复合的空间尺度中,如何将这些语汇重构,形成新的句法结构来实现今天的表达?

A437

学术主持
崔冬晖
中央美术学院
建筑学院副院长、教授

发言嘉宾
曼弗雷多·曼弗雷迪尼
奥克兰大学建筑与规划学院
副教授

宋协伟
中央美术美术学院
设计学院院长、教授

布利诺娃·埃琳娜·康斯坦丁诺夫娜
列宾美术学院
教授

周浩明
清华大学美术学院
教授

宋立民
清华大学美术学院
环境艺术设计系主任、教授

徐秀卿
淑明女子大学
设计学院执行院长、教授

谢璇
广州美术学院
教授

约翰·阿特金
拉夫堡大学设计创意艺术学院
艺术方向国际化总监、教授

ICADE 2021 清华国际 TSINGHUA
艺术与设计 INTERNATIONAL
教育大会 CONFERENCE ON
ART & DESIGN
EDUCATION

ASK:
OUR
DIVERSE
WORLD
向多样的
世界提问
ASK : OUR
DIVERSE WORLD
向多样的
世界提问

SYMPOSIUM 3

NEW VALUE?
IN MUTUAL LEARNING OF FORM AND FUNCTION

9:00 October 30th, 2021
A439, Block A, Academy of Arts & Design, Tsinghua University

Form serves function or function determines form? Innovative organizational forms as well as software and hardware experiments of innovation seem to have broken such a binary discussion, and even began to find a "new value", different from the past, in the mutual learning between the two ideas.

A439

MODERATOR

Qiu Song

Academy of Arts & Design, Tsinghua University
Chair of Basic Teaching and Research Group, Professor

SPEAKER

Zhao Chao

Academy of Arts & Design, Tsinghua University
Deputy Dean, Professor

Silvia Elvira Maria Piardi

School of Design, Polytechnic University of Milan
Professor

Chen Lei

Academy of Arts & Design, Tsinghua University
Chair of Department of Visual Communication,
Associate Professor

Xu Yingqing

Academy of Arts & Design, Tsinghua University
Professor

Duan Shengfeng

Sichaun Fine Arts Institute
Deputy Dean,Professor

Zhang Xinrong

Central Academy of Fine Arts
Deputy Dean of School of Design, Professor

Zhou Yanyang

Academy of Arts & Design, Tsinghua University
Associate Professor

Masako Kitazaki

Musashino Art University
Professor

第三会场
形式功能互鉴中的"新价值"

2021 年 10 月 30 日 9:00
清华大学美术学院 A 区 A439

形式服务于功能？功能决定了形式？今天创新组织形式和创新的软、硬件实验似乎已经打破了这样一种二元的讨论，更多的是开始在二者的互鉴中寻找到了一种不同于以往的"新价值"。

A439

学术主持

邱松
清华大学美术学院
基础教研室主任、教授

发言嘉宾

赵超
清华大学美术学院
副院长、教授

西尔维娅·埃尔维拉·玛丽亚·皮亚迪
米兰理工大学设计学院
教授

陈磊
清华大学美术学院
视觉传达设计系主任、副教授

徐迎庆
清华大学美术学院
教授

段胜峰
四川美术学院
副院长、教授

张欣荣
中央美术学院设计学院
副院长、教授

周艳阳
清华大学美术学院
副教授

北崎允子
武藏野美术大学
教授

SYMPOSIUM 4

NEW RESPONSIBILITY?
ART AS METHOD IN A CHALLENGING WORLD

9:00 October 30th, 2021
A440, Block A, Academy of Arts & Design, Tsinghua University

Since the concept of "the end of art" emerges, today's art gradually gets rid of the shackles of the traditional aesthetic paradigm, and participates in the construction of society, shouldering social responsibilities with humanistic spirit. In the world which is full of challenges, art should respond to these challenges through its own evolution, so as to generate new humanistic values.

A440

MODERATOR

Feng Fan

Academy of Arts & Design, Tsinghua University
Associate Professor

SPEAKER

Dong Shubing

Academy of Arts & Design, Tsinghua University
Chair of Department of Sculpture, Professor

Deng Yan

Academy of Arts & Design, Tsinghua University
Associate Professor

Snow Yunxue Fu

Tisch School of the Arts, New York University
Assistant Professor

Wen Zhongyan

Academy of Arts & Design, Tsinghua University
Chair of Department of Painting, Associate Professor

Susanne Slavick

School of Art, Carnegie Mellon University
Professor

Rut Blees Luxemburg

Royal College of Art
Lecturer

Jiang Tieli

Shanghai Academy of Fine Arts, Shanghai University
Deputy Dean ,Professor

David Schnuckel

Rochester Institute of Technology
Associate Professor

Annie Stanton

Tisch School of the Arts,New York University
Executive Director Administration

第四会场

回应世界挑战中的"新责任"

2021 年 10 月 30 日 9:00
清华大学美术学院 A 区 A440

在"艺术终结论"之后，今天的艺术逐渐摆脱了传统的审美范式的束缚，越来越多地参与着社会的构建，用人文精神承担起社会责任。在这个充满挑战的世界里，艺术应该通过自身范式的转移，来回应这些挑战，产生新的人文价值。

A440

学术主持
封帆
清华大学美术学院
副教授

发言嘉宾
董书兵
清华大学美术学院
雕塑系主任、教授

邓岩
清华大学美术学院
副教授

傅韵雪
纽约大学帝势艺术学院
助理教授

文中言
清华大学美术学院
绘画系主任、副教授

苏珊·斯拉维克
卡耐基·梅隆大学美术学院
教授

鲁特·布莱斯·卢森堡
皇家艺术学院
讲师

蒋铁骊
上海大学上海美术学院
副院长、教授

大卫·施纳克尔
罗彻斯特理工学院
助理教授

安妮·斯坦顿
纽约大学帝势艺术学院
行政副院长

ICADE
2021

清华国际
艺术与设计
教育大会

TSINGHUA
INTERNATIONAL
CONFERENCE ON
ART & DESIGN
EDUCATION

ASK:
OUR
DIVERSE
WORLD

向多样的
世界提问

ASK : OUR
DIVERSE WORLD

SYMPOSIUM 5

NEW EXPERIENCE?
UNDER A NEW TEMPORE-SPATIAL CONDITION

13:30 October 30th, 2021
A435, Block A, Academy of Arts & Design, Tsinghua University

In the information age, the way we communication has undergone a revolution with new technologies. What followed was a new time and space condition which mixed with Virtual/Real, on-line/off-line. In this instant, flat temporal and spatial concept, the production and research of art design has to adapt to a new experience.

A435

MODERATOR

Shi Danqing

Academy of Arts & Design, Tsinghua University
Associate Professor

SPEAKER

Yang Dongjiang

Academy of Arts & Design, Tsinghua University
Deputy Dean,Professor

Jussi Angeslevä

Berlin University of the Arts
Professor

Kostas Terzidis

College of Design and Innovation, Tongji University
Professor

Ico Lodovico

School of Design, Polytechnic University of Milan
Professor

Hans Bernhard

Academy of Media Arts Cologne
Professor

Akihiro Kubota

Tama Art University
Professor

Fei Jun

Central Academy of Fine Arts
Professor

Jonathan Stitelman

Sam Fox School of Design & Visual Arts,
Washington University in St. Louis
Lecturer

第五会场
混合时空状态中的 " 新体验 "

2021 年 10 月 30 日 13:30
清华大学美术学院 A 区 A435

在信息时代，我们交往、沟通的方式在技术的帮助下产生了革命性的改变。随之而来的是一个现实与虚拟、线上与线下混合的新时空状态。在这个即时、扁平的时间、空间状态里，我们艺术设计的生产、研究必然要适应一种新的体验。

A435

学术主持
师丹青
清华大学美术学院
副教授

发言嘉宾
杨冬江
清华大学美术学院
副院长、教授

尤西·安格斯莱瓦
柏林艺术大学
教授

康思达
同济大学设计创意学院
教授

依科·洛多维科
米兰理工大学设计学院
教授

汉斯·伯恩哈德
科隆媒体艺术学院
教授

久保田 晃弘
多摩美术大学
教授

费俊
中央美术学院
教授

乔纳森·斯蒂尔曼
圣路易斯华盛顿大学设计与视觉艺术学院
讲师

ICADE 2021 清华国际艺术与设计教育大会 TSINGHUA INTERNATIONAL CONFERENCE ON ART & DESIGN EDUCATION

ASK:
OUR
DIVERSE
WORLD
向多样的
世界提问
ASK : OUR
DIVERSE WORLD

SYMPOSIUM 6

NEW DIRECTION?
SEARCHING FOR A PATH FOR TRADITIONAL HERITAGE REVIVAL

13:30 October 30th, 2021
A437, Block A, Academy of Arts & Design, Tsinghua University

The rapid development of new technologies has impacted tremendously on how traditional art is learnt and taught. In the new era, setting a direction for the future technology and traditional wisdom is essential to all art educators and students.

A437

MODERATOR
Hang Jian
China Academy of Art
Director of Art Museum Complex of CAA, Professor

SPEAKER
Ma Sai
Academy of Arts & Design, Tsinghua University
Professor

Qiu Zhijie
Central Academy of Fine Arts
Dean of School of Experimental Art, Professor

Jiyong Lee
School of Art & Design,Southern Illinois University
Professor

Ian Campbell
School of Design and Creative Arts, Loughborough University
Professor

Chen Anying
Academy of Arts & Design, Tsinghua University
Chair of Department of Art History, Associate Professor

Morino Akito
Kyoto City University of Arts
Professor

Liu Runfu
Academy of Arts & Design, Tsinghua University
Associate Professor

Yamamura Shinya
Kanazawa College of Art
Professor

第六会场

传统复兴探索中的"新方向"

2021 年 10 月 30 日 13:30
清华大学美术学院 A 区 A437

新技术的飞速发展帮助我们更好地学习和继承传统艺术。在对传统的复兴之中，如何一方面适应并驾驭新技术，另一方面如何从历史传统中汲取营养，独立思考对未来的设定，是每一个艺术教育工作者和学生都需要找到的"新方向"。

A437

学术主持
杭间
中国美术学院
中国美术学院艺术博物馆群总馆长、教授

发言嘉宾
马赛
清华大学美术学院
党委书记、教授

邱志杰
中央美术学院
实验艺术学院院长、教授

李智勇
南伊利诺伊大学设计艺术学院
教授

伊恩·坎贝尔
拉夫堡大学设计创意艺术学院
教授

陈岸瑛
清华大学美术学院
艺术史论系主任、副教授

森野彰人
京都市立艺术大学
教授

刘润福
清华大学美术学院
副教授

山村慎哉
金泽工艺美术大学
教授

SYMPOSIUM 7

NEW AESTHETICS?
IN AN EXPRESSION OF MORPHOLOGICAL RECONSTRUCTION

13:30 October 30th, 2021
A439, Block A, Academy of Arts & Design, Tsinghua University

For a long time, our art college has been committed to pursuing a connection with tradition. Although it has a long teaching history, technological development still requires it to adapt to new trends and accept various changes in the world. In the new morphological reconstruction, future artists need to transform the reality into an abstract composition, so as to find a new aesthetic paradigm.

A439

MODERATOR

Bai Ming

Academy of Arts & Design, Tsinghua University
Chair of Department of Ceramic Design, Professor

SPEAKER

Zhang Gan

Academy of Arts & Design, Tsinghua University
Professor

Li He

Academy of Arts & Design, Tsinghua University
Professor

Hong Xingyu

Academy of Arts & Design, Tsinghua University
Chair of Department of Arts & Crafts, Professor

Li Jing

Academy of Arts & Design, Tsinghua University
Associate Professor

Andrey Alexandrovich Novikov

Repin Academy of Fine Arts
Dean of School of Sculpture, Professor

Cai Yonghua

Guangzhou Academy of Fine Arts
Deputy Dean, Professor

Guillaume Dégé

French National School of Decorative Arts
Professor

第七会场

形态重构表达中的"新审美"

2021 年 10 月 30 日 13:30

清华大学美术学院 A 区 A439

一直以来,艺术学院致力于追求与传统的联系。虽然学院有悠久的教学历史,技术发展还是要求其适应新潮流,接受世间种种形态的变化。在全新的形态重构中,未来艺术家需要将真实的自然转化为抽象的构图,从而找到新的审美范式。

A439

学术主持

白明
清华大学美术学院
陶瓷艺术设计系主任、教授

发言嘉宾

张敢
清华大学美术学院
教授

李鹤
清华大学美术学院
党委副书记、教授

洪兴宇
清华大学美术学院
工艺美术系主任、教授

李静
清华大学美术学院
副教授

安德烈·亚历山德罗维奇·诺维科夫
列宾美术学院
雕塑学院院长、教授

蔡拥华
广州美术学院
副院长、教授

纪尧姆·德热
法国国立高等装饰艺术学院
教授

ICADE 2021 清华国际艺术与设计教育大会 TSINGHUA INTERNATIONAL CONFERENCE ON ART & DESIGN EDUCATION

ASK:
OUR
DIVERSE
WORLD
向多样的
世界提问
ASK : OUR
DIVERSE WORLD

SYMPOSIUM 8

NEW TREND?
IN A MULTICULTURALIST COLLISION

13:30 October 30th, 2021
A440, Block A, Academy of Arts & Design, Tsinghua University

Where does the trend have been formed? It is the result of the convergence of various forces. Today's complex issues in the social, cultural and environmental fields—especially the topics of multiculturalism, health, and climate crisis—have collided with new "trends". This trend has promoted the growth of new disciplines and new formats. The design education and practice shall solve the problem of sustainable development in different works and shoulder the increasing social responsibility.

A440

MODERATOR
Zang Yingchun
Academy of Arts & Design, Tsinghua University
Chair of Department of Textile & Fashion, Professor

SPEAKER
Chen Zhengda
China Academy of Art
Associate Professor

Zhao Lu
LuXun Academy of Fine Arts
Deputy Dean,Professor

Zhang Lei
Academy of Arts & Design, Tsinghua University
Chair of Department of Industrial Design, Professor

Wang Yue
Academy of Arts & Design, Tsinghua University
Associate Professor

Bine Roth
Chelsea College of Arts,UAL
Associate Professor

Jessica Saunders
London College of Fashion
Professor

Nancy Veronica Morgado Diniz
Central Saint Martins,UAL
Professor

第八会场

多元文化碰撞中的"新潮流"

2021 年 10 月 30 日 13:30
清华大学美术学院 A 区 A440

潮流如何形成？它是各种力量汇聚的结果。今天社会、文化和环境领域出现的复杂问题——尤其是关于多元文化、健康、气候危机的话题，碰撞出了新的"潮流"。这个潮流促进了新学科、新的业态成长。我们的设计教学和创作，将在不同的工作中解决可持续发展问题，承担起日益增长的社会责任。

A440

学术主持

臧迎春
清华大学美术学院
染织服装艺术设计系主任、教授

发言嘉宾

陈正达
中国美术学院
副教授

赵璐
鲁迅美术学院
副院长、教授

张雷
清华大学美术学院
工业设计系主任、教授

王悦
清华大学美术学院
副教授

宾·罗斯
伦敦艺术大学切尔西艺术与设计学院
副教授

杰西卡·桑德斯
伦敦时装学院
教授

南希·维罗妮卡·莫加多·迪尼兹
中央圣马丁艺术与设计学院
教授

国际
艺术与设计
系列工作坊

INTERNATIONAL
ART & DESIGN
WORKSHOPS

INTERNATIONAL ART & DESIGN WORKSHOPS

**Venue:Multi-Function Hall, Block A, Academy of Arts & Design,
Tsinghua University**
Project Creating:October 16th – October 28th, 2021
Work Displaying:October 29th – November 15th, 2021

As an essential part of the 2021 Tsinghua International Art and Design Education Conference, the workshops themed "RE: ACTOR—International Art & Design Workshops" aim to allow young generations to respond more actively to the theme of the conference "ASK: Our Diverse World".

The Academy of Arts & Design,Tsinghua University has gathered teaching forces of the frontier disciplines of art and design, combined with teachers and students from many international colleges and universities, as well as social institutes and expert resources to form five thematic workshops across disciplinary and cultural boundaries. In the 5 workshops entitled "Crisis Countdown" "Robot Carnival" "Communication at a Distance" "Zero Gravity Fashion" and "Super Digital Scenes", to explore and bring forth new ideas in areas such as ecological art , machine personality, remote interaction, space fashion and digital experience.

国际艺术与设计工作坊

地点: 清华大学美术学院 A 区多功能厅
工作坊创作: 2021.10.16-2021.10.28
作品展览: 2021.10.29-2021.11.15

"RE:ACTOR 发声器——国际艺术与设计系列工作坊"是 2021 清华国际艺术与设计教育大会的重要组成部分, 旨在让青年力量发出更多声音, 以回应大会"向多样的世界提问"的主题。

清华大学美术学院集结了艺术与设计前沿学科的教学力量, 联合国际多所院校和社会机构的专家资源, 共同组成跨越学科和文化边界的五个工作坊, 以"危机倒计时""机器人嘉年华""远程'在一起'""零重力时尚"和"超级数字场景"为题, 分别在生态艺术、机器人格、远程互动、太空时尚和数字体验领域进行探究和创新。

ASK : 向多样的
世界提问

OUR

DIVERSE

WORLD

向多样的

世界提问

ASK : OUR

DIVERSE WORLD

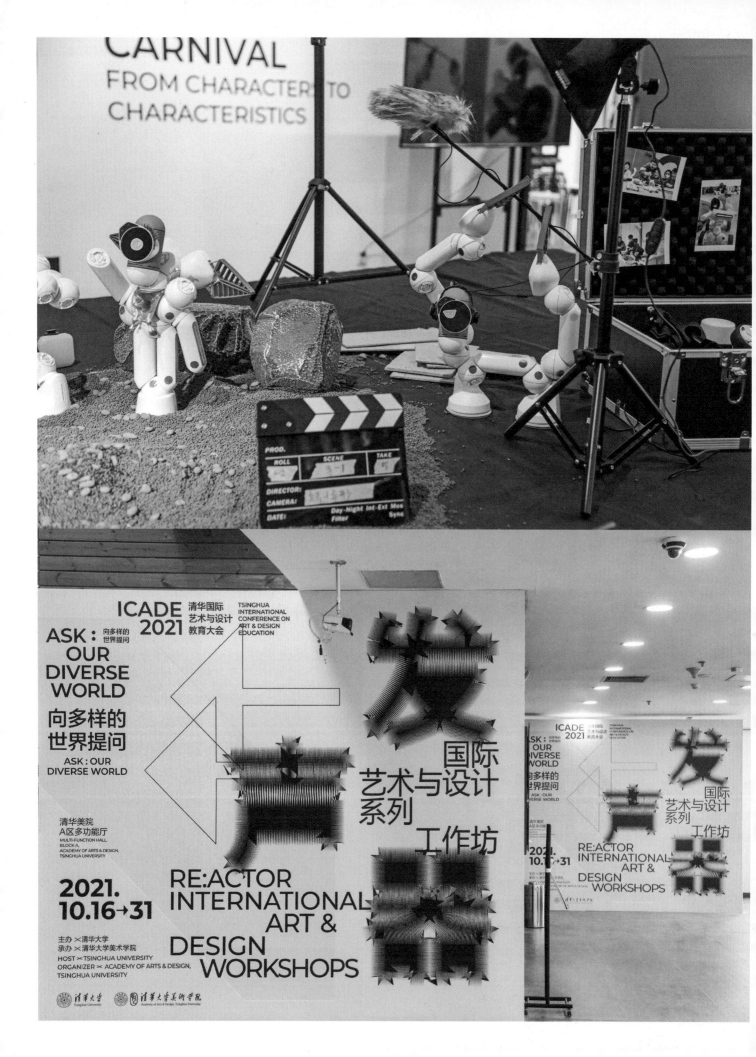

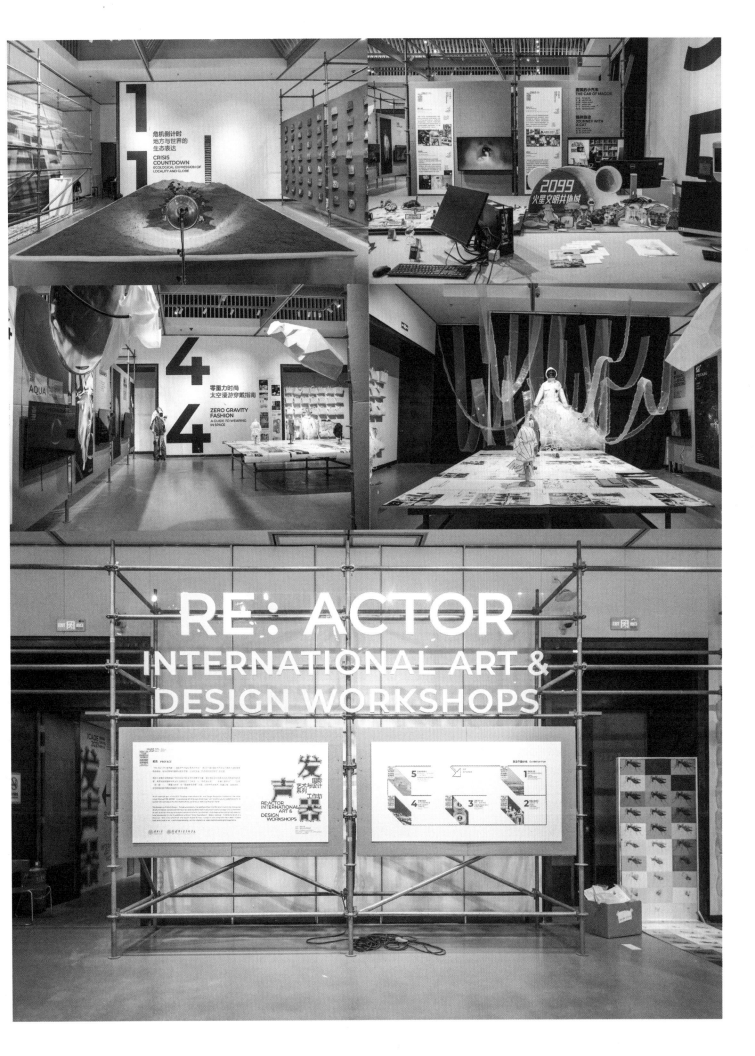

CRISIS COUNTDOWN - ECOLOGICAL EXPRESSION OF LOCALITY AND GLOBE

Tutors

Feng Fan
Associate Professor, Department of Painting, Academy of Arts & Design, Tsinghua University

Fu Bin
Associate Professor, Department of Painting, Academy of Arts & Design, Tsinghua University

Cai Wenjia
Associate Professor, Department of Earth System Science, Tsinghua University

Andrew Johnson
Associate Professor, School of Art, Carnegie Mellon University

Susanne Slavick
Chair Professor, School of Art, Carnegie Mellon University

Augustina Droze
Artist

Richard Satinoff
Artist

About

No one can stand alone in the face of global climate change. Compared with the issue of "carbon peaking and carbon neutralization", the issue of climate adaptation has yet to receive the same level of attention from the government. The effectiveness of a series of "double carbon" initiatives that have been implemented will not appear until 2050. No matter in Beijing or in Pittsburgh, our destiny is linked by an ongoing crisis. Will the weakness of institutions and systems lead to the failure of the overall destiny of mankind? How can art awaken frogs in warm water?

In the ecological art creation workshop organized and led by Fan Feng and Bin Fu, Associate Professors from the Academy of Arts & Design of Tsinghua University, two professors from Carnegie Mellon University brought their classroom-based artistic creation methods to the offline creative activities. Our creation will seek inspiration from the main conclusions of the "Lancet Health and Climate Change Report" written by Associate Professor Cai Wenjia, under the sub publication of "The Lancet" in 2021 – "Public Health", and interpret it from a macro and scientific perspective in combination with its research.

危机倒计时
地方与世界的生态表达

___ 导师组

封帆
清华大学美术学院绘画系 副教授

付斌
清华大学美术学院绘画系 副教授

蔡闻佳
清华大学地球系统科学系 副教授

安德鲁·约翰逊
卡耐基梅隆大学美术学院 副教授

苏珊妮·斯拉维克
卡耐基梅隆大学美术学院 讲席教授

奥古斯蒂娜·卓尔兹
艺术家

理查德·萨蒂诺夫
艺术家

___ 简介

在全球的气候变化面前, 没有人能独善其身。与"碳达峰""碳中和"问题相比, 气候适应问题并没有得到政府同样的重视。现在一系列"双碳"的举措, 其在气候变化方面的成效都将在 2050 年后才会显现。身在北京或匹兹堡, 我们的命运被一场正在发生的危机所联系, 机构和制度的无力是否会导致人类整体命运的失败? 艺术如何能唤醒温水中的青蛙?

在由清华大学美术学院封帆副教授、付斌副教授组织主导的生态艺术创作工作坊中, 卡耐基梅隆大学美术学院的两位教授将其课堂中的艺术创作方法带入线下的创作活动中。围绕清华大学地球系统科学系副教授蔡闻佳主笔的 2021《柳叶刀》子刊《公共健康》中 "柳叶刀健康与气候变化报告" 的主要结论, 我们的创作将从中寻找灵感, 结合其研究在宏观和科学的角度进行解读。

ICADE 2021

清华国际
艺术与设计
教育大会

TSINGHUA
INTERNATIONAL
CONFERENCE ON
ART & DESIGN
EDUCATION

ASK:
OUR
DIVERSE
WORLD

向多样的
世界提问

ASK : OUR
DIVERSE WORLD

ROBOT CARNIVAL -
FROM CHARACTERS TO CHARACTERISTICS

Tutors

Mi Haipeng

Associate Professor, Department of Information Art & Design,
Academy of Arts and Design, Tsinghua University

Chen Lei

Associate Professor, Department of Information Art & Design,
Academy of Arts and Design, Tsinghua University

Maria Luce Lupetti

Assistant Professor, Delft University of Technology

Zhang Qiushi

Clicbot Robot Engineer, Beijing KEYi Technology

About

With the theme of "Robot Carnival - From Characters to Characteristics", this workshop will explore the innovative form of future robot design through comprehensive application of the knowledge and skills across many disciplines such as robot technology, new media, interactive design and animation art.

This workshop will provide advanced modular robot creative platform components to support members with fast implementation of realistic robot design. From components to building roles to giving personality, we expect diversified robot design ideas to become a reality here.

We are rapidly entering a new robot era that is different from the common industrial robots period. Will future robots have more personalities? What kind of factors can affect robot's personality? Beauty, connotation, or its little temper? Incorporate bold ideas to create your robot buddy now!

机器人嘉年华
从角色到个性

导师组

米海鹏
清华大学美术学院信息艺术设计系 副教授

陈雷
清华大学美术学院信息艺术设计系 副教授

玛丽亚·卢兹·卢佩蒂
荷兰代尔夫特理工大学 助理教授

张秋实
北京可以科技有限公司 机器人工程师

简介

本工作坊以"机器人嘉年华——从角色到个性"为主题，将通过综合运用机器人技术、新媒体、交互设计、动画艺术等多个学科领域的知识与技能，探索未来机器人设计的创新形式。

我们将提供先进的模块化机器人创意平台组件，支持成员快速实现真实的机器人设计。从组件到构建角色，再到赋予个性，我们期待多样化的机器人设计创意在这里变成现实。

不同于当代更常见的工业机器人，我们正在快速迈入一个新的机器人时代。未来的机器人是否会具有更多样的个性？影响机器人个性的要素是什么？颜值、内涵，还是 TA 的小脾气？融入大胆的想法，来创造你的机器人小伙伴吧！

COMMUNICATION AT A DISTANCE - DESIGNING ACROSS SPACE AND TIME

Tutors

Xiang Fan

Associate Professor, Department of Visual Communication, Academy of Arts & Design, Tsinghua University

Sven Travis

Professor, Design and Technology, Parsons School of Design

Li Degeng

Associate Professor, Department of Visual Communication, Academy of Arts & Design, Tsinghua University

Tu Shan

Associate Researcher, Department of Environmental Art Design, Academy of Arts & Design, Tsinghua University

Cheng Peng

Founder, OF COURSE

About

Where is your closest person? By your side or far away from you? How do you communicate with each other if you are far away? Is there a closer way to communicate with each other? Have you ever imagined communication that is more realistic? Real time audio and video cannot solve the barriers of space and time difference, so we explore the way to integrate digital and analog technology, where people from all over the world can snuggle closely, and their true voices can be touched and resonated. The workshop explored the use of software and hardware to eliminate the obstacles of time and space, in order to provide a more intimate and real communication experience.

Remote working mode: Sven Travis, Founder of Design and Technology of Parsons School of Design, and Xiang Fan, Associate Professor from the Academy of Arts & Design of Tsinghua University, will hold the workshop simultaneously in New York and Beijing. Arduino and Touch Designer will be used together to explore more emotional remote expression.

远程"在一起"
时间、空间与体验

导师组

向帆
清华大学美术学院视觉传达设计系 副教授

斯文·特拉维斯
帕森斯设计学院设计与技术专业 教授

李德庚
清华大学美术学院视觉传达设计系 副教授

涂山
清华大学美术学院环境艺术设计系 副研究员

程鹏
OF COURSE 创始人

简介

你最亲密的人在哪里？在身边还是在远方？如果在远方彼此如何沟通？有更接近彼此交流的方式吗？有想象过更真实的沟通吗？实时的音频、视频并不能解决空间、时差的藩篱，所以我们探寻着数字与模拟技术相互融合的方式，让天各一方的人们可以亲密地依偎，使彼此真实的心声可以被碰触、被共鸣。本工作坊将探索利用软硬件去消隐时间、空间的障碍，探索让沟通成为一种更亲密、更真实的体验的可能性。

工作坊将采用远程工作模式，由帕森斯设计学院设计与技术专业创办人 SVEN TRAVIS 和清华大学美术学院向帆副教授分别在纽约和北京同步开展。将 ARDUINO 和 TOUCHDESIGNER 联动使用，探寻更具情感的远程表达。

ICADE 2021
清华国际艺术与设计教育大会
TSINGHUA INTERNATIONAL CONFERENCE ON ART & DESIGN EDUCATION

ASK: OUR DIVERSE WORLD
向多样的世界提问
ASK: OUR DIVERSE WORLD

ZERO GRAVITY FASHION - A GUIDE TO WEARING IN SPACE

Tutors

Shi Danqing

Associate Professor,Department of Information Art & Design, Academy of Arts & Design, Tsinghua University

Liu Ya

Assistant Professor, Department of Textile & Fashion Design, Academy of Arts & Design, Tsinghua University

Wang Yue

Associate Professor, Department of Textile & Fashion Design,Academy of Arts & Design, Tsinghua University

Liu Gang

Postdoctoral Fellow, Academy of Arts & Design / Future Laboratory, Tsinghua University

Zhong Shi

General Manager/Aerospace Science and Technology Expert, Beijing AZSPACE Technology Co., Ltd.

Li Jian

Concept Designer, College of Art and Design, Beijing University of Technology

Xi Xiaojin

New Media Artist

Liu Xin

Arts Curator, MIT Media Lab Space Exploration Initiative

Zhang Zhaohong

Artist, 5th Studio, Department of Sculpture, China Central Academy of Fine Arts

Rova Yilmaz

Scholar, Fashion, School of Design, Royal College of Art

Long Jin, Liu Haohai, Luo Qian

Engineering Technician, Toread Holdings

About

Focusing on the theme of space fashion, this workshop allows "fashion" to fly into space, from reality to science fiction, speculating future design needs with hard core technology, and challenging different application scenarios after space technology expands human life into space. It encourages students to boldly create the possibility of wearable design in zero gravity environment, predict the future interstellar life of mankind, and make a declaration for the future.

Through discussion and collaboration with tutors and experts, students can better understand interdisciplinary knowledge such as cutting-edge aerospace technology, space fashion design, intelligent textiles and digital programming. The workshop recruited students from specific disciplines at home and abroad to form a global innovation team and put forward targeted creative schemes.

Questions you may ask for the workshop are:
What is the fashion attitude and taste of space trendsetters?
How will a space wedding be held?
What should Mars base wear in 30 years?
How can new materials on Earth be incorporated in space clothes?

零重力时尚
太空漫游穿戴指南

导师组

师丹青
清华大学美术学院信息艺术设计系 副教授

刘亚
清华大学美术学院染织服装艺术设计系 助理教授

王悦
清华大学美术学院染织服装艺术设计系 副教授

刘岗
清华大学美术学院 / 清华大学未来实验室 博士后

钟时
北京紫微宇通科技有限公司 总经理 / 航天科技专家

李健
北京工业大学艺术设计学院 概念设计师

习晓瑾
新媒体艺术家

刘昕
麻省理工媒体实验室宇宙探索计划 艺术策划人

张兆宏
中央美术学院雕塑系第五工作室 艺术家

罗娃·耶尔马兹
皇家艺术学院时尚专业 学者

龙晋、刘昊海、罗倩
探路者集团 工程技术指导

简介

本工作坊以"零重力时尚——太空漫游穿戴指南"为主题,让"时尚"飞向太空,从现实到科幻,用硬核科技推测未来的设计需求,以挑战航天科技将人类生活扩展到太空领域之后的不同应用情景。鼓励学生大胆创意零重力环境下可穿戴设计的可能性,猜想人类未来的星际生活、提出未来宣言。

学生可与国内外跨学科导师团进行深度交流,和来自探路者及紫微科技相关领域的权威专家进行探讨与合作,了解前沿航天科技、太空服装设计、智能纺织品与数字编程等交叉学科知识。工作坊面向国内外特定学科背景的同学进行招募,共同组成全球创新团队,并提出针对性的创意方案。

在这里,你可能提出的问题是:太空潮人的时尚态度和审美是怎样的? 一场太空婚礼将如何举办? 在 30 年后火星基地应该穿什么? 地球上的新型材料怎样在太空服装中使用?

SUPER DIGITAL SCENES-
NEW SPACE ECONOMY & CITY CHANGE MAKER
/ MORE THAN GAMES

Tutors

Fu Zhiyong

Associate Professor, Department of Information Art & Design, Academy of Arts and Design, Tsinghua University

Zhang Lei

Professor, Department of Industrial Design, Academy of Arts & Design, Tsinghua University

Stefano Mangini

Professor, Polimoda Fashion School, Italy

Wang You

Founder of Youniversal

Expert from Roblox

Fang Ke

Lecturer, Tsinghua Shenzhen International Graduate School

Sun Xing

Lecturer, Tsinghua Shenzhen International Graduate School

Zhang Nick

NEXT Studios, Tencent Games

Chen Mo

Expert, Wujitang (Beijing) Culture Technology Co., Ltd.

Zhang Lance

Expert, Shenzhen Ember Culture Technology Co., Ltd.

超级数字场景
新太空经济·城市创变客 / 不止于游戏

导师组

付志勇
清华大学美术学院信息艺术设计系 副教授

张雷
清华大学美术学院工业设计系 教授

STEFANO MANGINI
意大利柏丽慕达时装学院 教授

王尤
万尤引力 创始人

罗布乐思专家

方可
清华大学深圳国际研究生院 讲师

孙兴
清华大学深圳国际研究生院 讲师

张哲川
腾讯游戏 NEXT STUDIO 游戏专家

陈默
无稽堂(北京)文化科技有限公司 专家

张臻然
深圳市余烬科技文化有限公司 专家

About

How can we create new value in the future super digital scene? Based on the theme of "Super Digital Scene", this workshop composes of "New Space Economy, City Change Maker" in the main venue in Beijing and "More than Games" in the Shenzhen venue.

"New Space Economy · City Change Maker"
(Main Venue at Academy of Arts & Design, Tsinghua University, Beijing)

When it is possible for humans to establish settlements on other planets, from earth to space, from design thinking to future thinking, the change makers participating in this workshop will explore the field of interdisciplinary disciplines, turn foresight into encounter, so as to give visionary innovation and respond to future challenges. We will think about how to start our journey, how to land in the mysterious space, and how to live in the boundless universe. It is planned to take Roblox as the main innovation platform tool to explore the theme of "New Space Economy, City Change Makers" in the digital virtual world. Taking space, city and economy as the key words, guide the workshop participants, stimulate creativity in groups, and create digital content that can be displayed, visited, explored and interactive in the digital virtual world with the help of the innovation tool platform. After getting familiar with the platform, the main challenge for the workshop participants is to integrate their creative content with the two themes of new space economy and urban innovation. At the same time, discuss and explore better ways to display the elements of space and city.

"More than Games"
(Shenzhen Branch, Tsinghua Shenzhen International Graduate School)

This workshop explores the inherent playfulness of science, engineering, medical treatment, education, architecture, management and other disciplines, encourages interdisciplinary cross collision to produce innovation, and realizes inspiration as interactive media works. In every corner of social life and scientific world, there are naturally many playful, fun and interactive existence. Through the form of interactive media, we can feel the scientific beauty and humanistic philosophy more intuitively, vividly and concretely. Our goal in this workshop is to expand the boundary of interactive media and explore the future of games from the perspective of interdisciplinary integration and practice. We will stimulate participants to re-examine the subject collision and explore the development direction of the interactive media industry through lectures, seminars, brainstorming, design and production of paper prototypes and digital works.

简介

在未来的超级数字场景中, 我们如何创造新的价值? 基于"超级数字场景"主题, 本工作坊由北京主会场的"新太空经济·城市创变客", 以及深圳分会场的"不止于游戏"两个板块组成。

"新太空经济·城市创变客"
(北京, 清华大学美术学院主会场)

当人类在其他行星建立定居点成为可能, 从地球到太空, 从设计思维到未来思维, 参加工作坊的创变客们将探索学科交叉的领域, 让预见变为遇见, 以赋予远见的创新回应未来的挑战。我们将思考以怎样的方式开启我们的征程, 以怎样的方式落地神秘的太空, 以怎样的方式安居在无垠的宇宙。我们计划以ROBLOX为主要创新平台工具, 探索在数字虚拟世界里聚焦"新太空经济·城市创变客"主题, 以太空、城市、经济为关键词, 引导工作坊参与群体分组激发创意。借助这个创新工具平台, 在数字虚拟世界中, 创造出可进行展示、游览、探索和交互的数字内容。在熟悉平台后, 如何将自身的创意内容与新太空经济和城市创变这两个主题整合, 成为工作坊成员的主要挑战。同时, 如何更好地展示太空和城市的要素, 也会成为重要的探讨和探索方向。

"不止于游戏"
(深圳, 清华大学深圳国际研究生院分会场)

探索科学、工程、医疗、教育、建筑、管理等学科内在的游戏性, 鼓励跨学科交叉碰撞产生创新, 并将灵感落地实现为互动媒体作品。在社会生活与科学世界的各个角落, 天然有着许多游戏性、乐趣性、交互性的存在。我们借由互动媒体的形式, 更直观、更形象、更具体地感受科学的美感、人文的哲思。我们的目标是从学科交叉融合出发, 以实践为基点, 扩展互动媒体的边界, 探索游戏的未来。我们将通过讲座、研讨、头脑风暴、纸面原型和数字作品的设计与制作等方式, 激发参与者对学科碰撞的重新审视, 为互动媒体行业的发展探索方向。

国际
艺术与设计
学生论坛

INTERNATIONAL
ART & DESIGN
STUDENT FORUM

INTERNATIONAL ART & DESIGN STUDENT FORUM

Time: October,31ᵗʰ,2021
Venue: Block A, Academy of Arts & Design, Tsinghua University

The International Art & Design Student Forum collects academic productions among graduate students, doctoral students and young scholars from China and all over the world, through two sections:" RE: ACTOR-International Forum of College Student Creativity" and "ASK: Our Diverse World – International Art and Design Doctoral Forum", aiming to build a platform that provides high-level, open-minded and multi-field academic exchanges, pushing for the development of art & design and fostering integration between different disciplines.

国际艺术与设计学生论坛

时间: 2021.10.31
地点: 清华大学美术学院 A 区

国际艺术与设计学生论坛通过"发声器——国际大学生创意论坛""向多样的世界提问——国际艺术与设计博士生论坛"两个环节, 面向中国和世界各地的研究生、博士生、青年学者征集最新学术研究成果, 旨在为青年学者提供一个高层次、开放性、多领域的学术交流平台, 在思想的交流与碰撞中推动艺术与设计领域学术发展, 促进多学科之间的贯通融合。

ASK ： 向多样的
世界提问

OUR
DIVERSE
WORLD

向多样的
世界提问

ASK ： OUR
DIVERSE WORLD

ASK:
OUR
DIVERSE
WORLD

向多样的
世界提问
ASK : OUR
DIVERSE WORLD

Time	Schedule

9:00-11:30

RE: ACTOR-International Forum of College Student Creativity
This forum of creativity is the final section of the international innovative education practice of "International Art & Design Workshops", where the students will present more than 30 creative projects. It is hoped that with this event, students' expressiveness will be amplified in innovative experimental teaching in a global context, inspiring college students to continuously meet new challenges and speak out their innovative ideas and propositions!

13:30-17:00

ASK: Our Diverse World –
International Art and Design Doctoral Forum
The doctoral forum, relying on the exchange platform and academic tradition of Tsinghua University, with the original intention of international vision and disciplinary integration, upholding an open, pragmatic, and innovative research and communication attitude, it brings together excellent young scholars from the fields of Art Theory and Fine Art and Design around the world. The forum invites academic institutions and experts in various fields to discuss and establish a "problem awareness", discovering and analyzing various problems comprehensively, in order to find better solution for the problems. With a view to expanding the boundaries of disciplines, the greater value of art and design can be brought into this diverse world.

时间	具体安排
9:00-11:30	**发声器——国际大学生创意论坛** 本次创意论坛是"国际艺术与设计系列工作坊"创新教育实践的收官环节。学生将作为青年创意发声人,发布 30 余件创想成果。希望借助此次活动,在全球语境中的创新实验教学中放大学生的表现力,激发国内外大学生不断迎接新的挑战,大声表达自己的创意与主张!
13:30-17:00	**向多样的世界提问——国际艺术与设计博士生论坛** 此次博士生论坛,依托清华大学的交流平台和学术传统,以国际视野及学科融合的初衷,秉持开放、务实、创新的研究与交流态度,汇集国际范围内优秀的艺术学理论、美术学、设计学及相关学科的青年学者,分享其最新学术成果。并邀请学术权威机构和各领域专家,共同探讨和建立"问题意识",发现多样问题,全面思考问题,进而更好地解决问题。以期拓展学科边界,在多样的世界中发挥艺术与设计学科更大的价值。

国际
艺术与设计
院校优秀毕业
作品展

INTERNATIONAL
GRADUATION EXHIBITION OF
ART & DESIGN INSTITUTES

INTERNATIONAL GRADUATION EXHIBITION OF ART & DESIGN INSTITUTES

October 29th – November 15th ,2021
Visual Art Center, Academy of Arts & design, Tsinghua University
Online Exhibition:https://ic.ad.tsinghua.edu.cn/2021show/

The annual graduation exhibition is the highlight moment that can best display the teaching achievements of an art and design institute. Each graduate's work bears witness to the growth process from student to mature artist/designer. However, due to the limitation of physical space, the graduation works exhibition of each institute is often independently scattered on their campuses all over the world.

On the occasion of the 2021 Tsinghua International Art and Design Education Conference, Academy of Arts & Design, Tsinghua University invites over 700 thesis works from more than 50 top art and design institutes around the world to be displayed both online and offline. Through 10 units and more than 2000 works, the exhibition provides a platform which the students could communicate with each other from diverse professional perspectives and raise questions to the world!

Chief Curator	Yang Dongjiang
Executive Curator	Shi Danqing, Feng Fan
Curatorial Team	Xiang Fan, Deng Yan, Wang Yue, Liu Runfu, Zhou Yanyang, Li Jing, Chen Luoqi, Wang Yinan, Liu Ya, Wang Yun, Sun Yue, Zhou Haoming, Gu Xin, Mi Haipeng
Visual Design	Wang Peng, Chen Si
Exhibition Design	Wang Chenya, Qin Xiao, Liu Qingzhou

国际艺术与设计院校
优秀毕业作品展

2021 年 10 月 29 日 –11 月 15 日
清华大学美术学院美术馆
线上展网址：https://ic.ad.tsinghua.edu.cn/2021show/

对于艺术与设计院校而言，每年的毕业作品展是最能集中展示教学成果的高光时刻，每一件毕业作品都深刻地见证着从学生到成熟艺术家 / 设计师的成长历程。但受制于物理空间限制，各个学校的毕业作品展往往是独立且分散在世界各地校园里。

正值 2021 清华国际艺术与设计教育大会召开之际，清华大学美术学院邀请全球 50 余所顶级艺术设计院校的近千位优秀毕业生的精彩作品，在线上和线下同步展出。本次展览通过 10 个单元，2000 余件作品，让学子们从各自专业角度彼此交流，向多样的世界提问！

ASK： 向多样的
世界提问

OUR
DIVERSE
WORLD

向多样的
世界提问

策展人	杨冬江
执行策展人	师丹青、封帆
策展团队	向帆、邓岩、王悦、刘润福、周艳阳、李静、陈洛奇、王轶男、刘亚、王韫、孙月、周浩明、顾欣、米海鹏
视觉设计	王鹏、陈思
展览设计	王晨雅、秦潇、刘清舟

ASK : OUR
DIVERSE WORLD

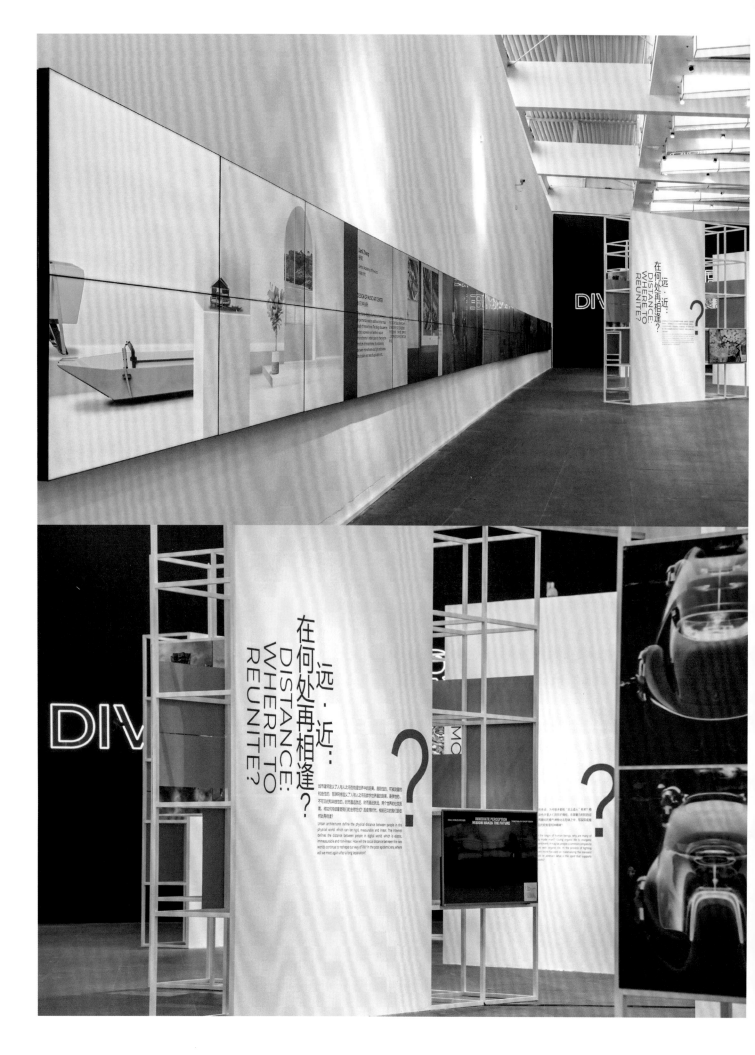

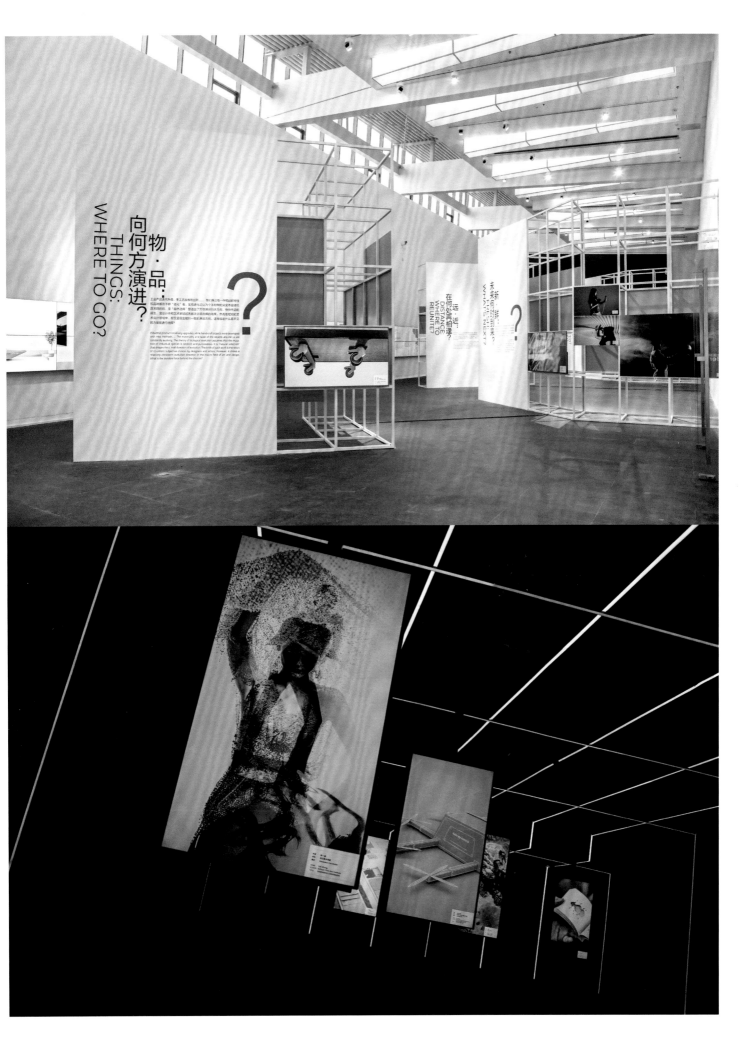

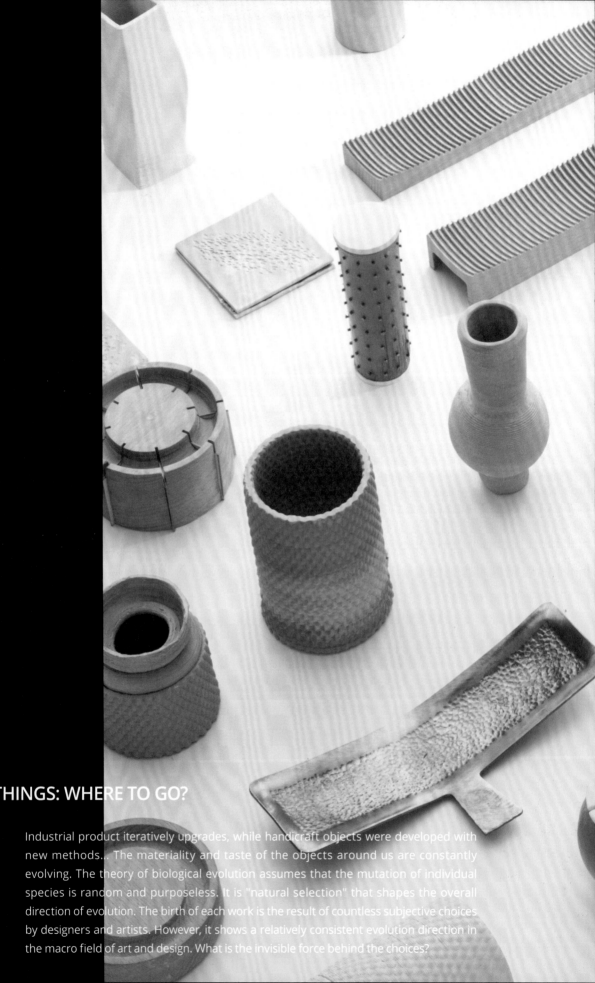

THINGS: WHERE TO GO?

Industrial product iteratively upgrades, while handicraft objects were developed with new methods... The materiality and taste of the objects around us are constantly evolving. The theory of biological evolution assumes that the mutation of individual species is random and purposeless. It is "natural selection" that shapes the overall direction of evolution. The birth of each work is the result of countless subjective choices by designers and artists. However, it shows a relatively consistent evolution direction in the macro field of art and design. What is the invisible force behind the choices?

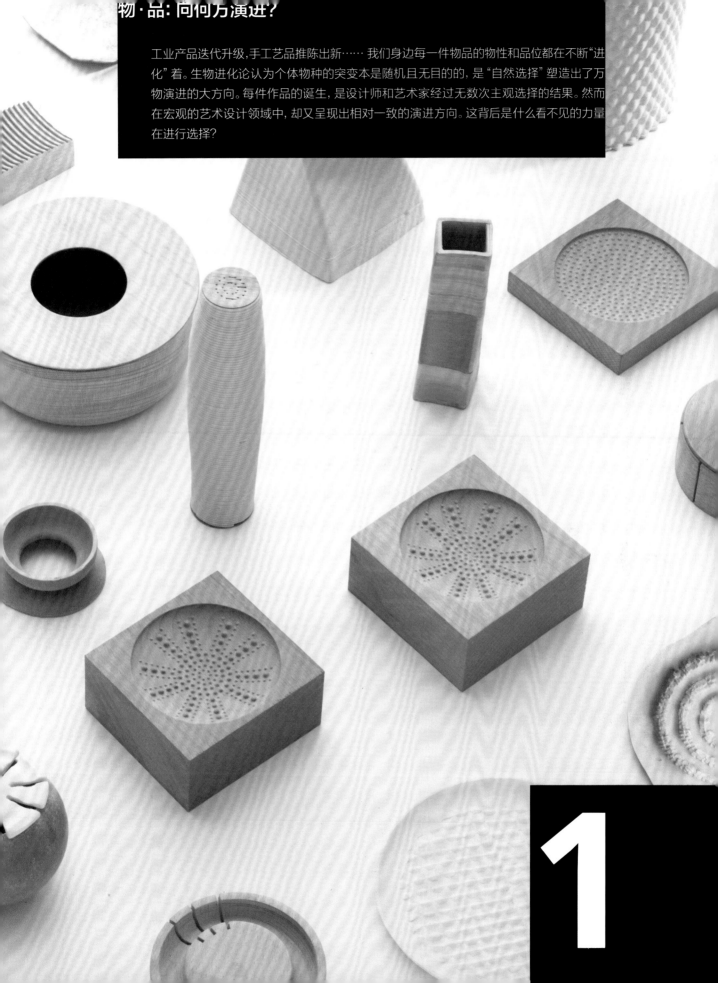

物·品：向何方演进？

工业产品迭代升级，手工艺品推陈出新……我们身边每一件物品的物性和品位都在不断"进化"着。生物进化论认为个体物种的突变本是随机且无目的的，是"自然选择"塑造出了万物演进的大方向。每件作品的诞生，是设计师和艺术家经过无数次主观选择的结果。然而在宏观的艺术设计领域中，却又呈现出相对一致的演进方向。这背后是什么看不见的力量在进行选择？

1

UNI·FORMES
Walckenaer Louise
French National Institute for
Advanced Studies in Industrial Design

万能餐具
瓦克奈尔·路易丝
法国国立高等工业设计学院

<div align="right">

ASIT
Xu Hengda
The Hong Kong Polytechnic University

ASIT
许恒达
香港理工大学

</div>

ON HUMAN RELATIONSHIP WITH PLANTS: BEYOND THE BLINDNESS TO PLANTS

Pauline Barbier
The Glasgow School of Art

论人类与植物的关系：超越对植物的盲目性
鲍琳 · 巴比尔
格拉斯哥美术学院

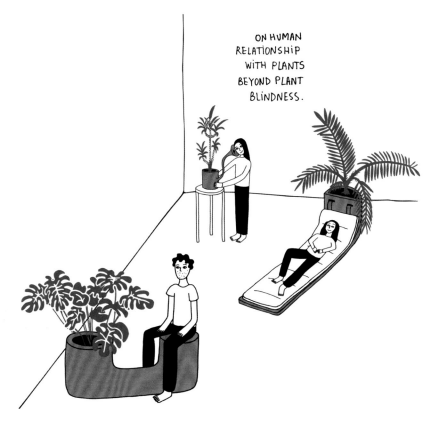

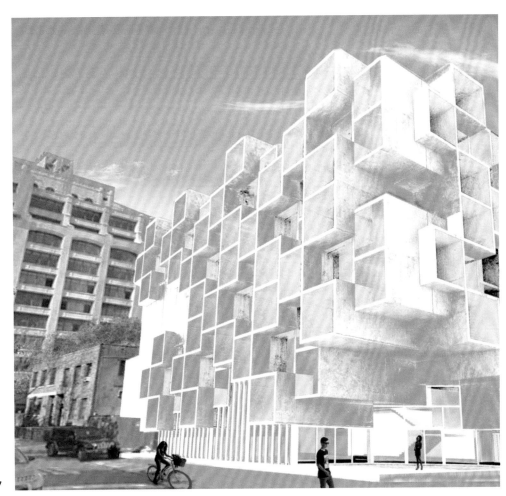

Hedonism
Zhu Ziqi
Academy of Arts & Design, Tsinghua University

体感游戏产品设计
朱子琪
清华大学美术学院

Easy Shelter
Zhang Zhaoyu
Academy of Arts & Design, Tsinghua University

易舱——方舱医院改建类产品系统设计
张兆宇
清华大学美术学院

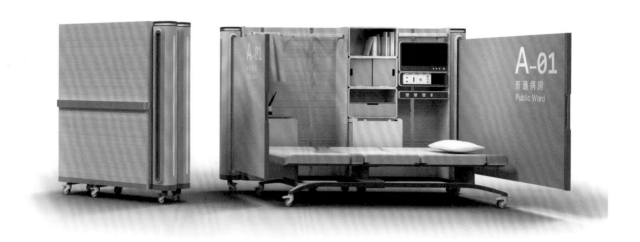

EXPEDITION
Yi Pengjun
Academy of Arts & Design, Tsinghua University

EXPEDITION
伊鹏郡
清华大学美术学院

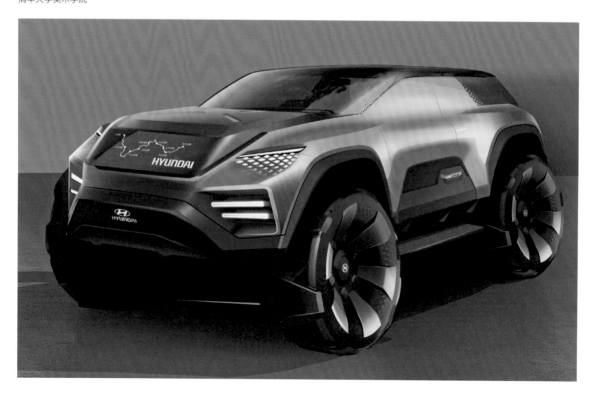

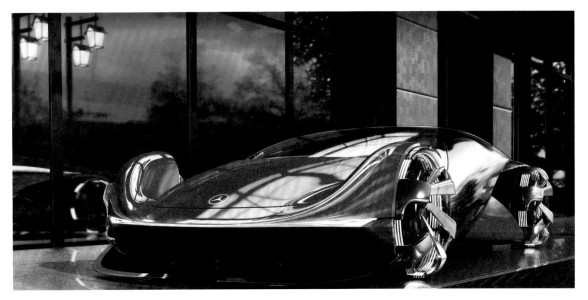

IMMERSIVE TRAVEL EXPERIENCE AND PRODUCT
DESIGN IN THE SMART ERA
Wang Xiqiao
Tongji University

智能时代下沉浸式出行体验与产品设计
王惜轿
同济大学

PURIFY - IF FURNITURES CAN BREATH
Tang Yuxin,Liang Siyu
China Academy of Art

净化——如果家具会呼吸
汤雨欣、梁思雨
中国美术学院

TEMPO PIANO - RESEARCH AROUND
THE CONCEPT OF FRESHNESS
Masseron Alice
French National Institute for Advanced Studies
in Industrial Design

节奏钢琴：新鲜概念研究
马瑟龙·爱丽丝
法国国立高等工业设计学院

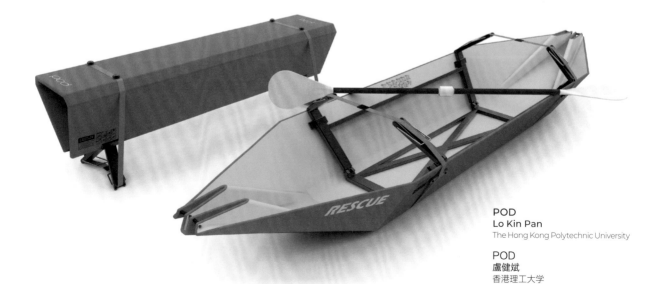

POD
Lo Kin Pan
The Hong Kong Polytechnic University

POD
盧健斌
香港理工大学

SELFISH PLANTS
Ryota Mizoguchi
Tama Art University

自私植物
沟口棱大
多摩美术大学

VITA/LIFE
Aidan O'Friel
The Glasgow School of Art

Vita/ 生活
艾丹 · 奥弗里尔
格拉斯哥美术学院

INNER
Yu Xiujia,Xiao Yixin,Li Yixuan
China Academy of Art

Inner 内心引力
于秀佳、肖一心、李宜萱
中国美术学院

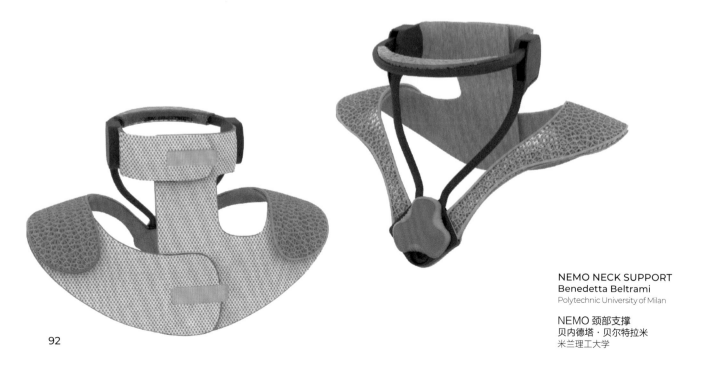

NEMO NECK SUPPORT
Benedetta Beltrami
Polytechnic University of Milan

NEMO 颈部支撑
贝内德塔·贝尔特拉米
米兰理工大学

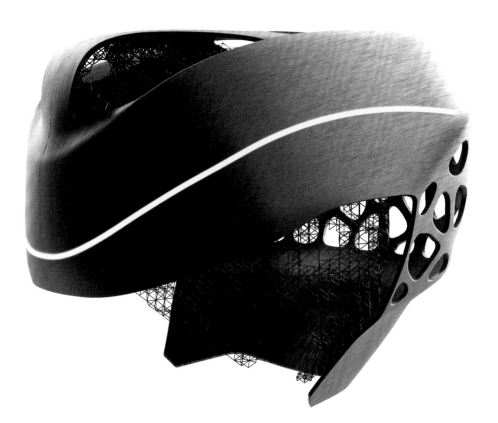

GENERATIVE HELMET
Chen Maoshuo
Tongji University

生成式设计头盔
陈茂烁
同济大学

NEAT
Lloyd Potter
Loughborough University

整洁
劳埃德·波特
拉夫堡大学

SOFT GARDEN
Simon-Thomas Marie
French National Institute for Advanced
Studies in Industrial Design

柔软的花园
西蒙－托马斯·玛丽
法国国立高等工业设计学院

FIL ROUGE
Pierre Murot
French National Institute for Advanced
Studies in Industrial Design

胭脂
皮埃尔·穆罗
法国国立高等工业设计学院

LANEUR
Henry Smallbone
Loughborough University

LANEUR
亨利·斯莫尔伯恩
拉夫堡大学

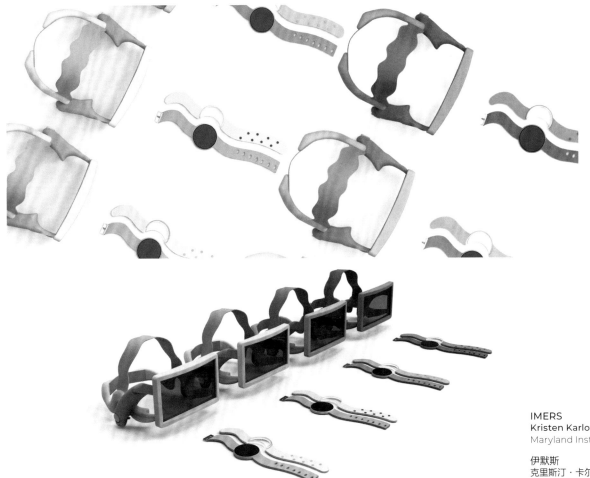

IMERS
Kristen Karlovich
Maryland Institute College of Art

伊默斯
克里斯汀·卡尔洛维奇
马里兰艺术学院

PSYCHOLOGICAL WELLBEING
THROUGH MUSIC LISTENING
Majed Boughanem
Rhode Island School of Design

用音乐疗伤
马吉德·博尼姆
罗德岛设计学院

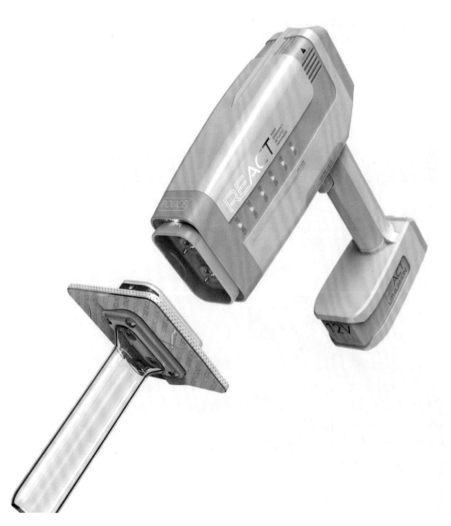

REACT – A NEW SYSTEM FOR
CONTROLLING BLEEDING
FROM A KNIFE WOUND
Joseph Bentley
Loughborough University

回应：一种控制刀伤出血的新系统
约瑟夫·本特利
拉夫堡大学

JOYRIDE
Reem Saleh
French National Institute for
Advanced Studies in Industrial Design

兜风
雷姆·萨利赫
法国国立高等工业设计学院

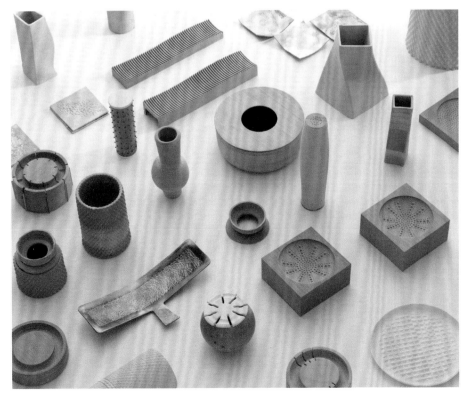

EN JOUER - TOWARDS A CULTURE
OF LISTENING TO OBJECTSP
Emma Lelong
French National Institute for
Advanced Studies in Industrial Design

En Jouer：迈向聆听物体的文化
艾玛·乐隆
法国国立高等工业设计学院

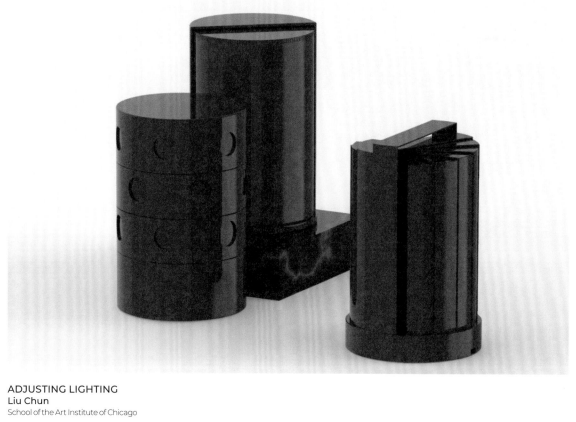

ADJUSTING LIGHTING
Liu Chun
School of the Art Institute of Chicago

调整照明
刘纯
芝加哥艺术学院

SOLAR-12
Yuan Xinlei
Tongji University

日影 –12
袁昕蕾
同济大学

CARING FOR SOMEONE WITH DEMENTIA
Ames Bayliss
Loughborough University

照顾痴呆症患者
艾姆斯·贝利斯
拉夫堡大学

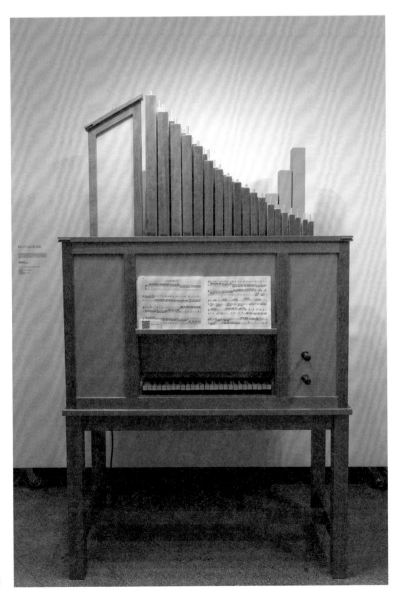

POSITIVE ORGAN
Kelly Cleveland
Rochester Institute of Technology

积极的管风琴
凯利·克利夫兰
罗切斯特理工学院

OBJECT PAINTING
Drew Slickmeyer
Rochester Institute of Technology

对象绘画
德鲁·斯利克迈尔
罗切斯特理工学院

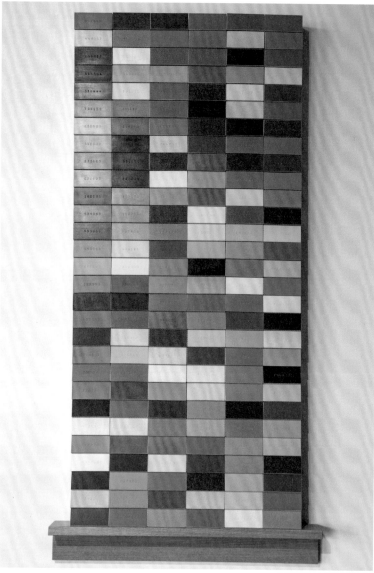

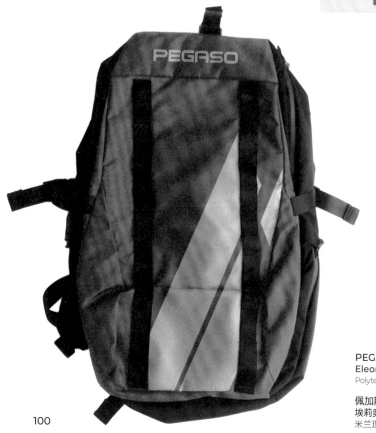

PEGASO
Eleonora Pellizzar
Polytechnic University of Milan

佩加斯
埃莉奥诺拉·佩利扎里
米兰理工大学

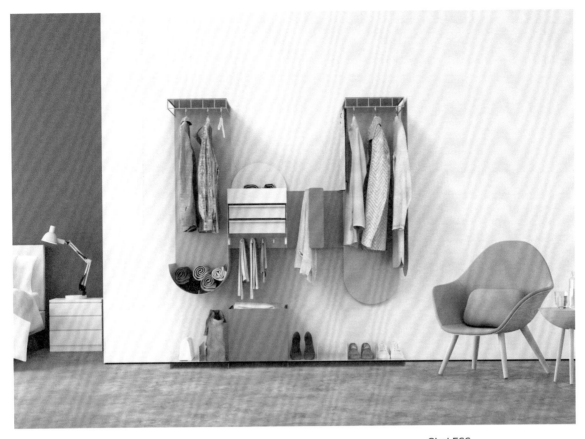

CLoLESS
Yang Liuqing
Parsons School of Design, the New School

CloLESS
杨柳青
帕森斯设计学院

INTERVAL
Carl Shen
Parsons School of Design, the New School

间隔
沈粒瑜
帕森斯设计学院

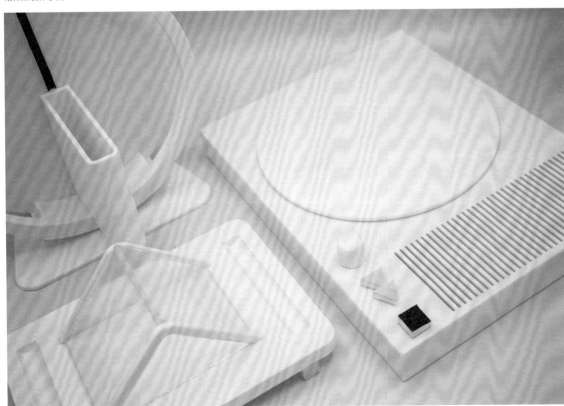

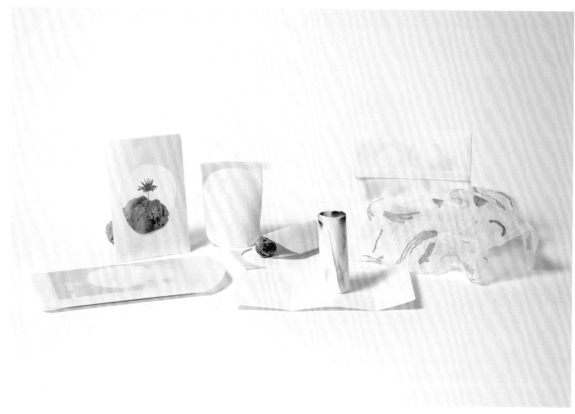

OBJET D' 🔲
Amélie Orhant
French National Institute for
Advanced Studies in Industrial Design

物品 d' 🔲
艾米莉·奥尔汉特
法国国立高等工业设计学院

RHEA PROPOSAL
Charlotte Davis
Loughborough University

Rhea 提案
夏洛特·戴维斯
拉夫堡大学

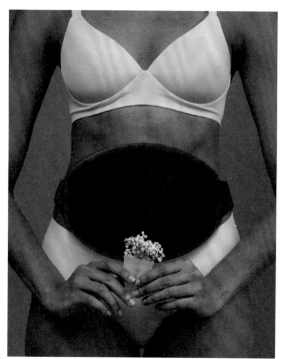

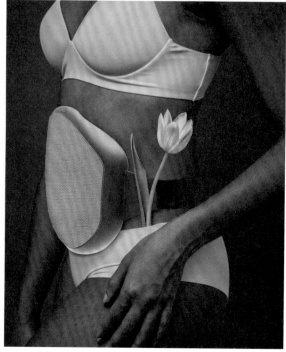

RESEARCH ON A ONE-HANDED
MAKEUP PRODUCT
Ayami Yasuda
Tama Art University

单手化妆产品研究
安田彩美
多摩美术大学

NOMA/FOOTWEAR
Rara Sekiguchi
Tama Art University

NOMA / 鞋类
关口乐乐
多摩美术大学

WISHFUL SERIES
Yan Jingyi
Shanghai Academy of Fine Arts,
Shanghai University

时时如意系列、室室如意系列、
食食如意系列、饰饰如意系列
颜静逸
上海大学上海美术学院

CHI-ME-RA
Sumika Togawa
Tama Art University

奇美拉
户川纯佳
多摩美术大学

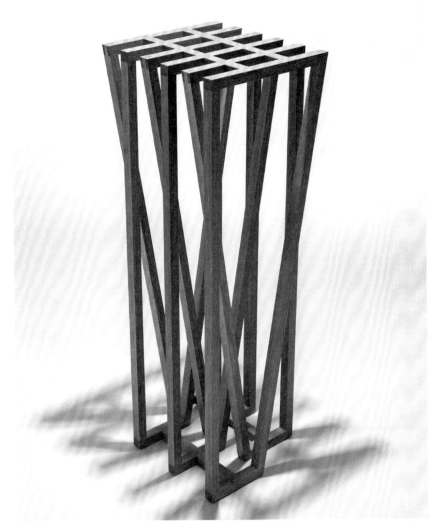

MONOLITH II
Ryan Zimmerman
Rochester Institute of Technology

诺克莱斯 II
瑞安·齐默曼
罗切斯特理工学院

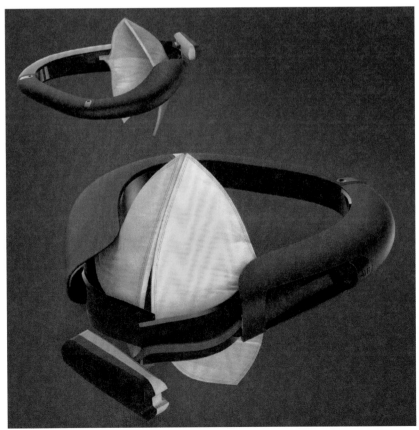

AYR - MORE AIR, MORE TIME
Finty Donovan
Loughborough University

艾尔：更多的空气，更多的时间
芬蒂·多诺万
拉夫堡大学

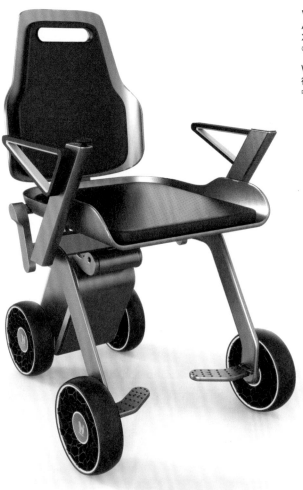

WILLCHEER SMART
AUXILIARY TRAVEL TOOL
Xu Yue,Cao Rui
China Academy of Art

WillCheer 智能辅助出行器
徐越、曹锐
中国美术学院

LEARNING WITHOUT PRESSURE,
SPACE AND SUPPLIES DESIGN FOR
EFFICIENT AND HAPPY LEARNING
Mo Wanying
Tongji University

压力之外的学习，
高效快乐学习的空间和用品设计
莫宛莹
同济大学

LUCET
Ryo Matsuoka
Tama Art University

闪耀
松冈谅
多摩美术大学

渡部真子
多摩美术大学

201 GILLESPIE DR. Franklin TN 37067
Mako Watanabe
Tama Art University

201 GILLESPIE DR. Franklin TN 37067
渡部真子
多摩美术大学

TYPE 1 DIABETES
MANAGEMENT SYSTEM
Daina Eadie
Loughborough University

1 型糖尿病管理系统
戴娜·伊迪
拉夫堡大学

OTO
Pepa Chesworth Russell
The Glasgow School of Art

OTO
佩帕·切斯沃斯·拉塞尔
格拉斯哥美术学院

MEDICAL BREATHING APPARATUS
Robert Wingate
Loughborough University

医用呼吸器
罗伯特·温盖特
拉夫堡大学

MODULAR ROVER
Claudius Kuo
Art Center College of Design

模块化漫游者
克劳迪奥·郭
艺术中心设计学院

WILD THINGS: OUTDOOR TOYS
FOR PLAYING IN NATURE
John Mawhorter
Rhode Island School of Design

狂野的东西：适合在大自然中玩耍的户外玩具
约翰·马沃特
罗德岛设计学院

SMART-MINIMUM
Alice Dian
Polytechnic University of Milan

智能最小值
爱丽丝·迪安
米兰理工大学

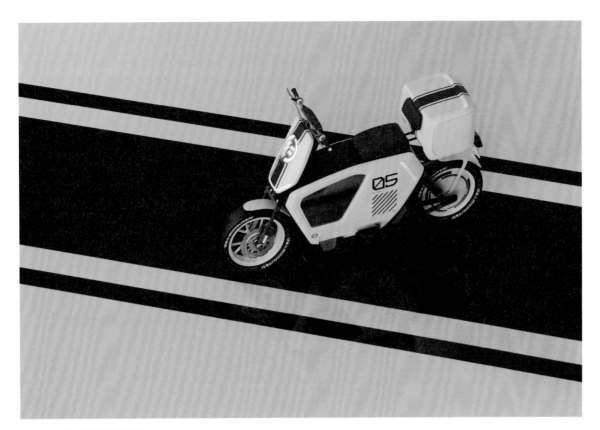

RESEARCH ON OPTIMAL
DESIGN OF ELECTRIC
BICYCLES OUTSIDE
Wang Haozhe
Tongji University

外面电动自行车的优化设计研究
王昊喆
同济大学

"GUWEI" SERIES OF
SANITATION EQUIPMENT
Wang Jiabin, Chen Tao
Guangzhou Academy of Fine Arts

"谷围"系列环卫装备
王加彬、陈涛
广州美术学院

VASE
Chelsea Hana Susilo
Tama Art University

花瓶
切尔西·哈娜·苏西洛
多摩美术大学

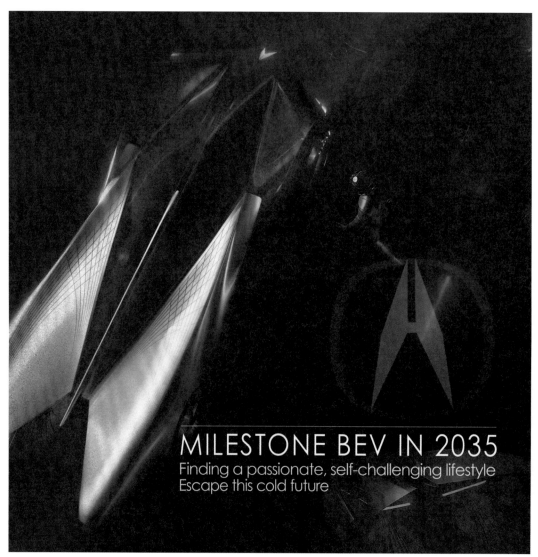

MILESTONE BEV IN 2035
Finding a passionate, self-challenging lifestyle
Escape this cold future

MILESTONE BEV IN 2035
Sui Guohao
LuXun Academy of Fine Arts

MILESTONE BEV IN 2035
隋国皓
鲁迅美术学院

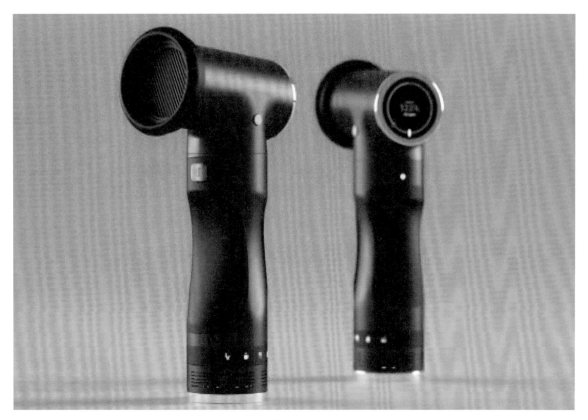

**RHINO - IMPROVING SAFETY AND REDUCING ANXIETY IN
PATIENTS WITH OLFACTORY DISORDERS**
Miles Bennett
Loughborough University

犀牛：提高嗅觉障碍患者的安全性和减少焦虑
迈尔斯·贝内特
拉夫堡大学

MID INDUSTRIAL DESIGN
Sean Kim (WOOJ)
Pratt Institute

MID 工业设计
金先恩 (WOOJ)
普瑞特艺术学院

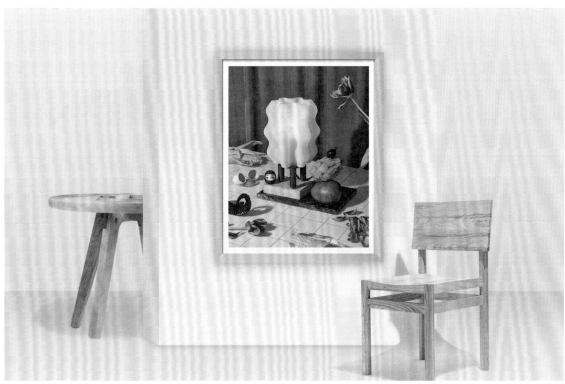

CONCEPT DESIGN OF NEGATIVE
PRESSURE AMBULANCE FOR COVID-19
Liao Jiawei
Hubei Institute of Fine Arts

新冠肺炎疫情下的负压救护车的概念设计
廖佳威
湖北美术学院

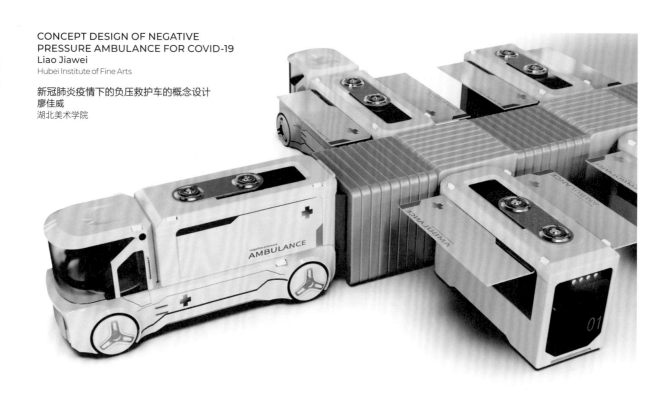

OPTIMIZED DESIGN OF
"RETROGRADE" FIRE TRUCK
Jia Zhuohang
LuXun Academy of Fine Arts

"逆行者"消防车优化设计
贾卓航
鲁迅美术学院

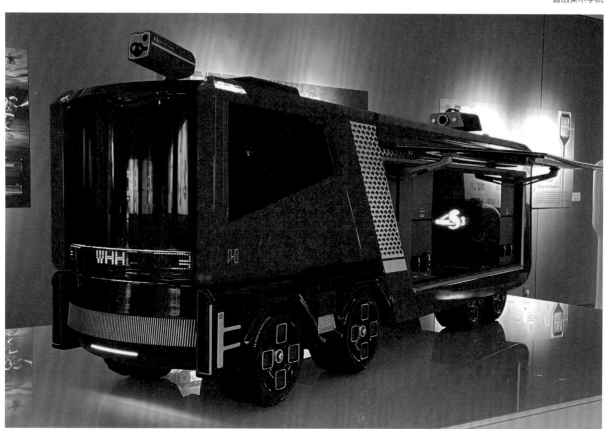

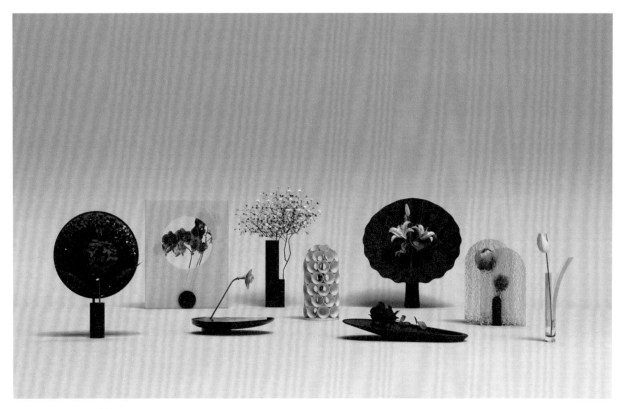

PRAISE OF FLOWERS
Chen Weijing
National University of Singapore

鲜花礼赞
陈玮静
新加坡国立大学

MUJO
Jessie Garbutt
Art Center College of Design

木乔
杰西·加布特
艺术中心设计学院

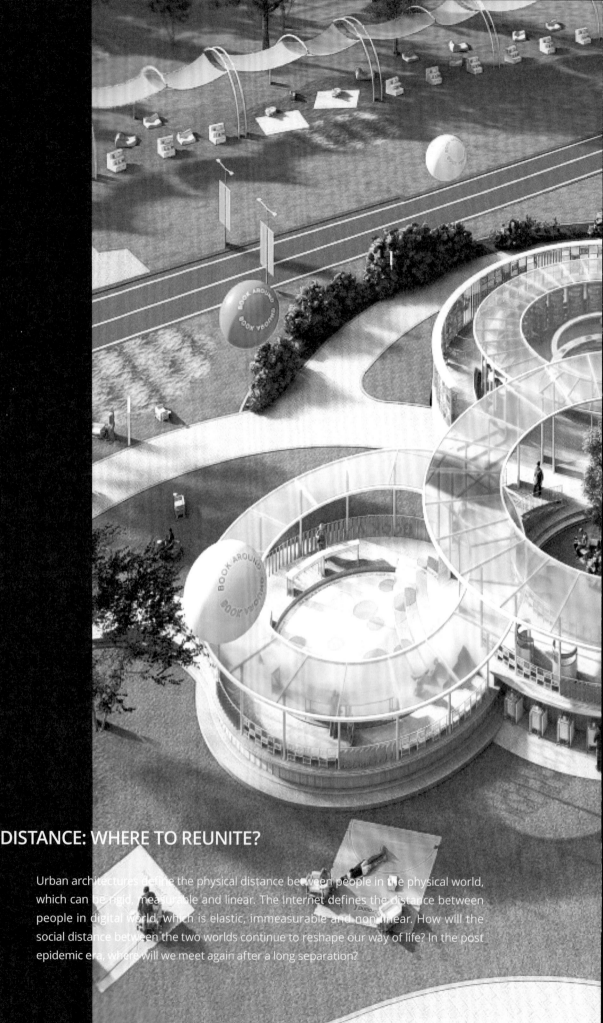

DISTANCE: WHERE TO REUNITE?

Urban architectures define the physical distance between people in the physical world, which can be rigid, measurable and linear. The Internet defines the distance between people in digital world, which is elastic, immeasurable and non-linear. How will the social distance between the two worlds continue to reshape our way of life? In the post epidemic era, where will we meet again after a long separation?

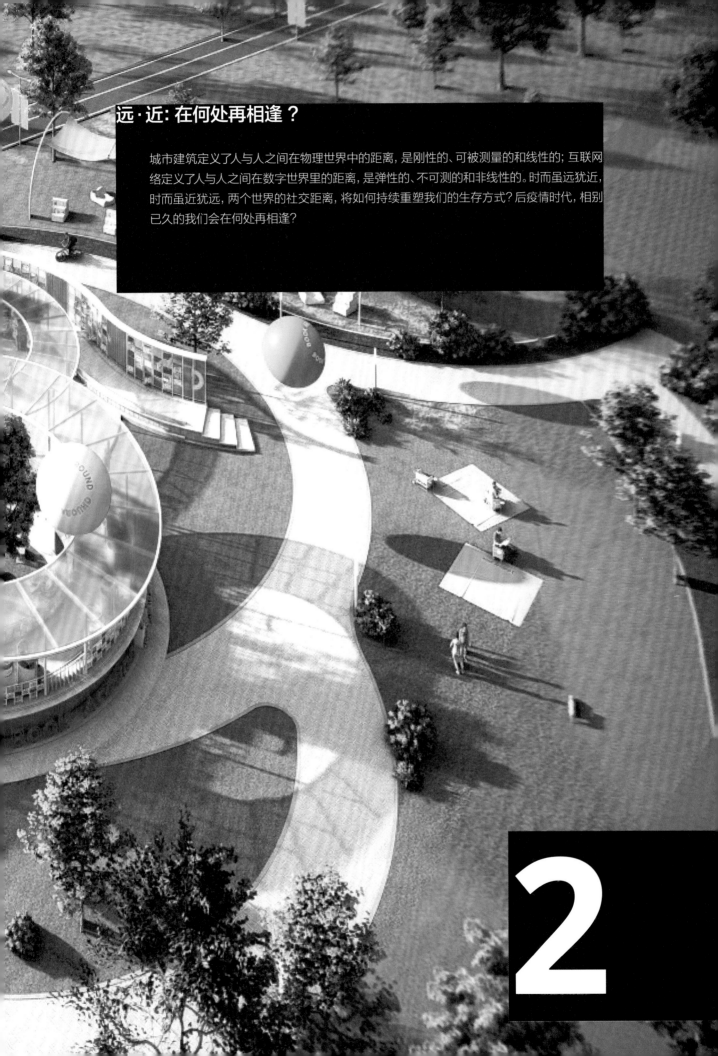

远·近: 在何处再相逢？

城市建筑定义了人与人之间在物理世界中的距离, 是刚性的、可被测量的和线性的; 互联网络定义了人与人之间在数字世界里的距离, 是弹性的、不可测的和非线性的。时而虽远犹近, 时而虽近犹远, 两个世界的社交距离, 将如何持续重塑我们的生存方式? 后疫情时代, 相别已久的我们会在何处再相逢?

2

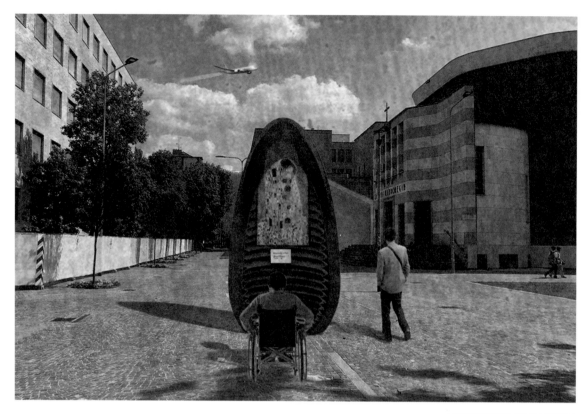

MURBS: URBAN MUSEUM
Andrea Escudé
Polytechnic University of Milan

Murbs：城市博物馆
安德里亚·埃斯库德
米兰理工大学

BOOKS AROUND
Chae rin lee,Da eun Jeong,
Hye rim Kong,Kyunghee Kim
Sookmyung Women's University

书香环绕
李彩麟、金达恩、孔慧琳、金敬熙
淑明女子大学

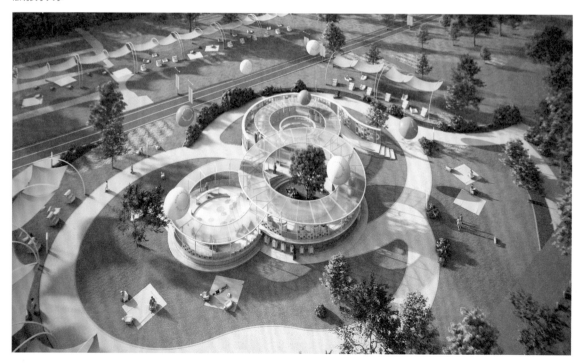

MENTAL RESTORATION AND THERAPEUTIC SPACE
Tommi Junnola
Aalto University

心理康复和治疗空间
托米·朱诺拉
阿尔托大学

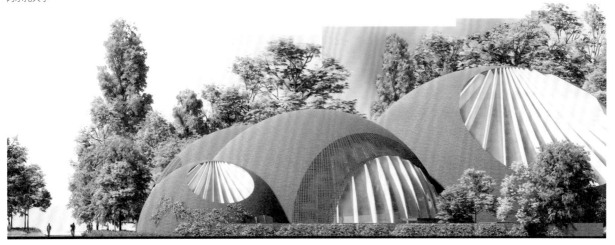

NEW CONVENIENCE RETAIL - A SPATIAL EXPERIENCE BUILT ON NEW LIFESTYLE DEMANDS
Zhou Yaxian, Zhao Tong
Polytechnic University of Milan

新便利零售——基于新生活方式需求的空间体验
周雅娴、赵彤
米兰理工大学

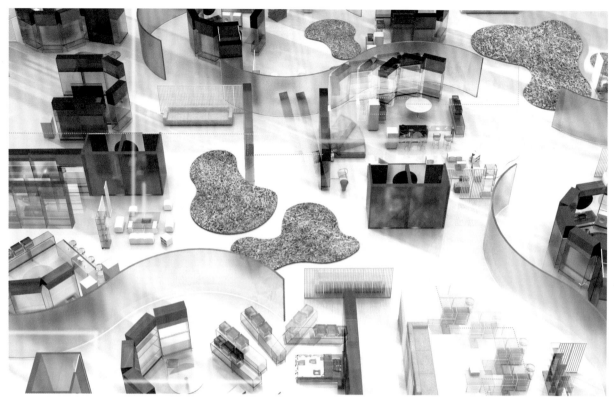

FORMAT / REFORM: A VISION OF A FUTURE HOME
Chi Ziwei
Academy of Arts & Design, Tsinghua University

格式化 / 重组：一次未来家的设想
池紫薇
清华大学美术学院

THE MILLENNIAL REVOLUTION
Zhang Xinqi
Academy of Arts & Design, Tsinghua University

千禧一代的"革命"
张新琦
清华大学美术学院

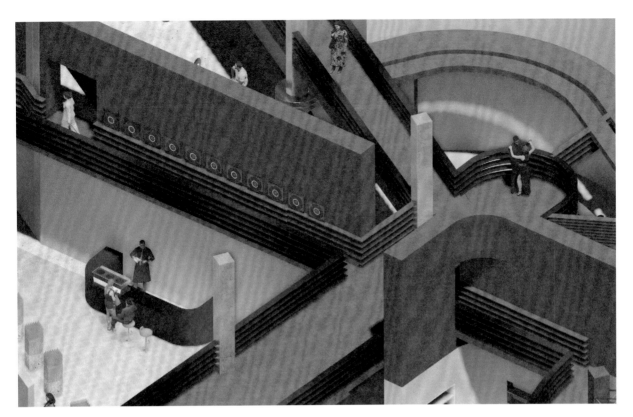

DESIGN OF MUSIC ART CENTER
Zhang Danli
Central Academy of Fine Arts

音乐艺术中心设计
张丹莉
中央美术学院

URBAN RESIDUAL SPACE RECONSTRUCTION BASED ON
ORGANIC RENEWAL - TAKING THE SPACE UNDER THE
VIADUCT OF SHANGHAI INNER RING AS AN EXAMPLE
Zheng Xiong
Tongji University

基于有机更新的城市剩余空间改造
——以上海内环高架桥下空间为例
郑雄
同济大学

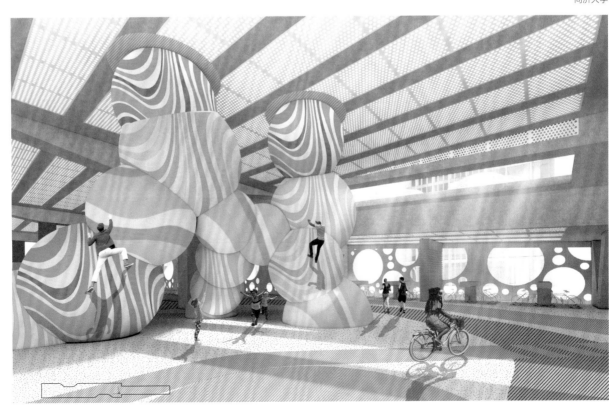

RIVERBERO
Elena Brambilla
Polytechnic University of Milan

混响
埃琳娜·布兰比拉
米兰理工大学

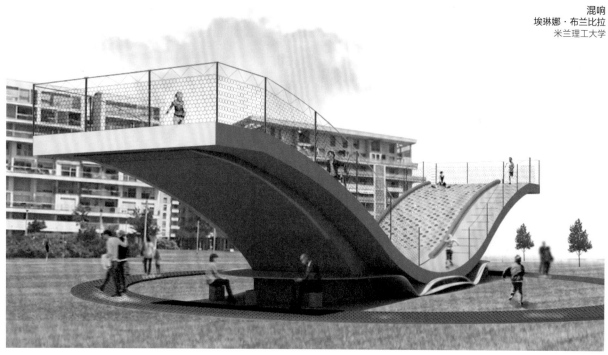

FINNISH CIVIL WAR MUSEUM
Matti Wäre
Aalto University

芬兰内战博物馆
马蒂·会
阿尔托大学

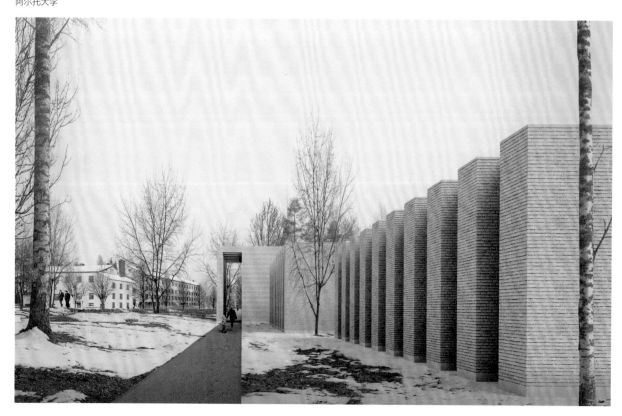

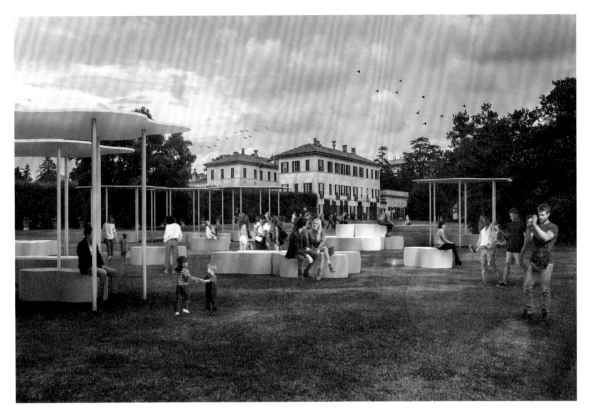

FLUCTUS / VILLA PANZA: NARRATIVE STAVE
Martina Parolini
Polytechnic University of Milan

Fluctus / Villa Panza：叙事五线谱
玛蒂娜·帕罗里尼
米兰理工大学

NOMADIC STATION
Gahyeong Chae,Hyun Jin Choi,Yeong-eun Bang
Sookmyung Women's University

游牧站
蔡嘉庆、崔贤镇、方永恩
淑明女子大学

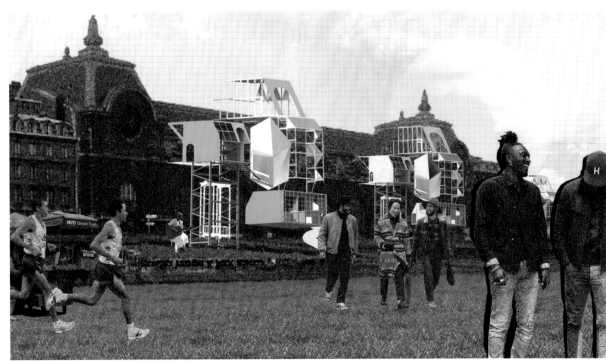

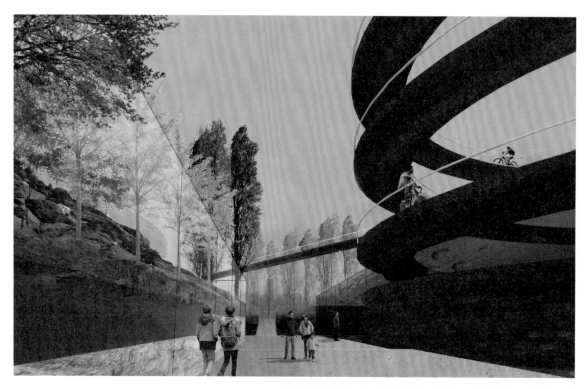

WATER AFTERLIFE: CHOREOGRAPHING THE LIFECYCLE OF
WATER IN THE CONTEXT OF STEEL-MAKING INDUSTRY
Chai Yanhao,Wu Dingwen
University of Pennsylvania

水热循环下的后工业景观塑造
柴彦昊、吴鼎闻
宾夕法尼亚大学

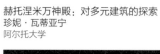

HERTTONIEMI PANTHEON -
A QUEST ON POLYVALENT ARCHITECTURE
Janne Vartiainen
Aalto University

赫托涅米万神殿：对多元建筑的探索
珍妮·瓦蒂亚宁
阿尔托大学

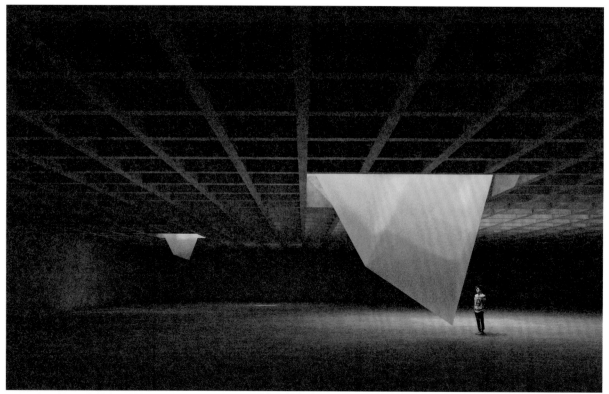

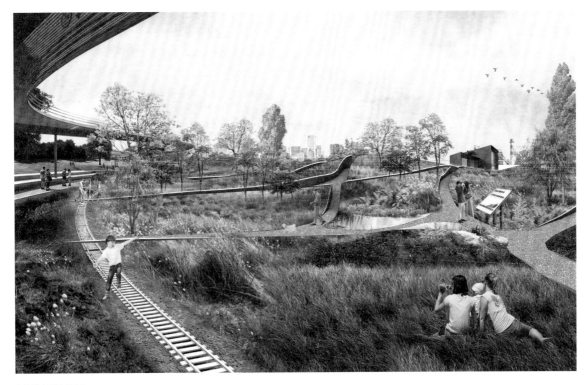

BACK ON RAIL
Tian Yuan
University of Pennsylvania

重回正轨
田媛
宾夕法尼亚大学

INTERNATIONAL EXHIBITION DESIGN OF QING DYNASTY
ARCHITECTURE BASED ON STYLE RAY
Zhang Haotian
Academy of Arts & Design, Tsinghua University

基于样式雷的清代建筑国际展示设计
张昊天
清华大学美术学院

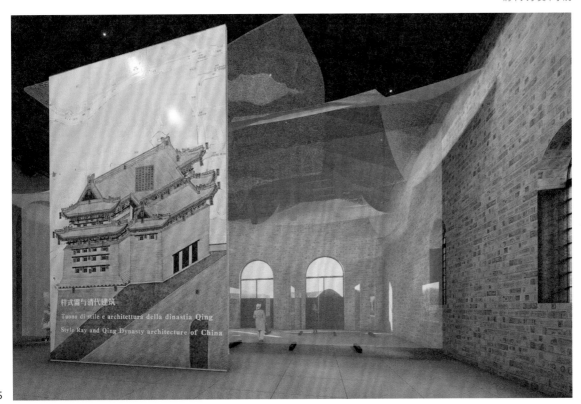

IMMEDIATE PERCEPTION, SMART
FUTURE - CONCEPTUAL SCHEME FOR
THEME PAVILION OF EXPO 2025 OSAKA
Huang Weimeng
Central Academy of Fine Arts

即刻感知，智造未来
——2025 大阪世博会主题馆概念方案
黄蔚萌
中央美术学院

More Surreal than Real
Li Xiaxi
Academy of Arts & Design, Tsinghua University

不真实的小现实
李夏溪
清华大学美术学院

ARCHAEOLOGY
Li Yunyi
The Hong Kong Polytechnic University

考古学
李云逸
香港理工大学

CHESTERFIELD PIER
Ethan Chiang
Washington University in St. Louis

切斯特菲尔德码头
姜亦珊
圣路易斯华盛顿大学

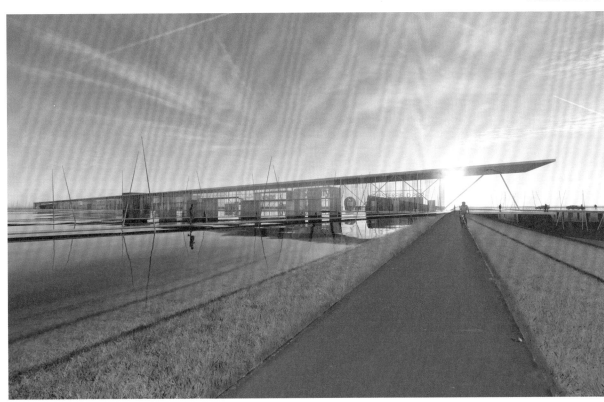

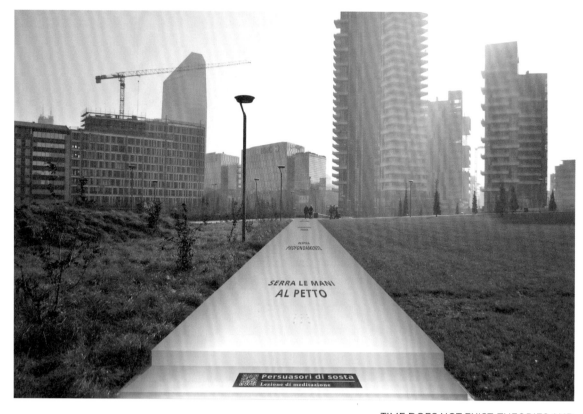

TIME DOES NOT EXIST: THEORIES AND
CONJECTIONS ON THE FOURTH DIMENSION
Viola Incerti
Polytechnic University of Milan

时间不复存在：第四维理论和猜想
薇欧拉·印瑟提
米兰理工大学

TRANSONORA:
SOUND TRANSITIONS OF TRADITION
Filippo Muzzi
Polytechnic University of Milan

Transonora：声音过渡的传统
菲利普·穆齐
米兰理工大学

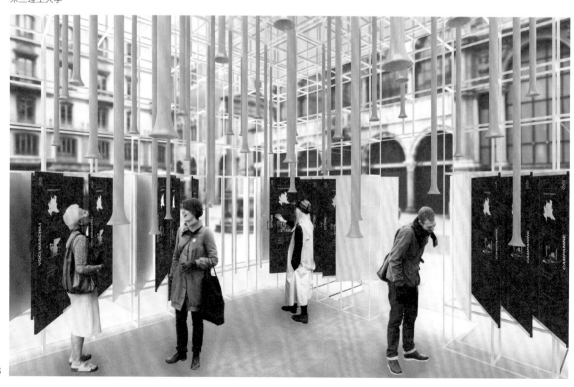

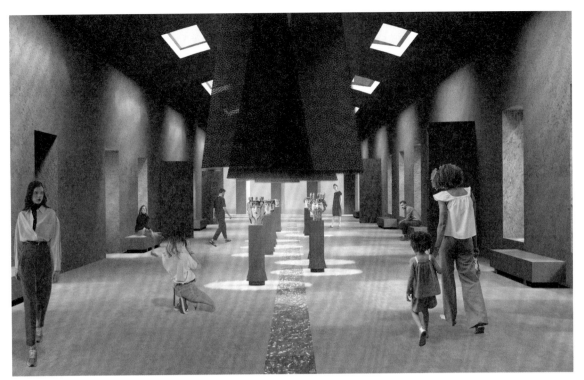

**MAGMA: A NEW STAGE TO SHOWCASE
LOCAL DESIGN AND ARTISANSHIP**
Giorgia Bonaventura
Polytechnic University of Milan

Magma：一个展示本地设计
和手工艺的新舞台
乔治亚·博纳文图拉
米兰理工大学

**STEP ON: ONE GROUND,
HUNDRED BEHAVIOURS**
Gianna Maria Strianese
Polytechnic University of Milan

极乐之地
吉安娜·玛丽亚·斯特里亚尼斯
米兰理工大学

PRECARIOUS BALANCE BETWEEN
REFUGE AND PRISON IN DOMESTIC
ENVIRONMENT - TEMPORARY HOME
Ludovica Donvito
Polytechnic University of Milan

家庭环境中避难所和监狱之间的
不稳定平衡：临时住所
卢多维卡·唐维托
米兰理工大学

NOISE POLLUTION INSIDE MONZA
CIRCUIT AND SOUND-SCAPE SOLUTION
Sara Berardo
Polytechnic University of Milan

蒙扎赛道噪声污染和音景解决方案
萨拉·贝拉多
米兰理工大学

POST COVID PROXEMICS IN EXHIBITION DESIGN
Benedetta Biffi
Polytechnic University of Milan

展览设计中的后疫情空间关系学
贝内德塔·比菲
米兰理工大学

CLIMB THE NET
Mariella Cappelletto,Silvia Guarnieri,Martina Mondonico
Polytechnic University of Milan

爬网
·玛丽埃拉·卡佩莱托、西尔维娅·瓜涅利、玛蒂娜·蒙多尼科
米兰理工大学

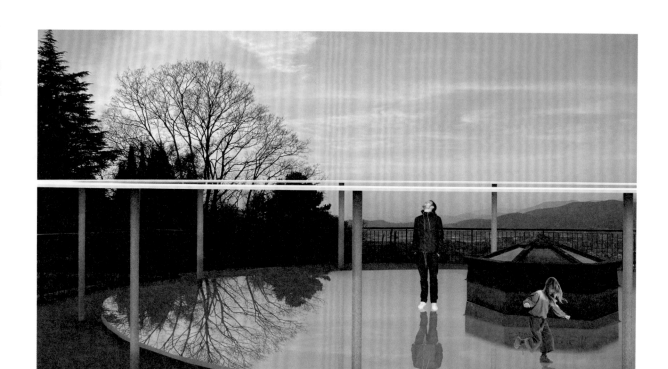

PRECARIOUS BALANCE BETWEEN REFUGE AND PRISON IN
DOMESTIC ENVIRONMENT - TEMPORARY HOME
Martina Gorio
Polytechnic University of Milan

家庭环境中避难所与监狱之间的不稳定平衡——亲密的界限
玛蒂娜・戈里奥
米兰理工大学

ME + WEINNOVATIVE RE-INNOVATIVE
EXPLORATION OF PRIVACY: A CASE STUDY
ON AN ACTIVITY-BASED WORKPLACE
Setareh Houshmand
Polytechnic University of Milan

Me + WeInnovative 对隐私的创新再探索：
基于活动的工作场所案例研究
塞塔瑞・豪什曼德
米兰理工大学

THE FUTURE OF INTERIORS:
EXPLORATION OF SUSTAINABLE
MATERIALS AND PRACTICES
Elena Salot
Polytechnic University of Milan

室内设计的未来：可持续材料和实践探索
埃琳娜·萨洛特
米兰理工大学

GESTURES OF VOID
Chiara Sangermani
Polytechnic University of Milan

虚空的姿态
奇亚拉·桑格玛尼
米兰理工大学

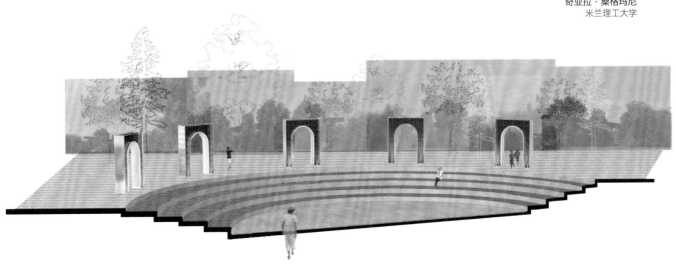

TIME IS MALLEABLE
David Ross
The Glasgow School of Art

时间可延展
大卫·罗斯
格拉斯哥美术学院

MAKER SPACE
Ross Ferguson
The Glasgow School of Art

创客空间
罗斯·弗格森
格拉斯哥美术学院

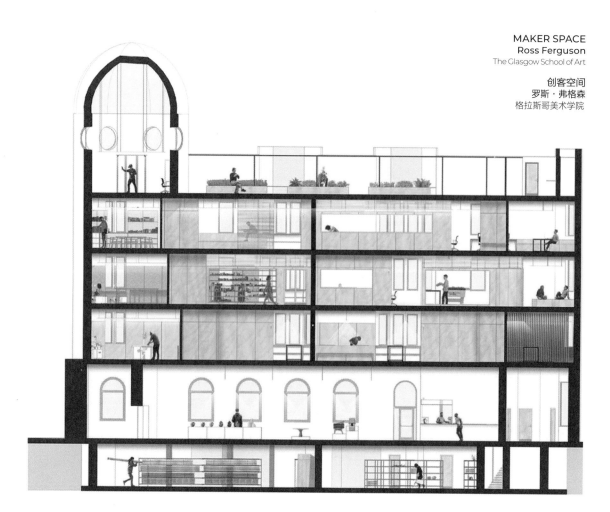

ABLE
Patricia Romo
Parsons School of Design

Able
帕特里夏·罗莫
帕森斯设计学院

SYMBIOSIS - STUDY ON CONCEPTUAL PLANNING FOR
WUYUAN GARRULAX COURTOISI PROTECTION AND
NODE PLANNING AND DESIGN OF YUELIANG BAY
Lu Boyun
Central Academy of Fine Arts

共生——婺源蓝冠噪鹛保护概念规划与
月亮湾节点规划设计研究
卢柏沄
中央美术学院

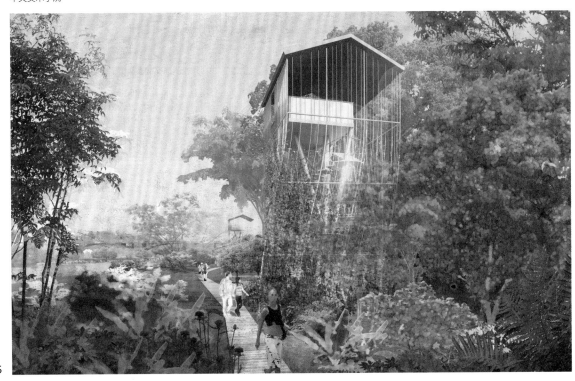

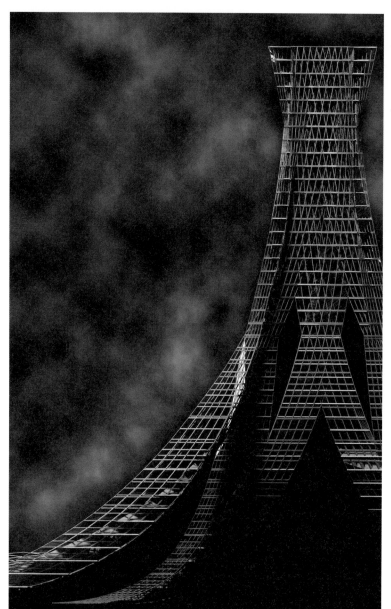

ARCHAEOLOGY 2750AD
Michael Toomey
Parsons School of Design

考古 2750AD
迈克尔·图米
帕森斯设计学院

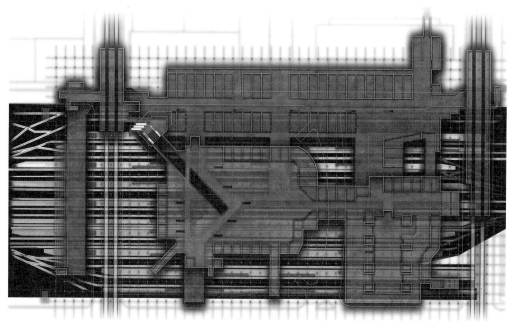

PAST (CUT) FUTURE
Kanat Derbissalinov
Parsons School of Design

过去（削减）未来
卡纳特·德尔比萨利诺夫
帕森斯设计学院

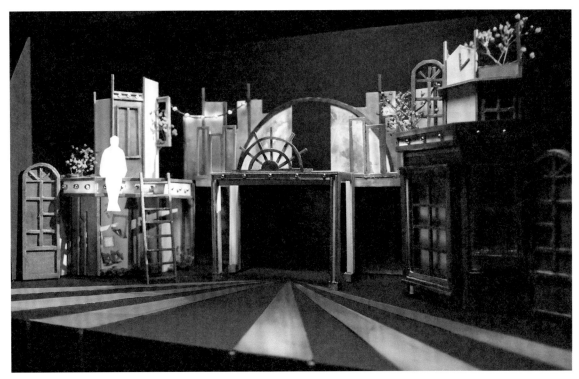

『·MEETS·』
Mako Yamane
Tama Art University

『·MEETS·』
山根茉子
多摩美术大学

SHIFTING
LANDSCAPE
Ruriko Masuda
Tama Art University

不断变化的景观
增田琉璃子
多摩美术大学

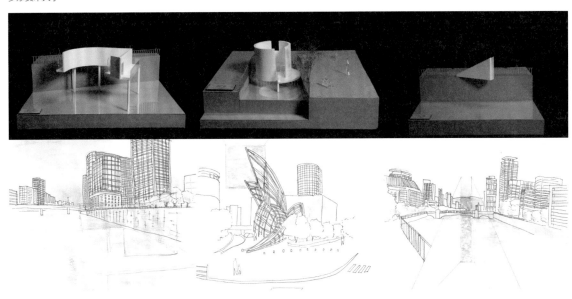

A space to experience the colors of the sunset
by reflecting the setting sun not directly but on the wall.

A space to cut out the architecture
of the National Museum of Art, Osaka.

A space that cuts off the Tosabori River, the city of Osaka,
and Mount Ikoma, with Mount Ikoma in the background.

"TUNING" THE TOWN
Miyu Nagashima
Tama Art University

为小镇调音
长岛未侑
多摩美术大学

MOKUMAMORI NURSERY SCHOOL
Yuri Koyano
Tama Art University

木森保育园
小谷野友里
多摩美术大学

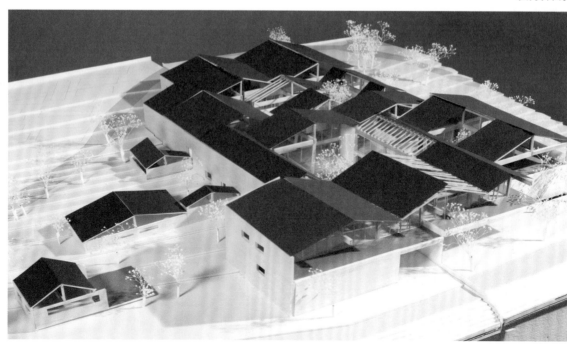

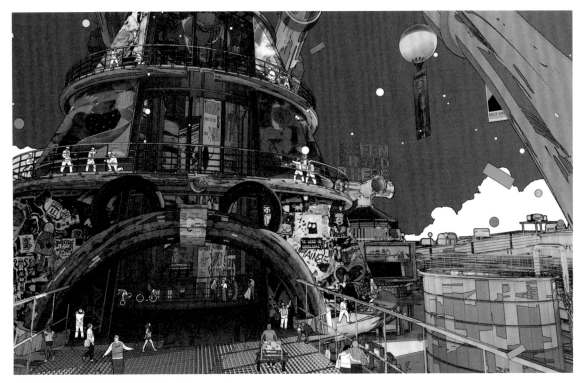

ADTOPIA: COUNTERSPACES OF RESISTANCE IN THE ERA
OF ADVANCED ABSTRACTIVE ADVERTISEMENTS
Daniel Choi
The University of Auckland

Adtopia：高级抽象广告时代的反抗空间
丹尼尔·崔
奥克兰大学

DARSANA: URBAN WELLNESS
Giulia Beltrami Batista,Tatiana Bonacina,Claudia Pelosi
Polytechnic University of Milan

德尔萨纳：城市健康
朱利亚·贝尔特拉米·巴蒂斯塔、塔蒂亚娜·博纳西娜、
克劳迪娅·佩洛西
米兰理工大学

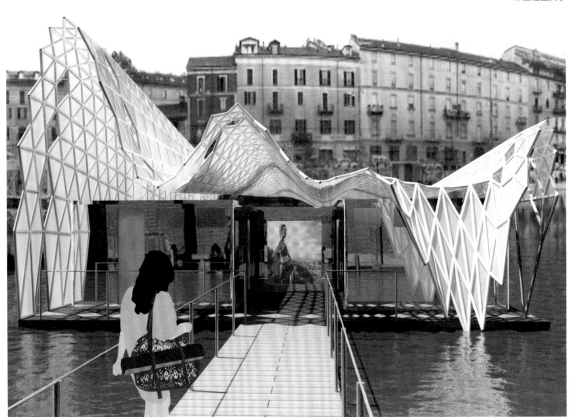

CURATING THE INDETERMINACY (FAKE CHURCH)
Jono Yoo
The University of Auckland

纠正不确定性（假教堂）
乔诺·尤
奥克兰大学

RESHAPING MOUNTAINS AND SEAS - URBAN DESIGN OF PARTIAL
PLOTS OF LINGANG NEW CITY UNDER THE LANDSCAPE CULTURE
Li Liangwei
Shanghai Academy of Fine Arts, Shanghai University

重塑山海——山水文化背景下的临港新城局部地块城市设计
李良伟
上海大学上海美术学院

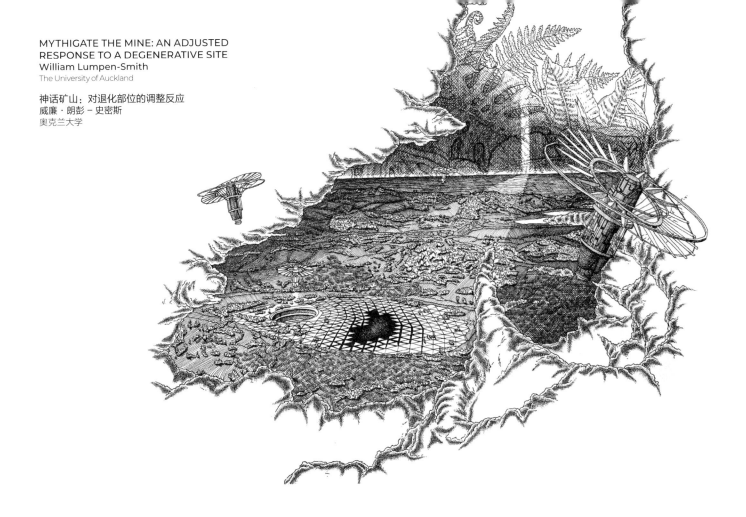

MYTHIGATE THE MINE: AN ADJUSTED RESPONSE TO A DEGENERATIVE SITE
William Lumpen-Smith
The University of Auckland

神话矿山：对退化部位的调整反应
威廉·朗彭－史密斯
奥克兰大学

VYBORG MUSEUM FRAME BASED ON FORTIFICATIONS OF XIII - XVIII CENTURIES
Philip Tyshkovskiy
Repin Academy of Fine Arts

基于十三至十八世纪防御工事的维堡博物馆框架
菲利普·蒂什科夫斯基
列宾美术学院

DRIFTSCAPE - MAXIMIZE THE USE OF URBAN
SPACE TO ADDRESS DENSIFICATION
Zhang Sida
Rhode Island School of Design

Drivescape——最大限度地利用
城市空间以解决致密化问题
张思达
罗德岛设计学院

NEGENTROPIC LANDSCAPE EXPERIENCE DESIGN
Aishwarya Janwadkar
Art Center College of Design

高分景观体验设计
艾西瓦娅·贾瓦德卡
艺术中心设计学院

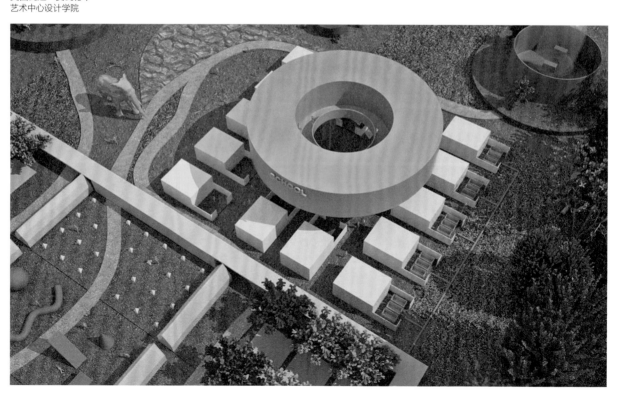

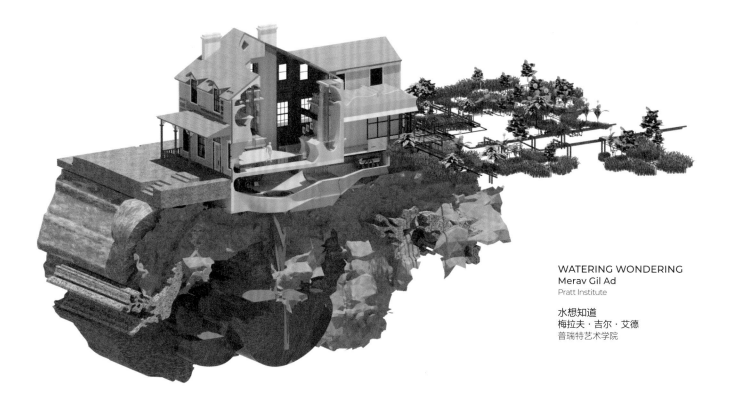

WATERING WONDERING
Merav Gil Ad
Pratt Institute

水想知道
梅拉夫·吉尔·艾德
普瑞特艺术学院

Design Story

A collection that creates
the intimate spaces that
make up the background to
your life. It's there to foster
and create those special,
everyday moments that
only home can bring us.
By utilizing comfort and
tactility, the pieces create a
space that everyone wants
to gather around.

nest

nest is a modular seating
element that is designed
with comfort in mind.
It features overstuffed
pillows for that pillow fort
kind of vibe.

"SEMI BAZAAR COMPANION" - INHERITANCE
AND REVIVAL OF TUJIA YANDAO BAZAARS
Liu Wenyu,Li Yijun,Fu Zhenyu,Wang Changxi
Hubei Institute of Fine Arts

"半集伴居"——土家族盐道集市的传承与复兴
刘文玉、李一君、付震宇、王长曦
湖北美术学院

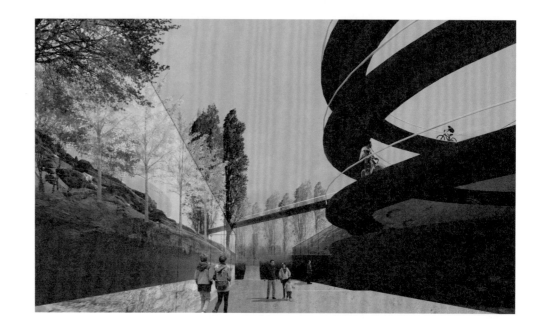

"OVER 100 MILLION YEARS IN ONE DAY"
JIULONGDONG DINOSAUR GEOLOGICAL MUSEUM
Yao Zihao,Wang Yuxin,Liao Jinglin
Hubei Institute of Fine Arts

"一日时光，跨越亿年"
九龙洞恐龙地质博物馆
姚子豪、王语馨、廖婧琳
湖北美术学院

THE THIRD SPACE OF THE CITY
Zhou Sheng
Shanghai Academy of Fine Arts, Shanghai University

城市第三空间
周晟
上海大学上海美术学院

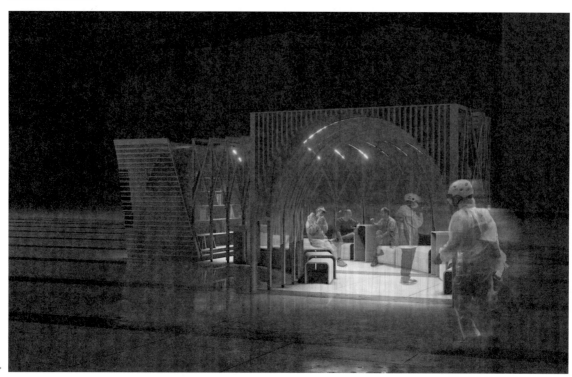

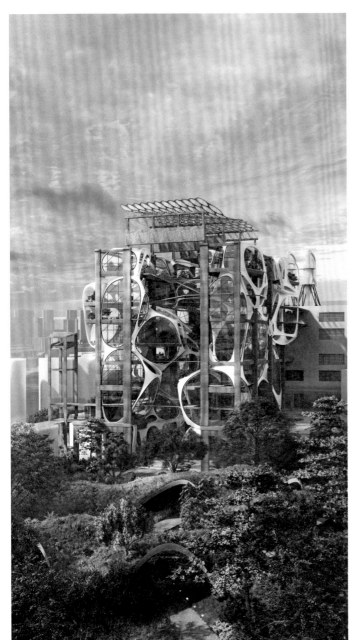

ORGANIC · TIME · GROWTH - "TIME CHANGES" ART PARK OF CHONGQING POWER PLANT - ECOLOGICAL ORGANIC BUILDING TRANSFORMATION
Huang Guanchang,Fu Wencan,Tang Zhiqiang
Sichuan Fine Arts Institute

有机·时间·生长——"时之境迁"
重庆电厂美术公园——生态有机建筑改造
黄冠昌、傅雯粲、唐志强
四川美术学院

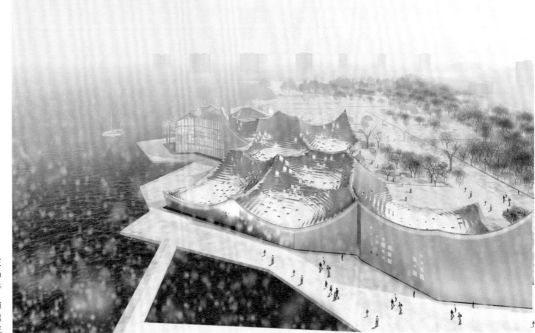

CITY PULSE
Dai Jingnan
LuXun Academy of Fine Arts

城市脉搏
代京男
鲁迅美术学院

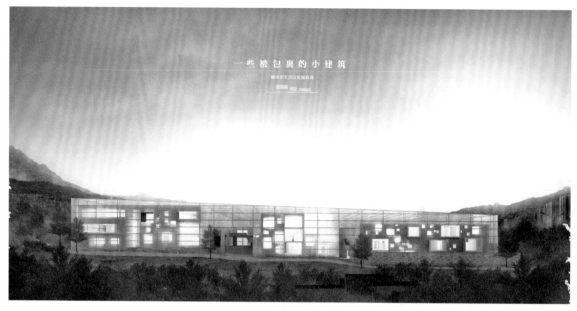

SOME SMALL BUILDINGS WRAPPED UP - RECONSTRUCTION OF
OLD LIVING QUARTERS IN FUSHUN CITY
Zhu Ziming
LuXun Academy of Fine Arts

一些被包裹的小建筑——抚顺市旧居住区改造
朱梓铭
鲁迅美术学院

ISOLATION NETWORK - EPIDEMIC PREVENTION
AND ISOLATION NETWORK BASED ON HUFF
MODEL AND DISTRIBUTION DESIGN
Lu Junwen
Guangzhou Academy of Fine Arts

隔离网络——基于 HUFF 模型的防疫隔离网络与布点设计
卢浚文
广州美术学院

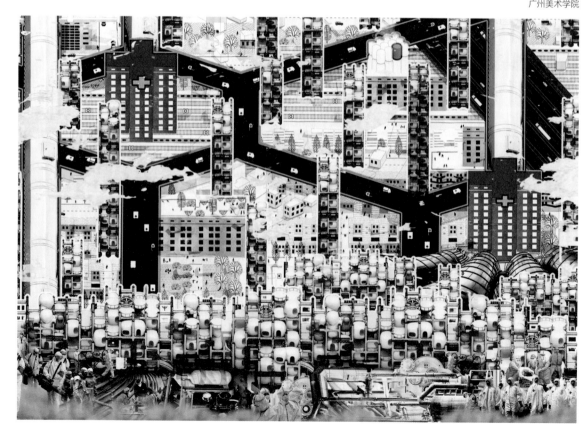

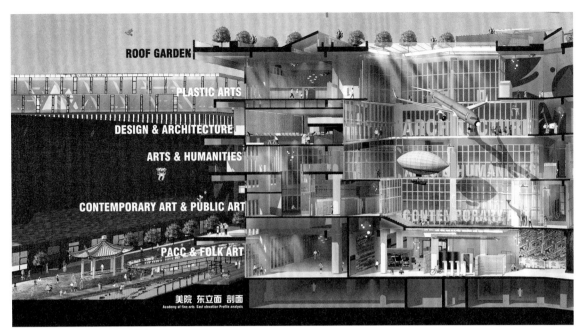

BEAUTY REPRESENTS ITSELF WITH DIVERSITY AND INTEGRITY -
INDOOR AND OUTDOOR ENVIRONMENT DESIGN OF NEW BUILDING OF
YANCHANG CAMPUS OF SHANGHAI ACADEMY OF FINE ARTS
Dou Zhichen
Shanghai Academy of Fine Arts, Shanghai University

美美与共——上海美术学院延长校区新大楼室内外环境设计
窦志宸
上海大学上海美术学院

HARD AS WATER - PUBLIC DESIGN OF SUNGANG
SLUICE ON BUJI RIVER IN SHENZHEN
Peng Ziqi
Guangzhou Academy of Fine Arts

坚硬如水——深圳布吉河笋岗水闸公共化设计
彭子琦
广州美术学院

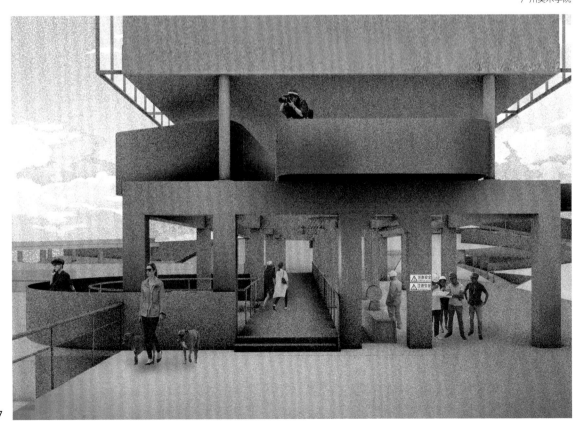

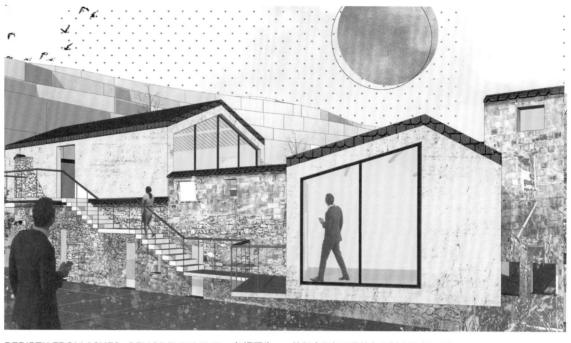

REBIRTH FROM ASHES - REMODELING THE RUINS OF DONGPING VILLAGE FROM THE MEMORIAL TO THE DAILY LIFE
Kang Yilan
Shanghai Academy of Fine Arts, Shanghai University

灰烬重生——从纪念回归日常的东屏村废墟空间重塑
康艺兰
上海大学上海美术学院

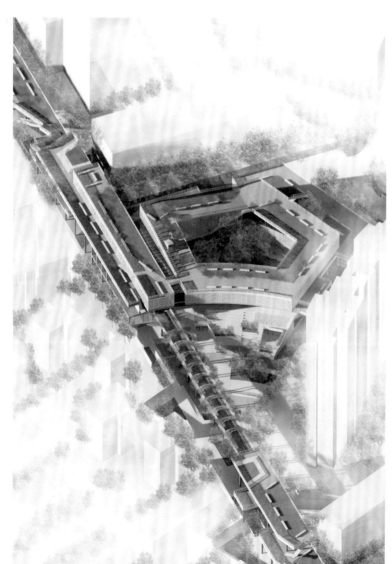

CONVEYOR BELT PLAN - REMODELING DESIGN OF CAOYANG NEW VILLAGE'S DAILY AND NON-DAILY PUBLIC SPACE
Yang Ying
Shanghai Academy of Fine Arts, Shanghai University

传送带计划
——曹杨新村日常与非日常公共空间重塑设计
杨颖
上海大学上海美术学院

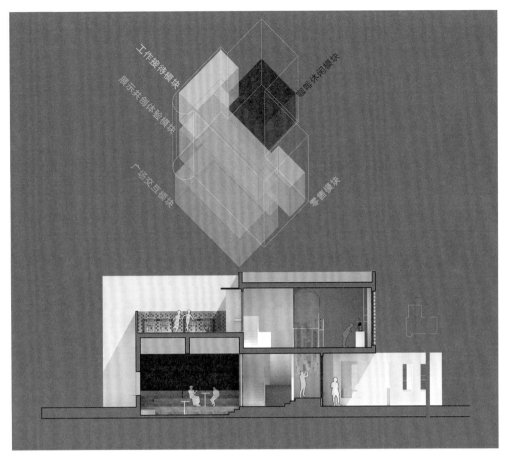

DESIGNER BRAND STRATEGY AND EXPERIENCE DESIGN IN
THE CONTEXT OF TONGJI UNIVERSITY 2.0 - TAKING ALDO
CIBIC'S PERSONAL BRAND AS AN EXAMPLE
Jiang Mu
Tongji University

环同济 2.0 场景下的设计师品牌策略及体验设计
——以 ALDO CIBIC 个人品牌为例
蒋沐
同济大学

ZIMING YE WORK COLLECTION
Ye Ziming
Pratt Institute

Ziming Ye 作品集
叶子铭
普瑞特艺术学院

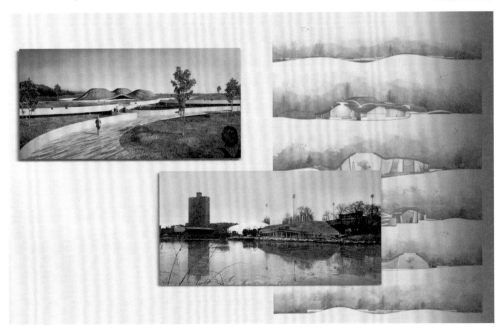

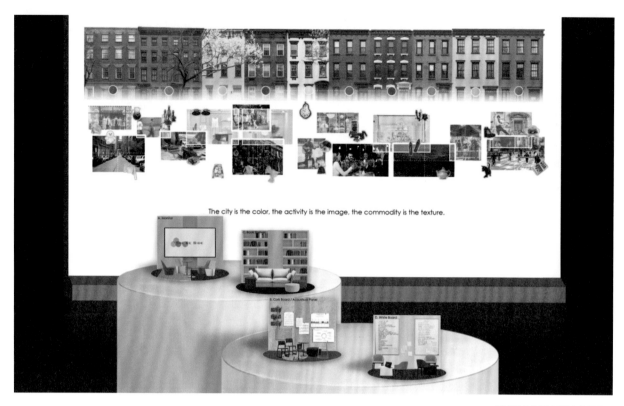

The city is the color, the activity is the image, the commodity is the texture.

EXPLORE WITH STAIRS
Cai Fangming
Pratt Institute

探索楼梯
蔡方明
普瑞特艺术学院

**BEYOND·STREET: URBAN DESIGN OF
WENDINGFANG STREET, XUHUI DISTRICT, SHANGHAI**
Ni Songnan
Shanghai Academy of Fine Arts, Shanghai University

超越 · 街道：
上海市徐汇区文定坊街道空间城市设计
倪松楠
上海大学上海美术学院

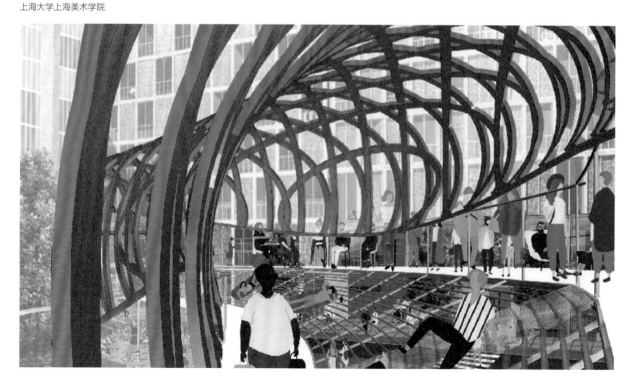

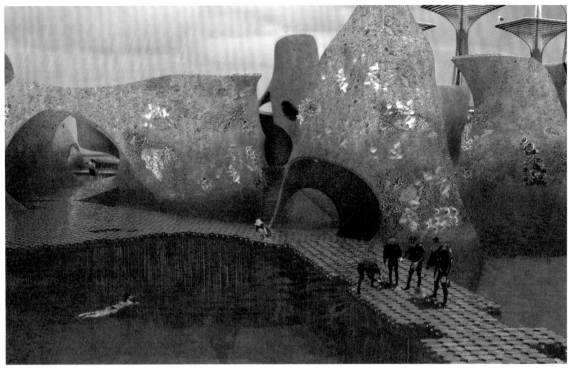

BLURRED BOUNDARY
Lin Wei
Pratt Institute

模糊的边界
林蔚
普瑞特艺术学院

INNOVATIVE DESIGN OF POP-UP MINIATURE
MUSEUM BASED ON EXPERIENCE ECONOMY
Sun Li
Tongji University

基于体验经济的快闪（pop-up）
微型博物馆创新设计
孙莉
同济大学

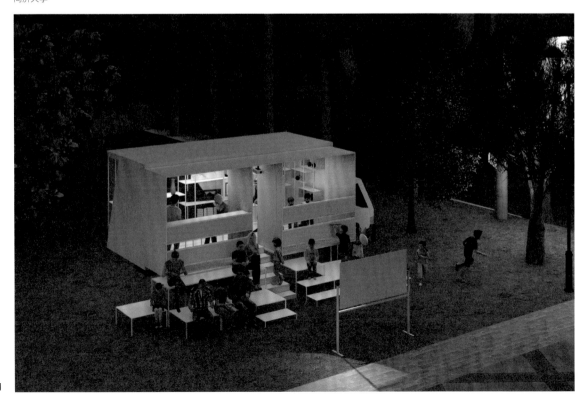

ECO-WASTE: HOUSEHOLD WASTE
MATERIAL FLOWS
Meng Erqi
Rhode Island School of Design

生态垃圾：家用垃圾物质流调
孟尔琪
罗德岛设计学院

FLUID GROUND
Liu Yuxi
Rhode Island School of Design

流体地面
刘昱希
罗德岛设计学院

LONELINESS/ TOGETHERNESS
Chen Huaqin
Rhode Island School of Design

孤独 / 热闹
陈华沁
罗德岛设计学院

HUCKLEBERRY FINN'S FLOATING PLACE
Shen Zifei
Washington University in St. Louis

哈克贝利·费恩漂流地
沈子飞
圣路易斯华盛顿大学

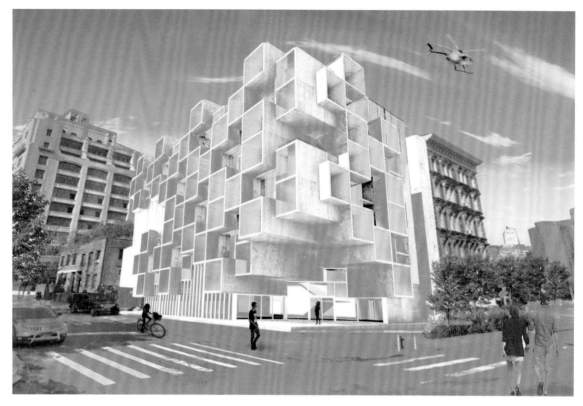

HAPPY COLOR
Chen Xin
Pratt Institute

乐色
陈欣
普瑞特艺术学院

STEEL X
Xu Yijia,Ma Zhimin
University of Pennsylvania

钢铁之交
徐易佳、马之敏
宾夕法尼亚大学

TALE OF CASTLE KEEP
Gao Mengzhen
Tama Art University

城堡要塞的故事
高梦真
多摩美术大学

**MORE HAPPINESE SHOP: VALUE
CONTINUATION OF CONTENT
CONSTRUCTION OF JAPANESE
ETHNIC COMMUNITY IN SHANGHAI
UNDER MULTICULTURALISM**
Luo Yunjing
Tongji University

多乐铺：多元文化下上海日本族裔社群
内容构建的价值延续
骆云婧
同济大学

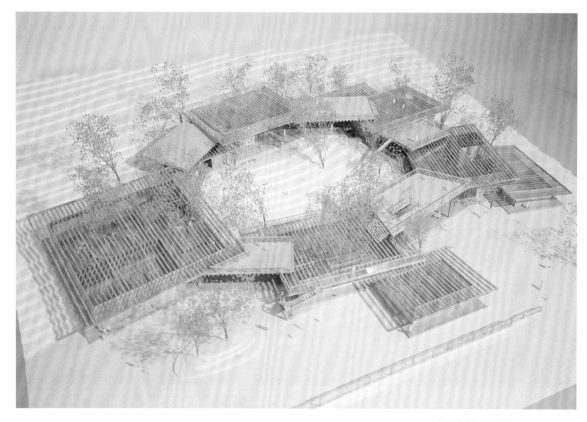

KINDERGARTEN IN FOREST
Huang Yanggang
Tama Art University

森林里的幼儿园
黄旸岗
多摩美术大学

MARGIN SPACE OF THE CITY - PUBLIC SPACE
AFTER THE UNDERGROUNDIZATION OF
SHIMOKITA RAILWAY WITH "LOCALIZATION"
Shen Yanru
Tama Art University

城市边缘空间：
下北铁道地下化后"本土化"的公共空间
沈晏如
多摩美术大学

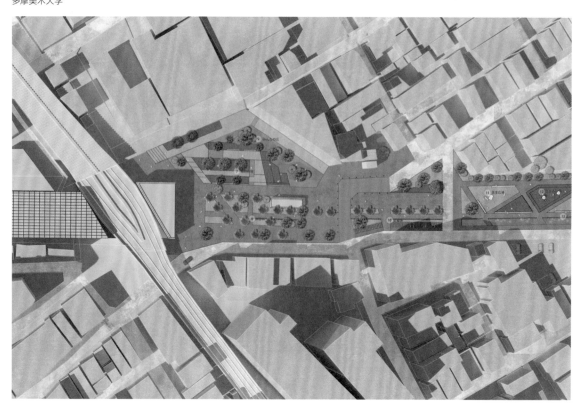

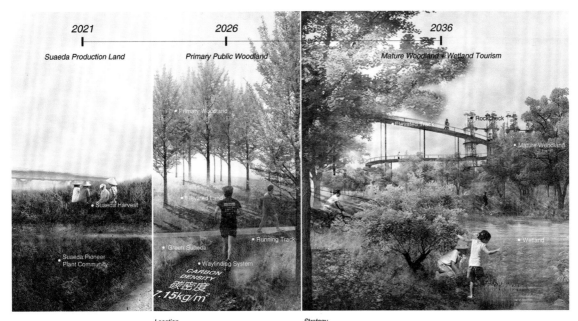

2021
Suaeda Production Land

2026
Primary Public Woodland

2036
Mature Woodland + Wetland Tourism

ROCKCHECK CARBON PARK

 Large Sport Area

 Dense Forest

Location

After harvesting some timber from the primary woodland system, the elevated tracks will be constructed, which can increase the interaction between people and Rockcheck, as well as attract tourists to visit this industrial area.

Strategy

 >>>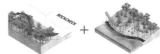

CARBON URBANISM: A DYNAMIC ECO-CITY SYSTEM IN TIANJIN
Huang Jin, Huang Yihan
University of Pennsylvania

碳中和城市：天津动态生态城市系统
黄津、黄逸涵
宾夕法尼亚大学

FAN BUBBLE NBA & BASKETBALL THEMED BARLIKE
Teng Mingfei
Art Center College of Design

粉丝泡沫 NBA ＆篮球主题酒吧
腾明非
艺术中心设计学院

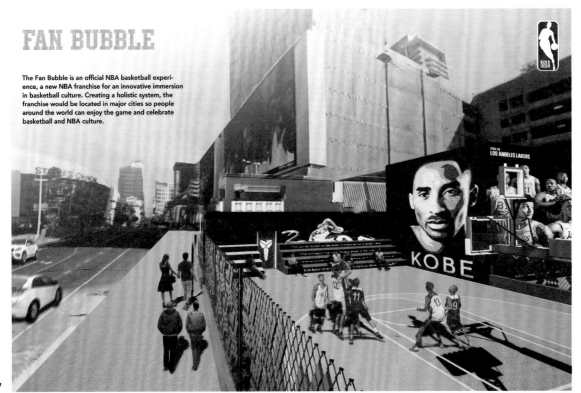

FAN BUBBLE

The Fan Bubble is an official NBA basketball experience, a new NBA franchise for an innovative immersion in basketball culture. Creating a holistic system, the franchise would be located in major cities so people around the world can enjoy the game and celebrate basketball and NBA culture.

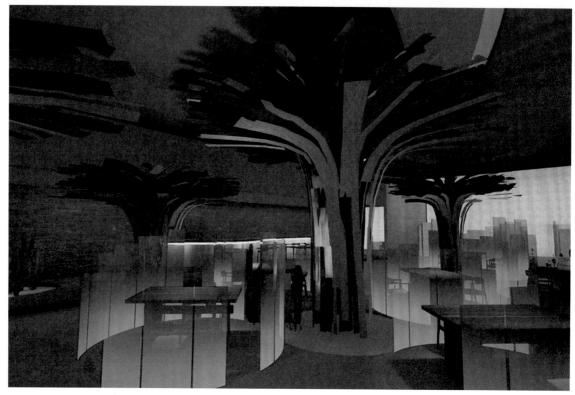

XUN - DINING EXPERIENCE
Yao Weiling
Art Center College of Design

旬——沉浸式餐厅体验
姚炜龄
艺术中心设计学院

Inside-Out
Liu Meihan,Wu Huize
Pratt Institute

内——外
刘美含、吴惠泽
普瑞特艺术学院

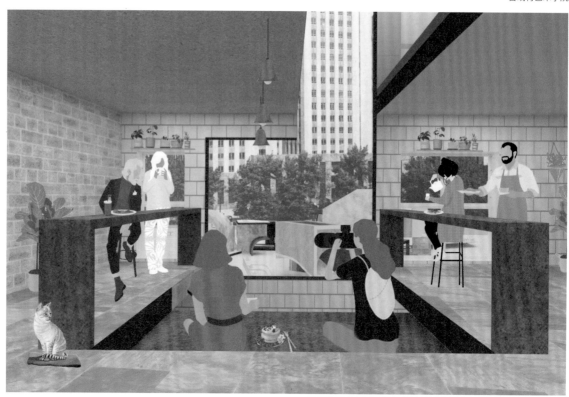

STALT: WHAT'S UNSEEN?

The graphic gestalt arouses people's innate visual power and creates dynamic tension in static state. How do we read information that is not visible to the naked eye? When graphics appear as a language of information, how does the syntax change in different media? How can the subtext be effectively communicated? See the unseen, and read the unspoken.

格·式: 如何看见未见?

图形格式塔调动人与生俱来的视觉动力, 在静态中架构出动态的张力。我们如何从肉眼不可见中, 读取意到而形未到的信息? 当图形作为信息传达的语言, 其语法如何在不同媒介上变格? 其蕴含的潜台词如何有效传达? 看见未见之形, 读出未言之语。

3

SEI NICHT ALBERN EINSTEIN!
Saskia van der Meer
University of the Arts Bremen

别傻了，爱因斯坦！
萨斯基亚·范德米尔
不来梅艺术学院

B()K
Yutaka Nagai
Tama Art University

B()K
永井浩
多摩美术大学

PALO TRANS MEDIA, BRANDING, PRINTLIKE
Jack Mcentee
Art Center College of Design

帕洛跨媒体、品牌、印刷
杰克·麦克森蒂
艺术中心设计学院

THE MYTHICAL
Miila Westin
Aalto University

神话
米拉·威斯汀
阿尔托大学

Yikai
Liu Yifei
Academy of Arts & Design, Tsinghua University

逸楷
刘逸飞
清华大学美术学院

叶	水	然	话	写	几	设	拟	日
么	悟	担	笔	一	和	别	西	立
的	轨	片	乐	天	问	校	加	而
五	但	还	赵	云	年	是	也	字
东	温	主	纯	功	劳	音	听	蛙
说	阳	风	迹	马	去	亲	其	布
元	打	远	里	每	啦	收	秋	印
空	刹	枫	飞	抖	排	送	雪	张
计	告	导	牙	科	饱	世	田	先
门	谷	书	指	叮	自	洞	住	背
专	实	派	那	没	间	从	七	工
习	满	审	开	参	到	学	包	姐

逸楷朴实可爱

小学语文教科书体

Where to Go
Sheng Yuqing
Academy of Arts & Design, Tsinghua University

游踪
盛雨晴
清华大学美术学院

1+1=?
Jiang Jiaying,Feng Xinyue,Zheng Aijia
China Academy of Art

1+1=？
江佳颖、冯欣悦、郑艾嘉
中国美术学院

24.KG
Lin Lingjia,Na Zimu,Wu Weiyao
China Academy of Art

24.KG
林令佳、那子木、吴炜尧
中国美术学院

EXPERIMENT X011 . . .
Ryan Bradford
Pratt Institute

实验 X011 ······
瑞安·布拉德福德
普瑞特艺术学院

WITHIN ONE METER
Ye Xinming,Cheng Yubing,Xu Wanwen
China Academy of Art

一米之间
叶昕明、程玉冰、许菀文
中国美术学院

COUCH WORKER EDITION
Eno Won
Emily Carr University of Art + Design

沙发工人版本
伊诺·万
艾米丽卡尔艺术与设计大学

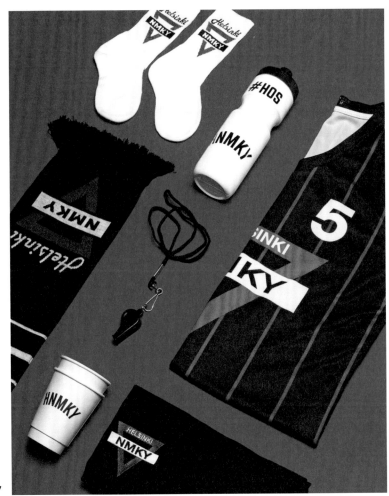

VISUALITY OF BASKETBALL TEAMS IN FINLAND
Veera Kesänen
Aalto University

芬兰篮球队的视觉性
维拉·凯萨宁
阿尔托大学

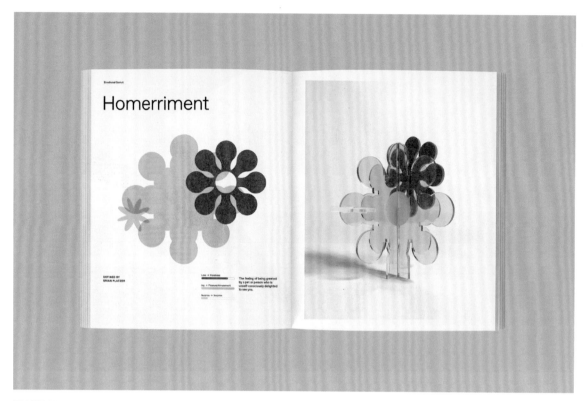

EMOTIONAL GAMUT
Akshita Chandra
Maryland Institute College of Art

情绪感知域
阿克西塔·钱德拉
马里兰艺术学院

HEALFLOR KIT
Fu Xiaoman
Maryland Institute College of Art

HealFlor 套件
付晓曼
马里兰艺术学院

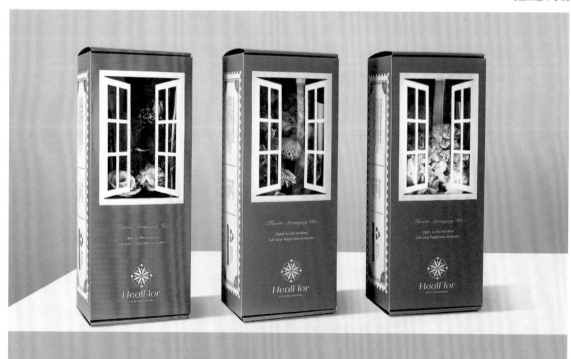

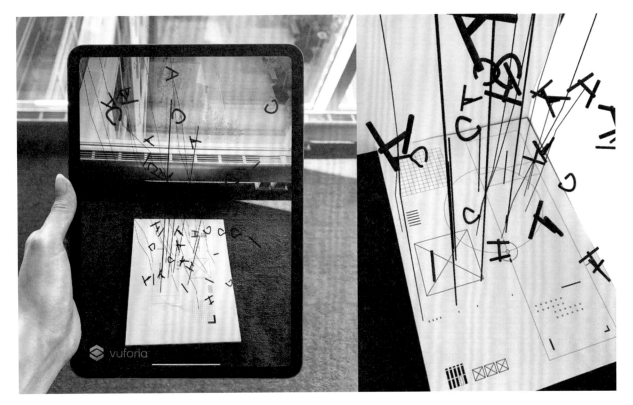

THE FIFTH MEDIUM
Yu Xinmeng
Maryland Institute College of Art

第五媒介
于欣萌
马里兰艺术学院

QUICKBOOKS 2019–2021
Luiza Dale
Yale University School of Art

QuickBooks 2019–2021
路易莎·戴尔
耶鲁大学艺术学院

JARANAN
Herdimas Anggara
Yale University School of Art

贾纳兰
赫迪马斯·安加拉
耶鲁大学艺术学院

THE DICTIONARY
Liang Xiaoying
Central Saint Martins

词典
梁晓盈
中央圣马丁艺术与设计学院

UNRELATED STORIES
Hyung Cho
Yale University School of Art

无关的故事
周翔
耶鲁大学艺术学院

YALE STAIRWAY
Junki Jung
Yale University School of Art

耶鲁楼梯
郑俊基
耶鲁大学艺术学院

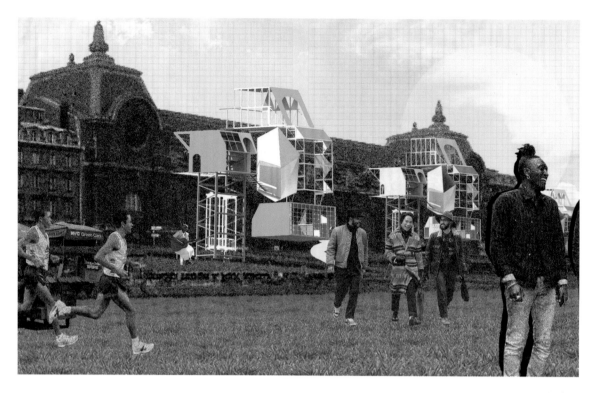

Gather
Song Xiaoyu
Maryland Institute College of Art

汇聚
宋晓宇
马里兰艺术学院

ALL AT ONCE (2021 YALE MFA
GRAPHIC DESIGN THESIS SHOW)
Milo Bonacci
Yale University School of Art

一次全部搞定
（2021 耶鲁 MFA 平面设计论文展）
米洛·博纳奇
耶鲁大学艺术学院

RURAL HAND LORE
Cody Tracy
Southern Illinois University

乡村手工艺传奇
科迪·特雷西
南伊利诺伊大学

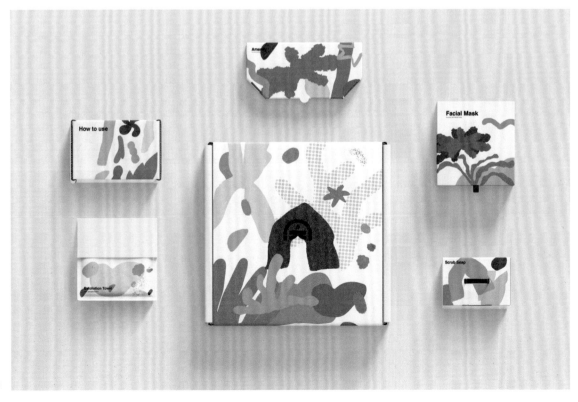

JJIM
Yeojin Park
Sookmyung Women's University

Jjim
朴永靖
淑明女子大学

CHARACTER DESIGNS
Fan Yu
Maryland Institute College of Art

角色设计
范瑜
马里兰艺术学院

DEPARTMENT OF DIGITAL REMAINS
Anjali Nair
Maryland Institute College of Art

数字遗骸部
安贾利·奈尔
马里兰艺术学院

EVERYDAY GIRLS
Gao Yufei
Maryland Institute College of Art

日常女孩
高羽菲
马里兰艺术学院

HYBRIDENTITY
Chen Ning
Maryland Institute College of Art

杂糅
陈凝
马里兰艺术学院

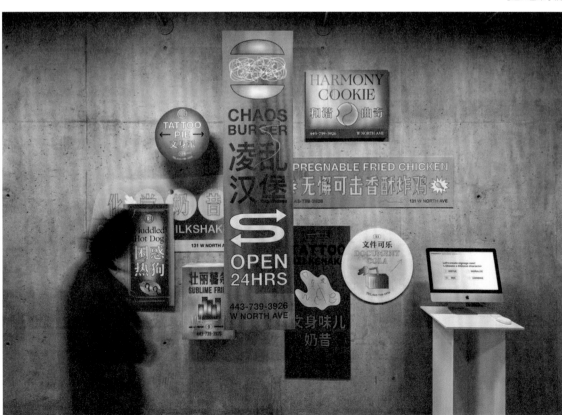

GARBATELLA: ATMOSPHERIC JOURNEY
Chiara Fabretti
Polytechnic University of Milan

加巴泰拉：氛围之旅
基亚拉·法布雷蒂
米兰理工大学

DISTANCE PAST
Xie Liwei
Maryland Institute College of Art

过往的距离
谢莉薇
马里兰艺术学院

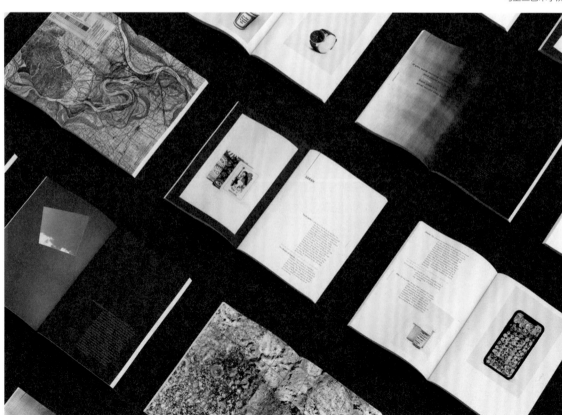

MULTIVERSO
Maria Alessandra Fratta,
Federica Inzani Federico Motta
Polytechnic University of Milan

多元宇宙
玛丽亚·亚历山德拉·弗拉塔、
费德里卡·因扎尼 费德里科·莫塔
米兰理工大学

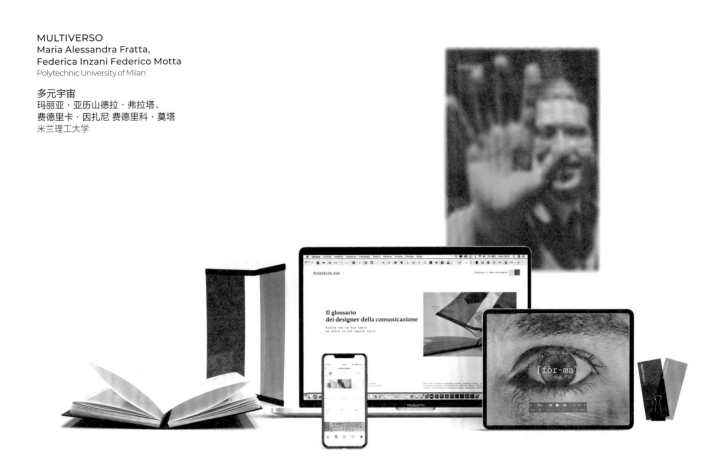

BIOPHILIA
Dong Xiang
Maryland Institute College of Art

本能
董翔
马里兰艺术学院

NARRATIVE BUILDING: GREEK
MYTHOLOGY IN SEOUL AND BREMEN
Naree Sin
University of the Arts Bremen

叙事建筑：首尔和不来梅的希腊神话
娜莉·辛
不来梅艺术学院

SUNRISE REAL ESTATE
Guo Xiaofeng
Maryland Institute College of Art

日出地产
郭晓峰
马里兰艺术学院

KOHINA KORVISSANI: DESIGNING A
VISUAL CONCEPT FOR AN ECOCRITICAL
Laura Kettu-Fox
Aalto University

科伊娜·科维萨尼：为生态批评设计视觉概念
劳拉·凯图－福克斯
阿尔托大学

MANHATTAN TYPE
Natalia Witwicka
The Glasgow School of Art

曼哈顿类型
娜塔莉亚·维特维卡
格拉斯哥美术学院

HOME
Wang Zhaoyan
The Glasgow School of Art

家
王昭妍
格拉斯哥美术学院

LOVE THIS PLACE
Maya Yajima
Tama Art University

爱上这个地方
矢岛茉绚
多摩美术大学

SEA MONSTERS
Yudai Kuwamoto
Tama Art University

海怪
锹本雄大
多摩美术大学

CITY MEADOWS
Clémence Bahout
Loughborough University

城市草地
克莱门斯·巴豪
拉夫堡大学

THE ATLANT OF TEXTURES: TEXTURE DESIGN,
GEOGRAPHIES AND VISUAL ATMOSPHERES
Sara Corradini
Polytechnic University of Milan

纹理图集：
纹理设计、地理与视觉氛围
萨拉·科拉迪尼
米兰理工大学

COBO: A PHYGITAL INTERACTIVE TOOLKIT
FOR CO-DESIGNING INTERACTIVE
OUTDOOR EXPERIENCES WITH PEOPLE
WITH INTELLECTUAL DISABILITY
Diego Morra
Polytechnic University of Milan

COBO：一个物理交互工具包，用于
与智障人士共同设计交互式户外体验
迭戈·迪
米兰理工大学

EXPLORING MULTICULTURALISM
THROUGH ILLUSTRATION
Parvati Pillai
Aalto University

通过插画探索多元文化主义
帕尔瓦蒂·皮莱
阿尔托大学

GUIDE TO PROJECT ARCHIVES
THROUGH THE TERRITORY: EXPOSED
ARCHIVES OF IMPLIED MAPS
Beatrice Borghi
Polytechnic University of Milan

跨领土项目档案指南：
隐式地图的广泛档案
比阿特丽斯·博尔吉
米兰理工大学

ANOTHER INTERPRETATION OF HIRAGANA
Yusuke Michikawa
Tama Art University

平假名的另一种解释
道川雄介
多摩美术大学

TOMATO PACKAGING DESIGN
Huang Linxi
Loughborough University

番茄包装设计
黄林溪
拉夫堡大学

SCHADENFREUDE METER TEST
Alessia Arosio,Lorenzo Bernini,Emanuele Coppo,
Enrico Monasteri,Filippo Testa
Polytechnic University of Milan

幸灾乐祸仪表测试
阿莱西娅·阿罗西奥、洛伦佐·贝尼尼、伊曼纽尔·科波、
恩里科·蒙纳斯特里、菲利波·泰斯塔
米兰理工大学

AMBIENCE' EP
Nathan Monaghan
Loughborough University

氛围专辑
内森·莫纳汉
拉夫堡大学

BUIO – ACCENDI IL TATTO!
Sara Bottaini
Polytechnic University of Milan

黑暗——点燃触觉！
萨拉·博泰尼
米兰理工大学

THE SOCIETY OF VISUALLY IMPARED SOUND ARTISTS
Josephine Hermanto
Royal Melbourne Institute of Technology

视觉受损的声音艺术家社群
约瑟芬·赫曼托
皇家墨尔本理工大学

AMAZON PRIME AIR
Zoë Adams
Loughborough University

亚马逊优质空气
佐伊·亚当斯
拉夫堡大学

CAV LIVERPOOL BRAND IDENTITY
Eileen Chiang
Art Center College of Design

利物浦洞穴俱乐部品牌标识
蒋爱玲
艺术中心设计学院

BEST YEAR - TWO THOUSAND AND TWENTY
Juuli Miettilä
Aalto University

最佳年份——2022
尤利·米蒂拉
阿尔托大学

JOURNEY TO HORIZON - SIGNAGE SYSTEM
DESIGN OF ZHEJIANG LIBRARY
Qian Jialing,Huang Ruiqi
China Academy of Art

视界之旅——浙江图书馆新馆导视系统设计
钱佳玲、黄睿琪
中国美术学院

LE RETOUR
Nao Tsukahara
Tama Art University

返
冢原菜绪
多摩美术大学

FRESH LOOK, FRESH START
Gerson Gilrandy
Royal Melbourne Institute of Technology

焕然一新，全新开始
格森·吉尔兰迪
皇家墨尔本理工大学

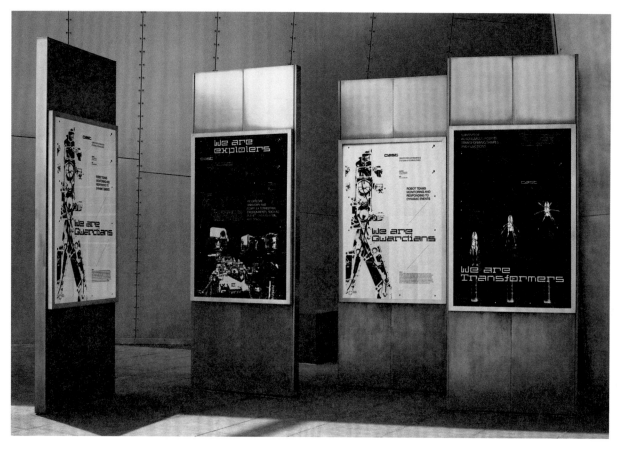

CAST VISUAL IDENTITY SYSTEM
Qta Sato
Art Center College of Design

CAST 视觉身份系统
佐藤八太
艺术中心设计学院

INVISIBLE CITIES: FROM VERBAL LANGUAGE TO PICTUREBOOK CODE SYSTEM, A PUBLISHING PROJECT FOR BOYS
Camilla Pilotto
Polytechnic University of Milan

意想不到的城市：从口头语言到图书代码
系统，一个适合儿童的编辑项目
卡米拉·皮洛托
米兰理工大学

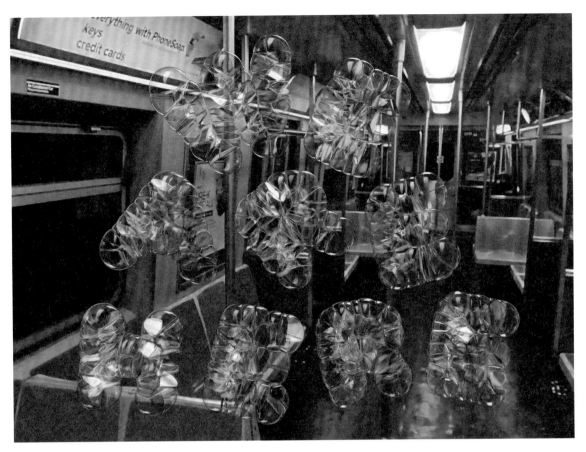

DREAM BUBBLE
Zhu Ruoyu
Parsons School of Design, The New School

梦幻泡沫
朱若瑜
帕森斯设计学院

CHINATI ART MUSEUM
Jisu Kim
Art Center College of Design

Chinati 艺术博物馆
金吉秀
艺术中心设计学院

THE O-SPACE SERIES
Brittany Mack
California College of the Arts

字母 O——空间系列
布列塔尼·麦克
加州艺术学院

EARTH OVERLOAD DAY
Chen Lingzi, Ding Ning, Lin Jingru
China Academy of Art

地球超载日
陈玲梓、丁宁、林敬如
中国美术学院

CONFUCIUS SAID
Hu Chuan,Xu Xiya,Yin Wenqi
China Academy of Art

子曰
胡川、徐茜雅、殷文琦
中国美术学院

ARCHIVE.UTOPIA
Lloyd Mostafa
Royal Melbourne Institute of Technology

档案．乌托邦
劳埃德·穆斯塔法
皇家墨尔本理工大学

PIECES OF A WHOLE
Rachel Adair
Emily Carr University of Art + Design

整体
雷切尔 · 阿黛尔
艾米丽卡尔艺术与设计大学

NIL TO NOWHERE
Claire Low
Nanyang Technological University, Singapore

静止的虚无
克莱尔 · 洛
新加坡南洋理工大学

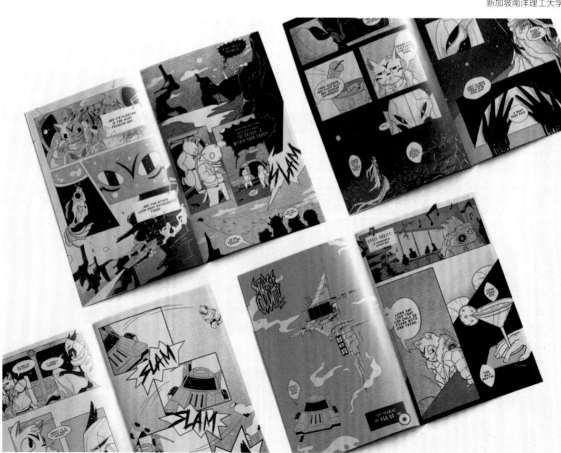

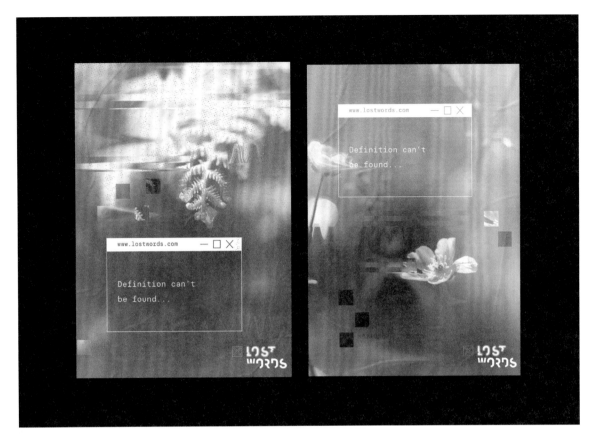

LOST WORDS
Indigo Price
Loughborough University

失语
印蒂亚戈·普莱斯
拉夫堡大学

GRAPHIC DESIGN
Riesling Dong
School of the Art Institute of Chicago

平面设计
董颖馨
芝加哥艺术学院

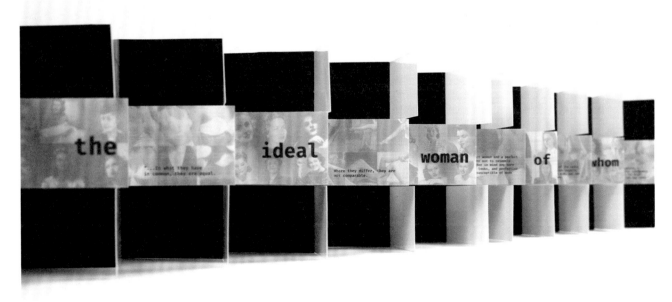

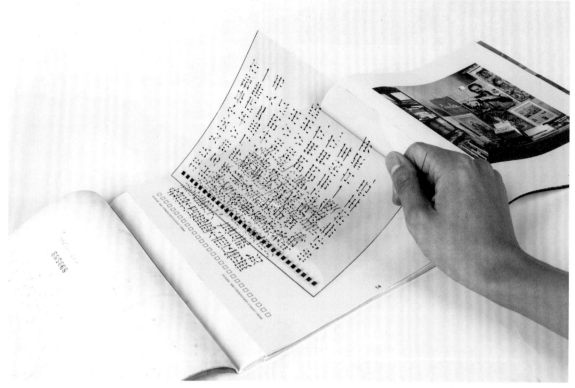

NON-LINEAR READING DESIGN
Zhang Yige
Tongji University

非线性阅读设计
张一格
同济大学

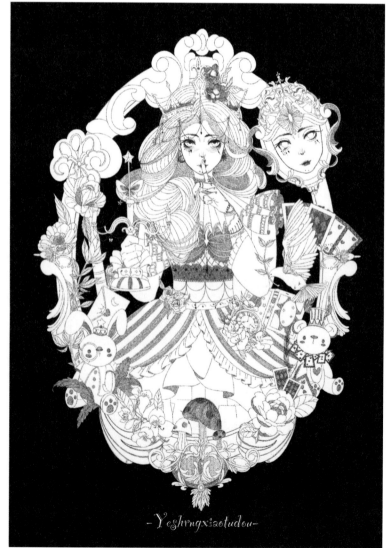

TUDOU'S DREAM
Chen Rushi
Hubei Institute of Fine Arts

Tudou 的梦
陈如诗
湖北美术学院

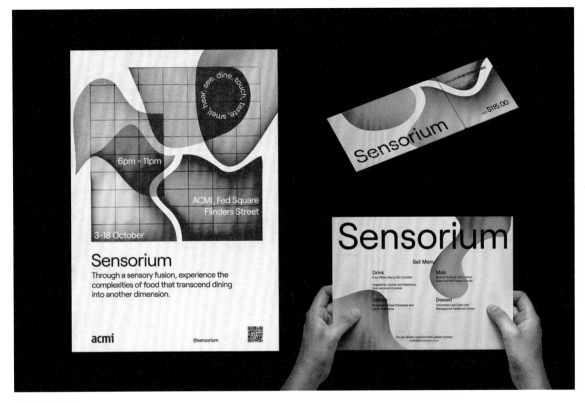

SENSORIUM
Georgia Williams
Royal Melbourne Institute of Technology

传感器
乔治亚·威廉姆斯
皇家墨尔本理工大学

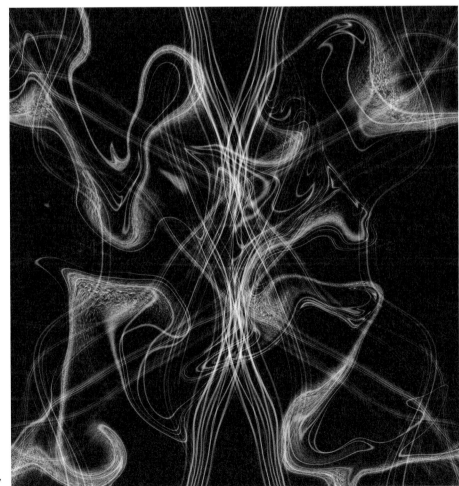

SEE YOUR VOICE
Deng Xuan, Zhang Ludan
Hubei Institute of Fine Arts

看见你的声音
邓璇、张栌丹
湖北美术学院

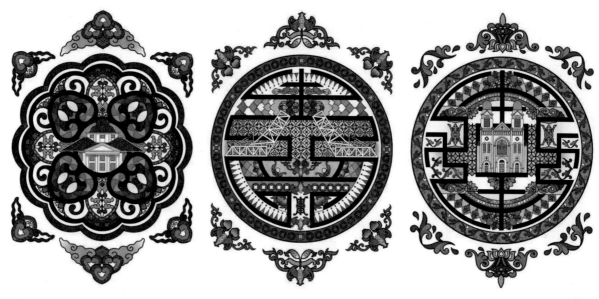

LIGHT AND SHADOW OF TIANJIN
Xu Xinyu
Tianjin Academy of Fine Arts

光影天津
许新语
天津美术学院

AN INCH OF TIME
Fan Zikuan,He Qianyu
China Academy of Art

一寸·光阴
范子宽、何倩瑜
中国美术学院

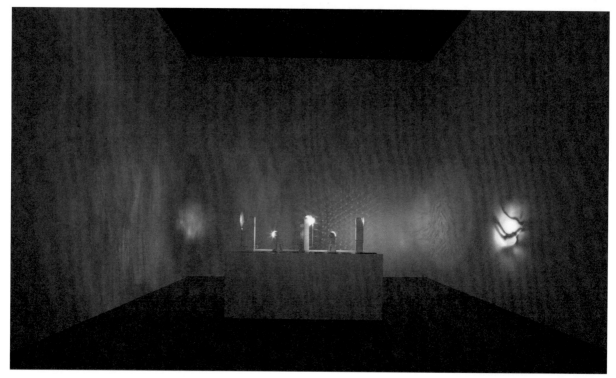

FROM FORMS TO CHAOS
Ashur He
Royal Melbourne Institute of Technology

从形式到混乱
何安琪
皇家墨尔本理工大学

GRANDMA'S STORY
Zhang Tingting
Pratt Institute

阿嬷的故事
张婷婷
普瑞特艺术学院

"FILIAL PIETY" MICRO SPACE
Zhou Qian
China Academy of Art

"孝"微空间
周倩
中国美术学院

**ALIVE - CONCEPTUAL PRODUCT
DESIGN OF RECYCLED PAPER**
Tang Tingting
Sichuan Fine Arts Institute

Alive——再生纸概念产品设计
唐婷婷
四川美术学院

PLANCK DISTANCE
Zhang Yangxue, Zhao Shiyu
China Academy of Art

普朗克距离
章阳雪、赵诗雨
中国美术学院

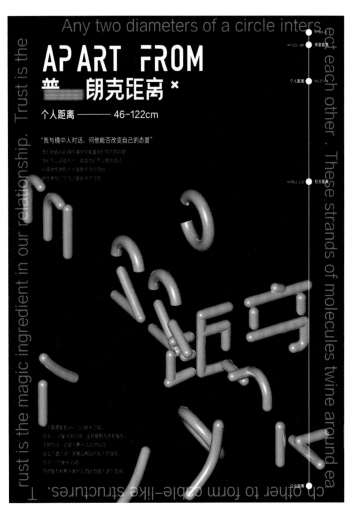

2019-NCOV AND CELLULAS
Liu Huijuan
Hubei Institute of Fine Arts

2019 新型冠状病毒与细胞
刘慧娟
湖北美术学院

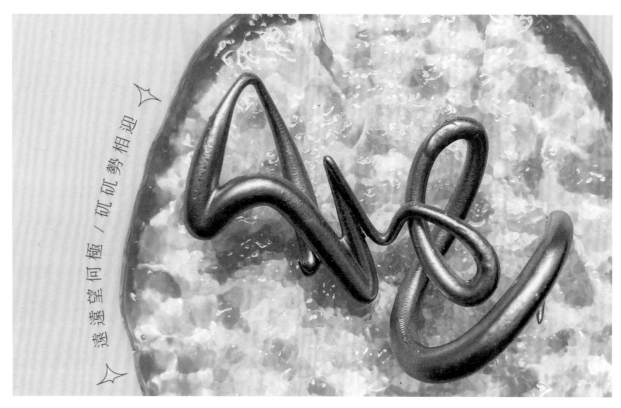

远遠望何極　矶矶勢相迎

INK GROWS THREE WORLDS
Li Yinuo
Tongji University

墨生三界
李一诺
同济大学

TANAH DI BAWAH ANGIN
Syahrul Anuar
Nanyang Technological University, Singapore

丹那迪巴瓦安金
沙鲁·阿努尔
新加坡南洋理工大学

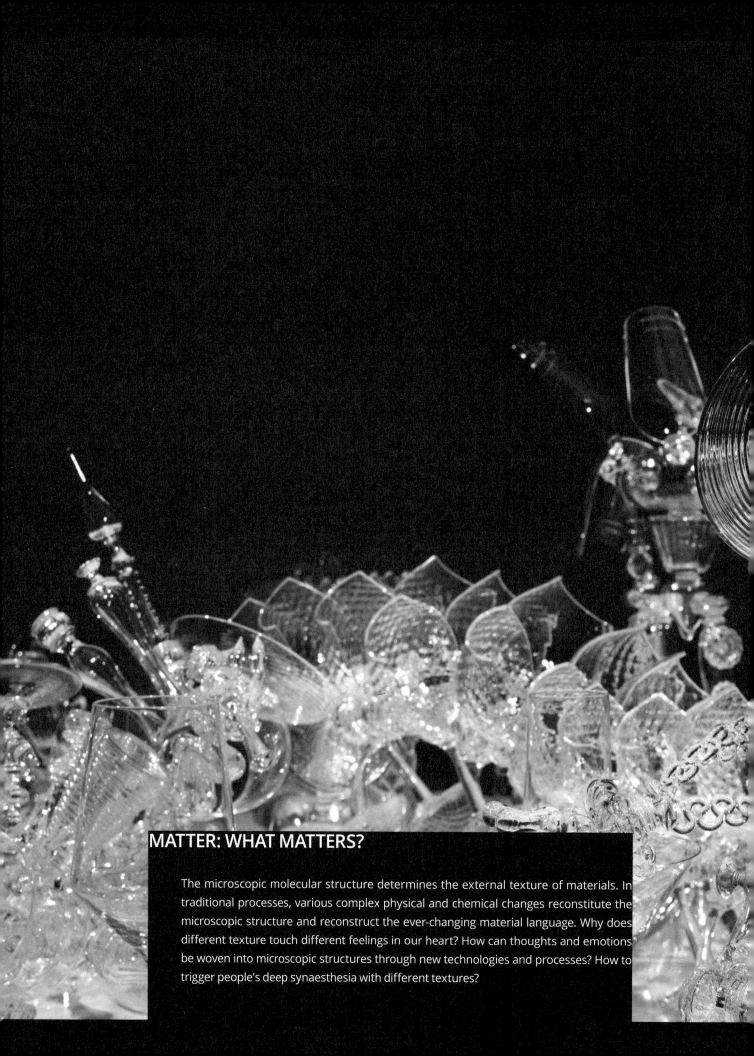

MATTER: WHAT MATTERS?

The microscopic molecular structure determines the external texture of materials. In traditional processes, various complex physical and chemical changes reconstitute the microscopic structure and reconstruct the ever-changing material language. Why does different texture touch different feelings in our heart? How can thoughts and emotions be woven into microscopic structures through new technologies and processes? How to trigger people's deep synaesthesia with different textures?

物·质: 缘何触动内心？

微观分子结构决定了材料的外在质地。传统工艺中，各种复杂的物理变化和化学变化在重新形成微观结构的同时，也重构出了千变万化的材质语言。为何不同的质感触动着内心不同的感受？如何通过新科技和工艺，将思想和情感编织在微观的结构中？如何用不同的质感触发人们深层的通感？

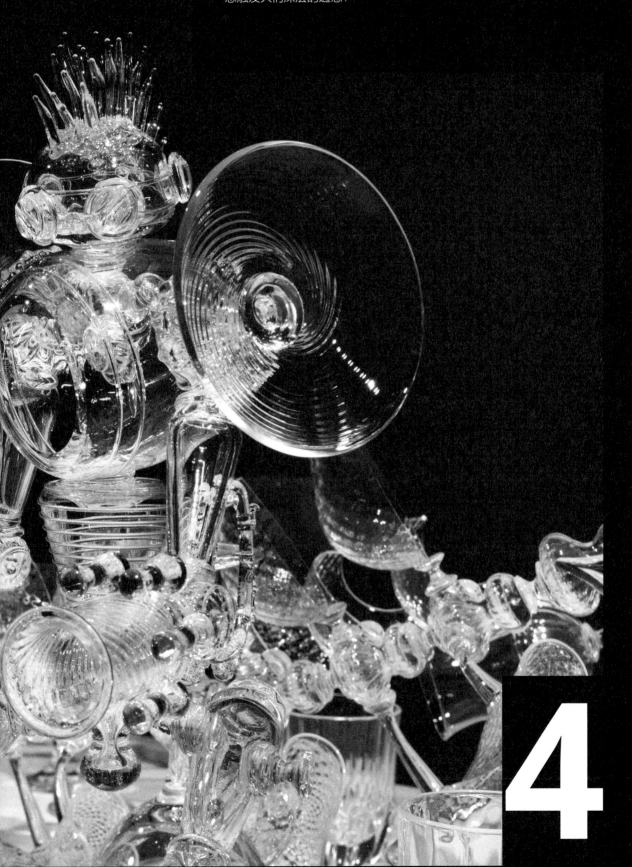

4

DISTILLING THE NARRAGANSETT BAY
Parker Ives
Rhode Island School of Design

纳拉甘西特湾提纯
帕克·艾夫斯
罗德岛设计学院

HIDING ETIQUETTE IN THE WORLD
Wu Runze
Academy of Arts & Design, Tsinghua University

世界隐秘礼仪
吴润泽
清华大学美术学院

TRAFFIC ISLAND
Lily Wilkins
Maryland Institute College of Art

安全岛
莉莉·威尔金斯
马里兰艺术学院

"I'M FINE, AND YOU?"
Song Danyang
Academy of Arts & Design, Tsinghua University

"我很好，你呢"
宋丹杨
清华大学美术学院

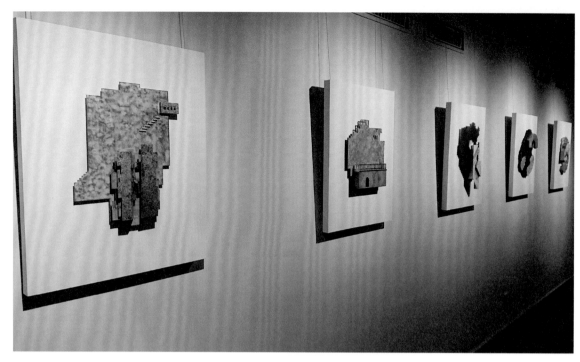

LITTLE CURIOSITY
Shiraki Kanako
Tokyo University of the Arts

小小的好奇心
白木加奈子
东京艺术大学

LEPIDOPTERA
Zhu Nan,Fang Yile
China Academy of Art

鳞翅
朱楠、方伊乐
中国美术学院

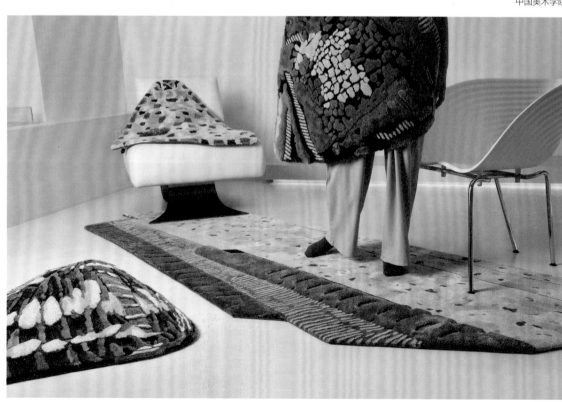

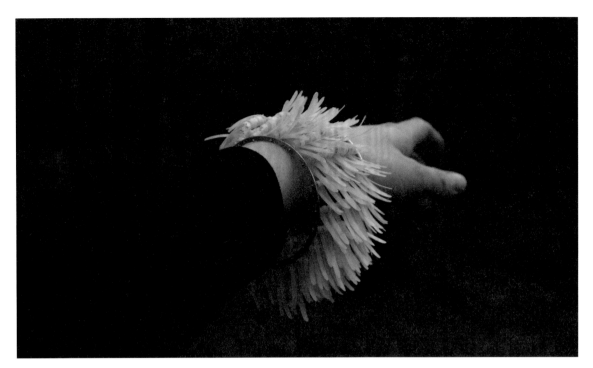

KINETIC NATURE
Cara Smith
The Glasgow School of Art

动力学性质
卡拉·史密斯
格拉斯哥美术学院

BEAST
Hoseok Youn
Southern Illinois University

野兽
尹浩锡
南伊利诺伊大学

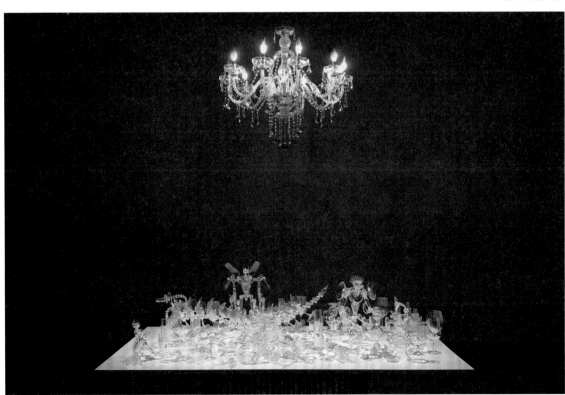

-- KANG --

KNOT · CHARACTER / FREE NORM
Kang Yunshu
Academy of Arts & Design, Tsinghua University

结·字／律·诗
亢云姝
清华大学美术学院

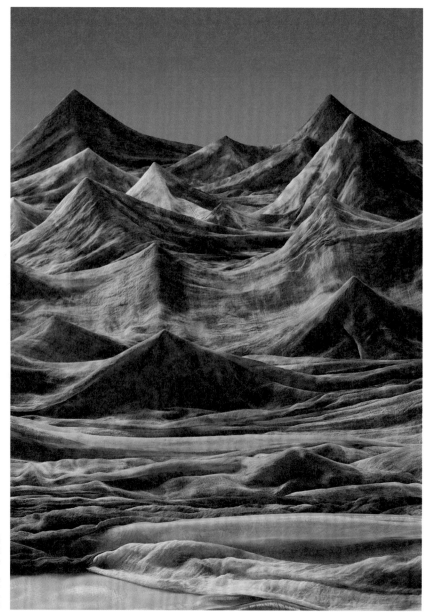

DREAMING WAVE
Kikyung Park
Sookmyung Women's University

梦想波
朴吉永
淑明女子大学

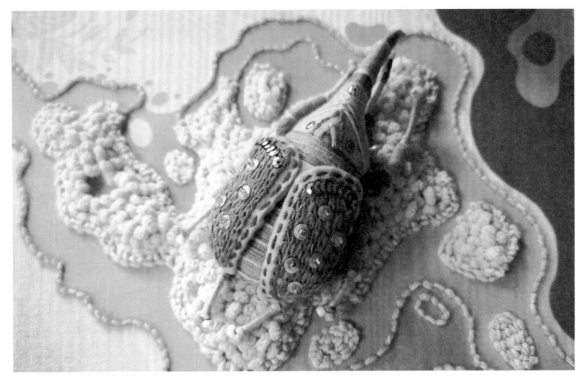

THE STORY OF INSECTS
Jerry Ma
Academy of Arts & Design, Tsinghua University

昆虫记
马文远
清华大学美术学院

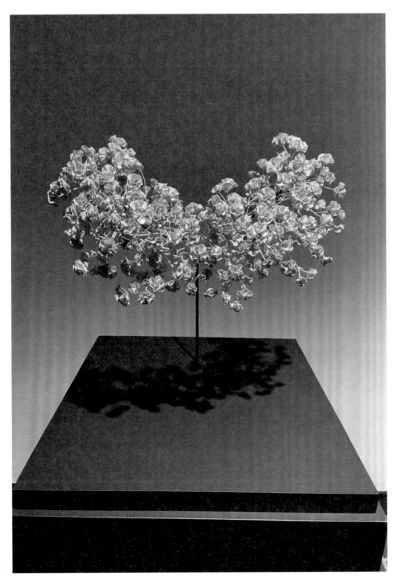

SHAPE OF INDIVIDUALITY
Terasaki Yumi
Tokyo University of the Arts

个性的形状
寺崎由美
东京艺术大学

CORPUS (COCOON)
Madeline Rile Smith
Rochester Institute of Technology

语料库（茧）
玛德琳·赖尔·史密斯
罗切斯特理工学院

HOW LONG WILL THE HOUSE STAY SHUT?
Livia Chaia papiernik
Royal College of Art

房门要关多久？
莉维亚·查亚·帕皮耶尼克
皇家艺术学院

JOGGERS WITH DREADLOCK DRAWSTRIN
Steven Montinar
School of Art, Carnegie Mellon University

一条饰有编织抽绳的慢跑裤
史蒂文 · 蒙蒂纳尔
卡耐基梅隆大学艺术学院

A DAILY SENSE OF SKY
Jieun Yoon
Rochester Institute of Technology

每日天空之感
尹志银
罗切斯特理工学院

FOREST, VARIATION 3
Aprille Nace
Rochester Institute of Technology

森林，变体 3
艾普莉尔·奈斯
罗切斯特理工学院

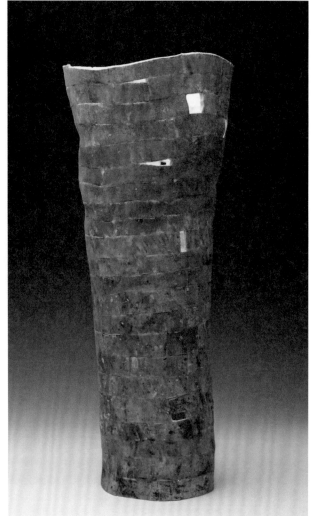

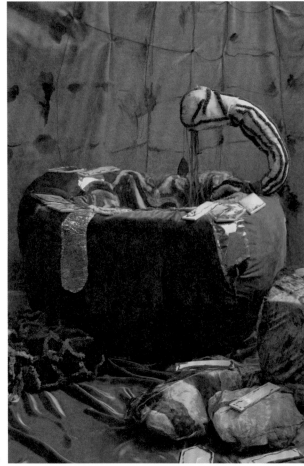

GREAT NEIGHBORHOOD OF
HAPPENSTANCE SQUARE
Chloé Rochefort
Royal College of Art

偶然事件广场的伟大街区
克洛伊·罗什福尔
皇家艺术学院

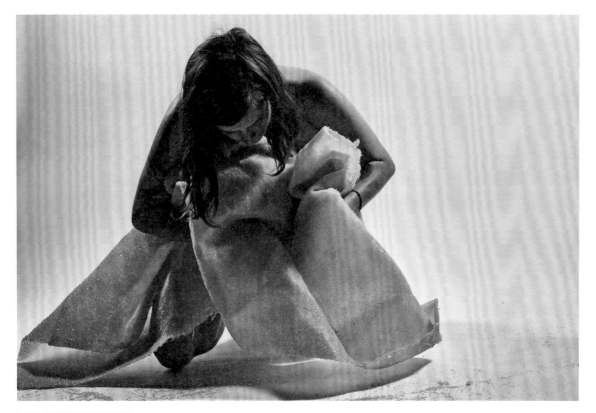

LAY ME DOWN TO REST
Gracia Nash
Rochester Institute of Technology

让我休息
格蕾丝·纳什
罗切斯特理工学院

EPHEMERAL JUSTICE
Eunsil Leem
Southern Illinois University

短暂的正义
恩斯·利姆
南伊利诺伊大学

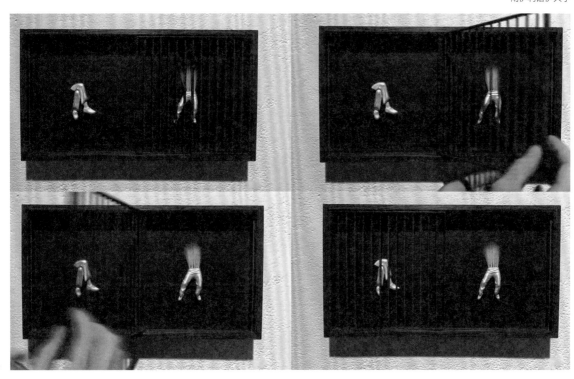

ISTHMUS I
Addison de Lisle
Southern Illinois University

地峡一号
艾迪生·德·莱尔
南伊利诺伊大学

COPPER HEAD
Kyle Lascelle
Rochester Institute of Technology

铜头
凯尔·拉塞尔
罗切斯特理工学院

CLOUD 9.9 SPACE [9.9 CLOUD]
Li Jiaxi
Royal College of Art

云9.9空间[9点9号云]
李镓汐
皇家艺术学院

LAST NIGHT'S DISHES
Kari Woolsey
Southern Illinois University

昨晚的菜肴
加力·伍尔西
南伊利诺伊大学

PROD
Kayla Cantu
Rochester Institute of Technology

Prod
凯拉·坎图
罗切斯特理工学院

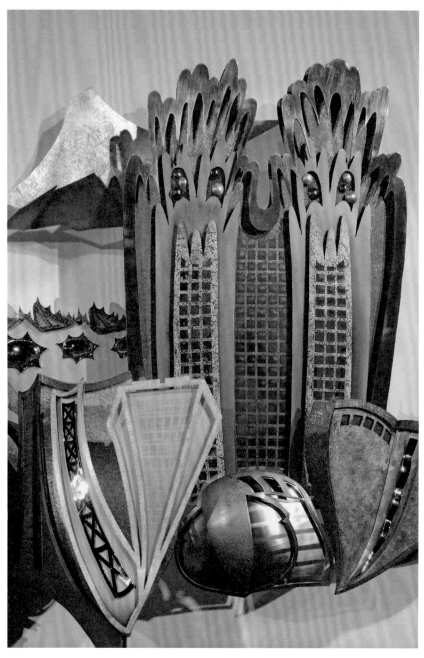

APPEARANCE OF TOKYO 2020
~ POP CITY~
Watanabe Ena
Tokyo University of the Arts

东京 2020
~流行城的出现~
渡边惠奈
东京艺术大学

WHEN IT SETTLES
Rachael Strittmatter
Rochester Institute of Technology

当它落下时
瑞秋·斯特里特马特
罗切斯特理工学院

IN SERENDIPITY
Jieun Oh
Sookmyung Women's University

并非机缘巧合
吴知恩
淑明女子大学

HALVDAN SWUNG ME
Thomas Ward
Southern Illinois University

令人震撼的哈尔夫丹
托马斯·沃德
南伊利诺伊大学

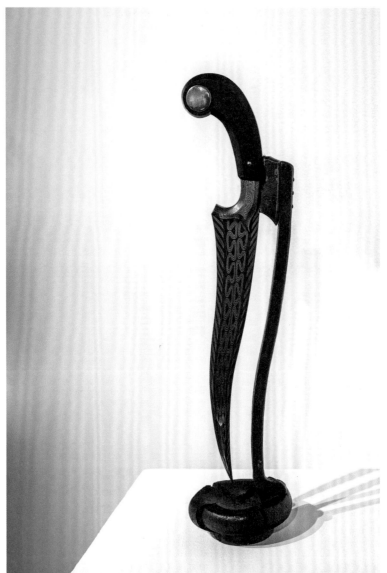

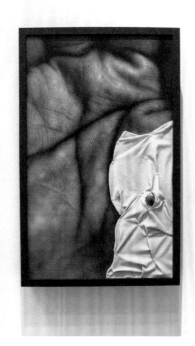

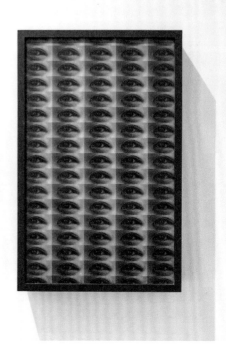

WHENEVER & WATCH YOU
Suhyeon Kang
Rochester Institute of Technology

无论何时望着你
姜秀贤
罗切斯特理工学院

HIDDEN HAIR
Meg Howton
Southern Illinois University

隐藏的头发
梅格·霍顿
南伊利诺伊大学

STILL LIFE
Eriko Kobayashi
Southern Illinois University

静物
小林绘里子
南伊利诺伊大学

221

COMPLICATED

Wang Zihan

Hubei Institute of Fine Arts

繁

王子菡

湖北美术学院

PODS

Megan Werner

Rochester Institute of Technology

豆荚

梅根·沃纳

罗切斯特理工学院

@I_AM____SEED 1.22.2021-2.7.21
Rinoi Imada
Rochester Institute of Technology

@ 我 _ 是 _____ 种子 1.22.2021-2.7.21
今田莉野生
罗切斯特理工学院

29 MEMORIES IN CERTAIN SHAPE
Hyemin Lee
Sookmyung Women's University

关于某个形状的 29 种记忆
李惠民
淑明女子大学

ONE-THIRD OF ZERO
Zhang Chao
LuXun Academy of Fine Arts

零的三分之一
张超
鲁迅美术学院

JAR 06
Dan Gabber
Rochester Institute of Technology

JAR 06
丹·加伯
罗切斯特理工学院

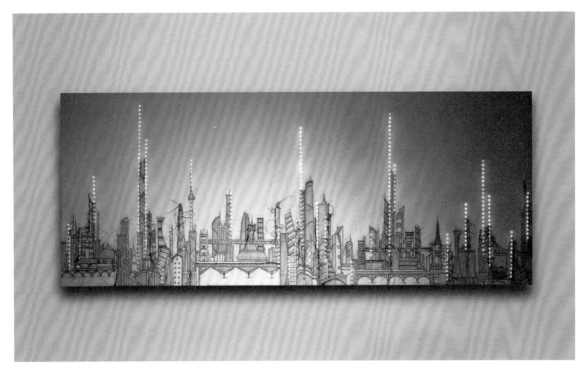

CITY LIGHTS: CITY & ENTANGLED
Sojung Ryu
Sookmyung Women's University

城市之光：城市 & 缠绕
柳昭政
淑明女子大学

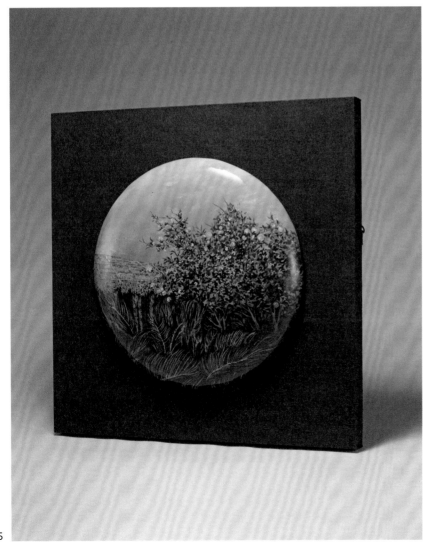

CITRUS AND PALM
Yoonji Shin
Sookmyung Women's University

柑橘和棕榈
尹志信
淑明女子大学

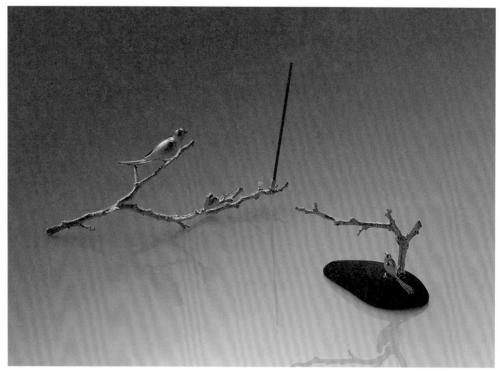

COEXISTENCE
(FLOW OF TIME AND FLOW OF LIFE)
Yunjeong Jang
Sookmyung Women's University

共存（时间流和生命流）
张允贞
淑明女子大学

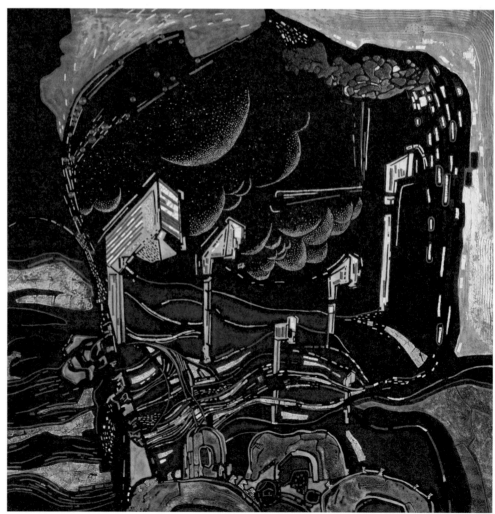

SHAPE OF LINE SERIES
Liu Jiaqian
Sichuan Fine Arts Institute

线之形系列
刘佳倩
四川美术学院

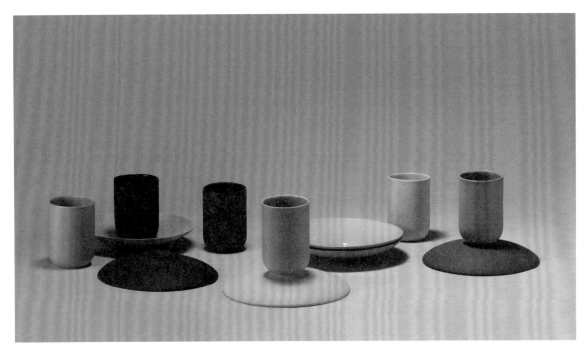

CONVERSATION
Yiju Song
Sookmyung Women's University

对话
宋異周
淑明女子大学

WINTER FLOWER
Dongkyung Seo
Sookmyung Women's University

冬花
肖东坤
淑明女子大学

SUSTAINABLE PACKAGING MATERIAL
FOR USER ACCEPTANCE
Luisa Jannuzi
Aalto University

用户接收的可持续包装材料
路易莎·詹努兹
阿尔托大学

YOU HAVE MADE ME WHAT I AM TODAY
Sugitani Akari
Tokyo University of the Arts

你成就了今天的我
杉谷明里
东京艺术大学

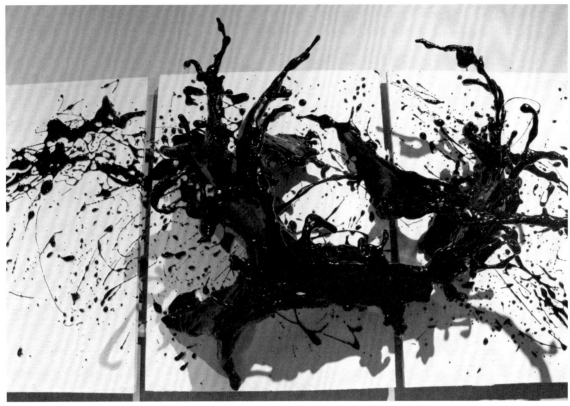

ECHO
Wang Wenxu
Xi'an Academy of Fine Arts

回声
王文续
西安美术学院

LITTLE POND
Kumasaka My
Tokyo University of the Arts

小池塘
熊坂缪
东京艺术大学

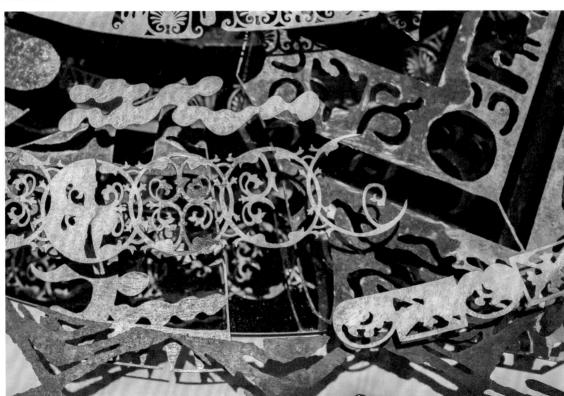

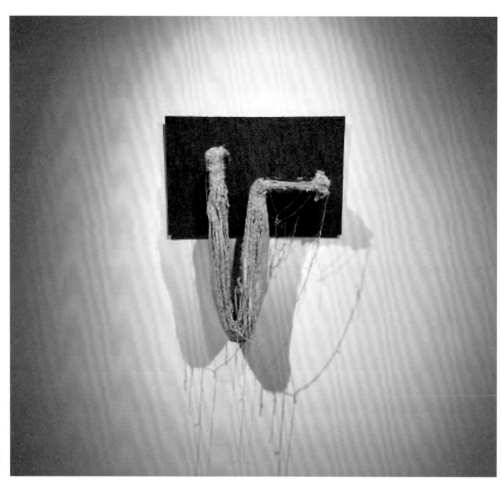

PRESSURE PLATES: BOOK ENDS
Kevin Dotson
Southern Illinois University

压力板：书本的尽头
凯文·多森
南伊利诺伊大学

HARA-NO-MUSHI
(MONSTER INSIDE)
Konishi Mai
Tokyo University of the Arts

Hara-no-mushi
（心中的怪物）
小西麻衣
东京艺术大学

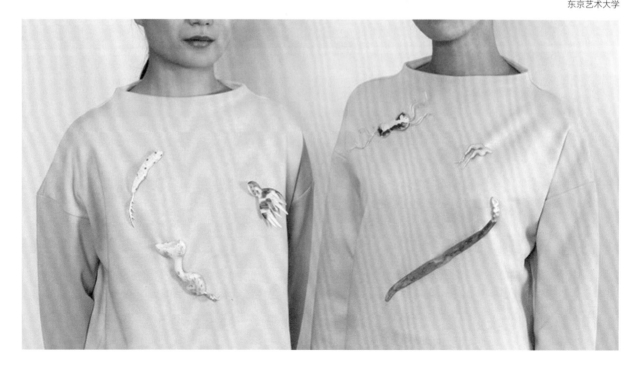

230

BOTTOM
Miyaishi Kensaku
Tokyo University of the Arts

底部
宫石健作
东京艺术大学

REVERENCE FOR
Umeda Reina
Tokyo University of the Arts

敬畏
梅田玲奈
东京艺术大学

COMPREHEND·EMPTINESS
Liu Lu
Tianjin Academy of Fine Arts

悟·空
刘璐
天津美术学院

EMBODIMENT FOR PERSONALITY
Sekiguchi Yuuki
Tokyo University of the Arts

个性的体现
关口有纪
东京艺术大学

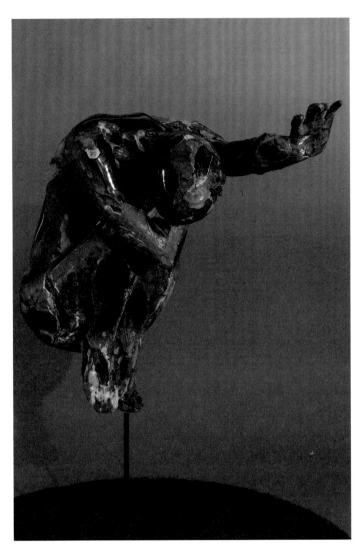

BY SOMEONE ELSE
Toda Emiri
Tokyo University of the Arts

第三方
户田埃米尔
东京艺术大学

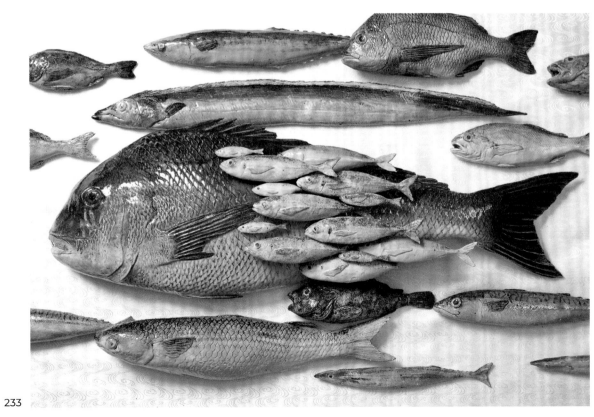

OLD MAN,
FISHING FREAK
Mori Kiyoka
Tokyo University of the Arts

老人、钓鱼怪胎
森清香
东京艺术大学

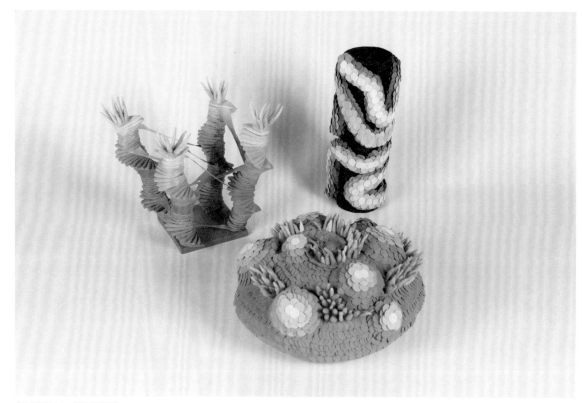

GARDEN IN EPHESUS
Flo Sargent
Loughborough University

以弗所的花园
弗洛·萨金特
拉夫堡大学

ENCOUNTER
Mu Chenyang
Rochester Institute of Technology

不期而遇
慕晨扬
罗切斯特理工学院

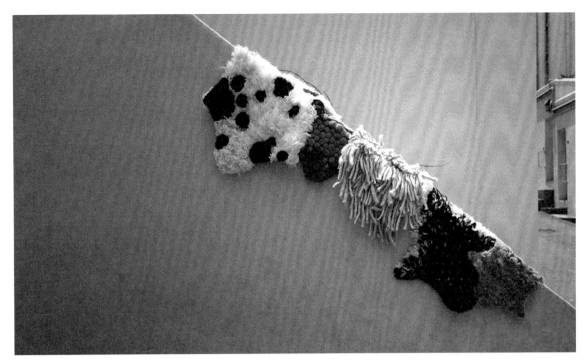

FURMIDABLE :
[AN EXPLORATION OF CHIENGORA FIBERS]
Cynthia Chan
National University of Singapore

坚韧不拔：
[狗毛纤维的探索]
陈俐欣
新加坡国立大学

BODIES OF CLAY
Jessica Lam
Emily Carr University of Art + Design

黏土尸体
林咏恩
艾米丽卡尔艺术与设计大学

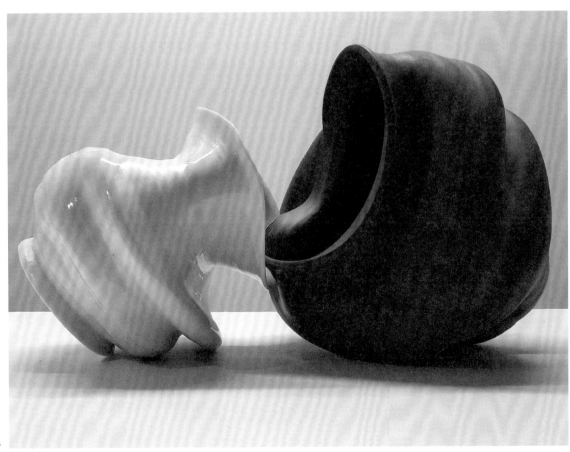

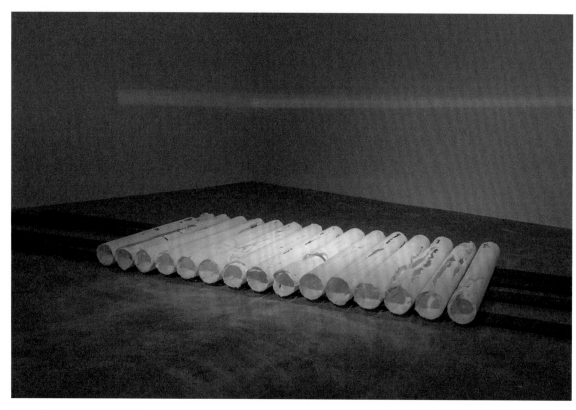

CLOUDS ON THE GROUND
Yuan Fangzhou
Tokyo University of the Arts

地上的云朵
袁方舟
东京艺术大学

PAPER LANGUAGE BRONZE
Wang Xu
Hubei Institute of Fine Arts

纸语青铜
王旭
湖北美术学院

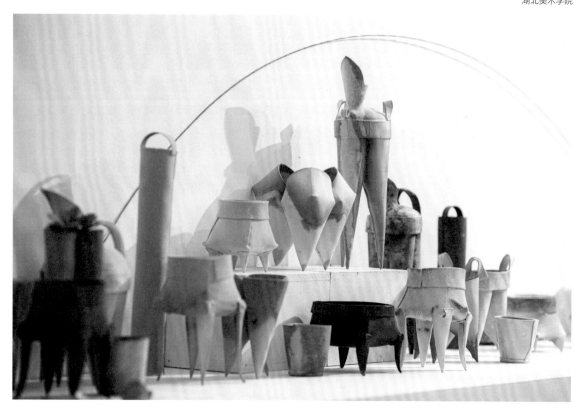

SIT
Zhang Lixin
LuXun Academy of Fine Arts

坐
张力心
鲁迅美术学院

SUN, MOON AND STARS
Chen Mu
Guangzhou Academy of Fine Arts

日月星辰
陈木
广州美术学院

TODAY THE PAST
Lu Wanqi
Guangzhou Academy of Fine Arts

今朝旧事
陆婉淇
广州美术学院

TRANSFORMATION
Zeng Xiaoshan
Tianjin Academy of Fine Arts

破茧
曾晓珊
天津美术学院

INSIDE
Yang Chenyue
Rochester Institute of Technology

内部
杨晨玥
罗切斯特理工学院

STUDY OF SNOW 2
Chen Suyu
Rochester Institute of Technology

雪的研究 2
陈素玉
罗切斯特理工学院

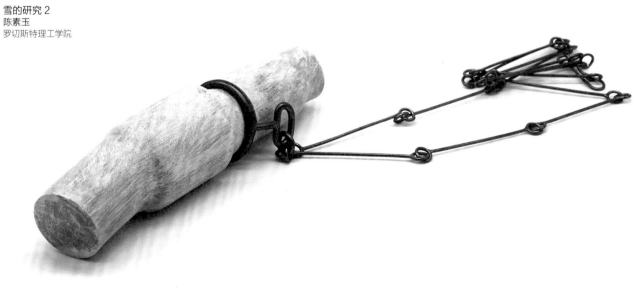

INTERNAL/ EXTERNAL
Song Chuchen
Southern Illinois University

内部 / 外部
宋楚晨
南伊利诺伊大学

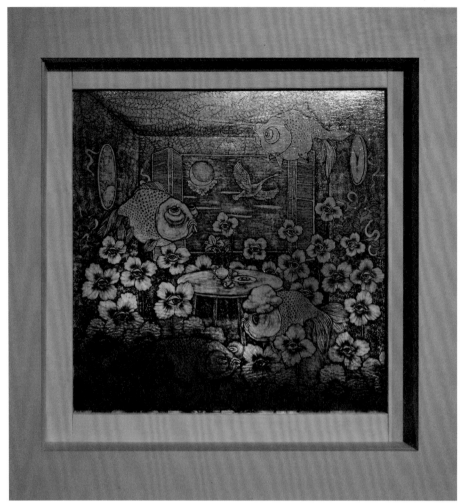

FLOWER - PORTRAITS OF
PERSONALITY
Zeng Siqin
Tokyo University of the Arts

人格花卉肖像
曾思勤
东京艺术大学

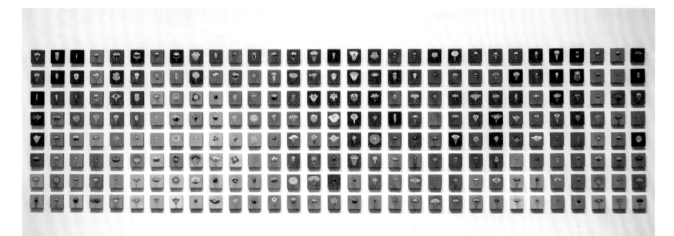

KANSHITSU MAKIE BOX
[FLOWER BUDS WAITING TO BLOOM]
Ren Shuang
Tokyo University of the Arts

脱胎莳绘盒「等待绽放的花蕾」
任爽
东京艺术大学

ESOTERIC TOURISM
AND STELLAR RELICS
Topolanski Josephine
French National School of
Decorative Arts

神秘的旅游和恒星遗迹
托波兰斯基·约瑟芬
法国国立高等装饰艺术学院

IS CRAFTSMANSHIP CONTEMPORARY?
Dafne de Marchi
Polytechnic University of Milan

手工艺是现代风格吗?
戴芬·德玛奇
米兰理工大学

MARS IS FOR FAGS
Justin Quaid Grubb
Rhode Island School of Design

火星天堂
贾斯汀·奎德·格拉布
罗德岛设计学院

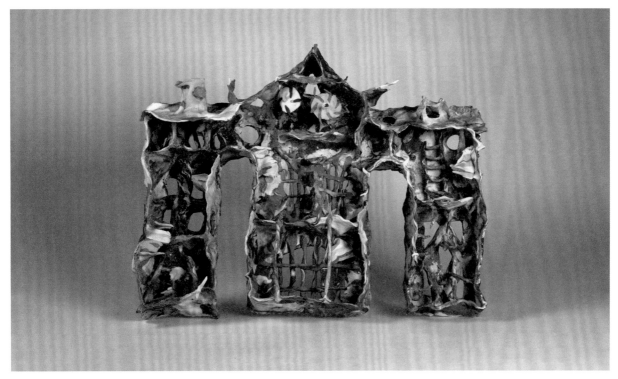

CAHUTE HUT
Barbaut Léo-paul
French National School of
Decorative Arts

卡胡特小屋
巴宝特·莱奥·保罗
法国国立高等装饰艺术学院

MATRIX
Yang Lizhi
Tianjin Academy of Fine Arts

矩阵
杨力智
天津美术学院

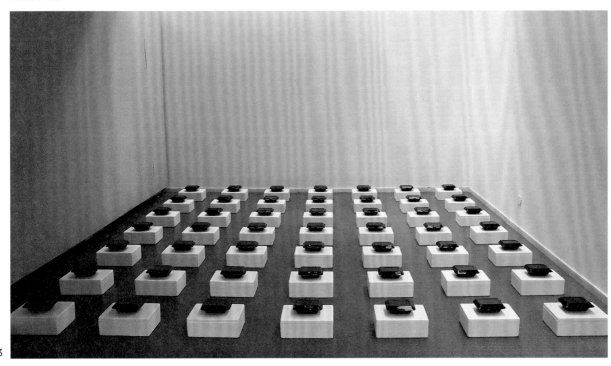

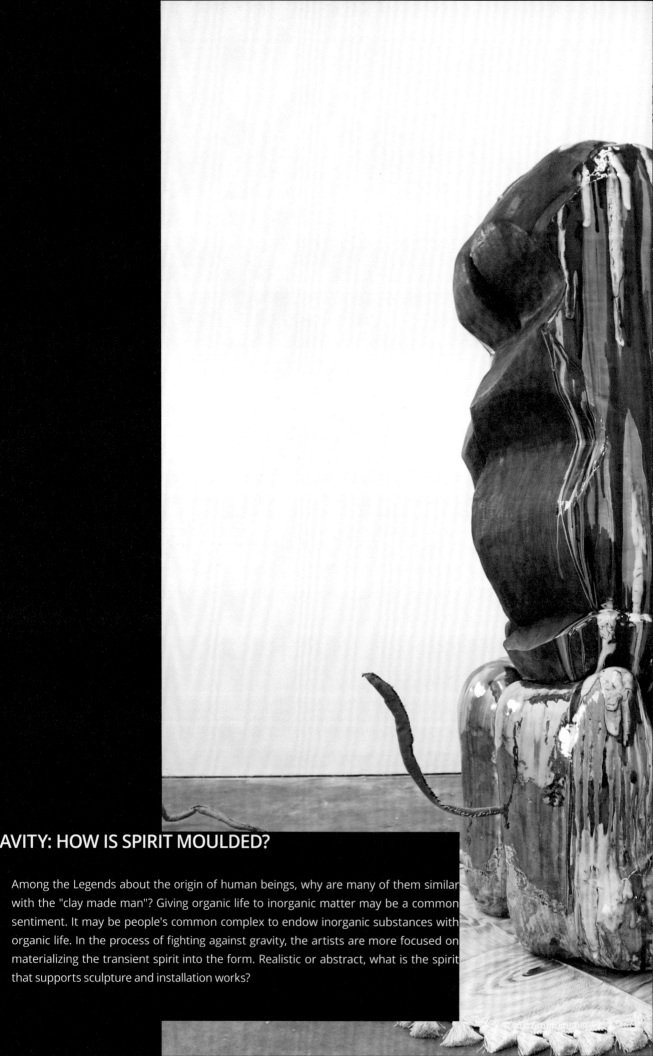

AVITY: HOW IS SPIRIT MOULDED?

Among the Legends about the origin of human beings, why are many of them similar with the "clay made man"? Giving organic life to inorganic matter may be a common sentiment. It may be people's common complex to endow inorganic substances with organic life. In the process of fighting against gravity, the artists are more focused on materializing the transient spirit into the form. Realistic or abstract, what is the spirit that supports sculpture and installation works?

重·力: 精神何以塑造?

世界各民族关于人类起源的传说, 为何很多都与"泥土造人"有关? 将无机的物质赋予有机的生命也许是人们共同的情结。 在跟重力对抗的过程中, 艺术家更是专注于将瞬间的精气神物化在形体之中。写实抑或抽象, 支撑起雕塑和装置作品的究竟是何种精神?

5

TRANSLATION OF REALITY
Sunyoung Park
Southern Illinois University

现实的翻译
朴善英
南伊利诺伊大学

TRY KEEPING IT BALANCED
Elko Braas
Kunsthochschule Kassel

试着保持平衡
埃尔科·布拉斯
卡塞尔艺术学院

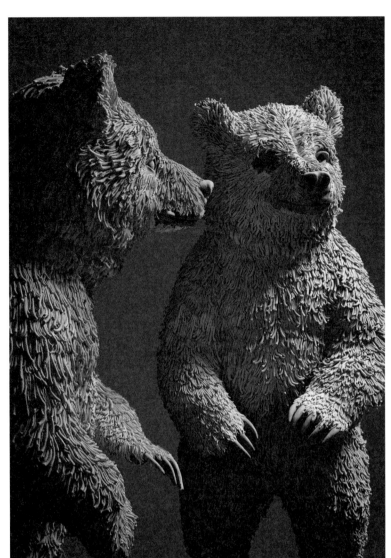

FEATURES
Wang Luxin
Academy of Arts & Design, Tsinghua University

模样
王路欣
清华大学美术学院

TOKEN
Kathleen Johnson
Rochester Institute of Technology

令牌
凯瑟琳·约翰逊
罗切斯特理工学院

21 SHELTERS (46 AMAZON BOXES)
Jen Candela
Emily Carr University of Art + Design

21个置物架（46个亚马逊盒子）
珍·坎德拉
艾米丽卡尔艺术与设计大学

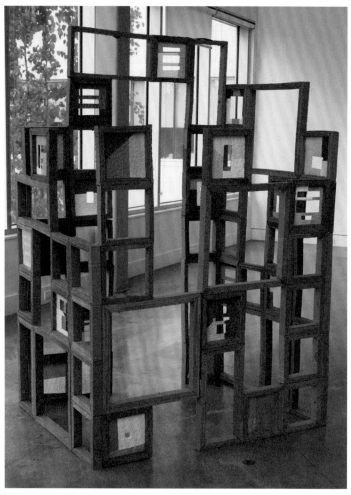

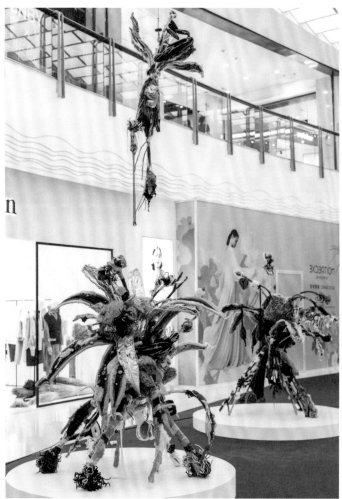

HEART, HEART REGION
Tang Moxi
Central Academy of Fine Arts

心、心域
唐默熹
中央美术学院

AIRCRAFT DESIGNER A.S. YAKOVLEV
Kovalev Ivan Sergeevich
Repin Academy of Fine Arts

飞机设计师 A.S. 雅科夫列夫
科瓦列夫·伊万·谢尔盖耶维奇
列宾美术学院

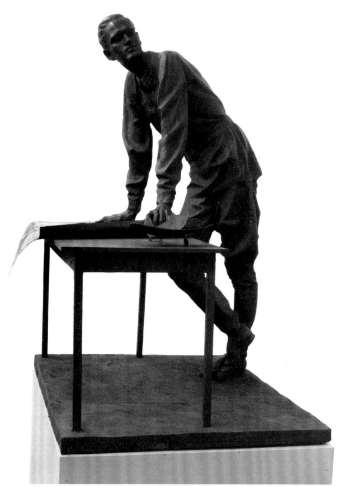

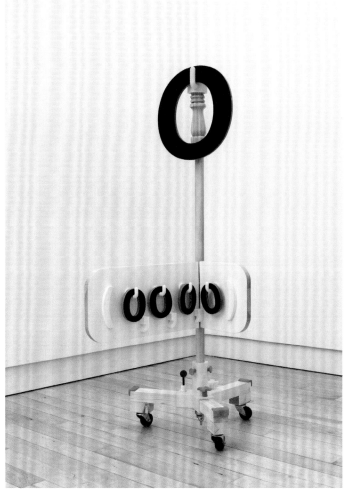

MY PLAYBENCH IN THE WORKGROUND
Xiang Huidi
School of Art, Carnegie Mellon University

工作场中的游戏台
向惠迪
卡耐基梅隆大学艺术学院

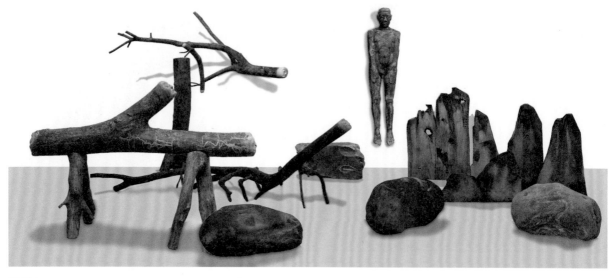

Old Memory
Zhu Puqian
Academy of Arts & Design, Tsinghua University

旧记
朱璞乾
清华大学美术学院

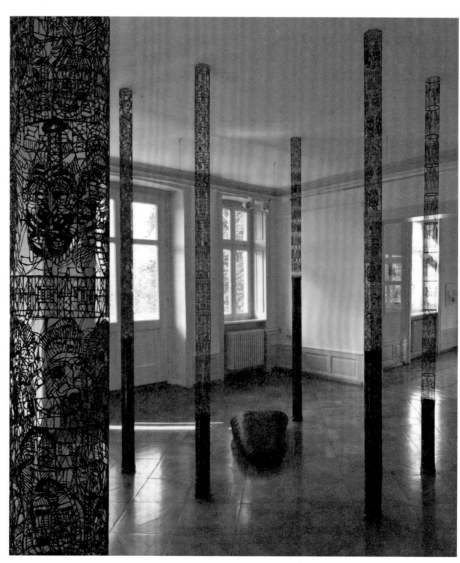

SODOM
Schuth Alessia
Stuttgart State Academy of Art and Design

索多玛
舒特·阿莱西亚
国立斯图加特艺术学院

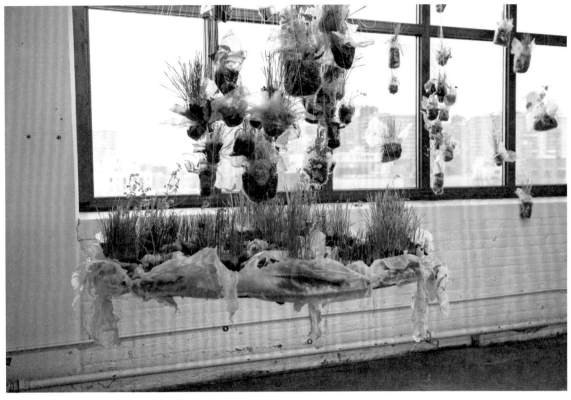

DEGREES OF SEPARATION
Elle Ellinger
Pratt Institute

分离程度
艾丽·艾灵格
普瑞特艺术学院

MOTHER, MOTHER
Jennifer de Luna
School of Art, Carnegie Mellon University

母亲、母亲
詹妮弗·德鲁纳
卡耐基梅隆大学艺术学院

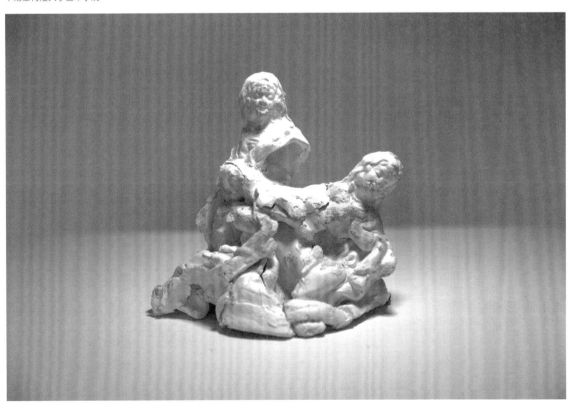

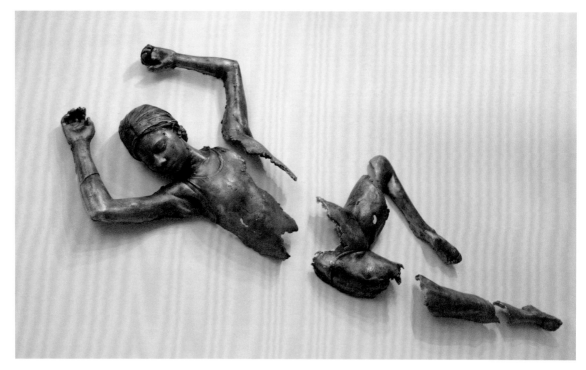

DREAMER
Nickolas Viele
Rochester Institute of Technology

梦想家
尼古拉斯·洛特
罗切斯特理工学院

STILL NIAGARA
Max Spitzer
School of Art, Carnegie Mellon University

静止的尼亚加拉大瀑布
马克斯·斯皮策
卡耐基梅隆大学艺术学院

BLUE GRID
Rebecca Senn
Rhode Island School of Design

蓝栅
丽贝卡·森
罗德岛设计学院

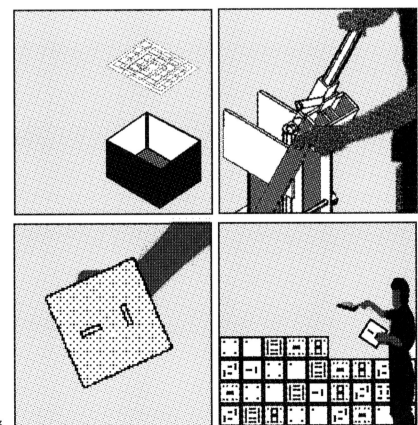

BREAKING THE MOLD
Sumanth Krishna
Rhode Island School of Design

打破模具
苏曼斯·克里希纳
罗德岛设计学院

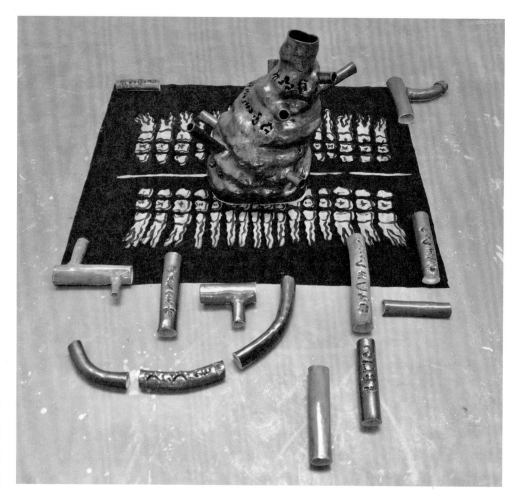

HUMMING TEETH
Haydn Albrow
Slade School of Fine Art,
University College London

低吟的牙齿
海顿·奥尔布罗
伦敦大学学院斯莱德美术学院

MANIFOLD
Ayako Kurimoto
Southern Illinois University

多样性
栗本绫子
南伊利诺伊大学

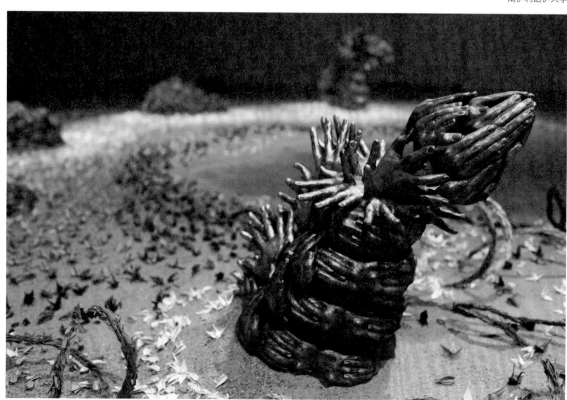

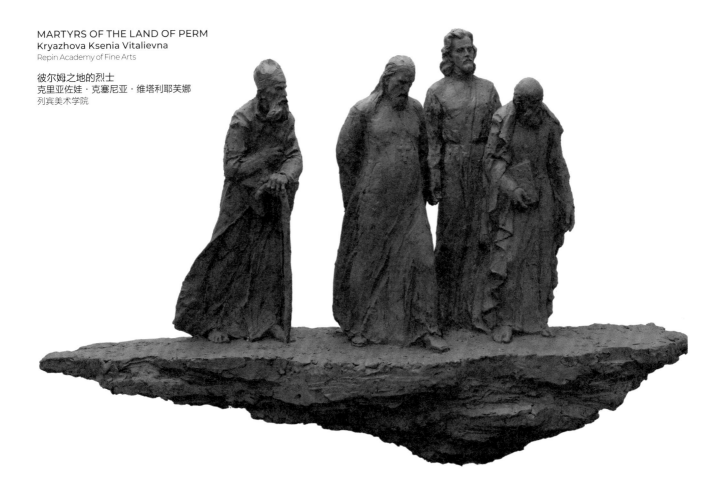

MARTYRS OF THE LAND OF PERM
Kryazhova Ksenia Vitalievna
Repin Academy of Fine Arts

彼尔姆之地的烈士
克里亚佐娃·克塞尼亚·维塔利耶芙娜
列宾美术学院

PLEASER
Padyn Humble
Southern Illinois University

取悦者
帕丁·汉博
南伊利诺伊大学

PERFORMING THE BODY
Katherine Smith
Slade School of Fine Art, University College London

唤醒你的身体
凯瑟琳·史密斯
伦敦大学学院斯莱德美术学院

SCULPTURE OF THE MACHINE
Zach Mason
The Glasgow School of Art

机器的雕塑
扎克·梅森
格拉斯哥美术学院

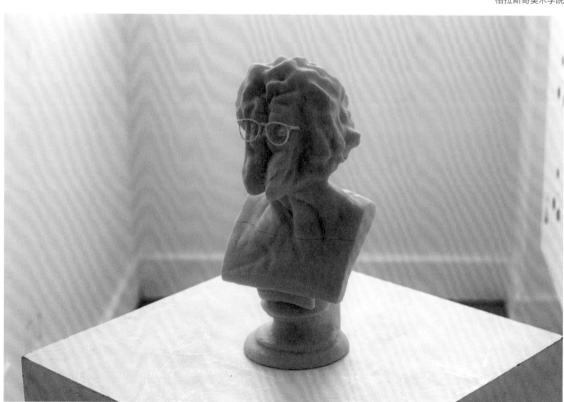

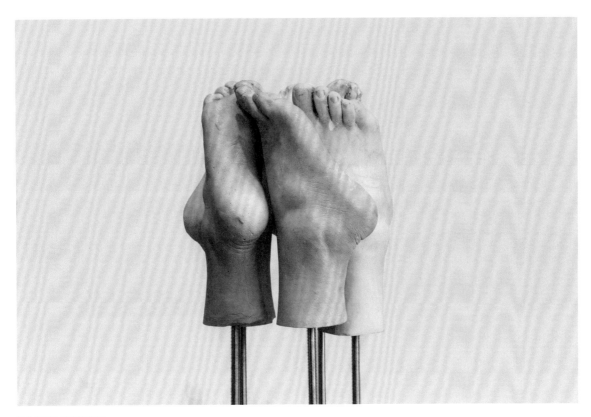

WHERE ARE YOU
Zhang Xusheng
LuXun Academy of Fine Arts

身在何处
张旭升
鲁迅美术学院

BURNED BOOKS
Wang Weiran
Stuttgart State Academy of Art and Design

焚烧的书籍
王蔚然
国立斯图加特艺术学院

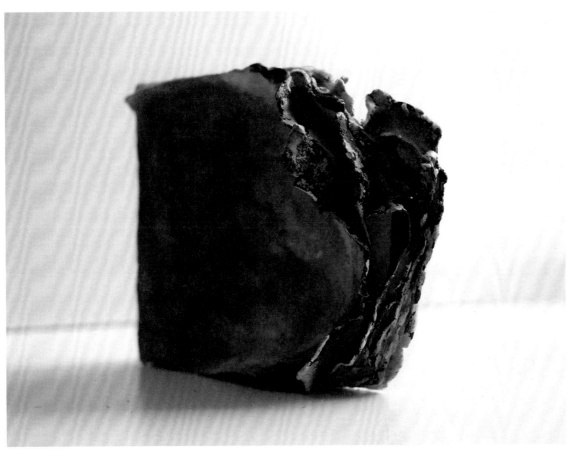

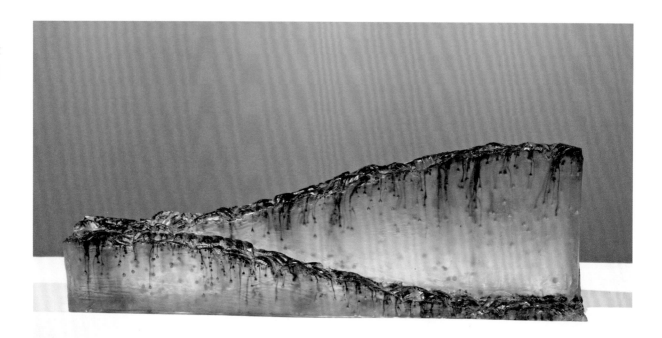

SWITCHBACK
Bill Sieber
Southern Illinois University

交换
比尔·西伯
南伊利诺伊大学

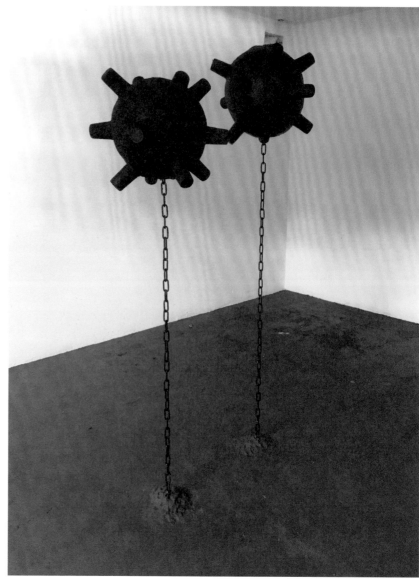

LEVEL 3: HYPERSPACE MEAT-TIME
Kyle Howie
Slade School of Fine Art, University College London

级别 3: 超空间食肉时间
凯尔·豪伊
伦敦大学学院斯莱德美术学院

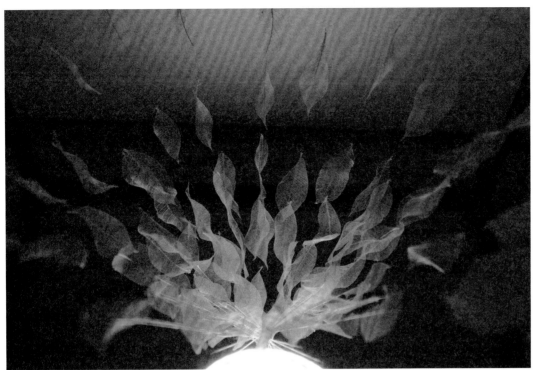

ORANGE
ARMAGEDDON
Lee Sarah
Parsons School of Design,
The New School

橙色启示录
李莎拉
帕森斯设计学院

MEME DRESS
Lee Jeunne
Tokyo University of the Arts

MEME 连衣裙
李知恩
东京艺术大学

FOREVER GRAY AREA
Ishii Tomohiro
Tokyo University of the Arts

永远的灰色地带
石井智博
东京艺术大学

ROOMS THAT HAUNT ME
Jestine Acebuche
Loughborough University

困扰我的房间
杰斯汀·阿斯布切
拉夫堡大学

POT
Maisy Zane
Loughborough University

锅
梅西·赞恩
拉夫堡大学

SACRIFICE OF ABRAHAM
Vladimir Brodarsky
Repin Academy of Fine Arts

亚伯拉罕的牺牲
弗拉基米尔·布罗达斯基
列宾美术学院

LESSONS OF LOVE
Burla Irina
Repin Academy of Fine Arts

爱的课程
布拉·伊琳娜
列宾美术学院

PHEFUMULA NAMI
Ndivhuho Rasengani
Rhode Island School of Design

宇宙图像探索
恩迪夫霍霍·拉森加尼
罗德岛设计学院

爱的课程
布拉·伊琳娜
列宾美术学院

DISMANTLING PAINTING
Jilianne Louise Acebuche
Loughborough University

拆解绘画
吉莉安·路易丝·艾斯布切
拉夫堡大学

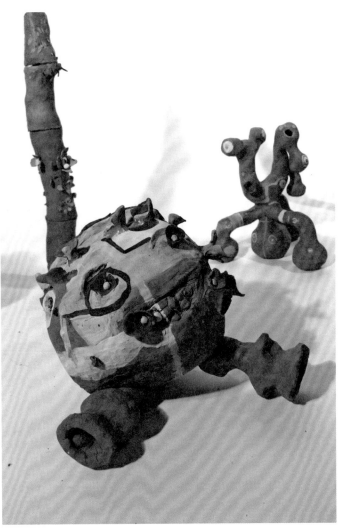

TERRA FRIENDZ
Maria Cepeda
Slade School of Fine Art, University College London

特拉·弗兰兹
玛丽亚·塞佩达
伦敦大学学院斯莱德美术学院

VIEW SERIES
You Youfang
Tianjin Academy of Fine Arts

观系列
游幼芳
天津美术学院

IN THE MUD AND THE MIRE
Orli Swergold
Rhode Island School of Design

在泥泞和泥潭中
奥利・斯沃戈尔德
罗德岛设计学院

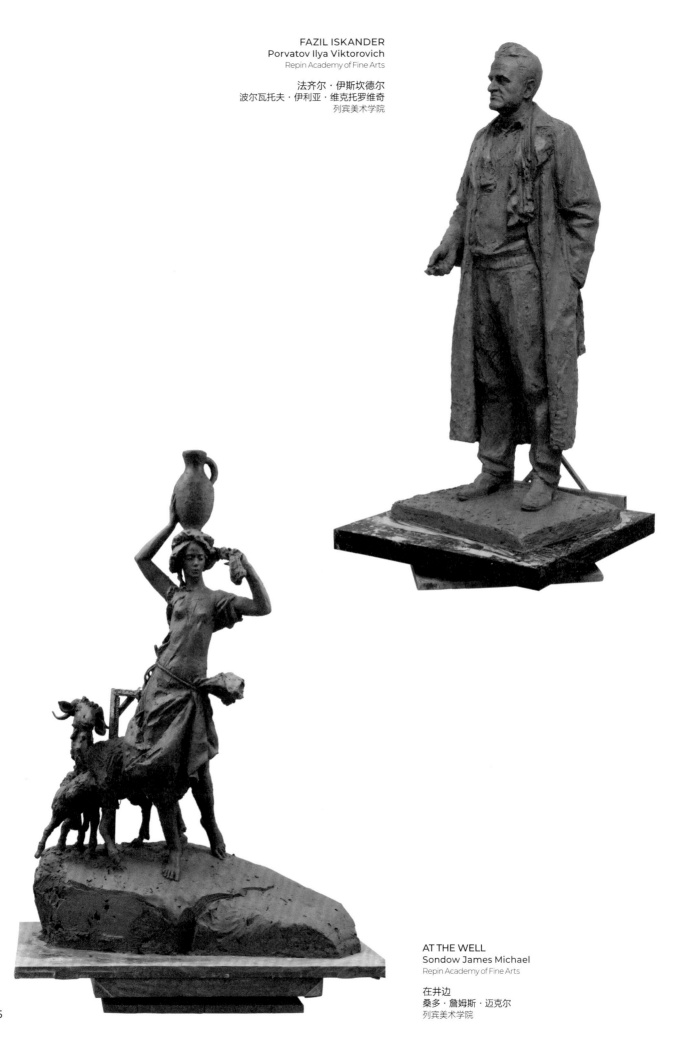

FAZIL ISKANDER
Porvatov Ilya Viktorovich
Repin Academy of Fine Arts

法齐尔 · 伊斯坎德尔
波尔瓦托夫 · 伊利亚 · 维克托罗维奇
列宾美术学院

AT THE WELL
Sondow James Michael
Repin Academy of Fine Arts

在井边
桑多 · 詹姆斯 · 迈克尔
列宾美术学院

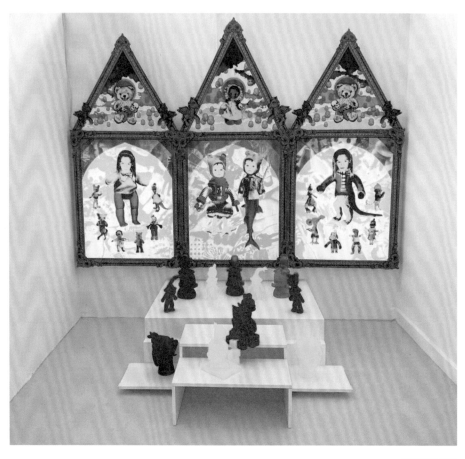

NOSTALGIA
Abigail Hughes, Phebe Hughes
Loughborough University

怀旧
阿比盖尔·休斯、菲比·休斯
拉夫堡大学

HEALTHY ADULT: I AM SAFE
Sara Osman
Loughborough University

健康成人：我安全
莎拉·奥斯曼
拉夫堡大学

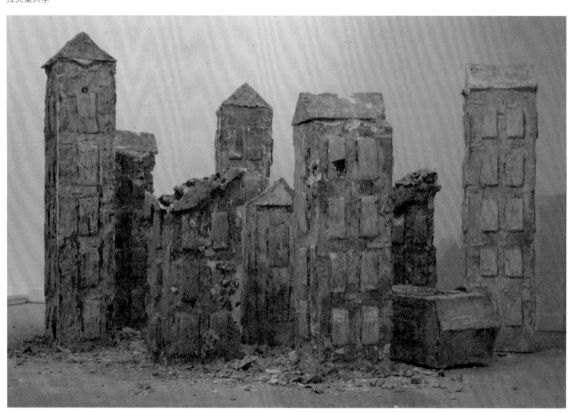

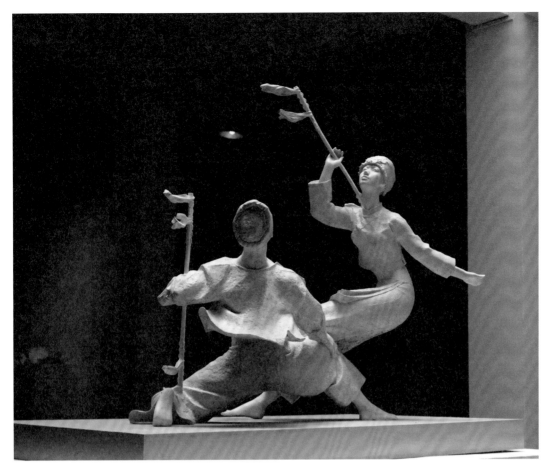

ECHO OF BA PEOPLE'S LEGACY
Yu Xilong
Hubei Institute of Fine Arts

巴人遗风的回响
余熙龙
湖北美术学院

NEW DICTIONARY
Chen Jiayan
Central Academy of Fine Arts

新字典
陈佳琰
中央美术学院

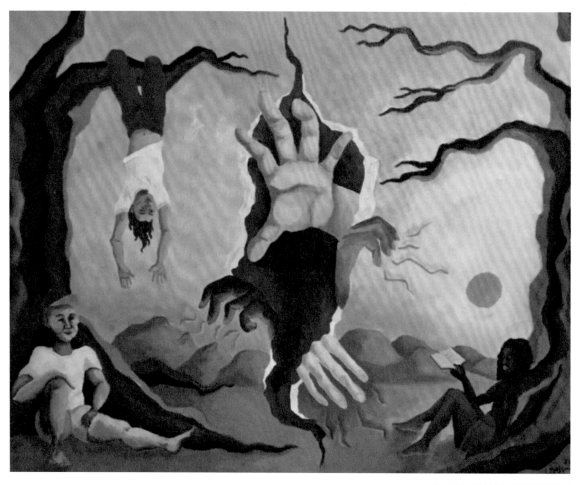

UNPLEASANTLY BEAUTIFUL
Annaleah Gregoire
California College of the Arts

令人不快的美丽
安娜莉亚·格雷戈里
加州艺术学院

PHOTO STILLS OF ACCLIMATE
Kajill Aujla
Emily Carr University of Art + Design

适应症的照片剧照
卡吉尔·奥杰拉
艾米丽卡尔艺术与设计大学

FRAILTY (FEMICIDES IN MEXICO)
Camilla Giordano Cerna
Emily Carr University of Art + Design

脆弱（墨西哥的女性杀戮）
卡米拉·乔尔达诺·塞尔纳
艾米丽卡尔艺术与设计大学

FINE ART
Mary Griffin
School of the Art Institute of Chicago

艺术
玛丽·格里芬
芝加哥艺术学院

COPENHAGEN SCHOOL -
BOHR AND THE POST-00S
Liu Botong
LuXun Academy of Fine Arts

哥本哈根学派——玻尔与 00 后
刘勃通
鲁迅美术学院

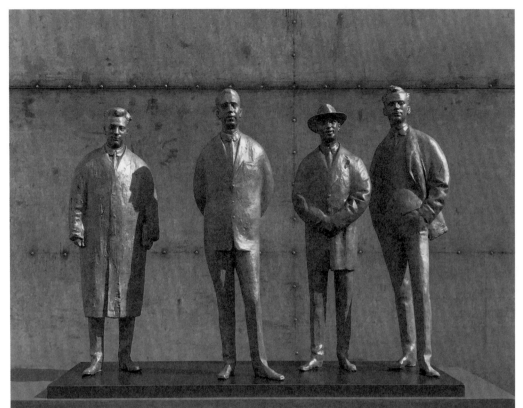

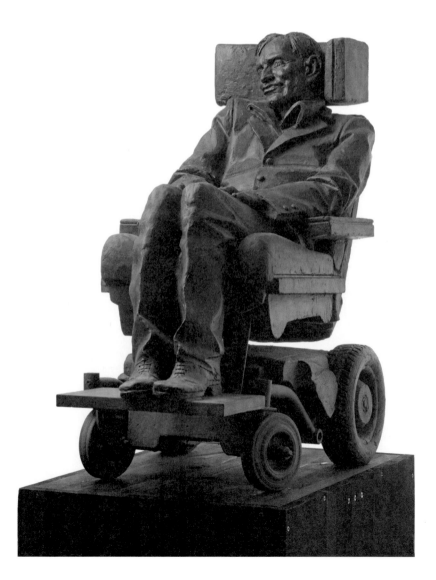

STEPHEN HAWKING
Tatyana Sergeevna Kunchukina
Repin Academy of Fine Arts

斯蒂芬·霍金
塔季扬娜·谢尔盖耶夫娜·昆楚基娜
列宾美术学院

"LUGGAGE" SERIES
Wu Xueyi
Shanghai Academy of Fine Arts,
Shanghai University

《行李》系列
邬雪屹
上海大学上海美术学院

SOMETHING TO SOMETHING
Meejung Soh
School of the Art Institute of Chicago

从某物到某物
苏美贞
芝加哥艺术学院

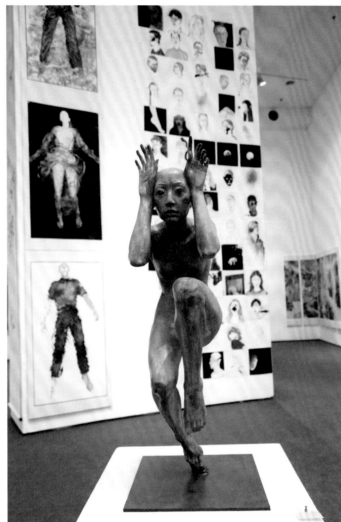

BIRD
Zhang Qiuyang
Shanghai Academy of Fine Arts,
Shanghai University

鸟
张秋阳
上海大学上海美术学院

**DO YOU KNOW WHY ANIMALS
DIE IN CAGES? THEIR SOUL DIES.**
Becca Guzzo
School of Visual Arts, New York City

你知道动物为什么会死在笼子里吗？
因为它们的灵魂消逝了。
贝卡 · 古佐
纽约视觉艺术学院

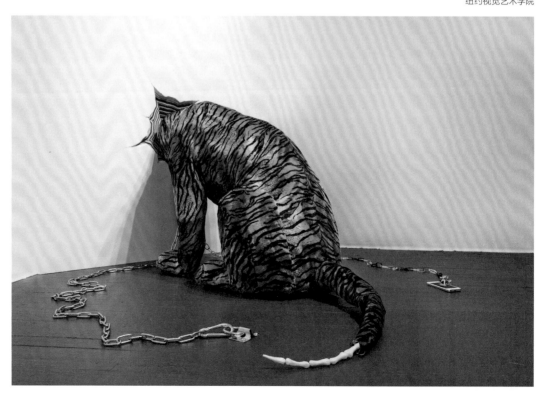

GO FIGURE
Jimmy Mezei
School of Visual Arts, New York City

弄清真相
吉米·梅泽
纽约视觉艺术学院

LIFE UP AND DOWN THE SCAFFOLDING
Guo Dingfen
Guangzhou Academy of Fine Arts

脚手架上下的生活
郭定奋
广州美术学院

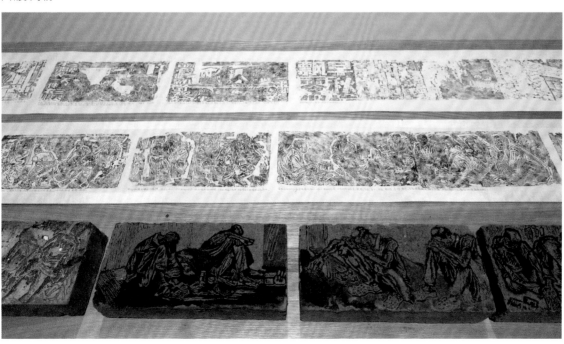

MOUNDS
Colette Bernard
Pratt Institute

丘
科莱特 · 伯纳德
普瑞特艺术学院

DARK CLOUDS CRUSH THE CITY
Wu Yun
Sichuan Fine Arts Institute

黑云压城城欲摧
吴运
四川美术学院

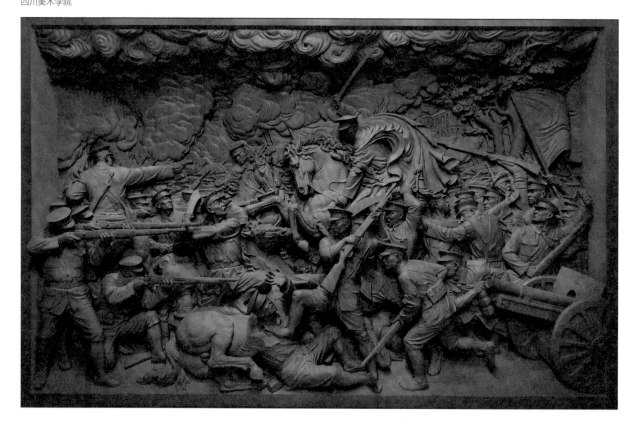

WARM KEEPS US AWAY
Zhang Meizeng
Xi'an Academy of Fine Arts

温暖使我们无法靠近
章镁增
西安美术学院

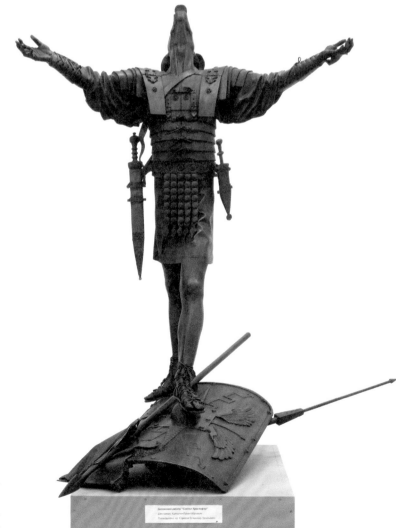

ST. CHRISTOPHER
Kaltygin Pavel Yuryevich
Repin Academy of Fine Arts

圣·克里斯托弗
卡尔蒂金·帕维尔·尤里耶维奇
列宾美术学院

VALUE
Li Weijia
Pratt Institute

价值
李玮佳
普瑞特艺术学院

BRIDE
Nugerbekova Zhanna Kazbekovna
Repin Academy of Fine Arts

新娘
努格别科娃·詹娜·卡兹别科夫娜
列宾美术学院

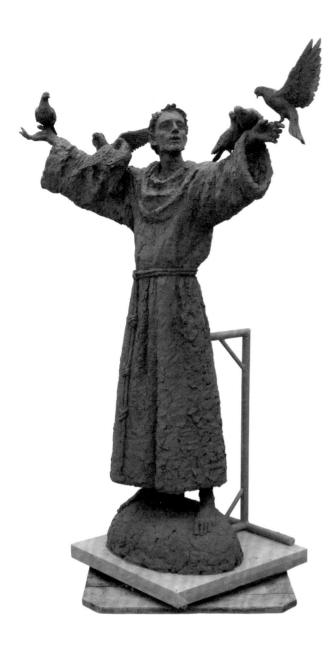

FRANCIS OF ASSISI
Shatalov Nikolai Ivanovich
Repin Academy of Fine Arts

阿西西的弗朗西斯
沙塔洛夫·尼古拉·伊万诺维奇
列宾美术学院

INCENSE
Huang Yongxin
Central Academy of Fine Arts

香火
黄勇鑫
中央美术学院

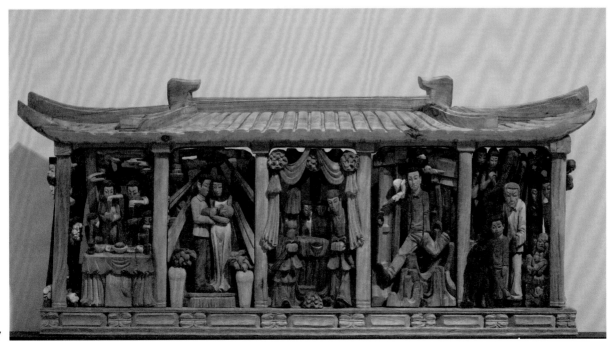

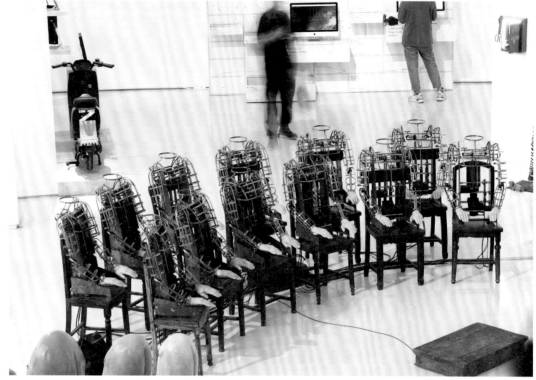

CHOIR
Liu Chang
Central Academy of Fine Arts

合唱团
刘畅
中央美术学院

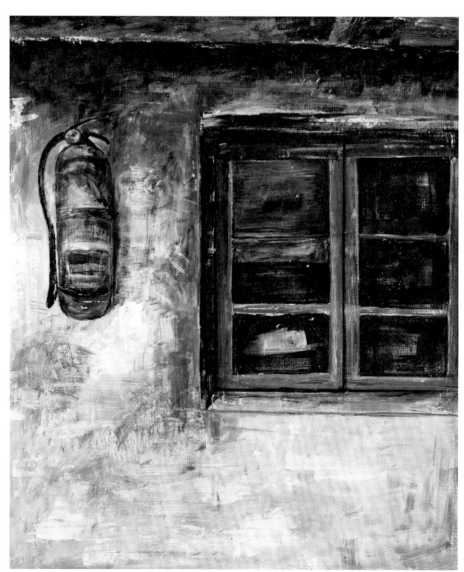

TIME MACHINE
Liu Yu
Hubei Institute of Fine Arts

时光贩卖机
刘雨
湖北美术学院

ɧ
Chen Yanjun
Sichuan Fine Arts Institute

ɧ
陈彦君
四川美术学院

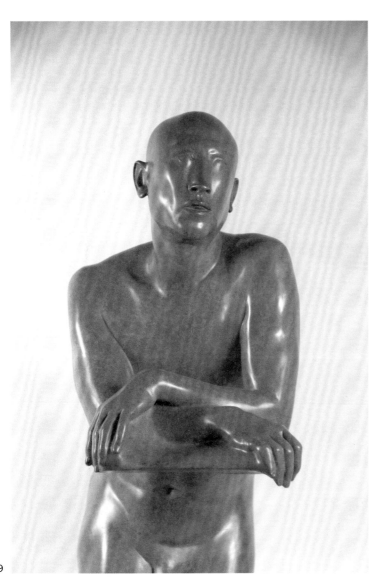

NO CONFUSION
Li Sui
LuXun Academy of Fine Arts

不惑
李遂
鲁迅美术学院

ABSENT - MINDEDNESS
Valenca Vaz Francisco
University of the Arts Bremen

心不在焉
瓦伦卡·瓦兹·弗朗西斯科
不来梅艺术学院

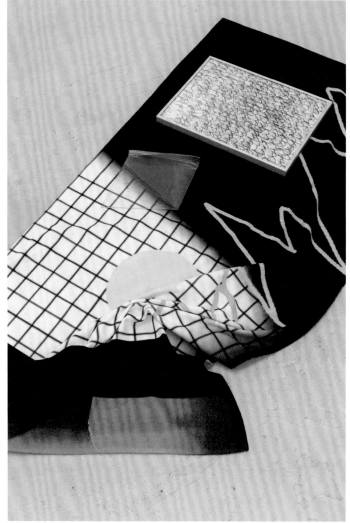

MY CLASSMATE
Zhu Hong
Repin Academy of Fine Arts

我的同学
朱虹
列宾美术学院

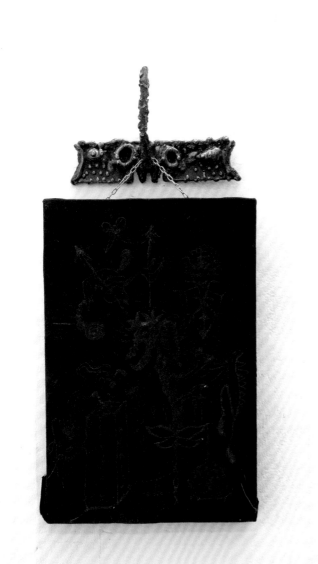

NIGHTMARE
Wei Jin
Slade School of Fine Art, University College London

梦魇
魏晋
伦敦大学学院斯莱德美术学院

BUNSHIN
Xu Yang
Tokyo University of the Arts

分身 Bunshin
徐杨
东京艺术大学

LIVE IN THE PRESENT
Van Jamie
Tokyo University of the Arts

活在当下
范洁敏
东京艺术大学

THREE-INCH GOLDEN LOTUS
Niu Weichun
Repin Academy of Fine Arts

三寸金莲
牛玮春
列宾美术学院

812 YEARS 7 MONTHS AND 13 DAYS
Zhu Qihao
School of The Art Institute of Chicago

812 年 7 个月 13 天
朱祺皓
芝加哥艺术学院

HUANG YUEMIN WORK COLLECTION
Huang Yuemin
School of The Art Institute of Chicago

黄越敏作品集
黄越敏
芝加哥艺术学院

ANOTHER DAY OF LAUNDRY
Yawen Erin Huang
School of Visual Arts, New York City

洗衣店的又一天
黄雅雯
纽约视觉艺术学院

DRIFT TO TOWNS
Courtney Lester
Southern Illinois University

城镇漂流
考特尼·莱斯特
南伊利诺伊大学

O.T
Zongos Charline
University of the Arts Bremen

O.T
宗戈·斯查琳
不来梅艺术学院

SKETCHY BUNCH - A STUDY OF
INDIRECT APPRECIATION OF ART
Ohara Yu
Tokyo University of the Arts

粗略束：对艺术间接升值的研究
大原优
东京艺术大学

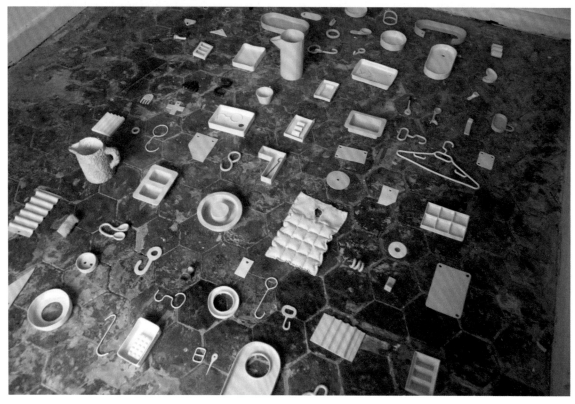

今天早上的大海是空的
特雷斯沃·杜·弗拉瓦尔·珍妮
法国国立高等装饰艺术学院

THIS MORNING THE SEA IS EMPTY
Tresvaux Du Fraval Jeanne
French National School of Decorative Arts

SUSPENSION STUDY ONE
Jared Abner
Rochester Institute of Technology

暂停研究之一
贾里德·艾伯纳
罗切斯特理工学院

STROKES: WHAT'S IN BETWEEN?

How to break the shape while maintaining the meaning between the "raise and fall" of the brushes? Brush strokes either layout, overlay, embellishment, or shading... Gradually form the painter's language, sometimes shouting, sometimes whispering. Contemporary painting has already gone beyond the limits of the frame. How to construct a new meaning system from scattered nodes inside and outside the painting?

笔·触: 形断如何意连？

笔起笔落间, 如何让形断而意不断? 笔触或铺排、或叠加、或点缀、或晕染…… 逐渐形成画家的语言, 有时疾呼呐喊, 又有时娓娓道来。 当代绘画早已超出画框的界限, 如何将画里画外散落的节点, 构建起新的意义体系?

6

AS I WALKED OUT
Alastair Kwan
Royal College of Art

当我走出去
阿拉斯泰尔·关
皇家艺术学院

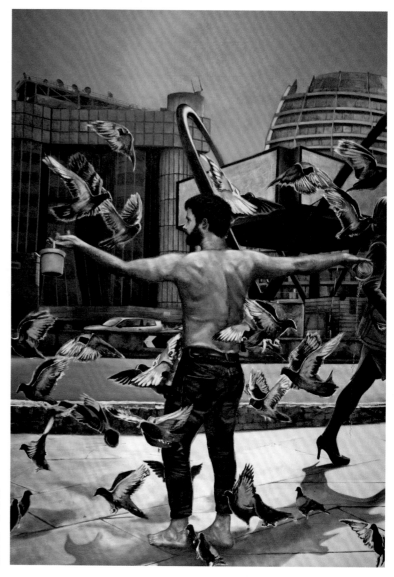

MAN OF PEOPLE
Sam Creasey
Royal College of Art

男性公民
山姆·克雷西
皇家艺术学院

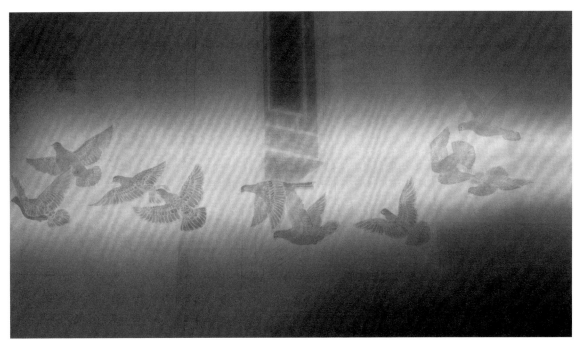

BORDERLINE
Deng Zhuoxuan
Academy of Arts & Design, Tsinghua University

界
邓卓煊
清华大学美术学院

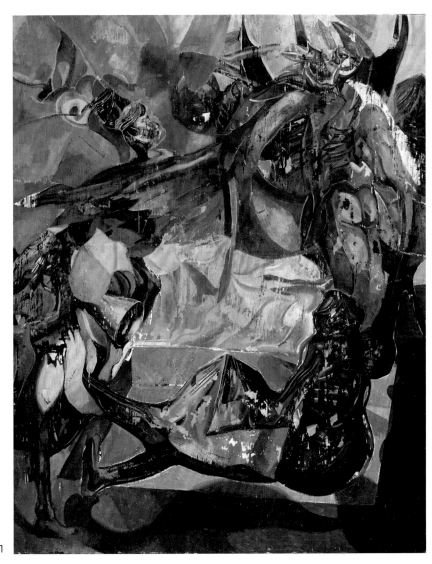

FUNGUS BLANKET, IN THE AIR FOR YOU
AND ME, LANDSCAPE, LANDSCAPE SET
PAINTINGS, REMAINS, PLAGUE OF AZEROTH
Wu Yanzhen
Central Academy of Fine Arts

菌毯、你我的空气、风景、
风景组画、遗骸、艾泽拉斯的瘟疫
吴彦臻
中央美术学院

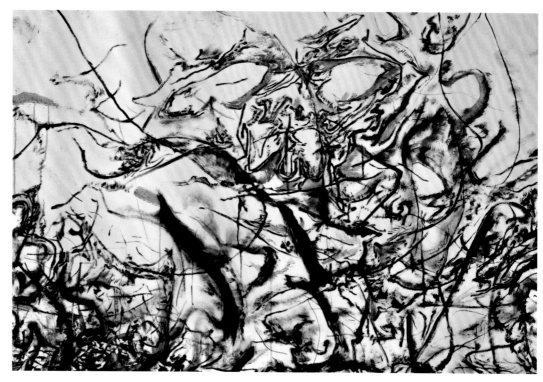

TIMEMAP: 725,328,000
SOHEE KIM
Academy of Arts & Design, Tsinghua University

时间地图：725,328,000
金昭希
清华大学美术学院

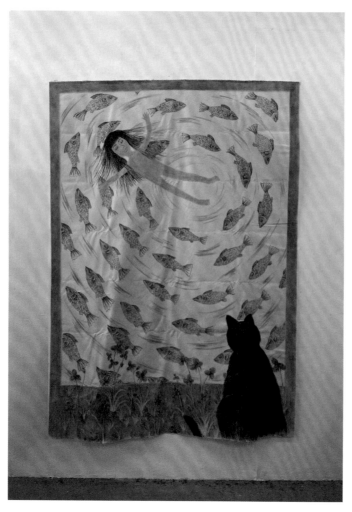

NIGHT GALLERY
Minyoung Kim
Slade School of Fine Art, University College London

夜画廊
金敏英
伦敦大学学院斯莱德美术学院

AIRPORT 2020
Sun Dikun
LuXun Academy of Fine Arts

机场 2020
孙帝坤
鲁迅美术学院

CHENG MIN'S WORKS
Cheng Min
Central Academy of Fine Arts

程敏作品
程敏
中央美术学院

ANNOUNCE·HAPPINESS
Sun Minze
Tianjin Academy of Fine Arts

报·喜
孙民泽
天津美术学院

BETWEEN MOUNTAINS AND RIVERS
Bai Jie
Tianjin Academy of Fine Arts

山水间
白杰
天津美术学院

SEA WORLD
Liao Huayi
Academy of Arts & Design, Tsinghua University

海上世界
廖华依
清华大学美术学院

HE WAS HERE
Wansi Ieong
Southern Illinois University

他到过这里
杨韵诗
南伊利诺伊大学

FORCE AND REACTION FORCE
Wang Jinbo
Sichuan Fine Arts Institute

作用力、反作用力
王金博
四川美术学院

BLUE SUPPER
Kana Tsumura
Musashino Art University

蓝色晚餐
津村果奈
武藏野美术大学

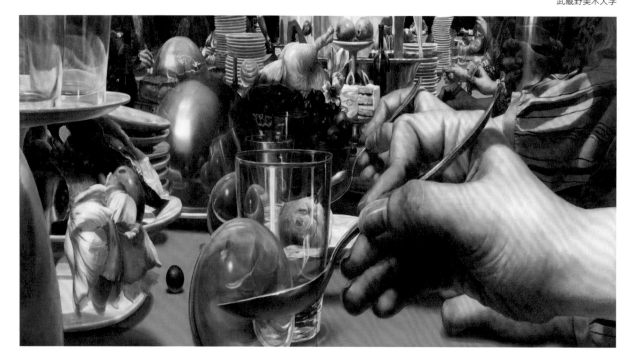

CYCLED ENTROPY
Alexa Barboza
Maryland Institute College of Art

循环熵
亚历克萨·巴博萨
马里兰艺术学院

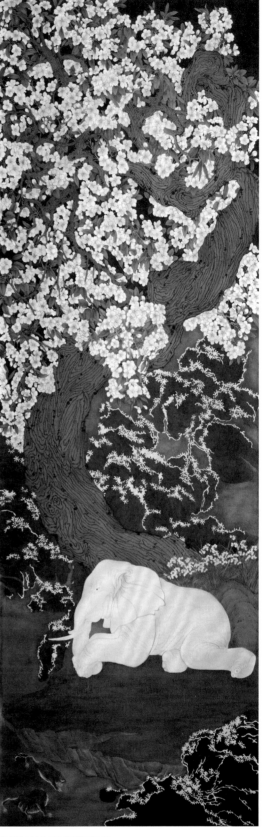

SELF MADE INTENTION
Xiang Xingming
Tianjin Academy of Fine Arts

初心自造
项兴明
天津美术学院

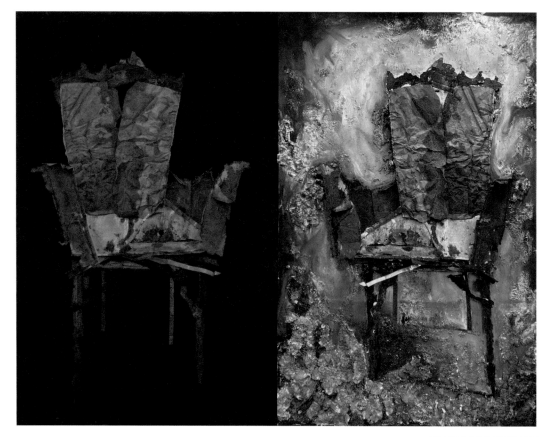

CHAIR OF INNOCENT X
Xu Yuanxiang
Sichuan Fine Arts Institute

英诺森十世的椅子
许源祥
四川美术学院

PUDDLE FISSURE HOLLOW
Rumi Saeki
Musashino Art University

水坑裂缝空洞
佐伯瑠美
武藏野美术大学

DESIRE
Jessica Mia Vito
Southern Illinois University

欲望
杰西卡·米娅·维托
南伊利诺伊大学

PERCEPTION OF IDENTITY
Briana Mason
Southern Illinois University

对身份的看法
布里安娜·梅森
南伊利诺伊大学

TO THE DARK WATER
Junho Jeong
Stuttgart State Academy of Art and Design

至黑暗的水
郑俊昊
国立斯图加特艺术学院

MEMORY WAREHOUSE
Yunhee Choi
Sookmyung Women's University

记忆仓库
崔允熙
淑明女子大学

INTERMITENT CALM IS BETTER THAN NOTHINGNESS
Ian Miyamura
Maryland Institute College of Art

间歇性平静胜过虚无
伊恩宫村
马里兰艺术学院

FENCE (BIRD) FALLEN LEAVES (1) NET (NIGHT)
Shimoyama Remi
Musashino Art University

栅栏（鸟）落叶（1）网（夜）
下山黎海
武藏野美术大学

TO HAVE TO BE
Stefanie Fleischhauer
Stuttgart State Academy of Art and Design

记忆碎片
斯蒂芬妮·弗莱施豪尔
国立斯图加特艺术学院

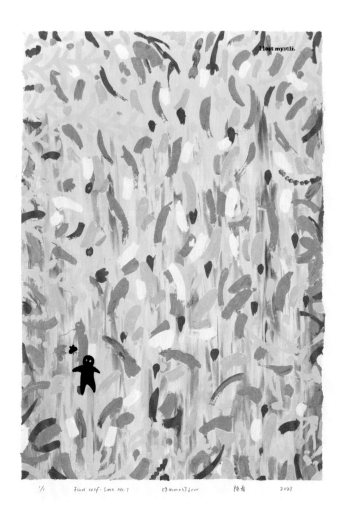

FIND SELF
Chen Kan
Shanghai Academy of Fine Arts,Shanghai University

找回自我
陈看
上海大学上海美术学院

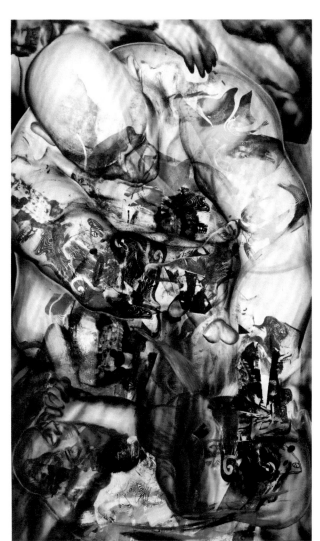

BECOMING ALL THAT PEOPLE SEE IN YOU
Ivan Zozulya
Stuttgart State Academy of Art and Design

投射效应
伊万·佐祖利亚
国立斯图加特艺术学院

CURSIVE SCRIPT OF FULL
FRAGRANCE IN THE COURT – TEA
Guo Zehui
Hubei Institute of Fine Arts

草书《满庭芳——茶》
郭泽辉
湖北美术学院

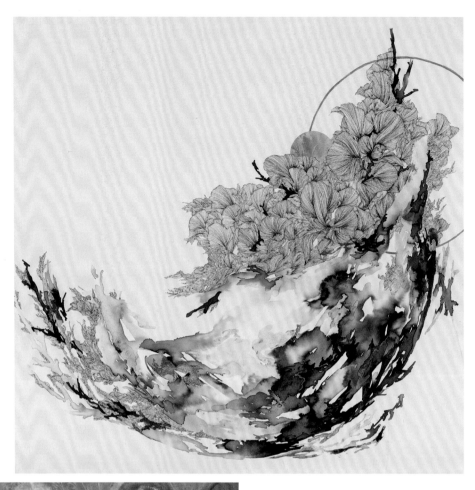

TEXTURE II 2020
Siwon Choi
Sookmyung Women's University

材质二，2020
崔斯文
淑明女子大学

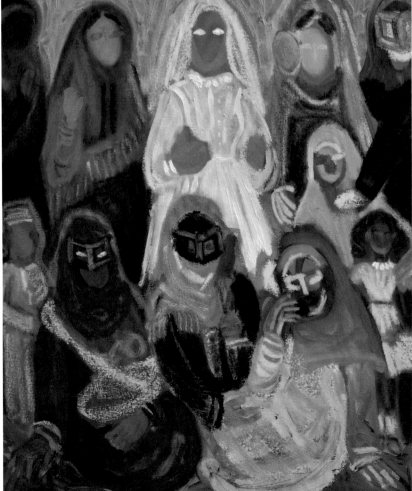

SALAMA
Latifah A Stranack
Slade School of Fine Art, University College London

萨拉马
拉蒂法·阿斯特拉纳克
伦敦大学学院斯莱德美术学院

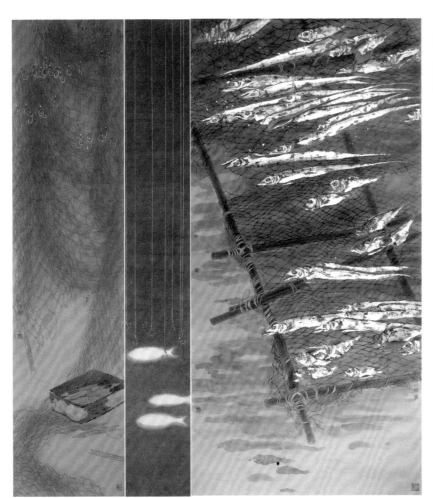

WEAVING DREAMS
Zheng Baiyang
Guangzhou Academy of Fine Arts

织梦
郑白杨
广州美术学院

BEFORE IT'S TOO EARLY
Leverrier Victor
French National School of Decorative Arts

在为时过早之前
勒沃里耶·维克多
法国国立高等装饰艺术学院

CONCENTRATION
Mikayla Washington
Southern Illinois University

专注
米凯拉·华盛顿
南伊利诺伊大学

DARK ROMANTICISM
Arthur Metz
Stuttgart State Academy of Art and Design

黑暗浪漫主义
阿瑟·梅茨
国立斯图加特艺术学院

STUPID. BAU BAU HYAKUKI.
Shiho Kono
Musashino Art University

愚蠢的 BAU BAU HYAKUKI.
河野志保
武藏野美术大学

GIRLS IN SILENCE
Blythe Thea Williams
Maryland Institute College of Art

沉默的女孩
布莱斯·西娅·威廉姆斯
马里兰艺术学院

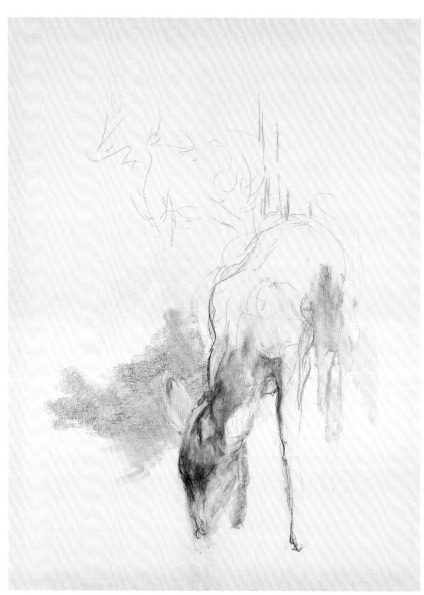

LIVING
Yerim Park
Sookmyung Women's University

活灵活现
朴尹敏
淑明女子大学

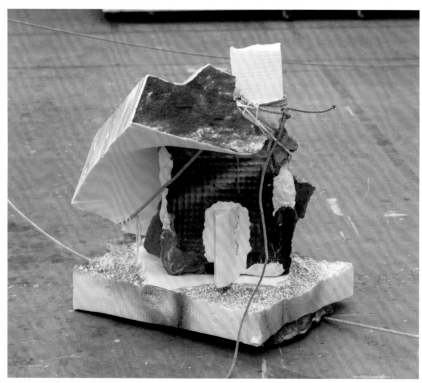

FEIKUREIYAADOCOODE'S
Tomomi Taoka
Musashino Art University

Feikureiyaadocoode's
田冈智美
武藏野美术大学

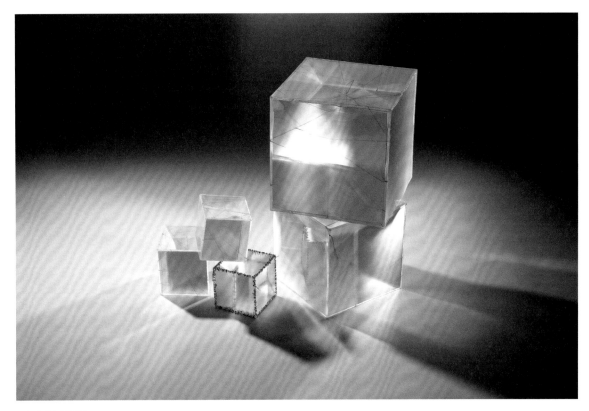

WILL BE FINE
Yebin Choi
Sookmyung Women's University

一切会好的
崔业斌
淑明女子大学

SEWING LIGHT
Katsuharu Tano
Musashino Art University

缝纫灯
田野胜晴
武藏野美术大学

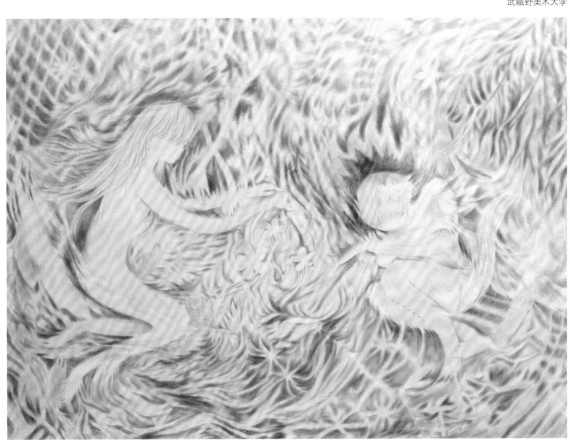

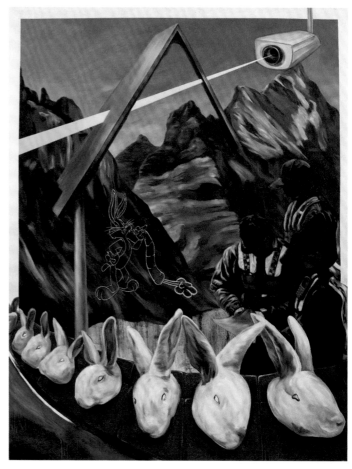

UNDER CONTROLL
Jinjoo Lee
Southern Illinois University

受控
李镇柱
斯图加特艺术学院

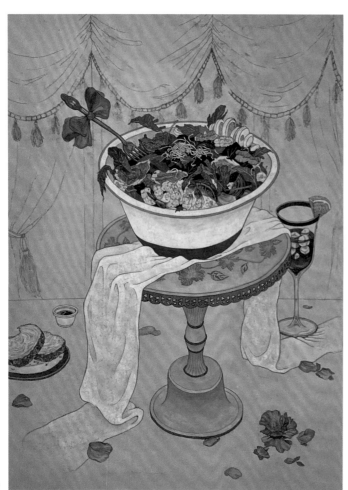

GLANCE: SALAD
Yu Jin Yea
Sookmyung Women's University

视线：沙拉
尹宇京
淑明女子大学

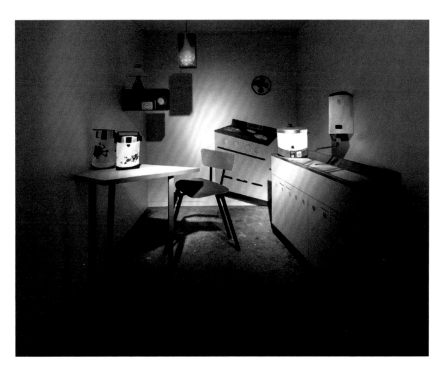

LIFE WITH A VIRTUAL IMAGE
Mai Higuchi
Musashino Art University

生命与虚拟图像
樋口舞
武藏野美术大学

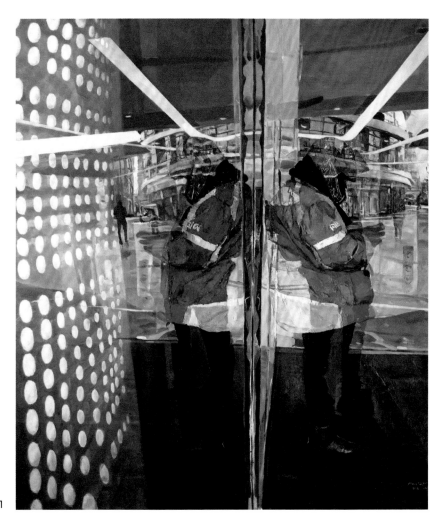

ORDER TAKING
Huang Yinyu
Central Academy of Fine Arts

接单
黄银宇
中央美术学院

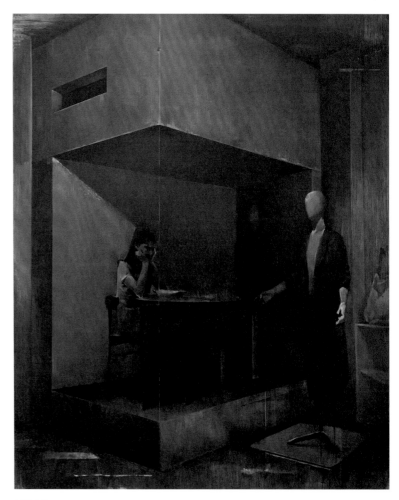

MODEL
Chen Haoran
Tianjin Academy of Fine Arts

模特
陈浩然
天津美术学院

ECHO
Ayaka Hashiba
Musashino Art University

回声
桥场文香
武藏野美术大学

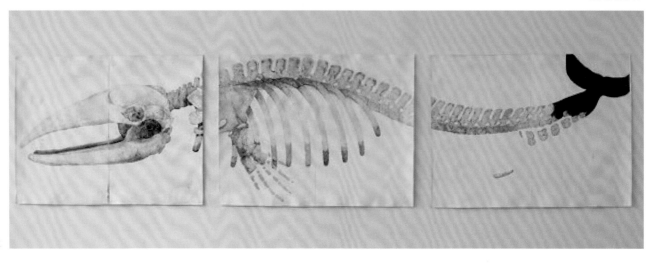

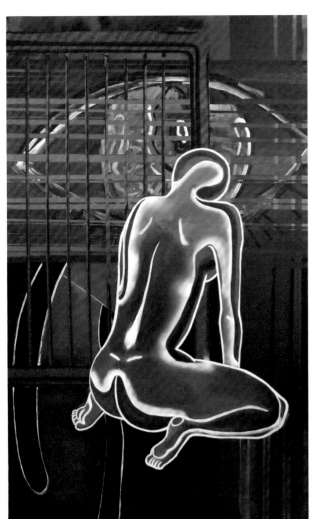

SEE HER VULNERABILITY
Tian Zhen
Hubei Institute of Fine Arts

看见她的脆弱
田珍
湖北美术学院

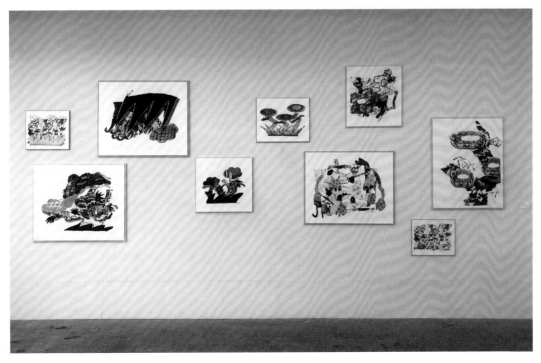

MY ROOM
Honoca Matsudo
Musashino Art University

我的房间
松户本佳
武藏野美术大学

BY CUTTING OUT, OR AS IF CUTTING OUT
Hanako Matsuo
Musashino Art University

切掉或仿佛被切掉
松尾华子
武藏野美术大学

"TO YOU ON SUNDAY"
Yui Mori
Musashino Art University

"星期天献给你"
森唯
武藏野美术大学

SEA CREATURES
Sohn Ari
Musashino Art University

海洋生物
索恩·阿里
武藏野美术大学

WU JUN'S LETTER TO ZHU YUANSI
Sun Zaiyuan
Tianjin Academy of Fine Arts

吴均与朱元思书
孙再源
天津美术学院

風煙俱淨天山共色従流飄蕩任意東西自富陽至桐廬一百許里奇山異水天下獨絕水皆縹碧千丈見底游魚細石直視無礙急湍甚箭猛浪若奔夾岸高山皆生寒樹負勢競上互相軒邈爭高直指千百成峰泉水激石泠泠作響好鳥相鳴嚶嚶成韻蟬則千轉不窮猿則百叫無絕鳶飛戾天者望峰息心經綸世務者窺谷忘反橫柯上蔽在晝猶昏疏條交映有時見日

FINE ARTS
Wendy Liang
California College of the Arts

纯艺术
梁薇
加州艺术学院

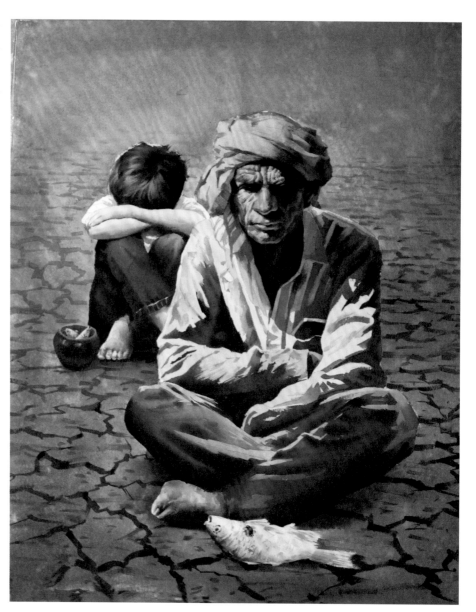

I AM A FLY
Monami Hayashi
Musashino Art University

我是一只苍蝇
林若菜未
武藏野美术大学

HEALING
Minseon Lee
Sookmyung Women's University

康复
李敏森
淑明女子大学

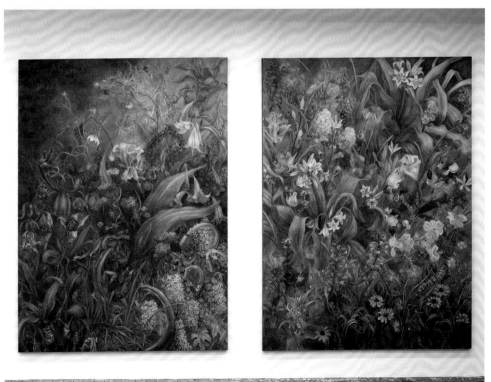

CRAWL, REALIZE, SWELL
Saki Ishita
Musashino Art University

爬行、实现、膨胀
井下纱希
武藏野美术大学

DREAMTALK SERIES, CLOUD AND
SMOKE, WOOD AND STONE, HORSE
Li Baige
Central Academy of Fine Arts

梦语系列、云烟图、木石图、行马图
李百舸
中央美术学院

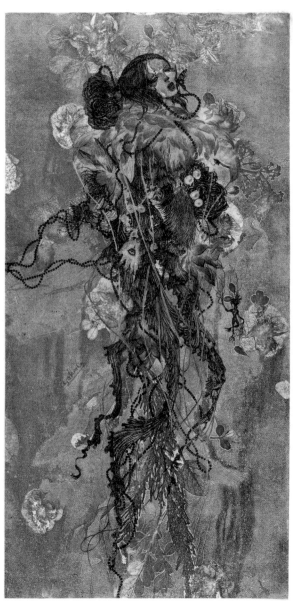

MELANCHOLY
Liu Xuan
Central Academy of Fine Arts

忧郁
刘璇
中央美术学院

STAY AT HOME
You Qinhuang
Central Academy of Fine Arts

待在家里
游钦煌
中央美术学院

LAYER OF LINES
Sana Iga
Musashino Art University

线条的层次
萨那伊贺
武藏野美术大学

VECTOR
Zhang Xichen
Central Academy of Fine Arts

矢量
张皙晨
中央美术学院

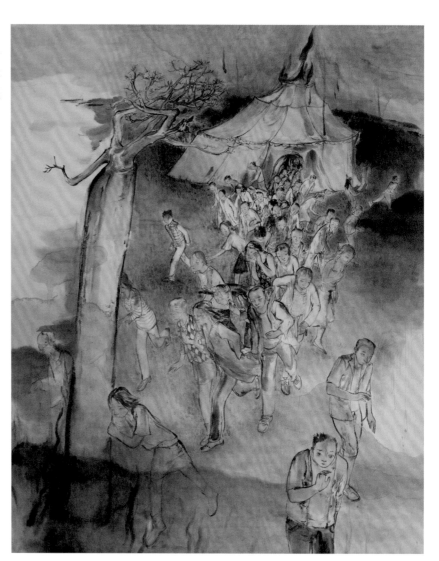

BLANK STELE 2021
Zhang Xiaoli
Central Academy of Fine Arts

无字碑 2021
张小黎
中央美术学院

CURSORY
Han Pengyi
Tianjin Academy of Fine Arts

浮光掠影
韩朋艺
天津美术学院

CHILD, HOUSE AND DOG
Han Yuqi
Tianjin Academy of Fine Arts

小孩儿、房子和小狗
韩雨琪
天津美术学院

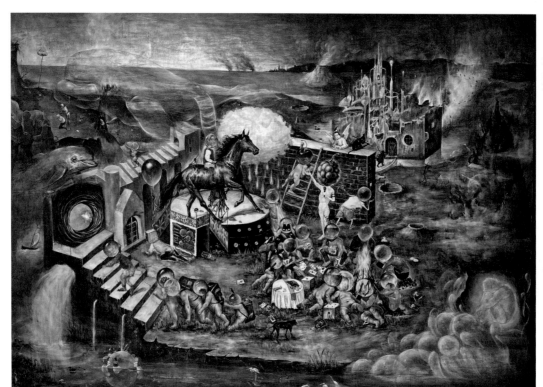

RESTLESS ISLAND
Zhu Qian
Hubei Institute of Fine Arts

不安之岛
朱谦
湖北美术学院

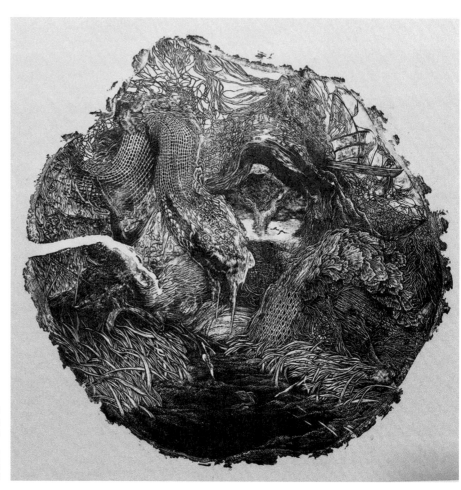

TO THE VOLCANO
Liu Meixiao
Hubei Institute of Fine Arts

到火山去
刘美晓
湖北美术学院

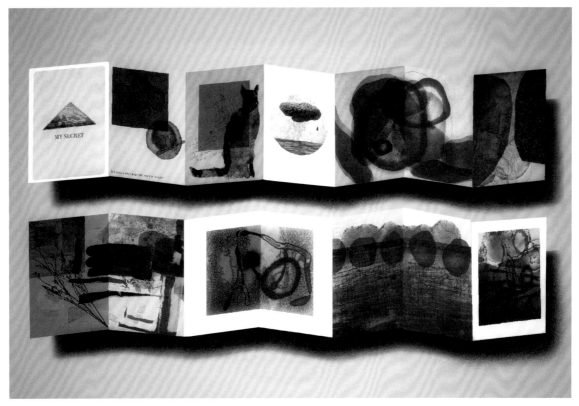

MY SECRET - 3
Zhao Yue
LuXun Academy of Fine Arts

我的秘密 -3
赵悦
鲁迅美术学院

COOL WIND IN SUMMER SERIES
Li Fang
Hubei Institute of Fine Arts

《夏有凉风》系列
李芳
湖北美术学院

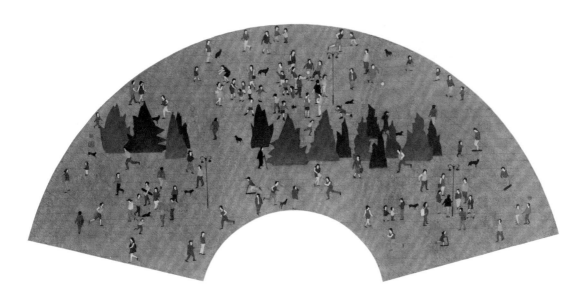

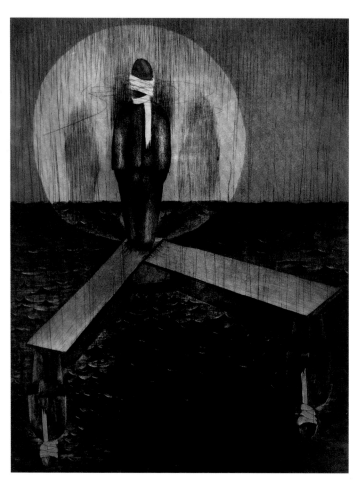

WE
Xu Hongwei
Tianjin Academy of Fine Arts

我们
许宏伟
天津美术学院

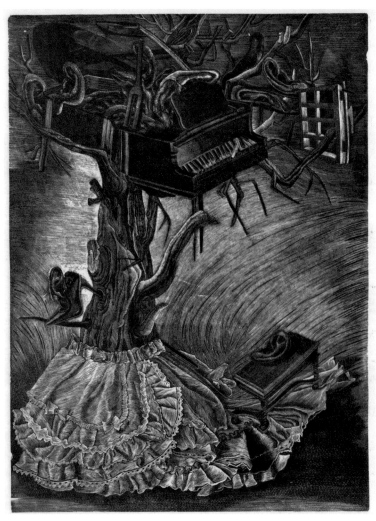

PASSING LOVE
Wang Yitong
Tianjin Academy of Fine Arts

流逝的爱
王艺潼
天津美术学院

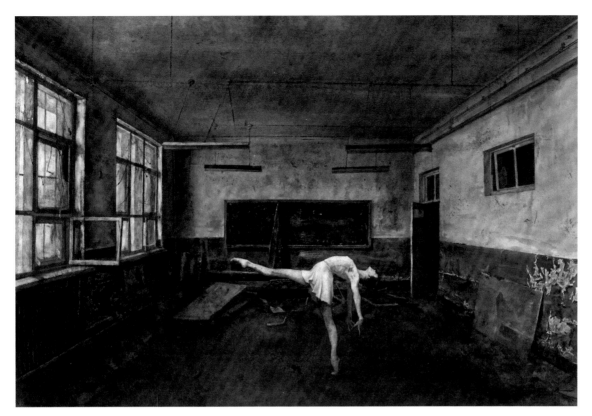

LEGACY CITY OLD DREAM SERIES
Chen Dezheng
Xi'an Academy of Fine Arts

《遗城旧梦》系列
陈德政
西安美术学院

FALSE FOREST GARDEN
Wang Qian
Tianjin Academy of Fine Arts

假述后林园
王茜
天津美术学院

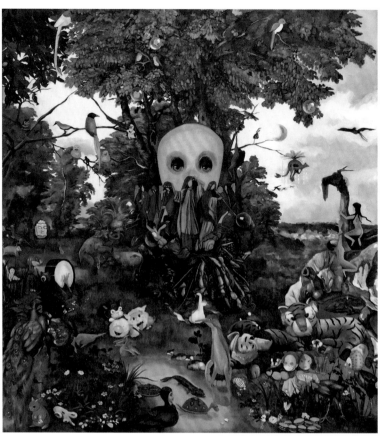

WHAT LEVEL IS THIS DREAM?
Sun Mingjun
LuXun Academy of Fine Arts

这是梦的第几层了？
孙铭珺
鲁迅美术学院

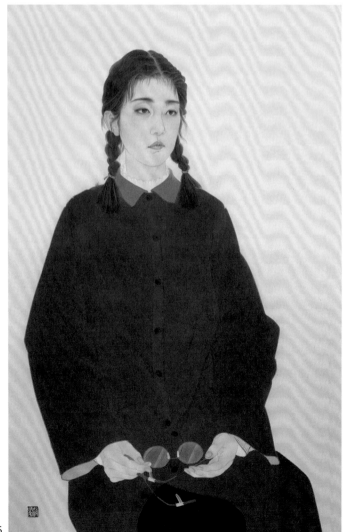

XIAOSHAN HUIZI
Zhao Bingyu
Tianjin Academy of Fine Arts

筱山慧子
赵炳宇
天津美术学院

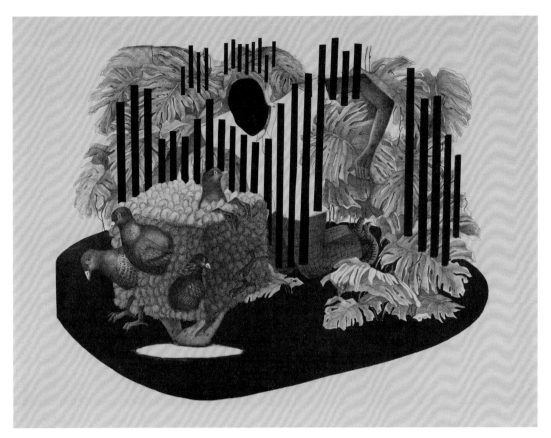

I'LL JUST LOOK OUTSIDE, WON'T GO IN
Wang Xinyue
Xi'an Academy of Fine Arts

我就在外面看看，不进去了
王新月
西安美术学院

TINGLU POTTERY SEAL
Zhou Shixu
Tianjin Academy of Fine Arts

汀庐陶印
周世旭
天津美术学院

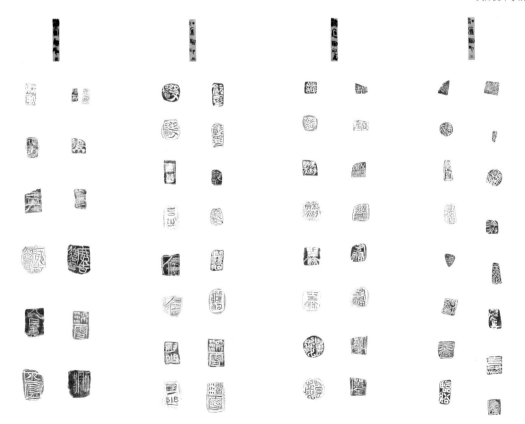

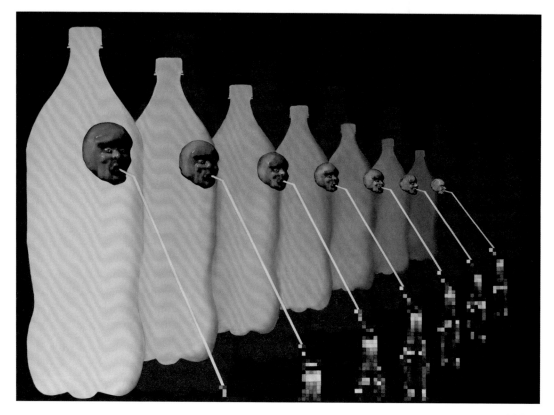

ORDER
Chen Huanyu
Sichuan Fine Arts Institute

有序
陈环宇
四川美术学院

IT'S ALL ME
Huang Xueyu
Hubei Institute of Fine Arts

其实全都是我
黄雪玉
湖北美术学院

IN THE WIND AND RAIN
Li Xiaohong
Hubei Institute of Fine Arts

风里雨里
李晓宏
湖北美术学院

CARESS THE PRESENT AND
CHERISH THE PAST
Lu Wenjing
Hubei Institute of Fine Arts

抚今怀昔
鲁文静
湖北美术学院

RIPPLE
Huang Lei
Shanghai Academy of Fine Arts,Shanghai University

涟漪
黄蕾
上海大学上海美术学院

SELECTED COPY OF SHULUN
Liu Lin
Xi'an Academy of Fine Arts

书论选抄
刘林
西安美术学院

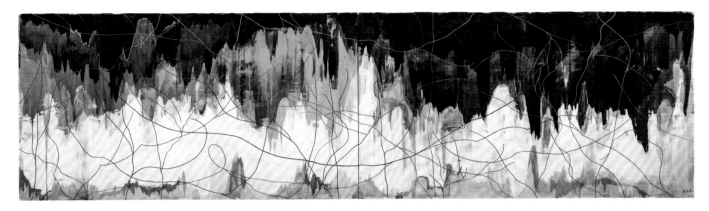

RUOMU
Zhang Jiahao
Hubei Institute of Fine Arts

若木
张家豪
湖北美术学院

PRAISE ON THE G STRING, AIR ON THE G STRING
Huang Zhuoxin
Xi'an Academy of Fine Arts

G 弦上的咏赞调、G 弦上的咏叹调
黄焯欣
西安美术学院

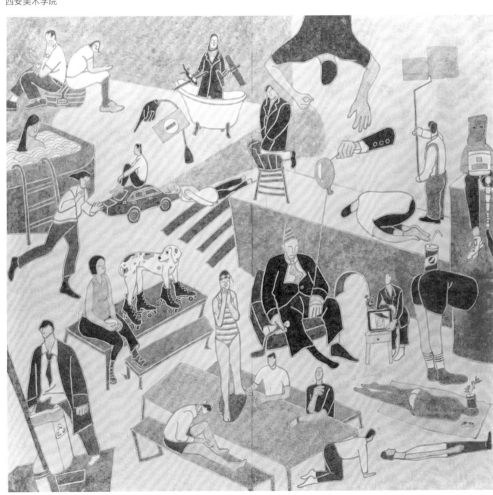

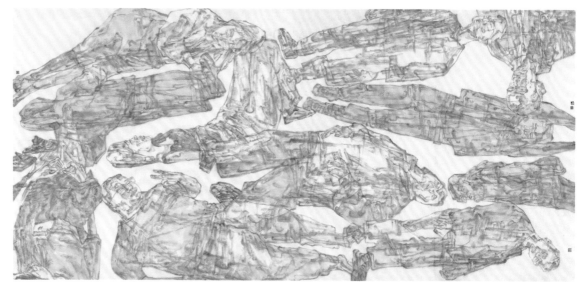

2018-2020
Zha Lijun
Sichuan Fine Arts Institute

2018-2020
查丽君
四川美术学院

JUNGLE SERIES
Zhao Yu
Sichuan Fine Arts Institute

丛林系列
赵宇
四川美术学院

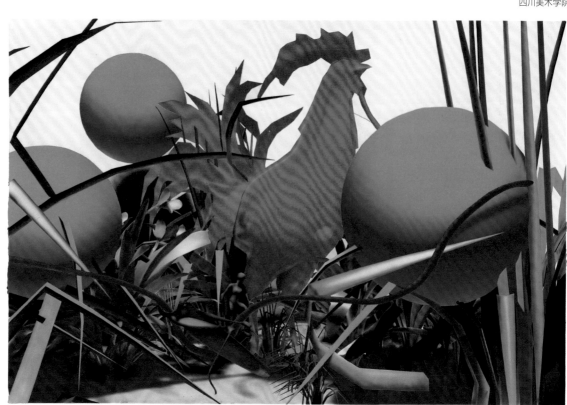

ALSO PEDESTRIAN
Zhang Diyang
Shanghai Academy of Fine Arts,Shanghai University

亦是行人
张笛扬
上海大学上海美术学院

HIDDEN WORLD
Zhao Zhiqiang
Sichuan Fine Arts Institute

隐秘的世界
赵志强
四川美术学院

RECLINING BUDDHA
Wang Binjie
LuXun Academy of Fine Arts

卧佛
王彬杰
鲁迅美术学院

WAR HORSE
Xu Shuo
LuXun Academy of Fine Arts

战马
徐烁
鲁迅美术学院

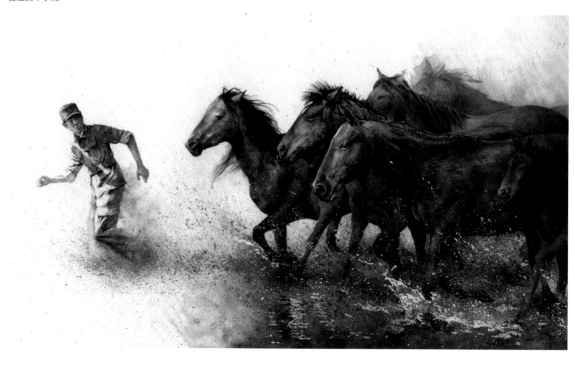

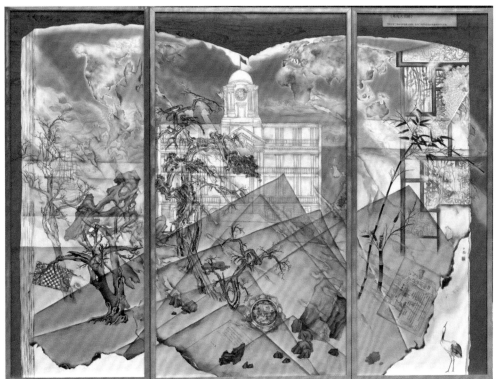

ANNAL OF GUANGDONG
MARITIME TRADE
Chen Shaoyan
Guangzhou Academy of Fine Arts

粤海图志
陈少颜
广州美术学院

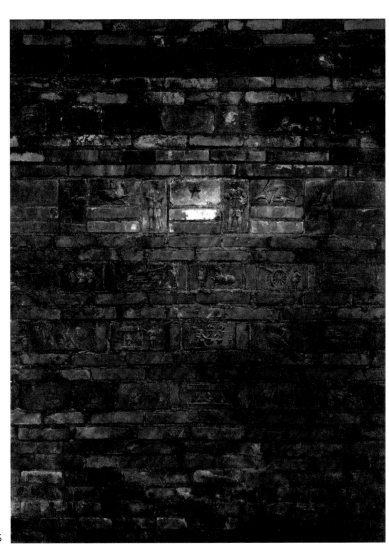

MONUMENT
Lin Zhiyan
Guangzhou Academy of Fine Arts

丰碑
林致言
广州美术学院

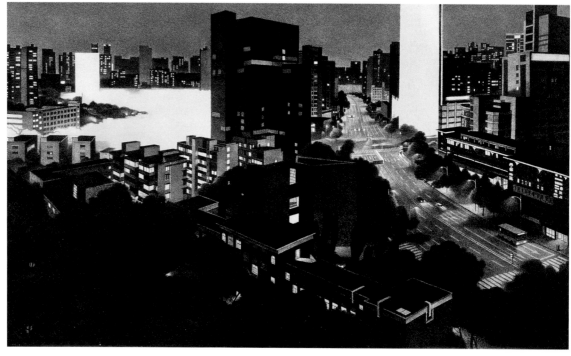

LIFE IS NOT ELSEWHERE SERIES
Qiao Luyao
Guangzhou Academy of Fine Arts

生活不在别处系列
乔路遥
广州美术学院

DREAM BACK TO THE SILK ROAD
Ji Jing
Xi'an Academy of Fine Arts

梦回丝路
吉婧
西安美术学院

INTERVAL
Guo Hao
Xi'an Academy of Fine Arts

间隔
郭昊
西安美术学院

OURSELVES SERIES
Wang Xiaodan
Shanghai Academy of Fine Arts,Shanghai University

《我们自己》系列
汪晓丹
上海大学上海美术学院

PANDEMIC PRISON
Li Shaosi
Xi'an Academy of Fine Arts

疫狱
李少思
西安美术学院

TOUR OF YOUTH
Ye Ke
Shanghai Academy of Fine Arts,Shanghai University

少年游
叶可
上海大学上海美术学院

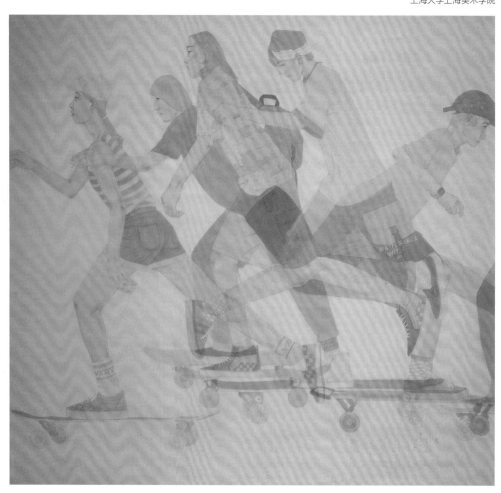

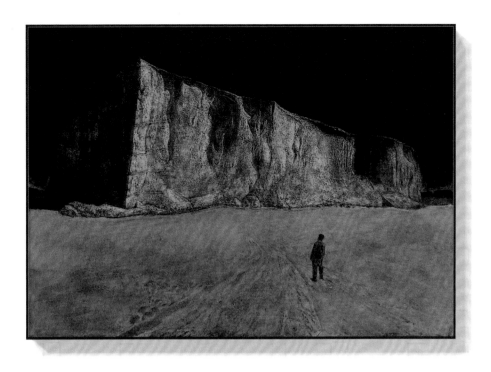

BARREN LAND
Hu Boshu
Xi'an Academy of Fine Arts

赤地
虎柏树
西安美术学院

STORY BEHIND THE OPERA STAGE
Zhang Yidan
Shanghai Academy of Fine Arts,Shanghai University

红氍毹下
张奕丹
上海大学上海美术学院

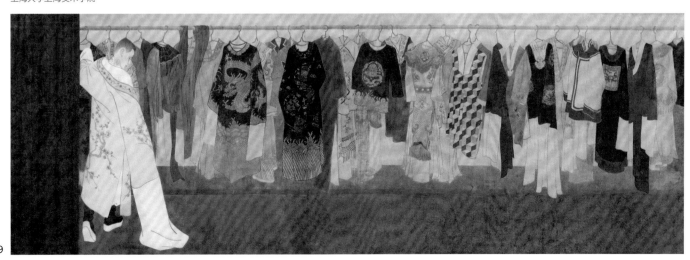

ALTHOUGH LIGHT WILL ALWAYS COME AS
SCHEDULED, LET ME SEE YOU AGAIN
Fu Bowei
Xi'an Academy of Fine Arts

尽管光总会如期降临，
让我再看你一眼
付柏伟
西安美术学院

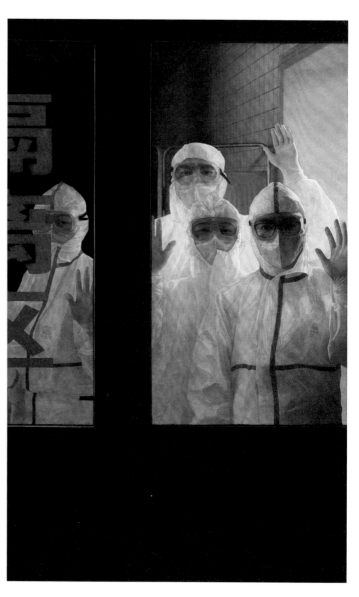

FIG ORCHARD
Shen Ruyi
Shanghai Academy of Fine Arts,
Shanghai University

无花果园
沈如意
上海大学上海美术学院

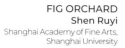

尽管光总会如期降临，
让我再看你一眼
付柏伟
西安美术学院

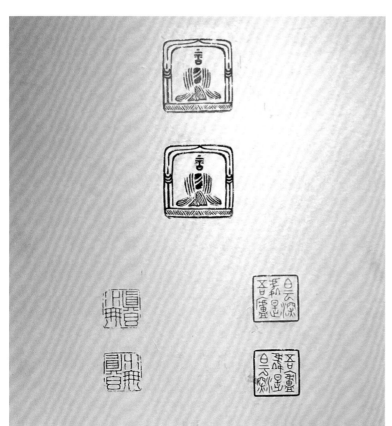

ZHU ZHENAN'S ENGRAVING, ANLU
LEARNING ENGRAVING
Zhu Zhen'an
Shanghai Academy of Fine Arts,Shanghai University

朱振安刻印、安庐学印
朱振安
上海大学上海美术学院

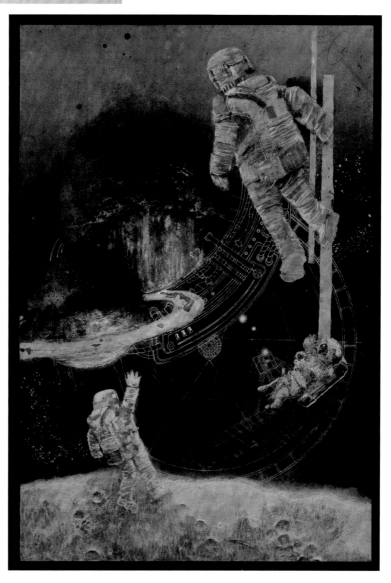

PLEASANT NIGHT
Yuan Shaokun
Xi'an Academy of Fine Arts

良夜
员少坤
西安美术学院

341

HELLO, FLOYD, STUDIO
Zhang Zheng
Tianjin Academy of Fine Arts

你好，佛洛依德、画室
张征
天津美术学院

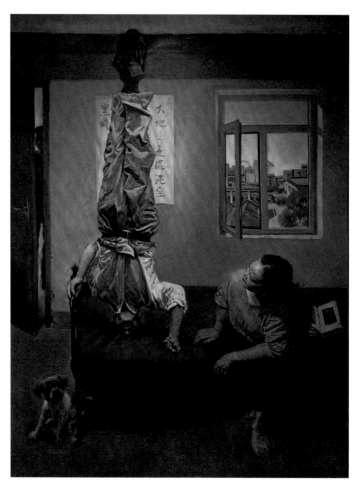

TRACK IS FAR AWAY FROM THE SAND, AND THE
MOON IS BRIGHT WHEN IT IS NEAR THE PASS
Zhang Nianchen
Xi'an Academy of Fine Arts

度迹迷沙远，临关讶月明
张念晨
西安美术学院

EXTRAORDINARY QINYUAN
Bai Tianyue
Xi'an Academy of Fine Arts

沁园毓秀
白天悦
西安美术学院

FIFTY-NINE SECONDS
Yu Qian
Xi'an Academy of Fine Arts

五十九秒
于茜
西安美术学院

EXCERPTS FROM SHANGSHU
Ma Rui
Xi'an Academy of Fine Arts

《尚书》节录
马睿
西安美术学院

HEAR! HEAR! NIGHT PATROL, LITTLE ARTIST
Kye Benjamin Stone
School of the Art Institute of Chicago

听！听！夜间巡逻，小艺术家
凯·本杰明·斯通
芝加哥艺术学院

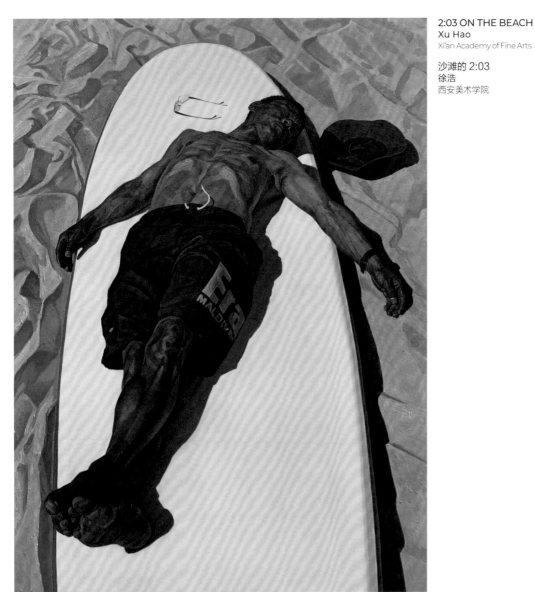

2:03 ON THE BEACH
Xu Hao
Xi'an Academy of Fine Arts

沙滩的 2:03
徐浩
西安美术学院

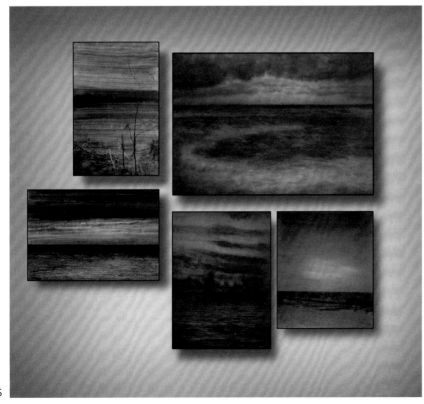

SILENT SEA SERIES
Meng Xianyang
Xi'an Academy of Fine Arts

《沉默的海》系列
蒙先阳
西安美术学院

345

BUTTERFLY
Zhou Hao
Musashino Art University

蝴蝶
周昊
武藏野美术大学

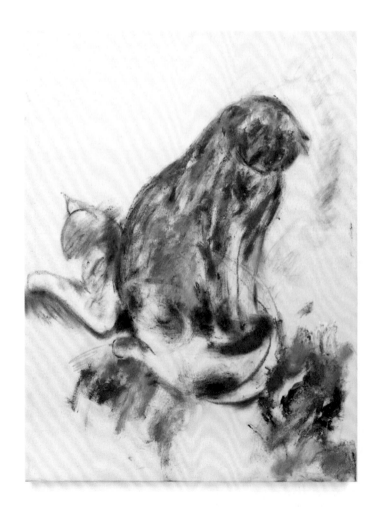

VITALITY - BUWEI IN THE STUDIO
Hu Buwei
Pratt Institute

生命力——不为的工作室
胡不为
普瑞特艺术学院

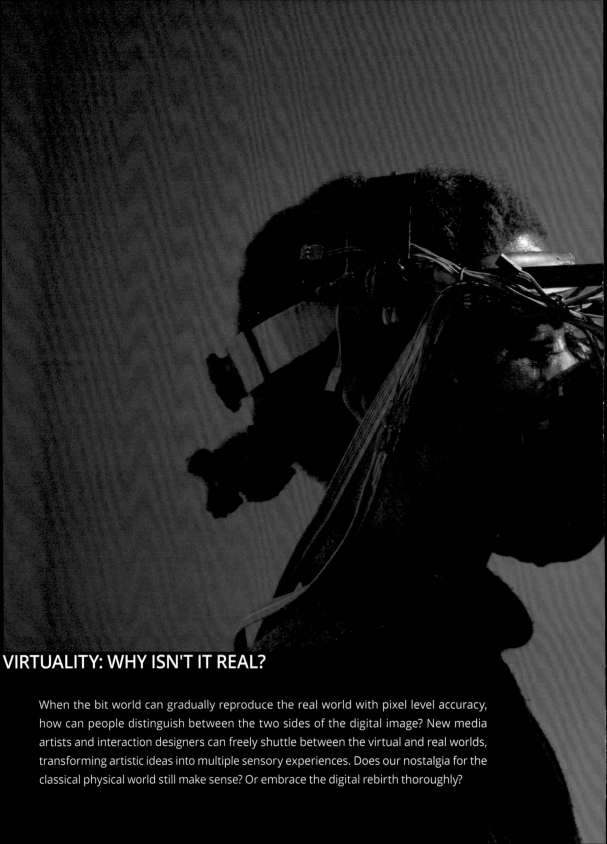

VIRTUALITY: WHY ISN'T IT REAL?

When the bit world can gradually reproduce the real world with pixel level accuracy, how can people distinguish between the two sides of the digital image? New media artists and interaction designers can freely shuttle between the virtual and real worlds, transforming artistic ideas into multiple sensory experiences. Does our nostalgia for the classical physical world still make sense? Or embrace the digital rebirth thoroughly?

当比特世界逐渐可以用像素级的精度复刻现实世界，人们如何区分数字镜像的两边？新媒体艺术家和交互设计师们，可以自由穿梭在虚实两界之间，将艺术创意转化成多元的感官体验。我们对经典物理世界的怀念是否仍有意义？抑或彻底拥抱数字新生？

7

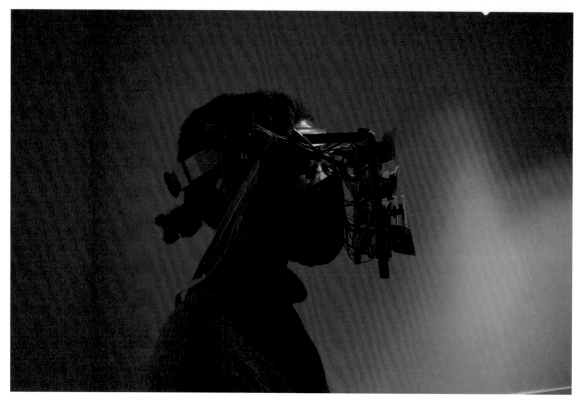

GAZE MACHINE/THE SECOND SPINE
Yang Yi
Rhode Island School of Design

凝视机器 / 第二根脊椎
杨艺
罗德岛设计学院

PROJECT NUMEN
Benny Zhang
Parsons School of Design, The New School

项目守护神
张思华
帕森斯设计学院

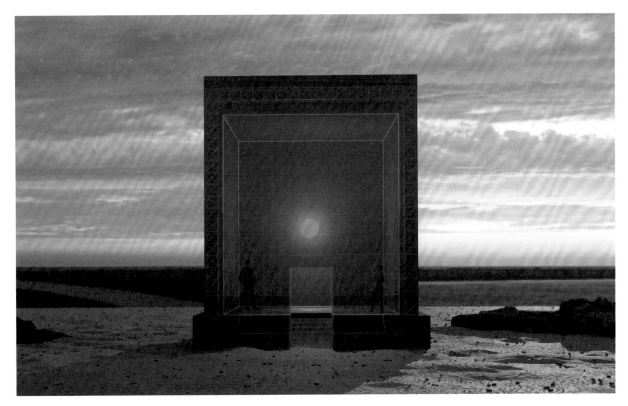

COSMUSICA
Qiu Yiyun
Academy of Arts & Design, Tsinghua University

宇宙八音盒
邱艺芸
清华大学美术学院

EXPERIENCE DESIGN BASED ON
DIGITAL ART IN PHYSICAL SPACE
Li Boning
Tongji University

基于数字艺术在物理空间下的体验设计
厉博宁
同济大学

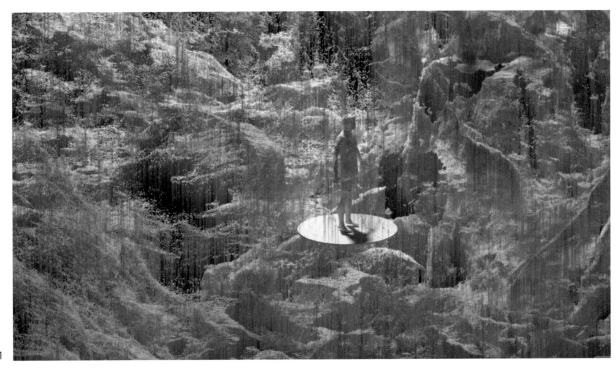

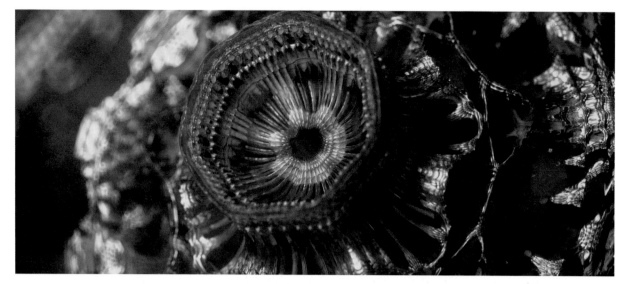

SPACE PARADOX
You Quan, Zhu Genle
LuXun Academy of Fine Arts

空间悖论
尤权、朱根乐
鲁迅美术学院

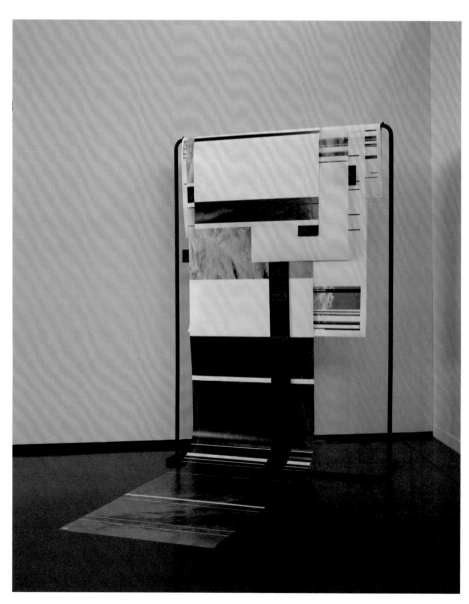

DO CLOUDS HATE
WEATHER SATELLITES?
Chen Zhanyi
Rhode Island School of Design

云讨厌天气卫星吗？
陈占义
罗德岛设计学院

EXPANSION OF WATERINESS
Asuya Sato
Tama Art University

扩大含水量
佐藤明日野
多摩美术大学

AI SMART SPACE
Li Jianwen
Guangzhou Academy of Fine Arts

AI 智慧空间
李建文
广州美术学院

A MATTER OF TIME
Huang Yajing
Maryland Institute College of Art

时间问题
黄雅婧
马里兰艺术学院

NEW ANCES
Jill Shah
Parsons School of Design, The New School

新发现
吉尔·沙
帕森斯设计学院

BEYOND THE BOW
Kiera Boyle
Maryland Institute College of Art

千钧一发
基拉·博伊尔
马里兰艺术学院

SHADOW NARRATION
Liang Haiying
Guangzhou Academy of Fine Arts

影叙
梁海盈
广州美术学院

355

DYING THOUGHT
Andrew Beyke
Southern Illinois University

垂死的思想
安德鲁·贝克
南伊利诺伊大学

BROKEN SIGNALS
Raymond Tully
Rochester Institute of Technology

破碎的信号
雷蒙德·徒利
罗切斯特理工学院

BROKEN THOUGHT MACHINE
Michael Dispensa
Rhode Island School of Design

破碎的思想机器
迈克尔·迪米斯
罗德岛设计学院

NUCLEAR
Grace Redman
Tisch School of the Arts, New York University

核
格蕾丝·雷德曼
纽约大学帝势艺术学院

EXHIBITION WITHOUT EXHIBITING
Zhao Qinyuan,Liu Yuhong,Zhang Lu
China Academy of Art

无展之展
赵沁园、刘雨泓、张璐
中国美术学院

HELLO? HEY!
Xing Yu
Guangzhou Academy of Fine Arts

喂？嘿！
邢雨
广州美术学院

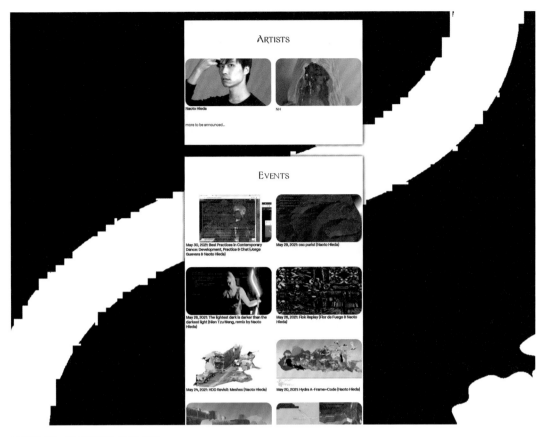

FESTIVAL, GLITCHES AND ME
Naoto Hieda
Academy of Media Arts Cologne

节日、小故障与我
比枝直人
科隆媒体艺术学院

WAR EPIDEMIC
Zhang Wenli,Lan Junhao
Hubei Institute of Fine Arts

战疫
张雯丽、蓝峻浩
湖北美术学院

AMBIGUOUS BORDERER
Chris Han
School of the Art Institute of Chicago

暧昧的边界
克里斯·韩
芝加哥艺术学院

STREAM OF PERCEPTION
Gabriela Valdespino
University of the Arts Bremen

感知流
加布里埃拉·瓦尔德斯皮诺
不来梅艺术学院

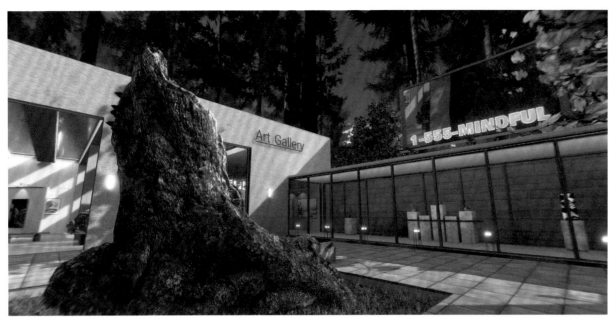

HERDING THE GAZE AWAY FROM THE PASTURE
Tyler Grimes
Maryland Institute College of Art

将目光从牧场移开
泰勒·格莱姆斯
马里兰艺术学院

GINETTE: AN ELECTRONIC INSTRUMENT
BASED ON THE ONDES MARTENOT
Petteri Mäkiniemi
Aalto University

Ginette：基于马特诺琴的电子乐器
佩特里·马基涅米
阿尔托大学

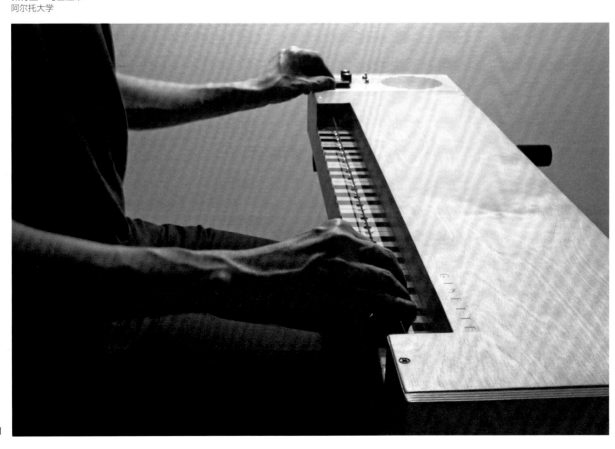

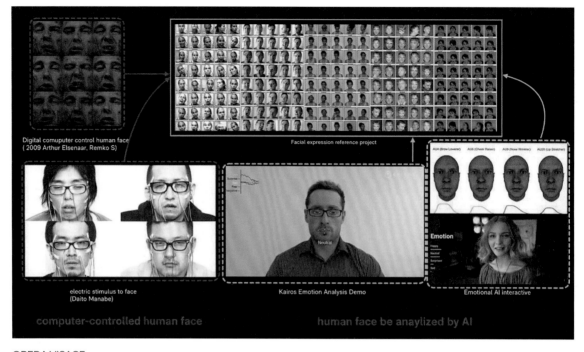

computer-controlled human face
human face be anaylized by AI

Digital comuputer control human face
(2009 Arthur Elsenaar, Remko S)

Facial expression reference project

electric stimulus to face
(Daito Manabe)

Kairos Emotion Analysis Demo

Emotional AI interactive

OPERA VISAGE
Zhang Yiran
Art Center College of Design

歌剧脸谱
张一然
艺术中心设计学院

JOURNEY
Austin Wolfe
The Glasgow School of Art

旅程
奥斯汀·沃尔夫
格拉斯哥美术学院

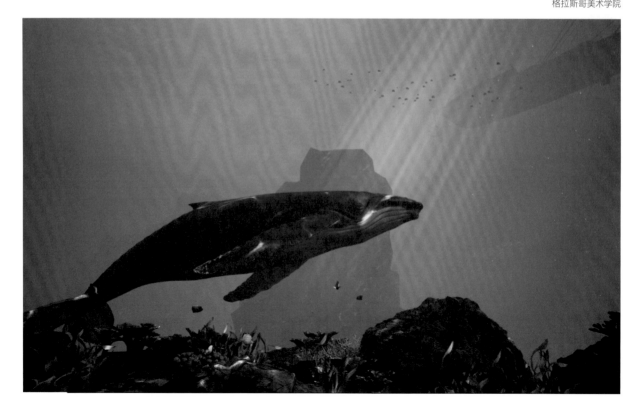

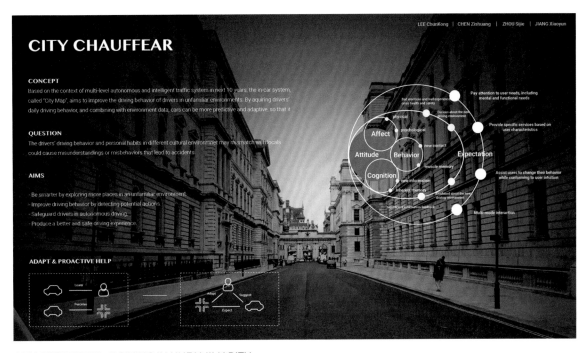

LEE ChunKong | CHEN Zishuang | ZHOU Sijie | JIANG Xiaoyun

CITY CHAUFFEAR

CONCEPT

Based on the context of multi-level autonomous and intelligent traffic system in next 10 years, the in-car system, called "City Map", aims to improve the driving behavior of drivers in unfamiliar environments. By aquiring drivers' daily driving behavior, and combining with environment data, cars can be more predictive and adaptive, so that it

QUESTION

The drivers' driving behavior and personal habits in different cultural environmnet may mismatch with locals could cause misunderstandings or misbehaviors that lead to accidents.

AIMS

- Be smarter by exploring more places in an unfamiliar environment.
- Improve driving behavior by detecting potential actions.
- Safeguard drivers in autonomous driving.
- Produce a better and safe driving experience.

ADAPT & PROACTIVE HELP

CITY CHAUFFEUR: DRIVING IN UNFAMILIARITY
Li Junguang,Zhou Sijie,Jiang Xiaoyun,Chen Zishuang
The Hong Kong Polytechnic University

城市司机：陌生驾驶
李俊光、周思洁、蒋晓云、陈子双
香港理工大学

AS ABOVE ,SO BELOW
Perry Stewart
The Glasgow School of Art

如上，如下
佩里·斯图尔特
格拉斯哥美术学院

UNTITLED
Mary Mikaelyan
Academy of Media Arts Cologne

无题
玛丽·米凯莉安
科隆媒体艺术学院

DIGITISING 'OPERATION'
Orla McCorry
The Glasgow School of Art

数字化"操作"
奥拉·麦考里
格拉斯哥美术学院

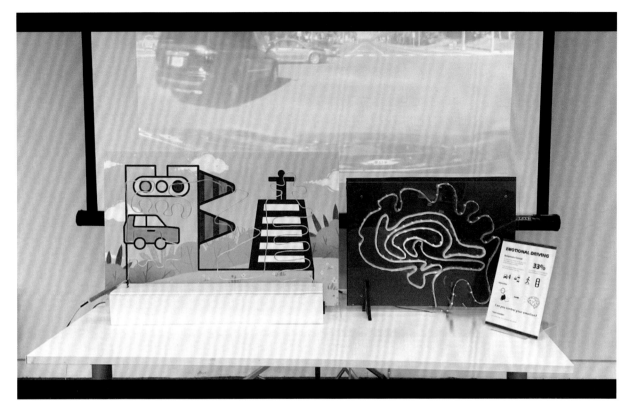

AN EMOTIONAL DRIVING
INTERACTIVE DEVICE
Hou Jianlin,Hu Yuyang,He Lu
The Hong Kong Polytechnic University

情绪化驾驶互动装置
侯健霖、胡玉洋、何璐
香港理工大学

CAPTURED TRANSITION
Marta Palacz
The Glasgow School of Art

俘获跃迁
玛尔塔·帕拉茨
格拉斯哥美术学院

TURNING STILL LIFE
Maki Fujioka
Tama Art University

旋转的静物
藤冈真祈
多摩美术大学

FLUENT MATERIALS
Jacob Höfle
Academy of Media Arts Cologne

流畅的材料
雅各布·霍夫勒
科隆媒体艺术学院

**INNER UNIVERSE: A STRESS MANAGEMENT
GAME FOR YOUNG ADULTS**
Gracia Fei
National University of Singapore

内在宇宙：适合年轻人的压力管理游戏
费玥
新加坡国立大学

SKA OBSERVATORIES
Eric Capper
School of the Art Institute of Chicago

SKA 天文台
埃里克·卡珀
芝加哥艺术学院

S/S 2029: JESTER
Bun Stout
School of the Art Institute of Chicago

S/S 2029：小丑
本・斯图特
芝加哥艺术学院

OP (PANTOMIMUS)
Andrew Chang
Goldsmiths, University of London

op（哑剧演员）
张嘉洋
伦敦大学金史密斯学院

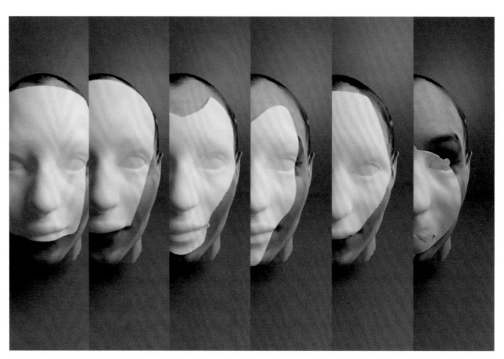

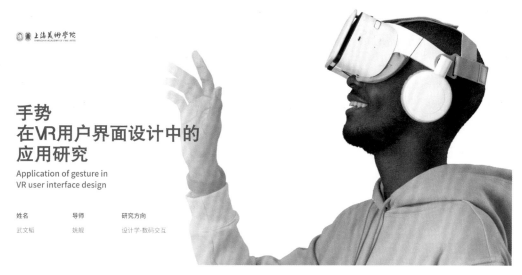

手势
在VR用户界面设计中的
应用研究

Application of gesture in
VR user interface design

姓名	导师	研究方向
武文韬	姚舰	设计学·数码交互

RESEARCH ON THE APPLICATION OF
GESTURES IN VR USER INTERFACE DESIGN
Wu Wentao
Shanghai Academy of Fine Arts, Shanghai University

手势在 VR 用户界面设计中的应用研究
武文韬
上海大学上海美术学院

ASHA-SYNESTHESIA OF COLOR AND MUSIC
Mao Xue,Lai Ningjuan
China Academy of Art

ASHA——音色联觉
毛雪、赖宁娟
中国美术学院

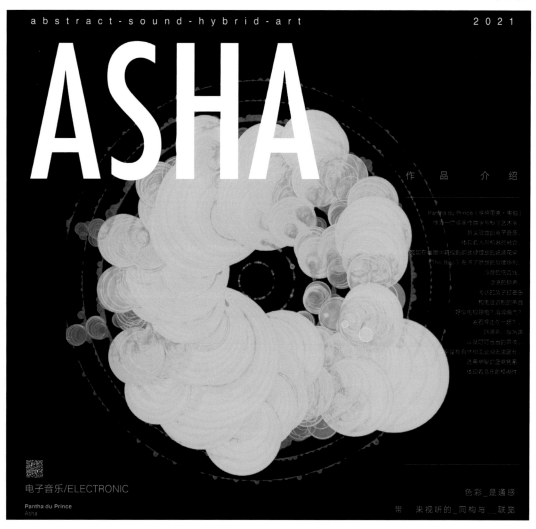

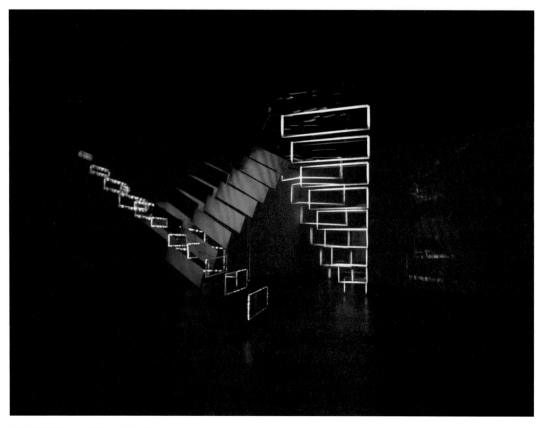

MISREADING DREAMLAND #2
Lin Qi
LuXun Academy of Fine Arts

误读梦境 #2
林奇
鲁迅美术学院

DOGMILY
Lau Yi Man,Chan Tsz Ching
The Hong Kong Polytechnic University

狗狗之家
刘绮雯、陈芷呈
香港理工大学

DATA CITY: BUILD DATE OWNERSHIP
AWARENESS WITH DATA
MATERIALIZATION DESIGN
Xie Hanlin
The Hong Kong Polytechnic University

数据之城：借助数据实体化设计
构建数据所有权意识
谢汉霖
香港理工大学

SEE ALL THE CHANGAN FLOWERS WITHIN ONE DAY
Huang Xiangyi
Tianjin Academy of Fine Arts

一日看尽长安花
黄湘怡
天津美术学院

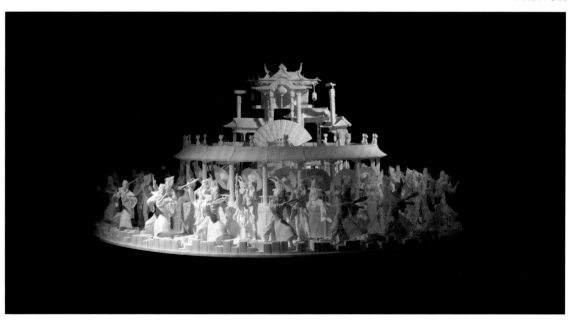

ARTIFACT INTELLGENCE × XILANKAPU

以机器之心再塑土家之花
以智能之心再绘西兰卡普

➡ 开始

Arbitrary style transfer
using TensorFlow.js | ResNet

SMART PAINTING CARP
Wang Jie
Sichuan Fine Arts Institute

智绘卡普
王杰
四川美术学院

4183万人
2020年全国各类高等教育在学总规模

素质育人

41.83 million people are enrolled

in higher education

坚持实施科教兴国战略
始终把教育摆在
优先发展的战略位置

建设教育
强国

2020年，更多的大学和学科
进入一流行列千所大学进入
世界一流大学前列

高校是国家创新
体系的重要组成
部分

2020年全国共有
其中本科院127
高职（专科）
各种形式的高
高等教育毛入

NEW AGE BILL
Xie Chaoyang,Wang Danni,Wang Xiaochan
LuXun Academy of Fine Arts

新时代账单
谢朝阳、王丹妮、王晓婵
鲁迅美术学院

中国高等教育
在传承中变革、在创新中成长

VISIT THE GUANGZHOU ACADEMY OF FINE ARTS BY CALENDAR
Zhong Guobin
Guangzhou Academy of Fine Arts

游"历"广美图
钟国斌
广州美术学院

THE THIRTEENTH GATE
Zhou Tingting
Guangzhou Academy of Fine Arts

第十三道门
周婷婷
广州美术学院

FEELING AND DYEING-PROJECTION
LIGHT INTERACTIVE DEVICE
Dong Jingyi
Shanghai Academy of Fine Arts, Shanghai University

感·染——投影灯光交互装置
董晶艺
上海大学上海美术学院

PURE MAN DRINKS SODA
Huang Zongxian
Rhode Island School of Design

纯男喝苏打水
黄宗贤
罗德岛设计学院

ROAD TO HARMONY
Fu Qiuyun,SunQian,Yang Sihang,Zhang Yun
The Hong Kong Polytechnic University

和谐的道路
付秋云、孙倩、杨思航、张云
香港理工大学

ROAD TO SERENITY
Wu Qishan,Li Jiajuan,Xia Jingjing,Li Zhuoyang
The Hong Kong Polytechnic University

心之所向
吴绮珊、李佳娟、夏晶晶、李卓阳
香港理工大学

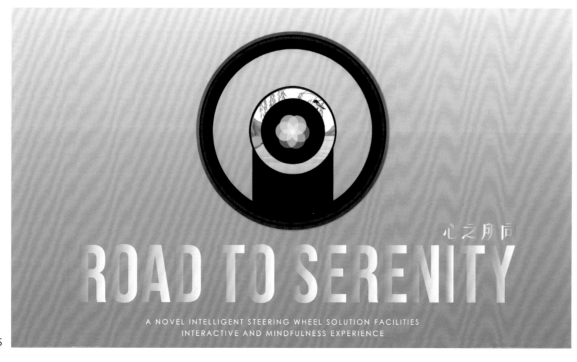

AM I REAL

AM I REAL
Chen Bolin
University of the Arts Bremen

我是真实的吗?
陈伯林
不来梅艺术学院

PAINTER
Zhou May
Parsons School of Design, The New School

痛苦讲述者
周梅
帕森斯设计学院

LODI LEE
Meng Xun
Tokyo University of the Arts

"李龙狄"
孟勋
东京艺术大学

NARRATOR USING AI TO ADD CONTEXT TO MESSAGESLIKE
Shao Chuqing
Art Center College of Design

使用 AI 将上下文添加到消息的叙述者
邵楚清
艺术中心设计学院

BID INDUSTRIAL DESIGN
Bao Han
Pratt Institute

BID 工业设计
包晗
普瑞特艺术学院

ASL FINGERSPELLER
Christian O'Brien
The Glasgow School of Art

ASL 指法
克里斯蒂安·奥布莱恩
格拉斯哥美术学院

378

HACKING ART
Yannick Westphal
Academy of Media Arts Cologne

黑客艺术
雅尼克·韦斯特法尔
科隆媒体艺术学院

ROLLING COMPOSITION
Mark Lim
Nanyang Technological University, Singapore

滚动的成分
李马克
新加坡南洋理工大学

FRESH: WHAT'S NEXT?

How to get freshness in new life? How does a new problem get a new solution? New technology promotes a new way of life, and the new way of life gives birth to another new technology. New service design, new APP design, new social innovation design... While we speed up the creation of novelty, we may also sell anxiety about the future. How to build reasonable expectations for the future, in order to have a moderate "taste"?

新·鲜: 未来何时到来？

新生活如何获得新鲜感？新麻烦如何得到新方案？新科技推动新的生活方式，新的生活方式催生新的科技。新的服务设计、新的 APP 设计、新的社会创新设计…… 我们在不断加速制造新鲜感的同时，也许也贩卖了对未来的焦虑。如何对未来建立合理的预期？从而有节制地"尝鲜"？

8

RHYTHM OF MATTER
Ganit Goldstein
Royal College of Art

物质的节奏
加尼特·戈尔茨坦
皇家艺术学院

SUGAMUXI, PASSIVE OVEN
Laura Stella Herrera Ayazo
Polytechnic University of Milan

Sugamuxi，被动烤箱
劳拉·斯特拉·埃雷拉·阿亚索
米兰理工大学

UNDER THE CITY
Marie Melcore
Central Saint Martins

城市之下
玛丽·梅尔科
中央圣马丁艺术与设计学院

SHAPE OF CONSCIOUSNESS
Fang Xiaowei
Academy of Arts & Design, Tsinghua University

意识形状
方小为
清华大学美术学院

FROM ZENGCHENG TO FENGCHENG:
LATE CHOY SUM AS A WAY OF COMMUNICATION
Cao Yuan
Guangzhou Academy of Fine Arts

从增城到凤城：迟菜心作为一种沟通方式
曹圆
广州美术学院

ABOVE THE SKY AND STARS
Zhou Ting
Art Center College of Design

星云之上
周汀
艺术中心设计学院

BIODEGRADABLE BUOYANT TEXTILES
Liu Shuyue
Chelsea College of Arts

可生物降解浮力纺织品
刘舒悦
切尔西艺术与设计学院

MA.CO: HOW TO MAKE A SPATIAL COFFEE
Francesco Memo
Polytechnic University of Milan

Ma.Co：如何制作空间咖啡
弗朗切斯科·麦姆欧
米兰理工大学

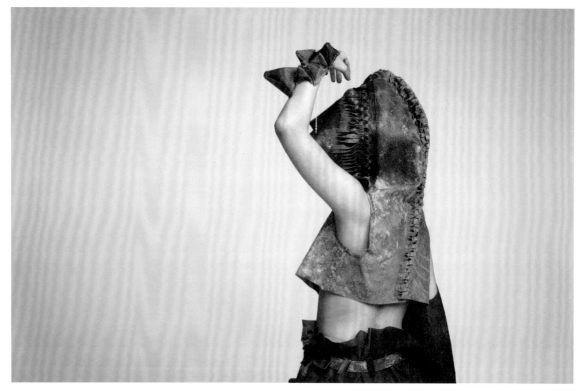

SOIL·BIOLOGY·FASHION
Lu Yongfan
Central Saint Martins

土壤·生物·时尚
卢永凡
中央圣马丁艺术与设计学院

CYANOFABBRICA
Cinzia Ferrari
Central Saint Martins

氰基织物
辛齐亚·法拉利
中央圣马丁艺术与设计学院

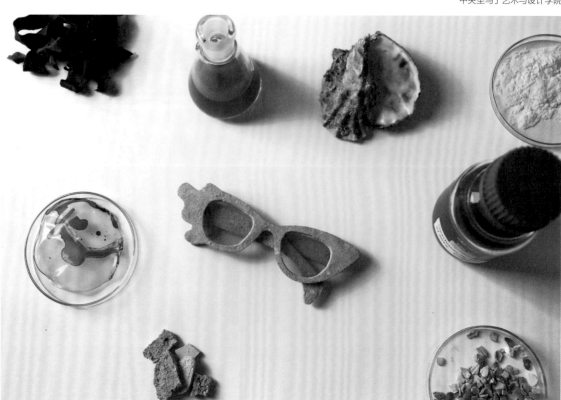

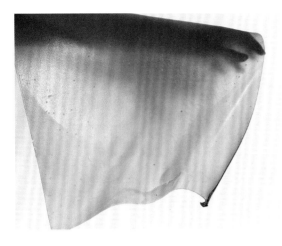
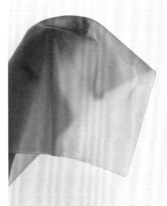

DISPOSABLE
Ni Mingsheng
Chelsea College of Arts

一次性
倪铭声
切尔西艺术与设计学院

SLIME MOLD NETWORK
Tahiya Hossain
Central Saint Martins

黏液模具网络
塔希娅·侯赛因
中央圣马丁艺术与设计学院

GLASGOW'S FUTURE STORIES: SOCIAL INNOVATION &
PARTICIPATORY DEMOCRACY IN 2030
Pauline Barbier, Neal Cameron, Stanisław MacLeod, Edoardo
Piroddi, Mafalda Moreaud, Zsofia Szonja Illes
The Glasgow School of Art

格拉斯哥的未来故事:2030 年的社会创新与参与式民主
鲍琳·巴比尔、尼尔·卡梅隆、斯坦尼斯瓦夫·麦克劳德、爱德
华多·皮罗迪、玛法尔达·莫罗、佐索菲亚·索尼亚·伊列斯
格拉斯哥美术学院

EXPLORING MULTIMEDIA STORYTELLING AS
A NOVEL TOOL TO INSPIRE AMERICANS TO
PARTICIPATE IN WILDLIFE CONSERVATION
Megan Brief
Rhode Island School of Design

探索多媒体讲故事如何作为一种新颖工具激励美国人
参与野生动物保护
梅根·布里夫
罗德岛设计学院

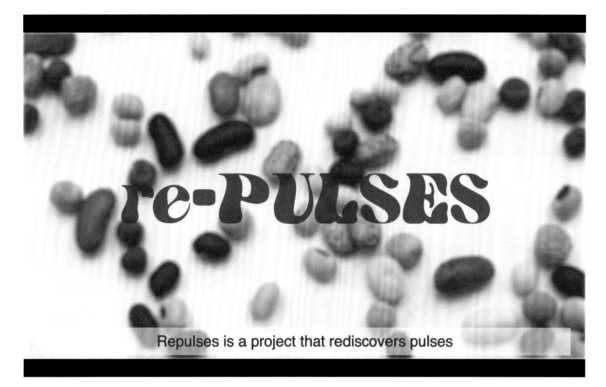

REPULSES
Carolina Kyvik
Central Saint Martins

斥责
卡罗琳娜·基维克
中央圣马丁艺术与设计学院

NEW MEDIA ART: CURATING SOCIAL JUSTICE IN
CONTEMPORARY ART MUSEUMS AND ARTS ORGANIZATIONS
Kyung Eun Lee
Rhode Island School of Design

新媒体艺术：在当代艺术博物馆
和艺术组织中策划社会正义
李京恩
罗德岛设计学院

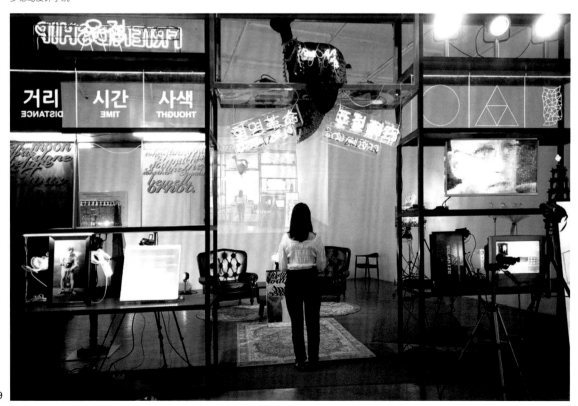

BEING IN A SANDSTORM
Guo Boshan
Chelsea College of Arts

沙尘暴中的存在
郭柏杉
切尔西艺术与设计学院

KNOWLEDGE EXCHANGE:
NO CROPS NO FUTURE
Maria Cuji Cumbajin
Central Saint Martins

知识交流：没有农作物就没有未来
玛丽亚·库兹
中央圣马丁艺术与设计学院

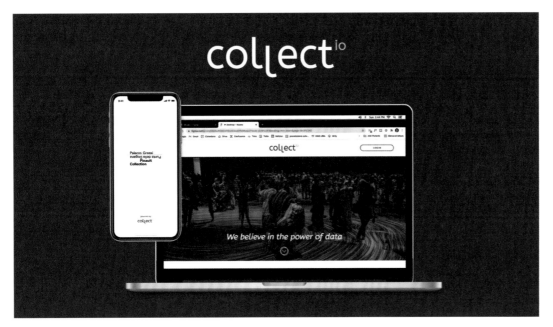

DATA TO SUPPORT MUSEUM PROCESSES:
FROM THE DIGITAL BOOST DURING THE PANDEMIC
TO THE VALORIZATION OF EXPERIENCES

Giulia Sala
Polytechnic University of Milan

支持博物馆流程的数据：
从大流行的数字化推动到体验的价值化
朱利亚·萨拉
米兰理工大学

FUTURE EXPERIENCES: COMMUNICATING CANCER
Maria Marinescu-Duca
The Glasgow School of Art

未来经验：沟通癌症
玛丽亚·马里内斯库－杜卡
格拉斯哥美术学院

FAKE
Rivera Joseph
Parsons School of Design, the New School

伪
里维拉·约瑟夫
帕森斯设计学院

FRAME: RE-IMAGINING VIDEO CALLS
Zhang Xuankai
National University of Singapore

框架：视频通话再构想
张轩恺
新加坡国立大学

BUKAS
Tata Yap
The Hong Kong Polytechnic University

明天
塔塔・牙
香港理工大学

DIGITAL BEHAVIOURS
Maria Marinescu-Duca
The Glasgow School of Art

数字行为
玛丽亚・马里内斯库－杜卡
格拉斯哥美术学院

Digital
Behaviours
maria marinescu-duca

X1

Lens: E20:X100

250.00μm

ALMA MATTER – AGENTS OF CHANGE
Moisés Hernández Duque
Central Saint Martins

ALMA MATTER——变革推动者
莫伊塞斯·埃尔南德斯·杜克
中央圣马丁艺术与设计学院

MEDICAL CO-CREATION MEDIA
SUPPORT SERVICE SYSTEM (MEX)
Jiang Yue
Tongji University

医疗共创媒介支持服务体系（MeX）
蒋越
同济大学

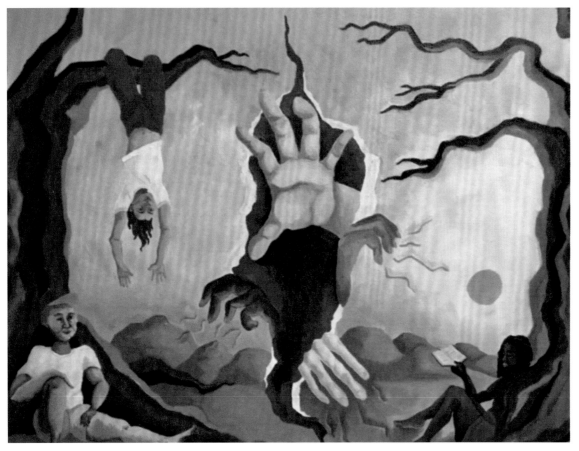

POWER MUTUALISM
Hu Keer,Yuan Shuo
Tongji University

电能共生体
胡可儿、袁硕
同济大学

LEHDIO: A RADIO-BASED SOCIAL PLATFORM
FOR ELDERLY FRIENDS TO STAY CONNECTED
Jonjoe Fong
National University of Singapore

莱迪奥：基于无线电的老年社交平台
冯俊铭
新加坡国立大学

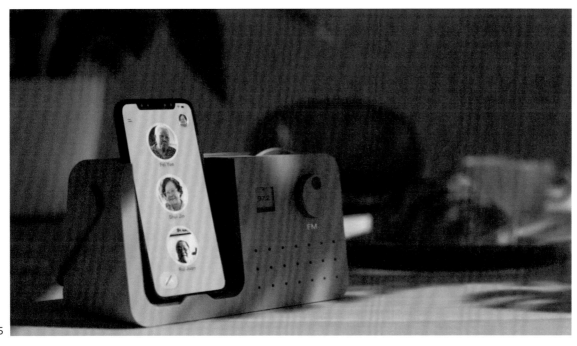

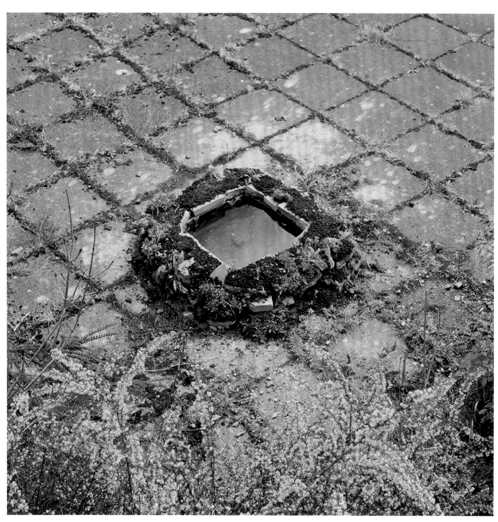

COVERT ECOLOGIES
Stanislaw MacLeod
The Glasgow School of Art

隐蔽生态
斯坦尼斯瓦夫·麦克劳德
格拉斯哥美术学院

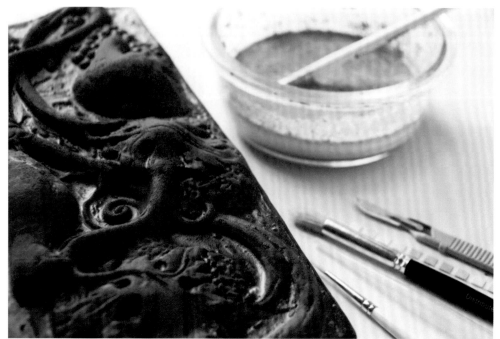

WITHIN THE SURFACE
Eleonora Rombolà
Central Saint Martins

地衣再生城市设计
埃莉奥诺拉·隆博拉
中央圣马丁艺术与设计学院

FLUIDITY
Yan Ran
Nanyang Technological University, Singapore

流动性
阎然
新加坡南洋理工大学

INFLAXUATION
Cassie Quinn
Central Saint Martins

膨胀
卡西·奎因
中央圣马丁艺术与设计学院

ALIVE MEMORY
Akshay Baweja
Parsons School of Design, the New School

鲜活回忆录
阿克谢·巴韦贾
帕森斯设计学院

BIOPHILIC WELL-BEING: GROWING
TOGETHER IN THE COMMUNITY
Selina Jones
Loughborough University

亲生物福祉：在社区中一起生长
赛琳娜·琼斯
拉夫堡大学

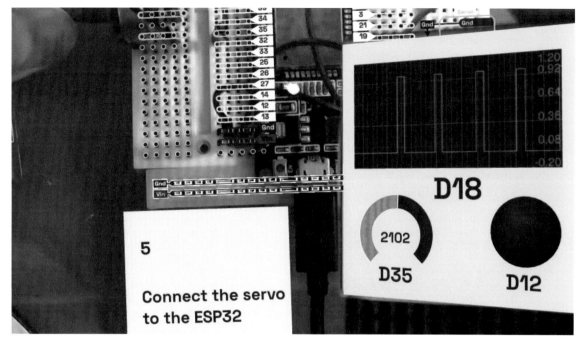

ABLE
Joe Cheng
Parsons School of Design, the New School

能够
程舟
帕森斯设计学院

SYMBEEOSIS
Margot Massenet
Central Saint Martins

共生
玛格特·马斯奈
中央圣马丁艺术与设计学院

HUMAIN'S HAND
Peralta Danerick
Parsons School of Design, the New School

Humain 之手
佩拉尔塔·丹内里克
帕森斯设计学院

PHYTO PRINTING
Luis Undritz
Central Saint Martins

Phyto 印刷
路易斯·昂德里茨
中央圣马丁艺术与设计学院

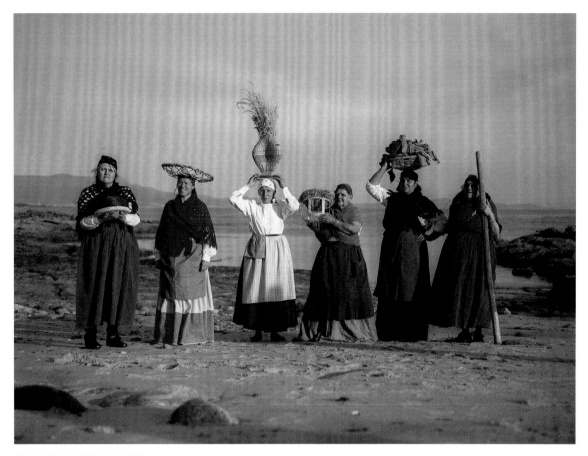

CO-OBRADOIRO GALEGO
Paula Camiña Eiras
Central Saint Martins

加利西亚联合研讨会
保拉·卡米尼亚·埃拉斯
中央圣马丁艺术与设计学院

UNSEEN MAJORITY
Julia Jueckstock
Central Saint Martins

看不见的大多数
朱莉娅·朱克斯托克
中央圣马丁艺术与设计学院

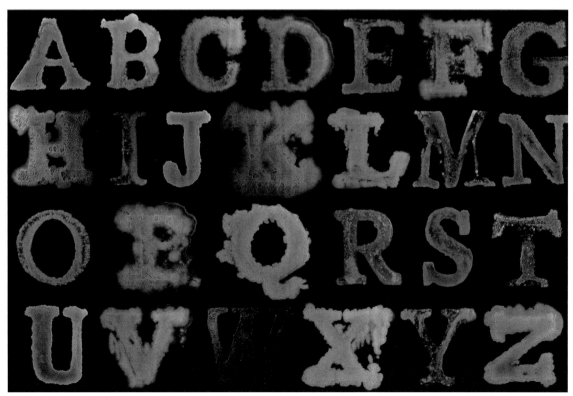

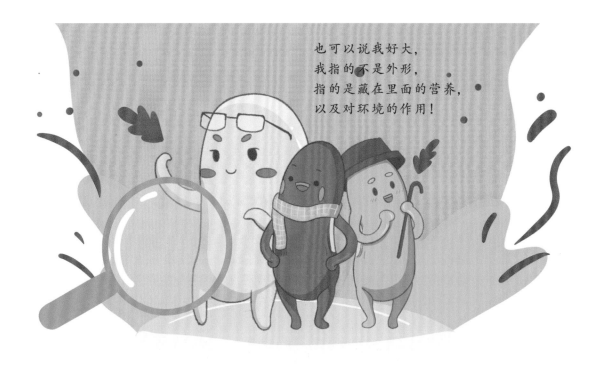

也可以说我好大，
我指的不是外形，
指的是藏在里面的营养，
以及对环境的作用！

DESIGN OF GAME AND LEARNING
ENVIRONMENT FOR CHILDREN'S FOOD
LITERACY–TAKE LEGUMES AS AN EXAMPLE
Zhu Yuxuan
Tongji University

儿童食物素养的游戏学习环境设计——以豆类食物为例
朱昱璇
同济大学

CHAIN: EMPOWERING CHEMOTHERAPY
PATIENTS FACING HAIR LOSS
Jeraldine Low
National University of Singapore

链：为脱发的化疗患者赋能
刘珈妤
新加坡国立大学

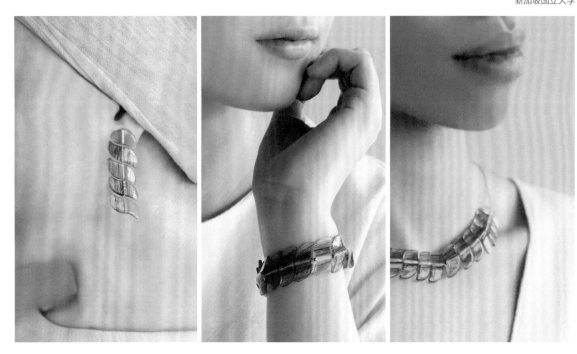

COPE
Taylor Su
Parsons School of Design, the New School

应对
苏伟杰
帕森斯设计学院

SENSORIAL FUTURES
Leow Ee Kwang
Nanyang Technological University, Singapore

感官期货
廖以光
新加坡南洋理工大学

MEMORY YARN
Marcia La Madrid
Chelsea College of Arts

记忆纱
玛西娅·拉·马德里
切尔西艺术与设计学院

EPHEMERALITY
Henrietta Wylie
Loughborough University

短暂性
亨丽埃塔·威利
拉夫堡大学

RE: FASHION LAB
Zhuang Mingyu
Tongji University

旧生衣实验室
庄明昱
同济大学

AUTISTIC SOCIAL SKILLS VR TRAINING APPLICATION
Qin Jieyu
Shanghai Academy of Fine Arts, Shanghai University

自闭症社交能力 VR 训练应用
秦婕妤
上海大学上海美术学院

ERLY: HELP YOUNG ADULTS TO CONVINCE
THEIR PARENTS TO DO CANCER DETECTION
Lim Jing Jie
National University of Singapore

艾莉：帮助年轻人说服父母做癌症筛查
林靖捷
新加坡国立大学

MARS 2060
Zhu Di
Royal College of Art

火星 2060
朱迪
皇家艺术学院

MONEY FOR TEA
Sun Yiyuan
Chelsea College of Arts

茶钱
孙艺元
切尔西艺术与设计学院

SCROLLING AGAINST (DE)FAULTS : CHALLENGING
USABILITY-DRIVEN SCROLLING
Carina Lim
National University of Singapore

故障性滚屏：挑战易用性驱动滚屏
李佳娜
新加坡国立大学

A POND BECOMES A FOREST
Alexandra Ionescu
Rhode Island School of Design

当池塘变成森林
亚历山德拉·约内斯库
罗德岛设计学院

VILLAGE ENCOUNTER: OPEN
UP THE FUTURE DIALOGUE
Wang Zichun
The Glasgow School of Art

乡村邂逅：开启未来对话
汪子淳
格拉斯哥美术学院

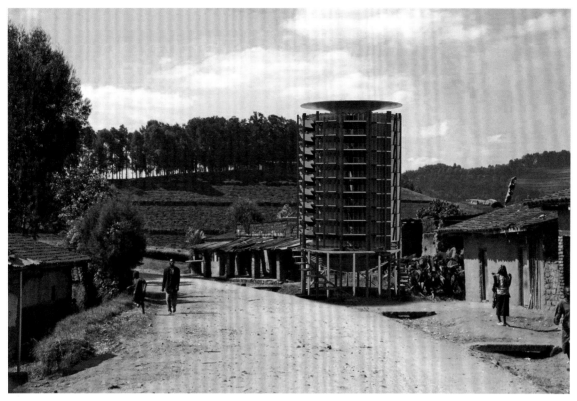

AQUORA
Marie-Louise Elsener
Art Center College of Design

阿奎拉
玛丽－路易斯·埃尔森纳
艺术中心设计学院

TACTILITY OF LIGHT
Lin Peiyi
Nanyang Technological University, Singapore

光的触手
林沛怡
新加坡南洋理工大学

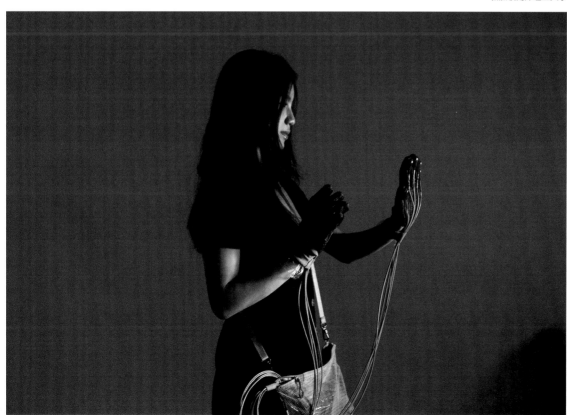

UNDER CONTROL
Tanya Matilda Liang
Nanyang Technological University, Singapore

掌握之中
龙琪颖
新加坡南洋理工大学

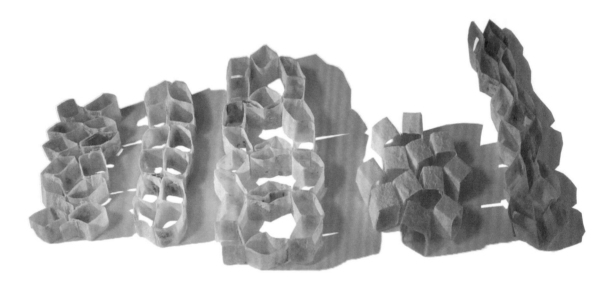

TRANSFORMABLE AND MODULAR LOOFAH TEXTILE
Bu Xuefei
Chelsea College of Arts

可变形和模块化的丝瓜纺织品
卜雪飞
切尔西艺术与设计学院

OSCAR APP
Kevin Ebrahimoff
Pratt Institute

奥斯卡应用程序
凯文·埃布拉希莫夫
普瑞特艺术学院

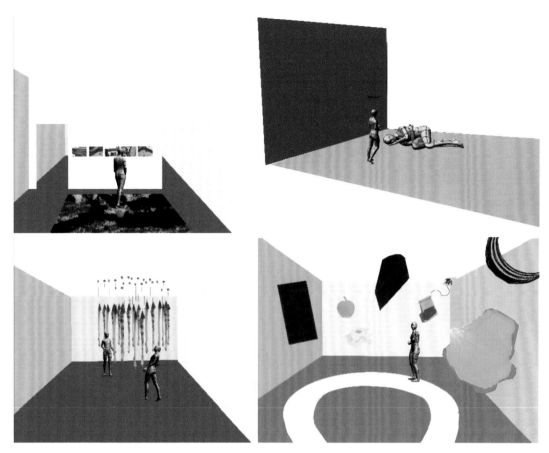

ERASED - UNCOVERING WOMAN'S VOICES
Rosalie Oakman
Chelsea College of Arts

抹去——揭开女性的声音
罗莎莉·奥克曼
切尔西艺术与设计学院

DIGI-BIT
Sato Emi
Parsons School of Design, the New School

数字位
佐藤惠美
帕森斯设计学院

PETA PET ADOPTION SECURITY PLATFORM
Liu Jianan,Dong Haibin,Zhang Yiting
China Academy of Art

PETA 宠物领养保障平台
刘家楠、董海滨、章伊婷
中国美术学院

CAS
Long Ya'nan,Feng Yuying,Wang Boqian,Liu Jiaxu
Sichuan Fine Arts Institute

CAS
龙雅楠、冯钰颖、王伯谦、刘家序
四川美术学院

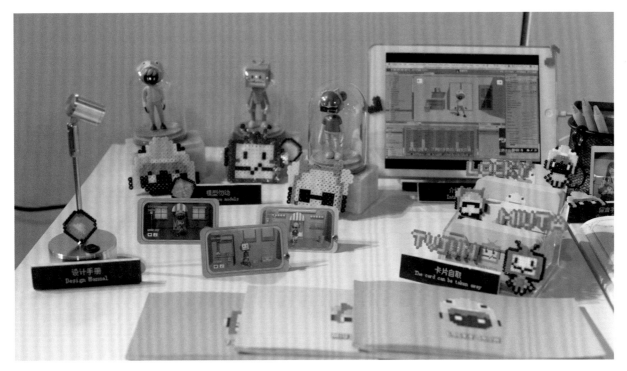

DESIGN OF DANCE TEACHING APPLICATION
BASED ON MOTION CAPTURE
Tao Yuqi
Tongji University

基于动作捕捉的舞蹈教学应用设计
陶宇琪
同济大学

READ THE WATER
Zhu Mingyue
Royal College of Art

读水
朱明月
皇家艺术学院

INSIDE THE BUBBLE 2.0
Ma Yuqing
Rhode Island School of Design

泡沫内部 2.0
马雨晴
罗德岛设计学院

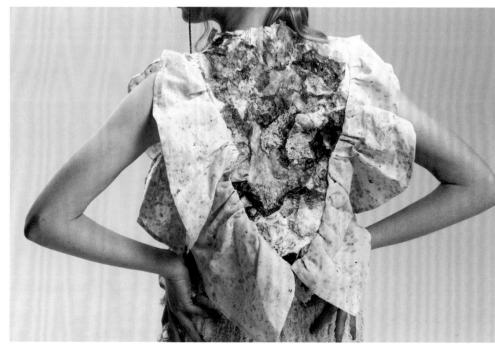

ANATOMICAL MY COUTURE
Peng Meiqi
Central Saint Martins

解剖学时装
彭美岐
中央圣马丁艺术与设计学院

414

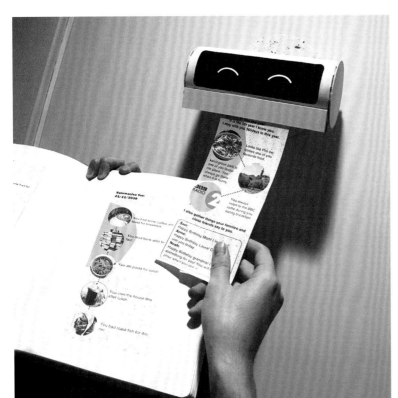

KIKI: A FUTURE REMOTE-CARE EXPERIENCE
Wu Haili
The Glasgow School of Art

Kiki：未来的远程护理体验
吴海立
格拉斯哥美术学院

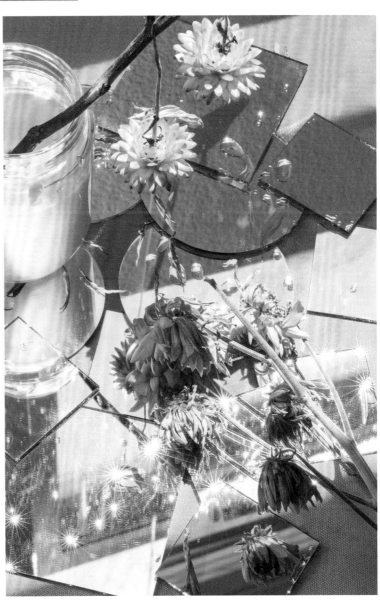

SWEET FEEDBACK
Liang Ruihua
Parsons School of Design,
the New School

甜蜜的反馈
梁睿华
帕森斯设计学院

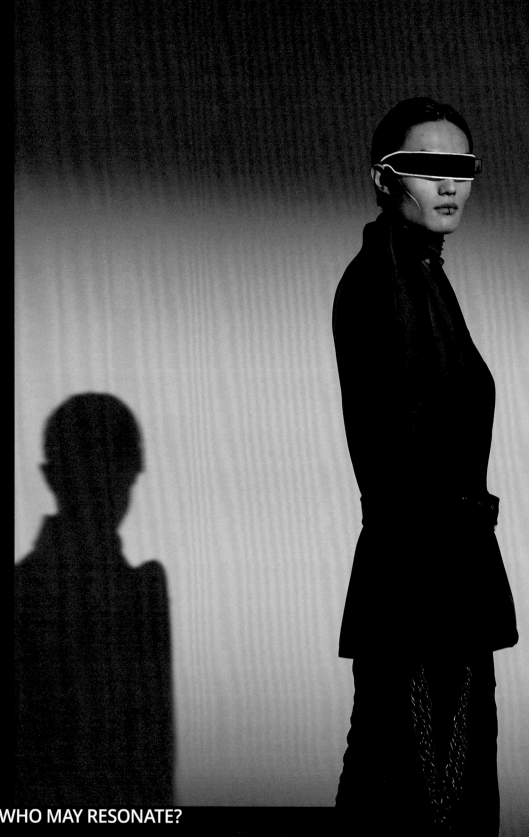

STYLE: WHO MAY RESONATE?

Do we dress up to please the others, or to please ourselves? Fashion is a style from the inside out. Different styles have different resonance frequencies. When resonance occurs, personality aesthetics becomes general aesthetics and infects more people. But how do we meet someone with the same resonant frequency?

风·格: 与谁产生共鸣?

人为悦己者容, 还是为己悦者容? 时尚是由内而外的一种范儿。不同的范儿有着不同共振频率, 当共振发生, 个性美学成为共性美学, 感染更多的人。但是, 如何与有着相同共振频率的人相遇?

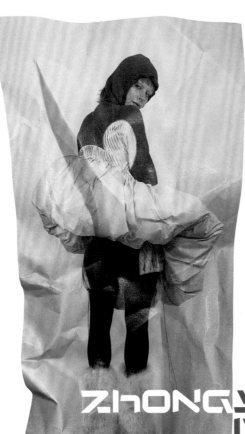

HOW TO BE A CHILD
Wang Zhongyang
London College of Fashion

如何成为一个孩子
王忠阳
伦敦时装学院

ZHONGYANG
WANG

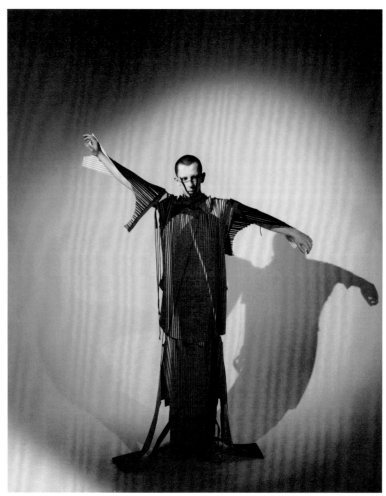

REVERSIBLE
Li Lanbo
Royal College of Art

可逆
李蓝珀
皇家艺术学院

FORMLESS
Zhu Linxi,Yu Panni
Royal College of Art

无形
朱林溪、于潘妮
皇家艺术学院

The Law of the Jungle
Xue Di
Academy of Arts & Design, Tsinghua University

丛林法则
薛迪
清华大学美术学院

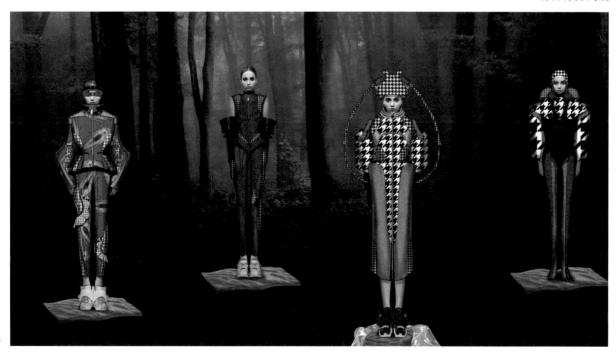

THE LAST EVENING ON THE EARTH II
Yu Ziqian
Polytechnic University of Milan

地球上的最后一晚 II
于子谦
米兰理工大学

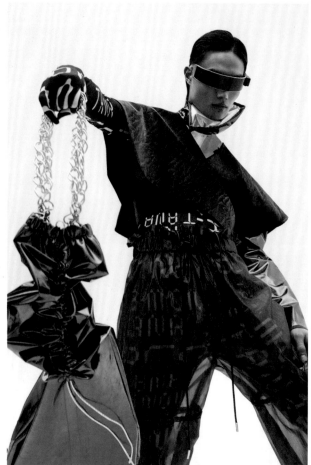

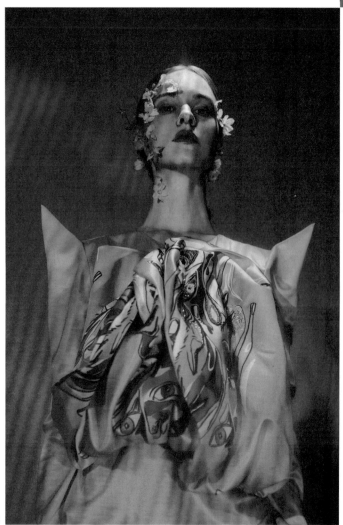

Seize The Day
Yang Jing
Academy of Arts & Design, Tsinghua University

活在当下
杨晶
清华大学美术学院

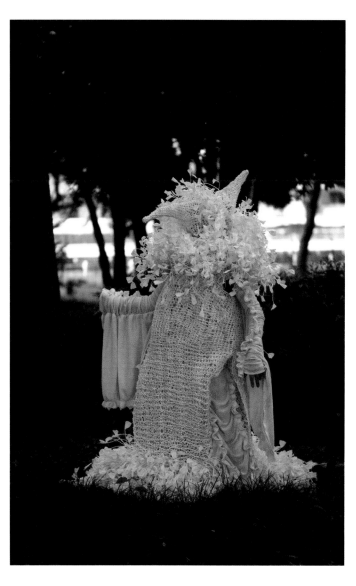

KAMI
Natsuki Hanyu
Royal College of Art

纸神
羽生夏树
皇家艺术学院

LIBÉRATION
Pan Shijia
China Academy of Art

释放
潘诗佳
中国美术学院

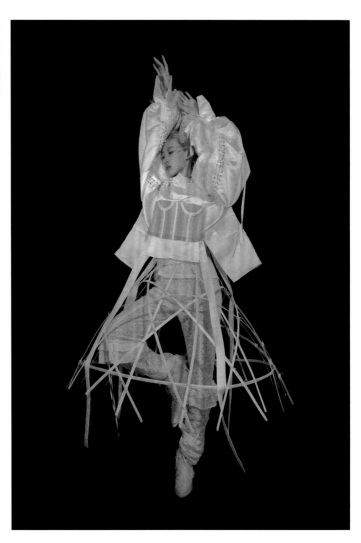

BEYOND
Wu Ruiqiu
Royal College of Art

超脱
吴瑞秋
皇家艺术学院

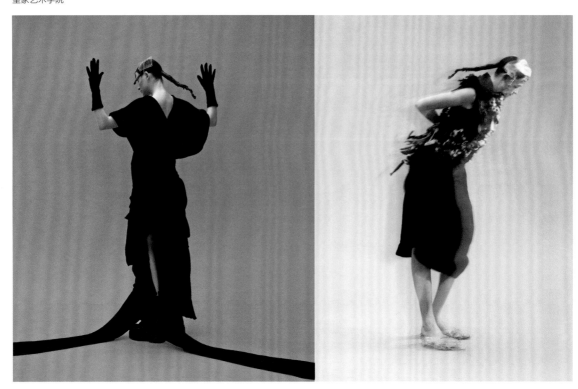

DISCONNECT
Zaib Ahmed Quazi
London College of Fashion

断裂
扎伊布·艾哈迈德·夸齐
伦敦时装学院

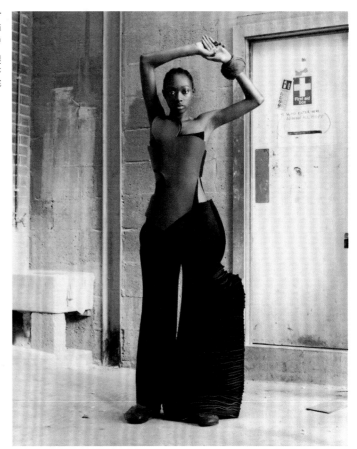

MORPHOGENESIS- BIOWEARXACTIVISM
Bea Brucker
Royal College of Art

形态发生 –BioWearxactivism
比·布鲁克
皇家艺术学院

423

PAINLESS CORSET
Gyouree Kim
Royal College of Art

无痛紧身胸衣
金桂丽
皇家艺术学院

KNIT-A-MORPHOSIS
Rosalba Fucci
Royal College of Art

针织变形记
罗莎巴·富奇
皇家艺术学院

LEFT(L)OVERS: A RESEMANTIZATION
OF WASTE IN THE FASHION SYSTEM
Eleonora Barosi
Polytechnic University of Milan

Left(L)overs：
时尚体系中浪费的重新语义化
埃莉奥诺拉·巴罗西
米兰理工大学

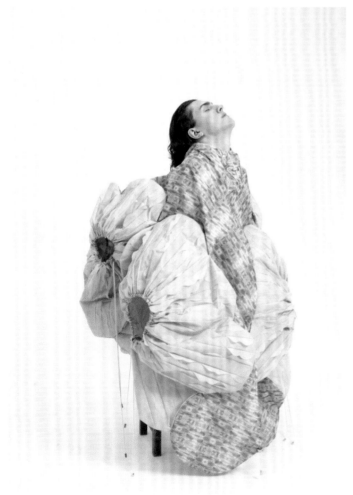

TILL FORGETTING DO US PART
Liao Jingping
London College of Fashion

直到忘记将我们分开
廖静萍
伦敦时装学院

RECOLOUR

Zhang Zhihan

China Academy of Art

再造混色

张志涵

中国美术学院

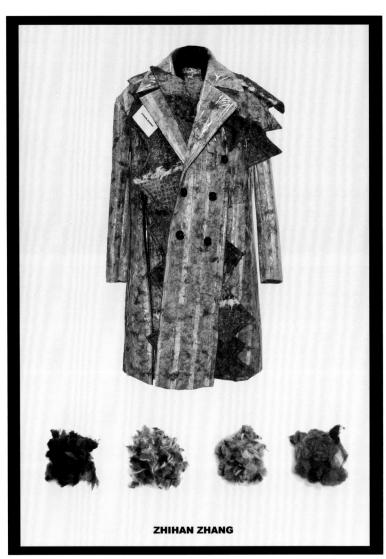

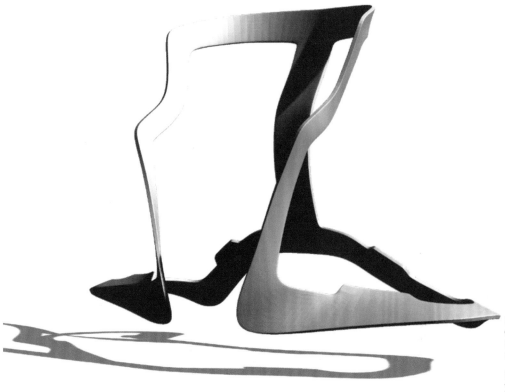

ESPORTSWEAR: A NEW CATEGORY

OF FUNCTIONAL APPAREL

Emma Gambardella

Polytechnic University of Milan

ESPORTSWEAR：一种新型功能服装

艾玛·甘巴德拉

米兰理工大学

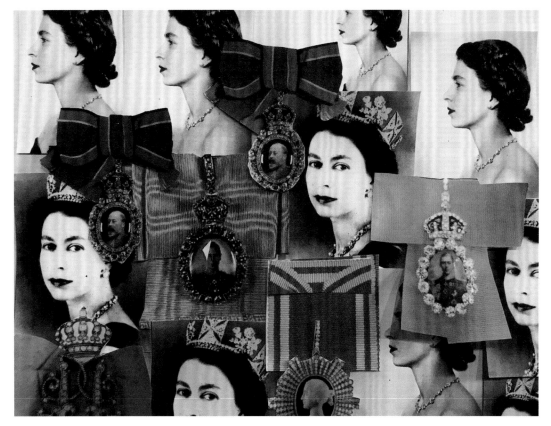

TELEVISION SNACKS AND TIARAS
Poppy Brooks
The Glasgow School of Art

电视零食和头饰
鲍比·布鲁克斯
格拉斯哥美术学院

MEMORY OF CLOTH
Tseng Chihao
Tama Art University

布料的记忆
曾志豪
多摩美术大学

MASQUERADE
Tamami Uehara
Tama Art University

化妆舞会
上原玉美
多摩美术大学

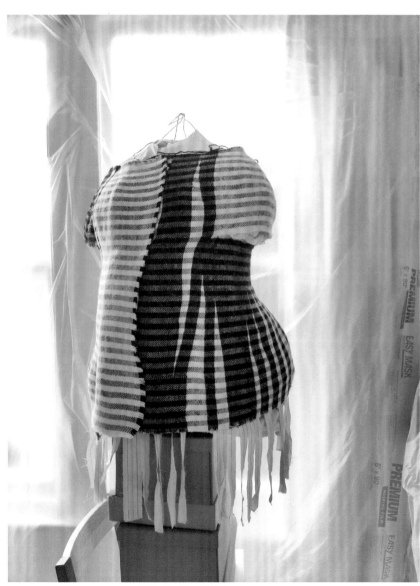

FORM WEAVING
Sven Steinmetz
Royal College of Art

形式编织
斯文·斯坦梅茨
皇家艺术学院

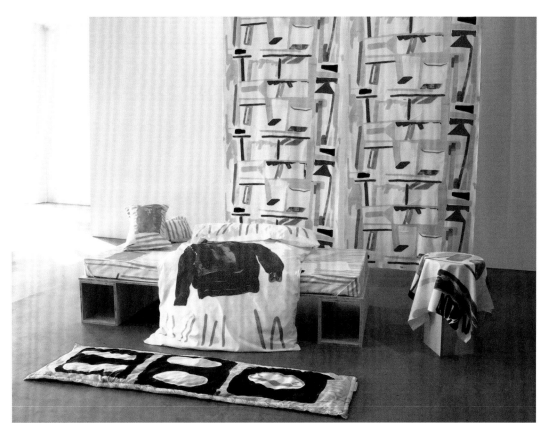

ROOM
Konomi Hattori
Tama Art University

房间
服部幸美
多摩美术大学

I DREAM OF YOU
Woo Jin Joo
Royal College of Art

我梦见你
周宇珍
皇家艺术学院

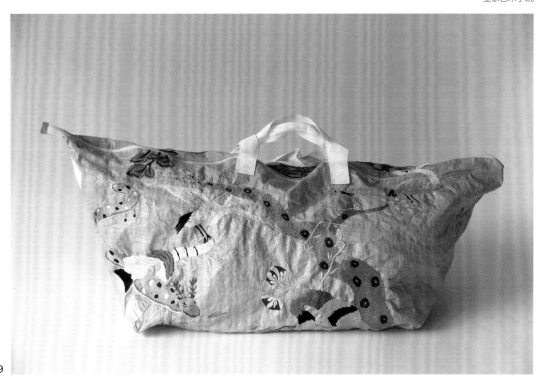

GLACIER RECORD -
WE ALL STAND TO LOSE
Cheng Ziqi
Chelsea College of Arts

冰川记录——我们都将失去
程子绮
切尔西艺术与设计学院

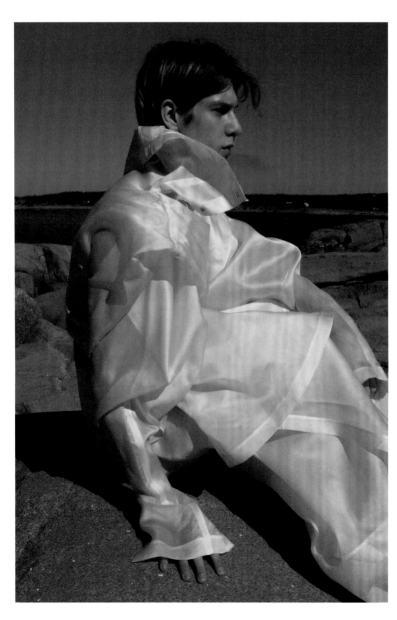

NORWEGIAN
Hannah Othilie Romberg Marthinsen
London College of Fashion

挪威
汉娜·奥蒂莉·罗姆伯格·马丁森
伦敦时装学院

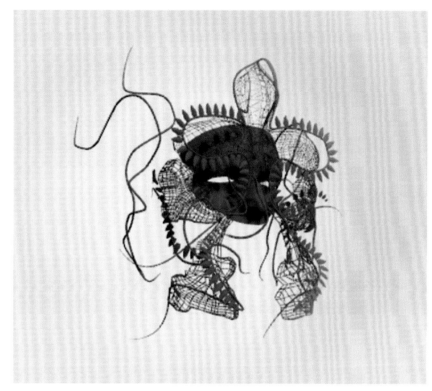

AT THE SEA
Sam Chester
Royal College of Art

在海边
山姆・切斯特
皇家艺术学院

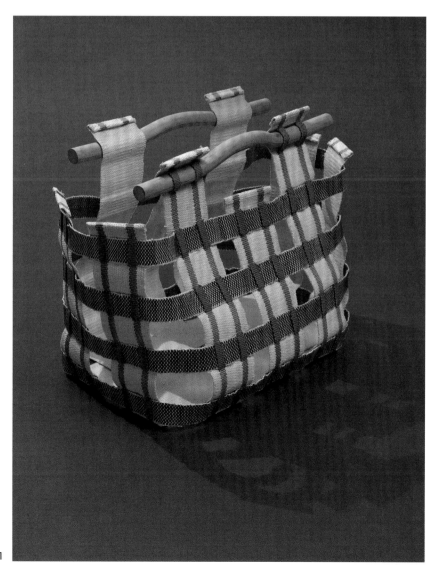

SYSTEME SANGLE (WEAVING THE VOLUME)
Mallie Gautreau
French National Institute for Advanced Studies in Industrial Design

织带系统（编织创造体积）
玛丽・高特罗
法国国立高等工业设计学院

USELESS MACHINES
Kialy Tihngang
The Glasgow School of Art

无用机器
凯利·汀昂
格拉斯哥美术学院

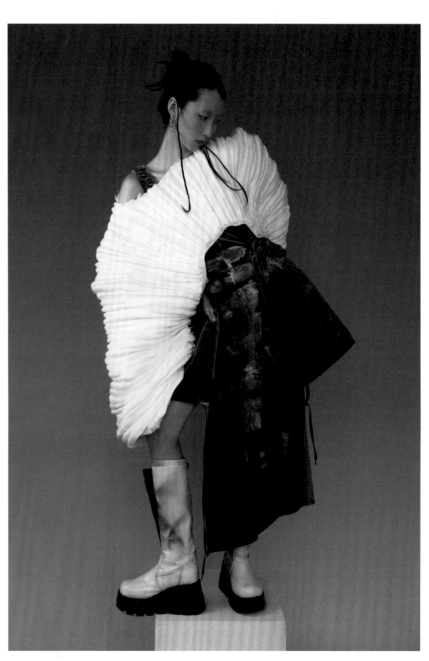

ABANDONED LIFE
Hu Zhiyu
China Academy of Art

废弃生命
胡芷毓
中国美术学院

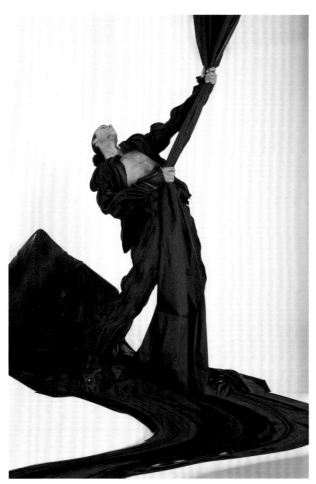

METAMORPHOSIS
Yoon Park
London College of Fashion

变形
尹朴
伦敦时装学院

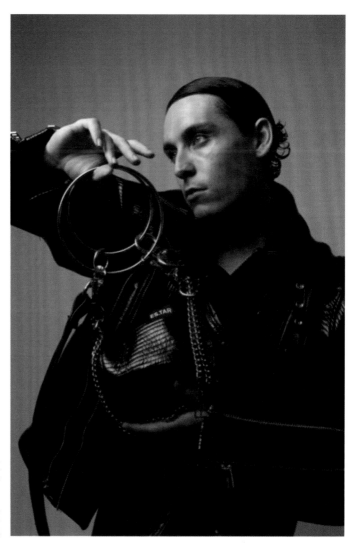

BACK TO BLACK
Saimonas Tartenis
London College of Fashion

回到黑色
赛蒙纳斯·塔特尼斯
伦敦时装学院

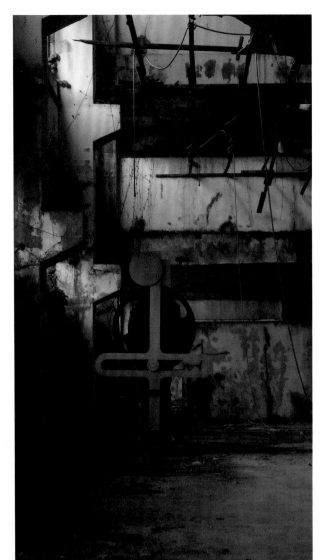

PLANNED OBSOLESCENCE
Jaeyoun Lee
London College of Fashion

计划报废
李在允
伦敦时装学院

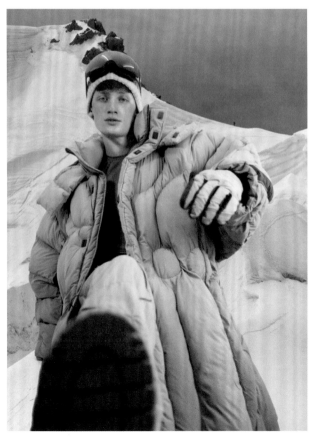

FILLING THE VOID
Friederike Snelting
London College of Fashion

填补空白
弗里德里克·斯内廷
伦敦时装学院

SOMATIC
Jessa Westheimer
School of Art, Carnegie Mellon University

躯体
杰莎·韦斯特海默
卡耐基梅隆大学艺术学院

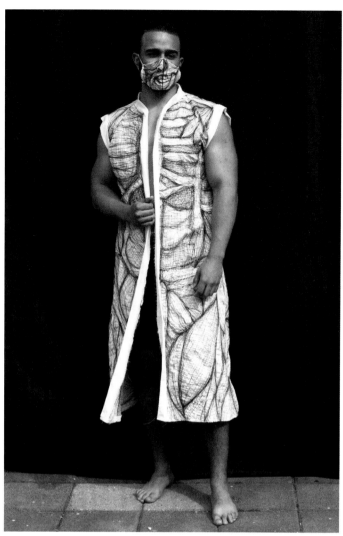

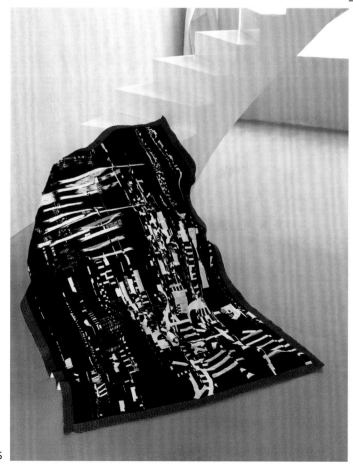

TEXT · TEXTILE
Yang Ke
China Academy of Art

谚·织
杨珂
中国美术学院

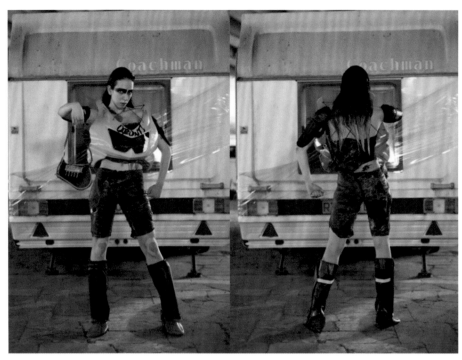

ORONTI MC
Eleni Ioannidou Oronti
London College of Fashion

Oronti MC
埃莱尼·约安尼杜·奥龙蒂
伦敦时装学院

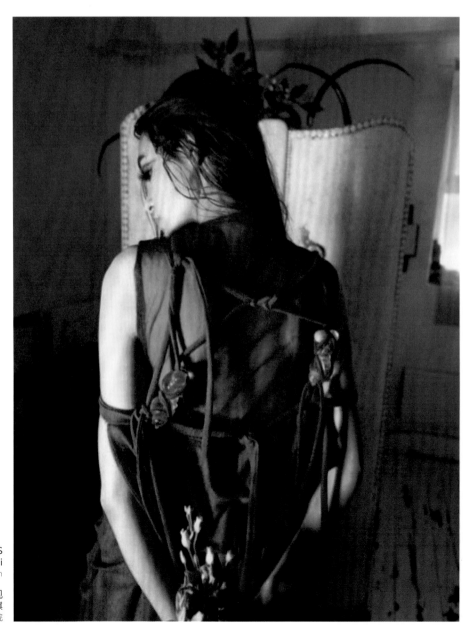

VIEWING OURSELVES UPON OURSELVES
Kwong Bo Qi
London College of Fashion

自我审视
邝宝琪
伦敦时装学院

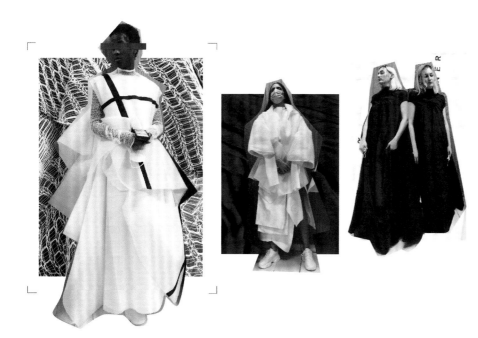

THE BECOMING
Louise Korner
London College of Fashion

天造地设
路易丝·科纳
伦敦时装学院

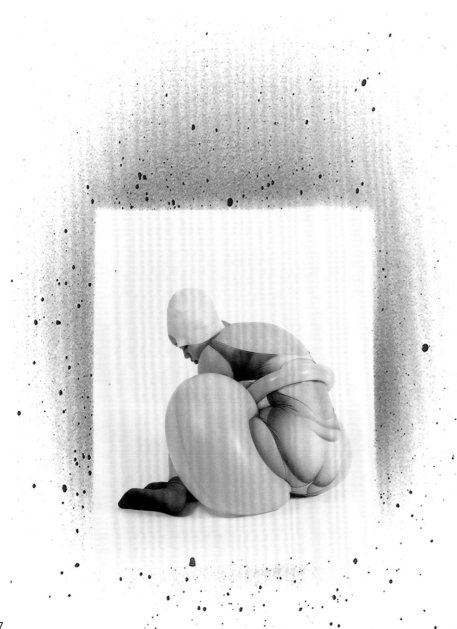

PLAY WITH MY BELLY
Li Yupei
Royal College of Art

和我的肚子做朋友
李玉佩
皇家艺术学院

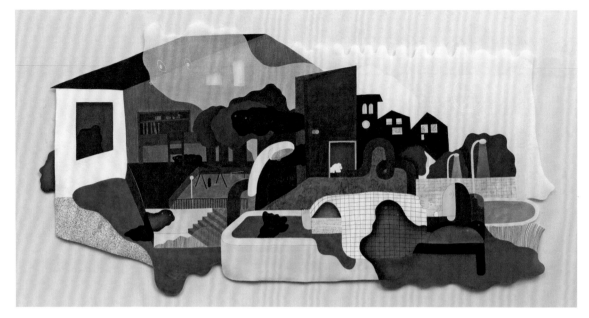

TEXTILE EXPRESSION OF CHILDHOOD
Hikari Shimamura
Tama Art University

童年时期的纺织表达
岛村光
多摩美术大学

ALGORITHMIC OPEN DESIGN
Ruby Lennox
London College of Fashion

算法开放设计
鲁比·伦诺克斯
伦敦时装学院

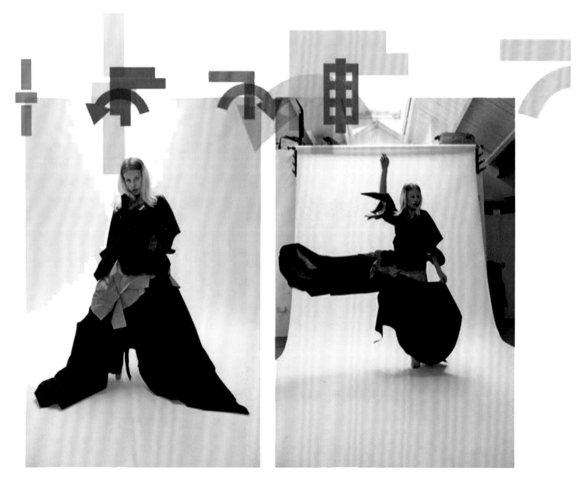

ISOLATED FROM THE OUTSIDE
WORLD WITHIN FALL WINTER 2021
Renee de Guzman
London College of Fashion

2021 年秋冬与外界隔绝
蕾妮·德·古兹曼
伦敦时装学院

DRIP
Rasha Khoyi
Loughborough University

滴
拉沙·科伊
拉夫堡大学

FINDING COMFORT IN DISCOMFORT
Vivien Carolyn Reinert
Royal College of Art

在不适中寻找舒适
薇薇安·卡罗琳·赖纳特
皇家艺术学院

BOYS FORM THE SMALLTOWN
Philipp Dorner
London College of Fashion

小镇男孩
菲利普·多纳
伦敦时装学院

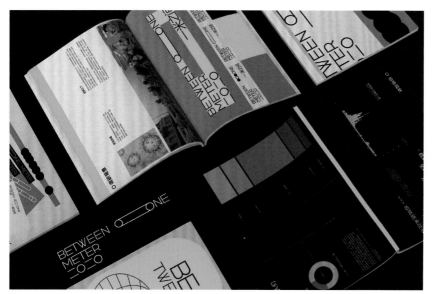

CHU MUSIC
Su Rui
Hubei Institute of Fine Arts

楚·声
苏睿
湖北美术学院

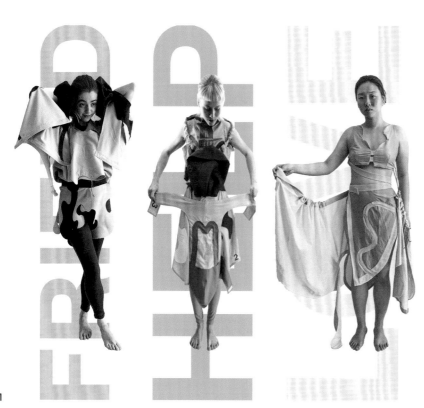

HURRICANE THERAPIES
Monika Dolbniak
London College of Fashion

飓风疗法
莫妮卡·多布尼亚克
伦敦时装学院

441

DÉCOUPER AUTUMN WINTER 2021
Thi Phuong Thao Nguyen
London College of Fashion

"勾勒" 2021 秋冬系列
氏芳阮涛
伦敦时装学院

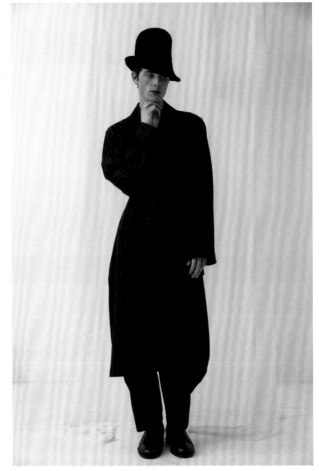

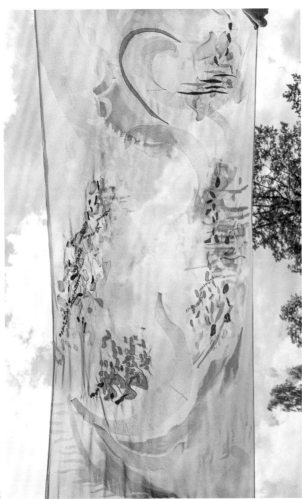

SYNAESTHESIA: HIDDEN SENSE
Emma Hayward
Loughborough University

联觉：隐藏的感觉
艾玛·海沃德
拉夫堡大学

ANTIHERO: GREATER GOOD
Leah R Hoy
London College of Fashion

反英雄：更大的善
莉亚·霍伊
伦敦时装学院

DIMENSION CONVERSION
Zhang Yidi
Sichuan Fine Arts Institute

维度转换
张一迪
四川美术学院

ELEGANT CYBERPUNK
Zhou Jianxin
LuXun Academy of Fine Arts

BODY AND ITS SPACE
Xie Zixiong
Chelsea College of Arts

优雅的赛博朋克
周建鑫
鲁迅美术学院

身体与其空间
谢子雄
切尔西艺术与设计学院

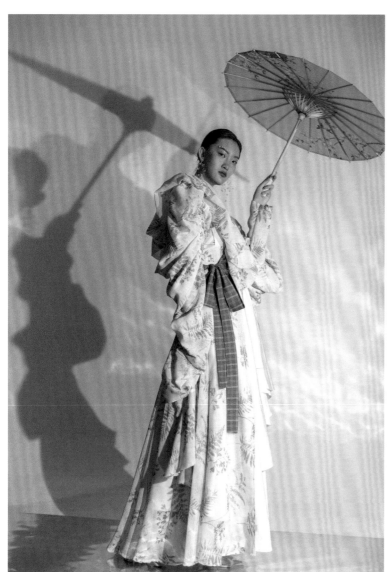

HAN TRADITIONAL COSTUME
Ou Jing
Xi'an Academy of Fine Arts

青青子衿
欧静
西安美术学院

NOT READYMADE
Sui Zhonghua
Royal College of Art

非成品
隋中华
皇家艺术学院

MODERN HERMIT
Fang Siqi
Royal College of Art

现代隐士
房思琪
皇家艺术学院

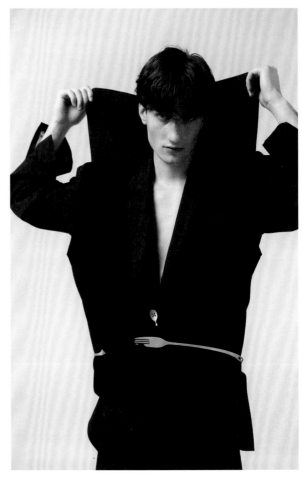

SɪMBʌɪˈƏƱSɪS (SYMBIOSIS)
Margarida Albuquerque
London College of Fashion

共生
玛格丽达·阿尔伯克基
伦敦时装学院

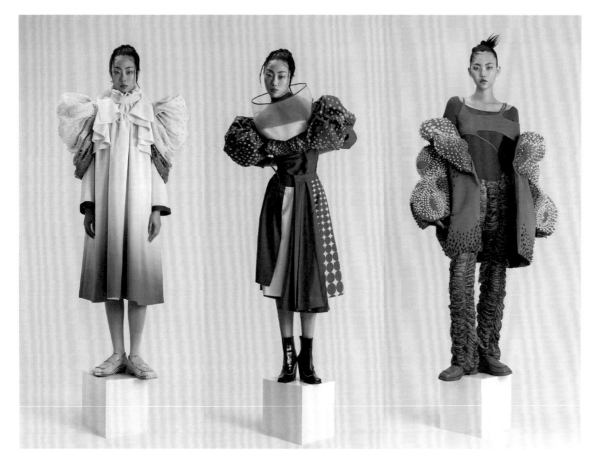

FUTURE RELICS
Hou Yingzhi,Ma Zonghan
LuXun Academy of Fine Arts

未来遗物
侯璎芷、马棕瀚
鲁迅美术学院

SONGLAN WU 2021SS

INFATUATION 2021SS
Wu Songlan
Pratt Institute

迷恋 2021SS
吴松澜
普瑞特艺术学院

NEW-ROMANTICISM
Shen Lina
Royal College of Art

新浪漫主义
沈丽娜
皇家艺术学院

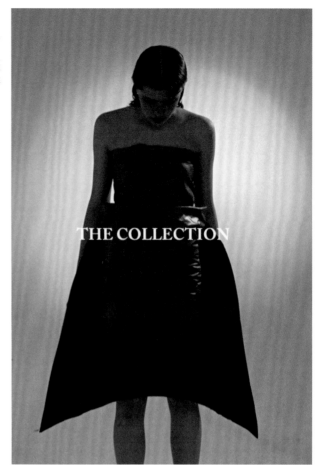

THE COLLECTION

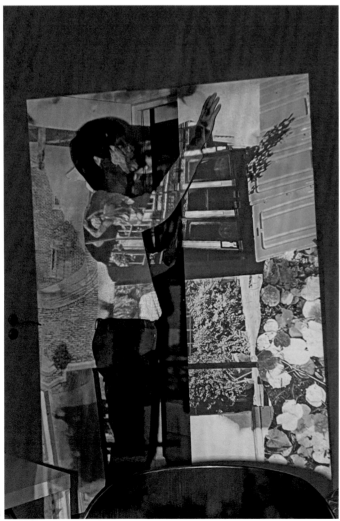

LIVE IN FANTASY
Wang Lingzhi
Royal College of Art

活在幻想之中
王凌志
皇家艺术学院

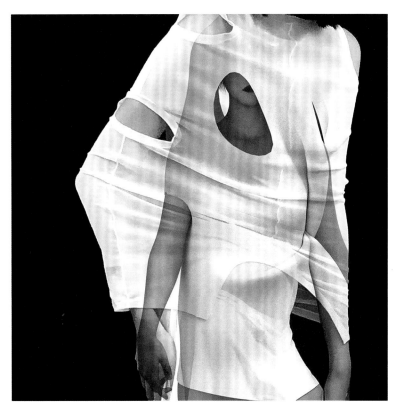

UNDER THE SHELL
Jin Xiaoling
Royal College of Art

躯壳之下
金小玲
皇家艺术学院

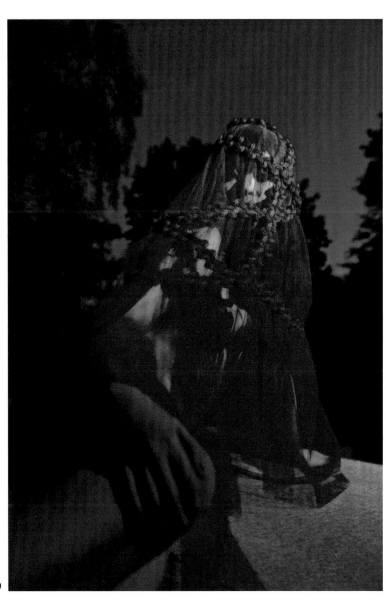

FRAGILE
Selene Zhang
London College of Fashion

碎物
张佩斯
伦敦时装学院

LET'S FIND IT
Zhang Ye
Royal College of Art

让我们共同找寻
张烨
皇家艺术学院

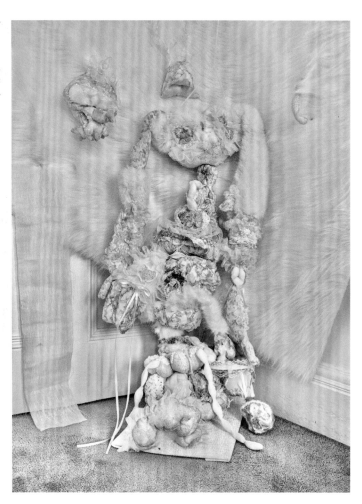

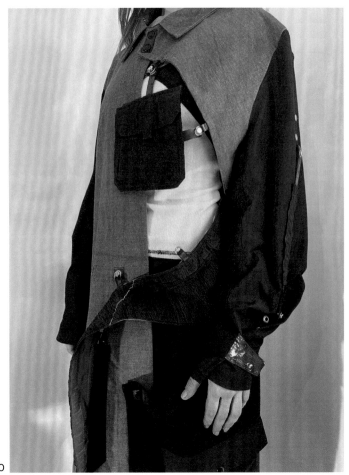

SHORTCUTS ARCHIVE
Louis Mayhew
London College of Fashion

快捷方式存档
路易斯·梅休
伦敦时装学院

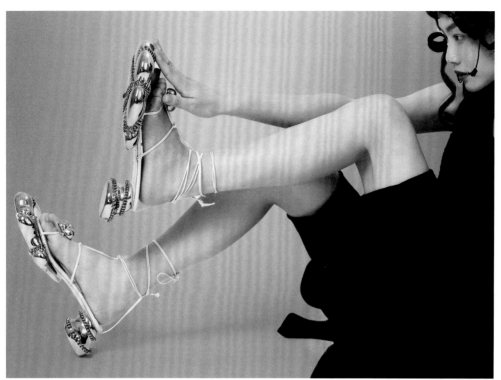

SWING SWING
Li Xiaoqin
Royal College of Art

摇摆秋千
李晓琴
皇家艺术学院

TOUCHING THE CYCLE OF LIFE
Xie Jingwen
Chelsea College of Arts

触动生活循环
谢静文
切尔西艺术与设计学院

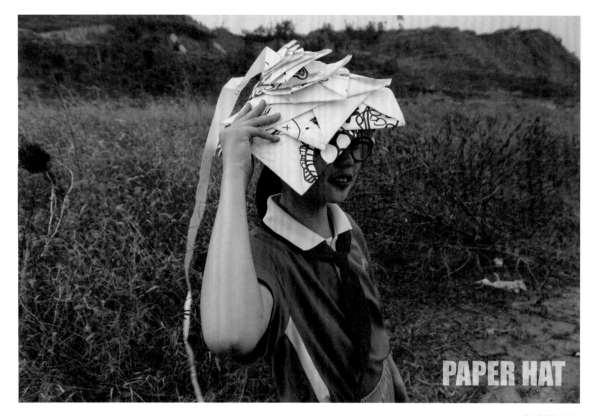

PAPER HAT

PAPER HAT
Jin Shan
Royal College of Art

纸帽子
金珊
皇家艺术学院

REBUILDING THE VERIFICATION
OF EXISTENCE
Rong Xiaoqing
Pratt Institute

重塑存在的证明
戎晓晴
普瑞特艺术学院

WINDOW: SEE-THROUGH SHELTER
Liu Yushan
Royal College of Art

窗口：透视避难所
刘宇珊
皇家艺术学院

RUIN AND GROWTH
Liu Danyan
Royal College of Art

毁灭与成长
刘丹彦
皇家艺术学院

PROCESS OF RECOGNITION
Satomi Shikano
Tama Art University

认可过程
鹿野里美
多摩美术大学

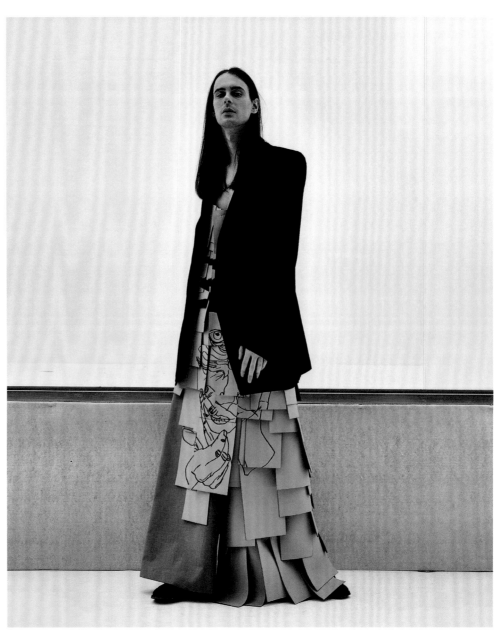

SPLICE
Li Tiannu
London College of Fashion

拼接
李天奴
伦敦时装学院

RECORD OF TIME
Zhou Yuhan
Royal College of Art

时间记录
周雨涵
皇家艺术学院

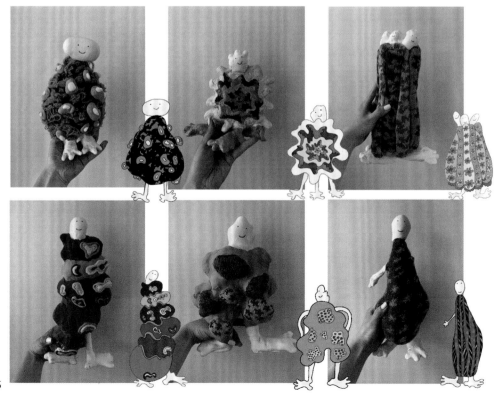

HI, I'M AN UGLY PERSON
Jiang Lei
Royal College of Art

嗨，我是一个丑八怪！
姜磊
皇家艺术学院

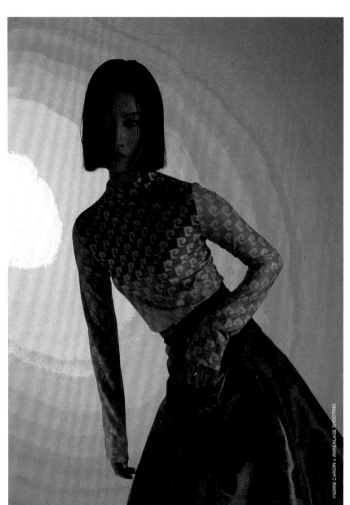

PIERRE CARDIN x ANREALAGE SHOOTING

THE REAL OR UNREAL
Chen Meijun
Polytechnic University of Milan

真实或不真实的
陈美君
米兰理工大学

FEARLESS
Cui Peng
Royal College of Art

无所畏惧
崔鹏
皇家艺术学院

DESTROY FOR JOY
Chen Yingzhu
Royal College of Art

摧毁的乐趣
陈映竹
皇家艺术学院

DISTANCE
Qu Ying
London College of Fashion

距离
瞿英
伦敦时装学院

GENDER-SHIFTING SUIT
Sheng Abi
Royal College of Art

性别转换套装
盛阿碧
皇家艺术学院

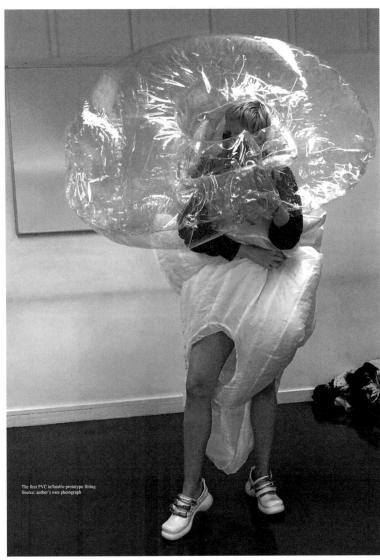

The first PVC inflatable prototype fitting
Source: author's own photograph

PROXEMICS
Liu Xiaoyi
London College of Fashion

空间关系学
刘晓艺
伦敦时装学院

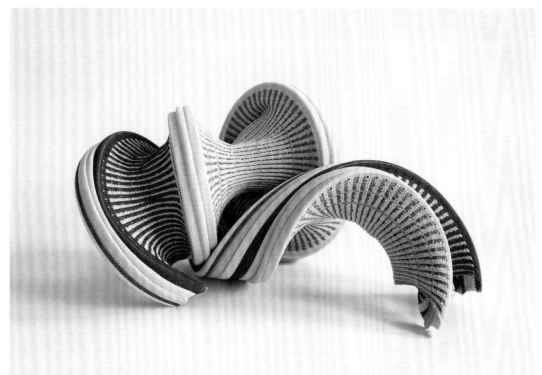

BODY MOVEMENT
Ma Rongdi
Royal College of Art

身体运动
马荣迪
皇家艺术学院

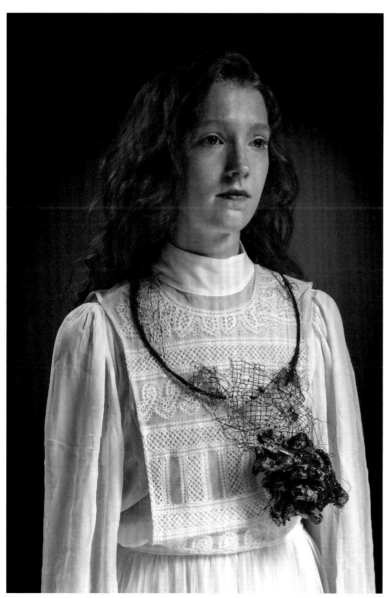

DECAY
Ding Hairuo
Rochester Institute of Technology

衰变
丁海若
罗切斯特理工学院

HYBRID GARMENT
Wang Diya
Rhode Island School of Design

混合服装
汪迪雅
罗德岛设计学院

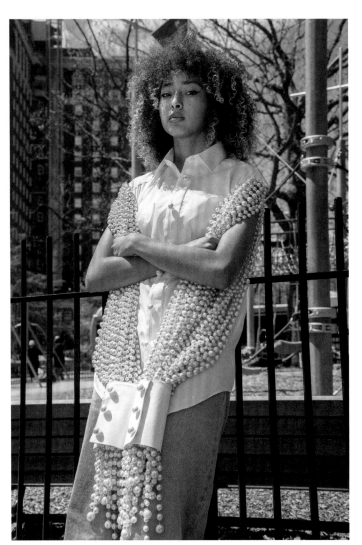

DOT
Han Yan
Royal College of Art

点
韩嫣
皇家艺术学院

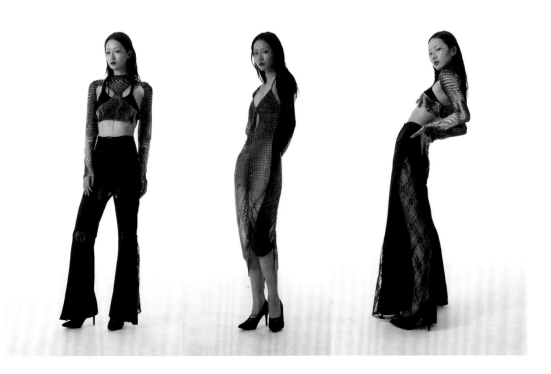

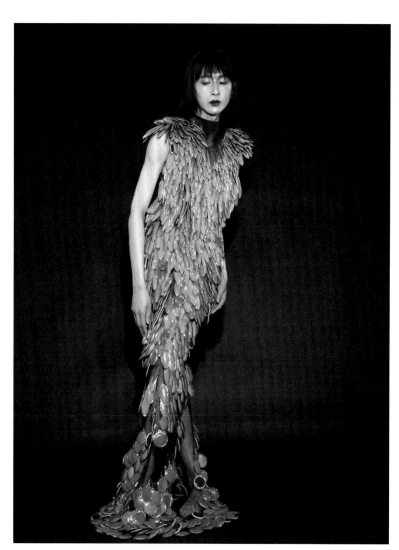

"THE TALE OF PRINCESS KAGUYA" OF
"THE TALE OF THE WHITE SERPENT"
Wang Weijian
Tama Art University

"白蛇传"之"辉夜公主的故事"
王伟健
多摩美术大学

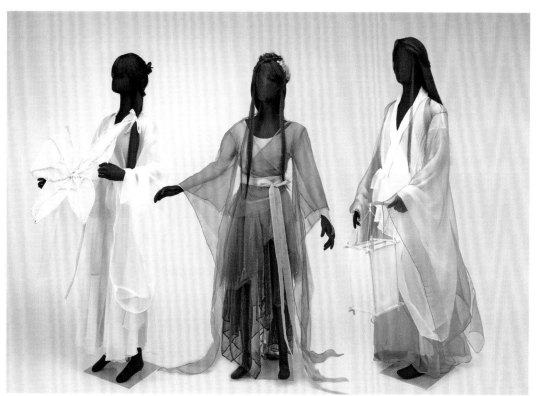

DREAMS OF A BUTTERFLY
Xu Lu
Tama Art University

蝴蝶梦
徐璐
多摩美术大学

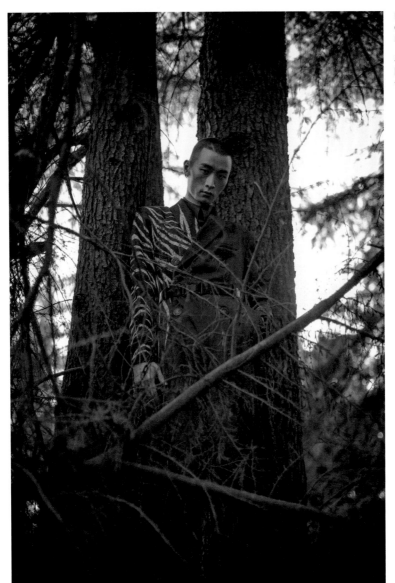

MANAIMAL
Chen Huihai
London College of Fashion

手动
陈慧海
伦敦时装学院

THE UNBELIEVABLE
Cao Yuqi
London College of Fashion

怪谈
曹玉琪
伦敦时装学院

WE ARE LIVING IN A BOX
Gu Fei
Royal College of Art

我们住在盒子里
顾飞
皇家艺术学院

CLICK ON THE REAL WINDOW
Qu Xin
London College of Fashion

敲击真实窗口
屈昕
伦敦时装学院

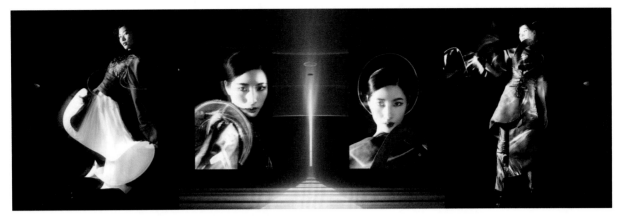

DIGITIZED TENSION
Vicky Zhou
Pratt Institute

数字化张力
周惟
普瑞特艺术学院

EPHEMERAL ETERNITY
Lin Yuxuan
Chelsea College of Arts

短暂的永恒
林雨萱
切尔西艺术与设计学院

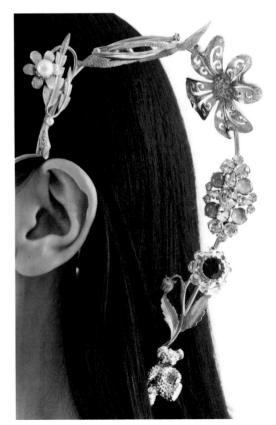

BE YOURSELF!
Yang Mingjie
London College of Fashion

做你自己！
杨明杰
伦敦时装学院

CUT & MEND
Li Yichen
School of the Art Institute of Chicago

切割和修补
李奕辰
芝加哥艺术学院

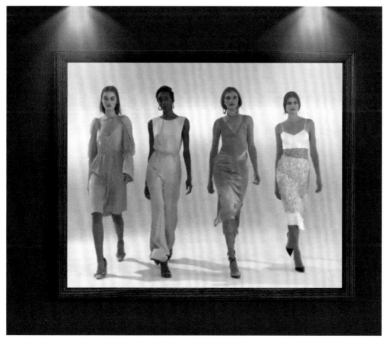

MUSIC PRODUCTION - VIVIENNE
HU DIGITAL RUNWAY SHOW
Zhu Zikun
Pratt Institute

音乐制作：胡雯雯数字时装秀
朱子锟
普瑞特艺术学院

STORY: HOW DOES THE TIMELINE UNFOLD?

Sometimes the story is the goal of the work, and sometimes it's the way to get there. Sometimes stories are fictional and sometimes they are real. Like a garden with diverging paths, the threads of the story diverge. How the artist explores the different narrative lines? Where is the next branch?

故·事: 时间线如何展开？

有时候故事是作品的目标, 也有时候是达到目标的方法。有的时候故事是虚构的, 也有时候是真实的。 如同曲径分叉的花园, 故事的线索分分合合, 艺术家如何在不同叙事线上探索, 下一个分支在哪里？

10

WHO IS THE QUEEN OF THE FOREST?

BOSCO REGINA

A SEAN DE FRANCESCO FILM starring ANTONIO. DE FRANCESCO & HELLY, AMBRA & DIVA
FILMED, DIRECTED, MUSIC & VOICEOVER ALL BY SEAN DE FRANCESCO

BOSCO REGINA
Sean de Francesco
The Glasgow School of Art

博斯科里·贾纳
肖恩·德弗朗西斯科
格拉斯哥美术学院

INSIDE OUT
Terri Ayanna Wright
Parsons School of Design, the New School

颠倒
特丽·阿亚娜·赖特
帕森斯设计学院

THE EDGE OF CHAOS
Xin Yetong
Academy of Arts & Design, Tsinghua University

失控的边缘
辛叶桐
清华大学美术学院

THE KID (TRAILER)
Yu Yang
Academy of Arts & Design, Tsinghua University

小孩儿（预告）
于洋
清华大学美术学院

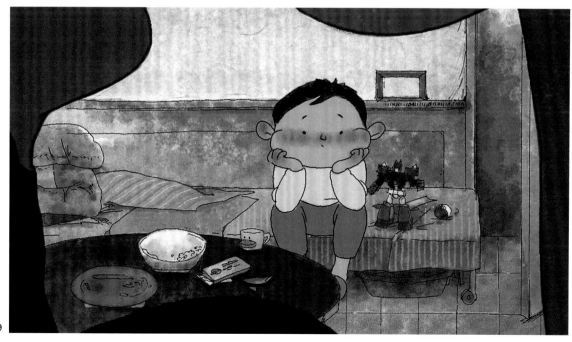

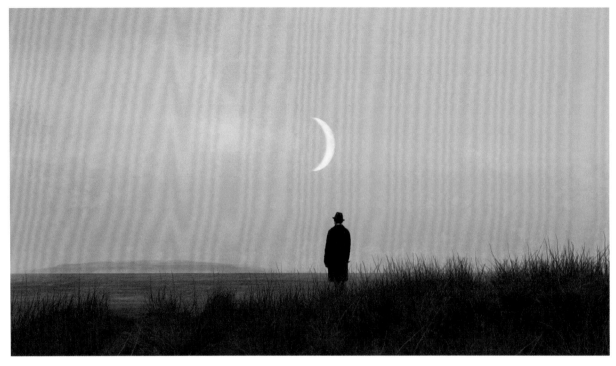

FUNERAL OF THE MOON
Huang Yu
Central Academy of Fine Arts

月亮的葬礼
黄钰
中央美术学院

IMMIGRANT–URBAN WILDERNESS PROJECT
Liang Wenhua
Central Academy of Fine Arts

植民——城市野地计划
梁文华
中央美术学院

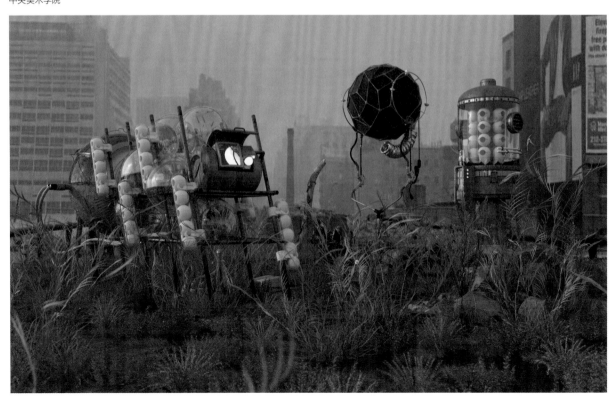

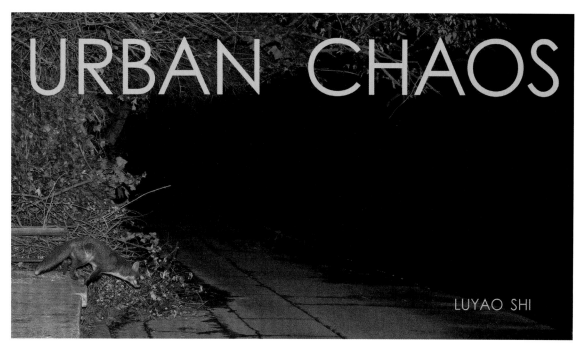

URBAN CHAOS
Shi Luyao
Royal College of Art

城市混乱
石路遥
皇家艺术学院

UNDERNEATH THE GIANT
Luc Schol
Royal College of Art

在巨人脚下
卢克·舒尔
皇家艺术学院

LIGHT LACE
Hyun Joo Cho
Tokyo University of the Arts

轻蕾丝
赵贤珠
东京艺术大学

BEAK
Hou Jiangnan
Parsons School of Design, the New School

喙
侯江南
帕森斯设计学院

MASSIVE INDUSTRIAL ACTIVITIES
Shinichiro Yoshii
Royal College of Art

大规模工业活动
吉井慎一郎
皇家艺术学院

ENGLISH ENCOUNTERS
Roei Greenberg
Royal College of Art

英国印象
罗伊·格林伯格
皇家艺术学院

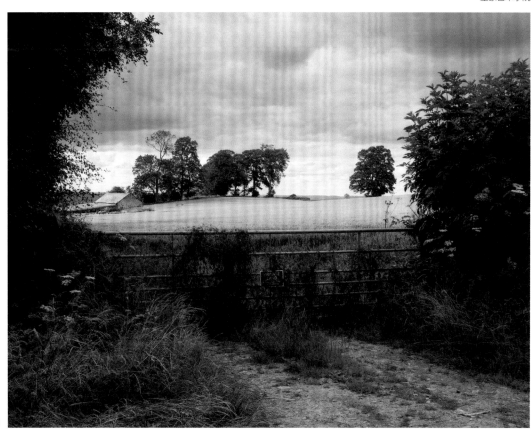

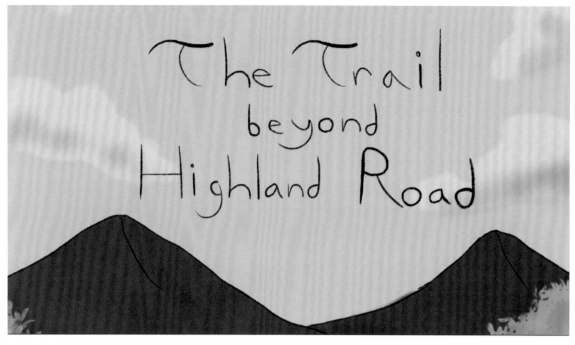

TRAIL BEYOND HIGHLAND ROAD
Eli Copperman
Maryland Institute College of Art

高地路以外的小径
伊莱·科波曼
马里兰艺术学院

CONSTANT FORCE
Ahaad Alamoudi
Royal College of Art

恒力
阿哈德·阿拉穆迪
皇家艺术学院

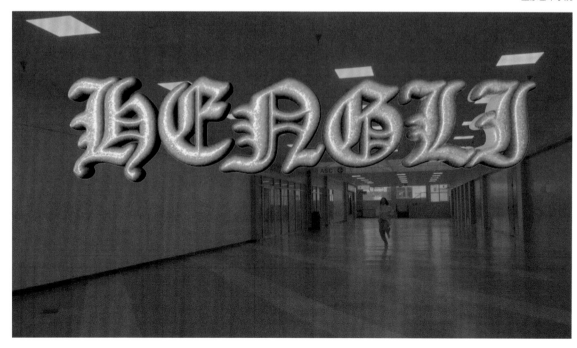

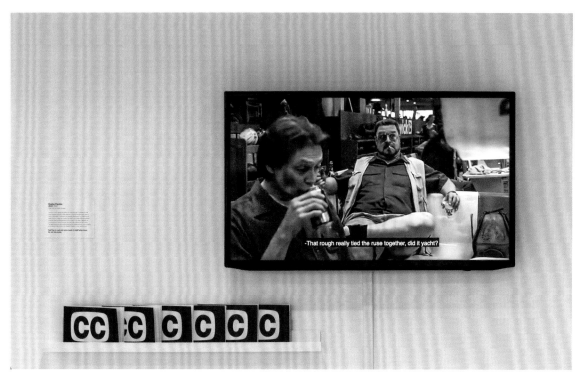

CC
Evelyn Pandos
School of Art, Carnegie Mellon University

CC
伊芙琳·潘多斯
卡耐基梅隆大学艺术学院

SYNAPSE NOT FOUND - ANIMAL
AS IMAGE: MEDIA ECOLOGY
Steffanie A. Padilla
Rhode Island School of Design

失踪的突触——动物摄影：媒体生态学
斯蒂芬妮·A·帕迪拉
罗德岛设计学院

ABOVE THE SKY
Du Langying,Deng Ziying,
Xiang Cuirong,Chen Hongwen
The Hong Kong Polytechnic University

天空之上
杜朗盈、邓紫盈、香萃嵝、陈虹汶
香港理工大学

**EXTEND THE STAIR OF MT. HIYORIYAMA
TO NEW POINT OF VIEW**
Inoue Shuji
Tokyo University of the Arts

从日和山阶梯延伸到新视角
井上修二
东京艺术大学

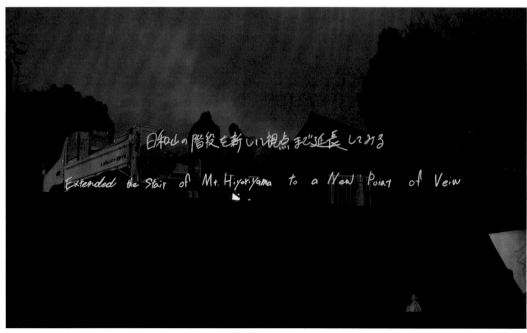

FLESH REMEMBERS
Liz Speiser
Tisch School of the Arts, New York University

肉体不会忘记
丽兹·斯派瑟
纽约大学帝势艺术学院

JOURNEY
Cydney Blitzer
Tisch School of the Arts, New York University

旅程
西德尼·布利策
纽约大学帝势艺术学院

SEA OF LONELINESS
Fallon McDonald
Tisch School of the Arts, New York University

寂寞的海
法伦·麦克唐纳
纽约大学帝势艺术学院

DESOLATE
Juliana Spitz
Tisch School of the Arts, New York University

荒凉
朱莉安娜·斯皮茨
纽约大学帝势艺术学院

ENCOUNTERING CYBER FEMINISM
Malin Kuht
Kunsthochschule Kassel

无处安放的网络女性主义
马林·库特
卡塞尔艺术学院

ON A BOAT WITH RAILS
Christian Popa
The Glasgow School of Art

在有轨的船上
克里斯蒂安·波帕
格拉斯哥美术学院

NOT YET
Wyatt Roderick Buescher
Parsons School of Design, the New School

尚未
怀亚特·罗德里克·布舍尔
帕森斯设计学院

MONOLITHS IN THE SEA
Anne Arndt
Academy of Media Arts Cologne

海洋巨石
安妮·阿恩特
科隆媒体艺术学院

RHO-DO-DEN-DRON
Julia Maja Funke
Academy of Media Arts Cologne

杜－鹃－花
茱莉亚·玛雅·芬克
科隆媒体艺术学院

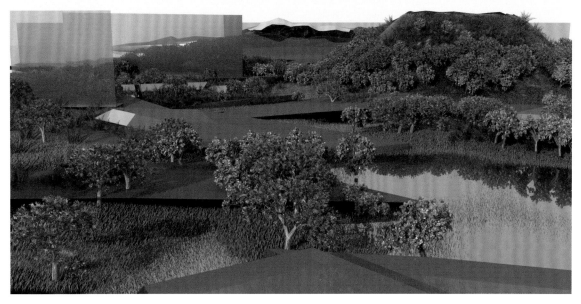

HALLUCINATIONS
Brian Uchiyama
Tisch School of the Arts, New York University

幻觉
布雷恩·内山
纽约大学帝势艺术学院

PEGASUS FLASH
Laila Majid
Slade School of Fine Arts, University College London

飞马流光
莱拉·马吉德
伦敦大学学院斯莱德美术学院

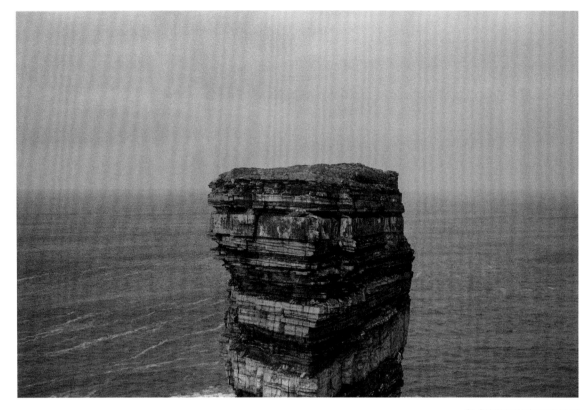

SLOWLY WESTWARDS
Mark McGuinness
Aalto University

慢慢西进
马克·麦吉尼斯
阿尔托大学

LOGON
Isabelle Beauchamp
Tisch School of the Arts, New York University

登录
伊莎贝尔·博尚
纽约大学帝势艺术学院

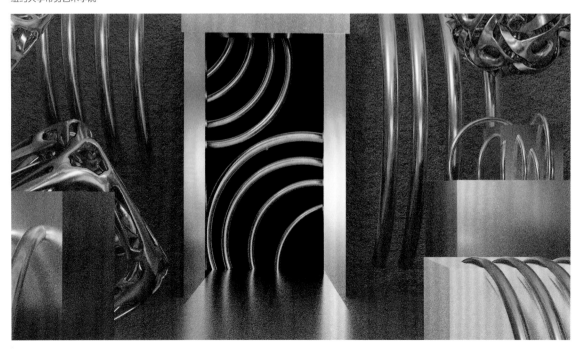

GLASGOW 1980
Caitlin Fraser
The Glasgow School of Art

格拉斯哥 1980 年
凯特琳·弗雷泽
格拉斯哥美术学院

7 TREES
Silke Zapp Sermon
The Glasgow School of Art

七棵树
西尔克·扎普·瑟尔蒙
格拉斯哥美术学院

DISORIENT
Sun Park
Parsons School of Design, the New School

迷失方向
朴生
帕森斯设计学院

RHYTHMS OF WINDING
Huw Messie
School of Art, Carnegie Mellon University

缠绕的节奏
休·梅西
卡耐基梅隆大学艺术学院

GHOST OF A PLANT
Sophie Chalk
Parsons School of Design, the New School

植物的幽灵
苏菲·乔克
帕森斯设计学院

REUNION
Lukas Sheehan
Tisch School of the Arts, New York University

团圆
卢卡斯·希恩
纽约大学帝势艺术学院

LIMINAL WORLD
Ama Dogbe
Loughborough University

阈限世界
阿玛·多贝
拉夫堡大学

RHYTHM ENLIGHTENMENT - FOUR PROLOGUE
Yuan Ruiyang
Sichuan Fine Arts Institute

声律启蒙——四序
袁瑞阳
四川美术学院

DEATH OF MYTH-MAKING
(29TH BIRTHDAY)
Conrad Cheung
School of the Art Institute of Chicago

神话的死亡（29 岁生日）
康拉德·张
芝加哥艺术学院

CITY OF CHANCES
Jordan Shum
Emily Carr University of Art + Design

机会之城
乔丹·沈
艾米丽卡尔艺术与设计大学

HOLY MOUNTAIN
Miray Atakan
Pratt Institute

圣山
米瑞·阿塔坎
普瑞特艺术学院

THREE PLACES AND ONE SOUL
Gong Bentong
Central Academy of Fine Arts

三点一生
宫本瞳
中央美术学院

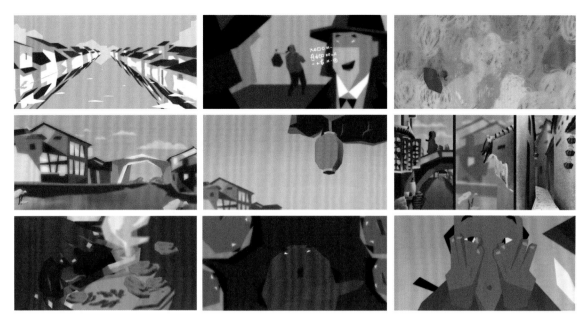

IMAGINATION OF THE TRUE STORY OF AH Q
Cai Mengyuan,Lv Liangjun,Nan Sihui
LuXun Academy of Fine Arts

《阿 Q 正传》异想篇
蔡梦圆、吕良军、南思卉
鲁迅美术学院

SOLARIS
Zhang Yuqi
Tisch School of the Arts, New York University

索拉里斯
张钰琪
纽约大学帝势艺术学院

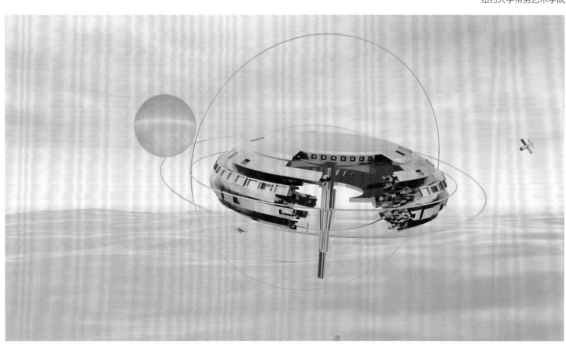

AVATAR
Fu Yuhong
Tisch School of the Arts, New York University

化身
傅玉宏
纽约大学帝势艺术学院

CONVERSATION WITH MYSELF
Liu Jiaqi
Parsons School of Design, the New School

与自己交谈
刘佳琪
帕森斯设计学院

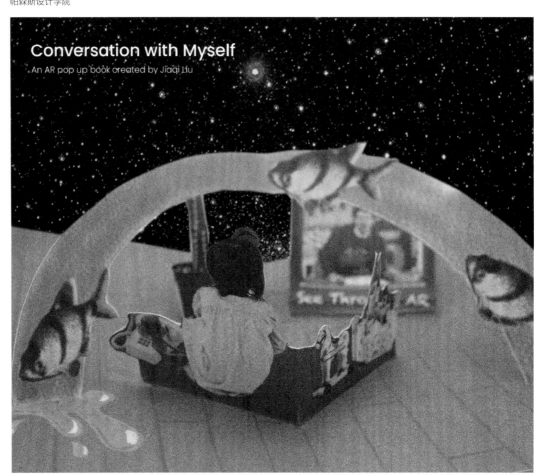

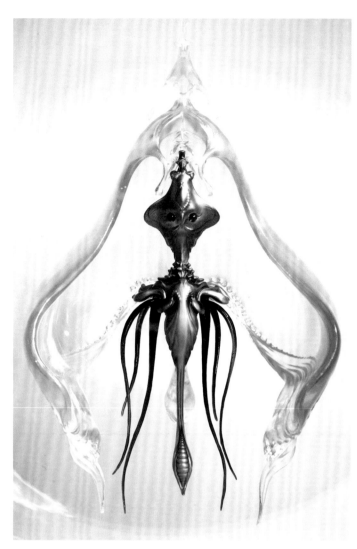

EIGHT DIAGRAMS
Yu Wenlu
LuXun Academy of Fine Arts

竜震
于雯露
鲁迅美术学院

KUAFU RUNS AFTER THE SUN
Cao Yanbin
Tongji University

夸父逐日
曹彦斌
同济大学

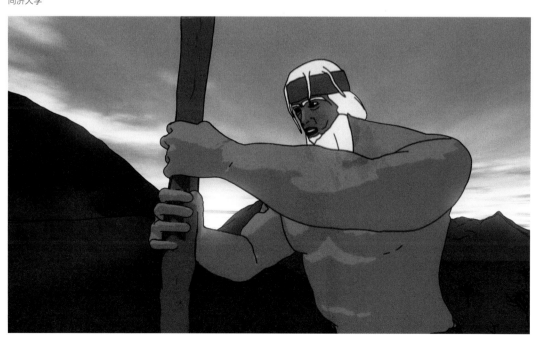

DIALOGUE: HOW TO TAKE A PORTRAIT OF A COLONY
Mei Xinyi
Tongji University

对谈：如何拍摄一块殖民地的肖像
梅心怡
同济大学

MUTUALLY EXCLUSIVE
Li Mengran
Xi'an Academy of Fine Arts

互斥
李梦然
西安美术学院

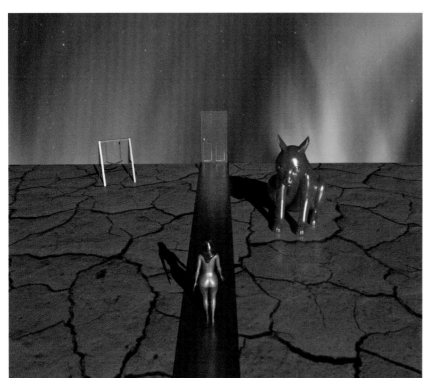

CLOUDY WITH A CHANCE FOR MEATBALLS
Katerina Vo
Tisch School of the Arts, New York University

多云，有吃肉丸的机会
卡特琳娜·沃
纽约大学帝势艺术学院

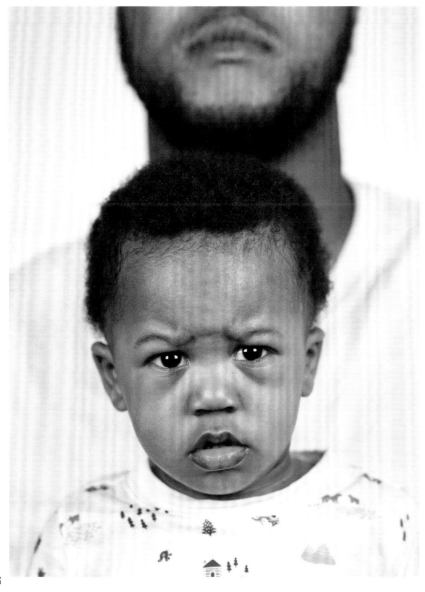

FATHER AND SON
Gene Tolan
Parsons School of Design, the New School

父与子
吉恩·托兰
帕森斯设计学院

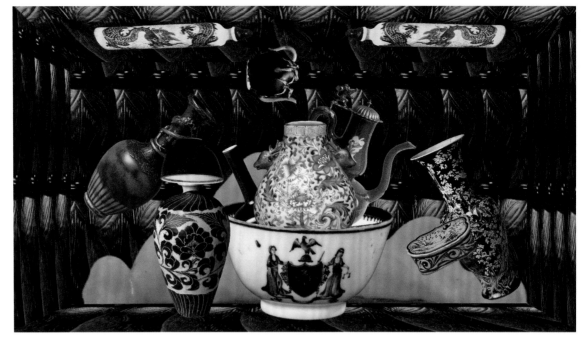

MIRAGED FINE CHINA
Wang Wujian
Maryland Institute College of Art

瓷器幻影
王武剑
马里兰艺术学院

DILEMMAS FOR EARTHLINGS
Jiang Zongbo
Royal College of Art

地球人的困境
蒋宗波
皇家艺术学院

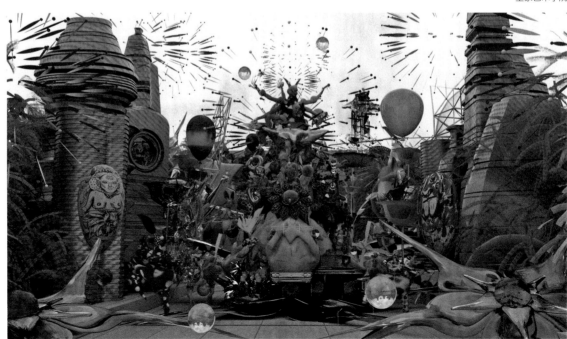

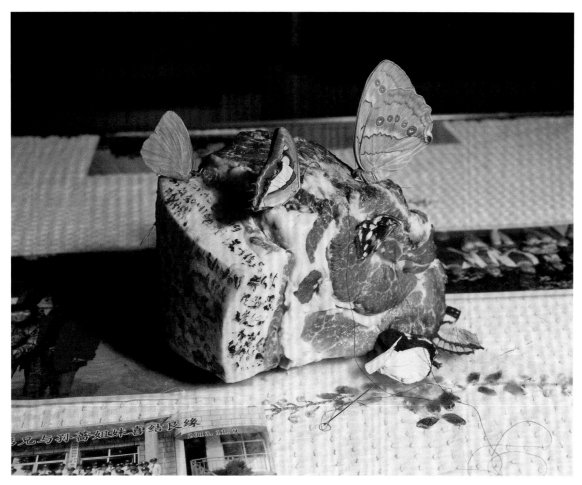

IF SPRING COULD FEEL ACHE
Yang Bowei
Royal College of Art

如果春天会痛
杨伯威
皇家艺术学院

INTERNAL PEELING
Liu Lijuan
Royal College of Art

内部剥离
刘丽娟
皇家艺术学院

METAMORPHOSIS
Wang Naitian
Tisch School of the Arts, New York University

变形
王乃天
纽约大学帝势艺术学院

CYCLE
Hu Junyan
Tisch School of the Arts, New York University

循环
胡峻岩
纽约大学帝势艺术学院

BREAK THE SPEED, I
Sven Witte
The Glasgow School of Art

打破时速，我
斯文·威特
格拉斯哥美术学院

THE OTHER SIDE OF THE WINDOW
Liu Shuhao
Parsons School of Design, the New School

窗户的另一边
刘书豪
帕森斯设计学院

WANDERER
Wang Yichan
Parsons School of Design, the New School

流浪者
王艺禅
帕森斯设计学院

UNDERWATER
Xia Elijah
Parsons School of Design, the New School

水下
以利亚·夏
帕森斯设计学院

FOOD
Jason Lau
Art Center College of Design

食物
刘家晋
艺术中心设计学院

BEAR
Hu Yongtao
Pratt Institute

熊
胡勇涛
普瑞特艺术学院